Egyptian
Sculpture

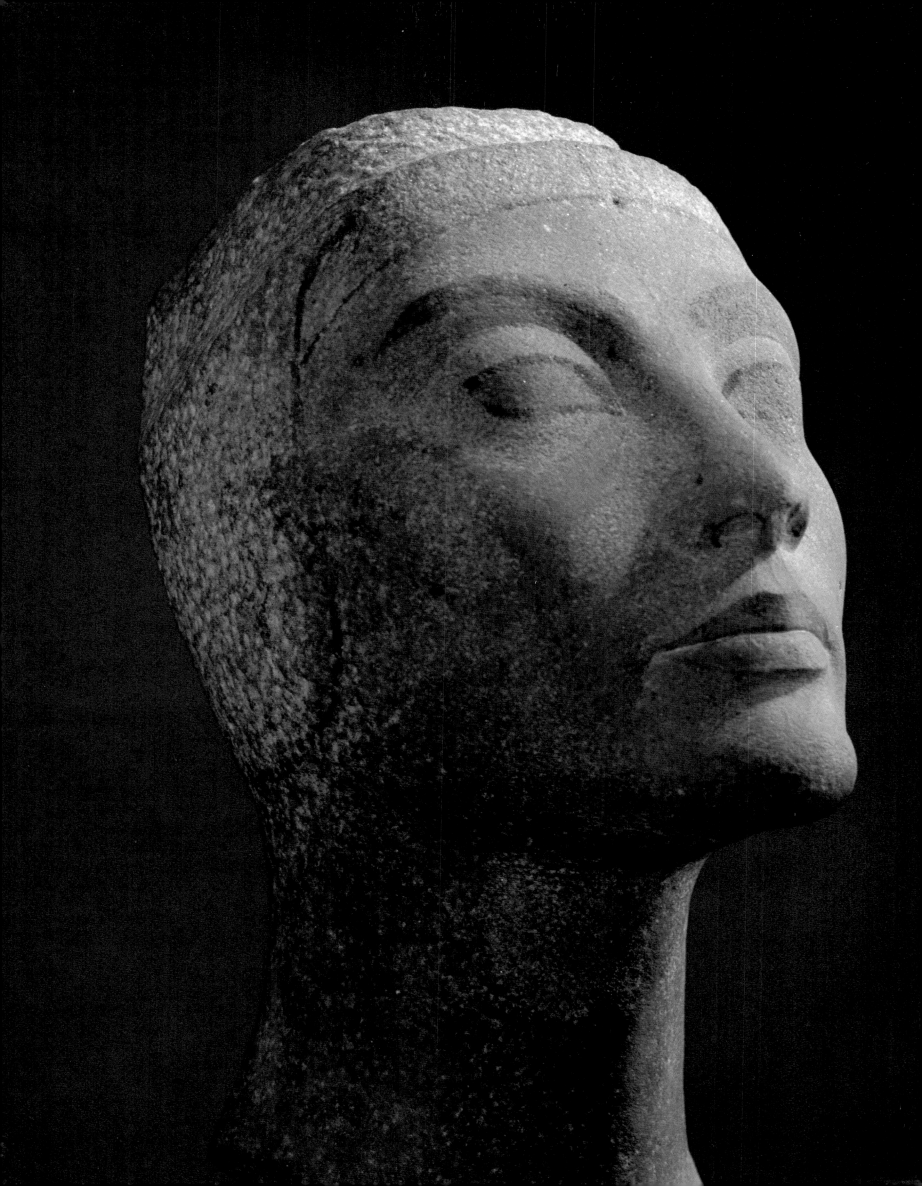

Egyptian Sculpture

Cairo and Luxor

by Edna R. Russmann
photographs by David Finn

University of Texas Press, Austin

Frontispiece:
Unfinished head of Queen Nefertiti
see also pp. 118–119

First Edition, 1989

Requests for permission to reproduce
material from this work
should be sent to Permissions,
University of Texas Press,
Box 7819, Austin, Texas 78713-7819.

The paper used in this publication
meets the minimum requirements
of American National Standard for
Information Sciences —
Permanence of Paper for Printed Library Materials,
ANSI Z39.48–1984.

Design and typography
by George Lenox

*Publication of this book
was made possible in large part
by a grant from the late
Mrs. Lutcher Brown, San Antonio, Texas.*

LIBRARY OF CONGRESS
CATALOGING-IN-PUBLICATION DATA

Russmann, Edna R.
 Egyptian sculpture : Cairo and Luxor / by Edna R.
Russmann ; photographs by David Finn. — 1st ed.
 p. cm.
 Bibliography: p.
 Includes index.
 ISBN 0-292-70402-X (alk. paper)
 1. Portrait sculpture, Egyptian — Egypt — Cairo.
2. Portrait sculpture, Ancient — Egypt — Cairo.
3. Portrait sculpture, Egyptian — Egypt — Luxor.
4. Portrait sculpture, Ancient — Egypt — Luxor. I. Finn,
David, 1921– . II. Title.
NB1296.2.R87 1989
732′.8 — dc19 89-5315
 CIP

Contents

Foreword

FASCINATION WITH ANCIENT EGYPT, a subject of universal appeal, captivated me first as a young girl. I discovered the Temple of Karnak, with its magnificent and unusual architecture, as an artist's beautiful reconstruction in a book. Unfamiliar lines, truly unbelievable scale, and fantastic antiquity aroused in me wonder and interest. I read that the huge pylons I saw in the pictures were built three thousand years before Greece and Rome. An interest was kindled that only grew brighter with age. As I became older, I enthusiastically read about these remarkable people and of the revolutionary capabilities and creative work that pervade the great temples and pyramids. That others may share a similarly enjoyable wonder and appreciation of ancient Egypt became the inspiration for this book.

"Do not be content," my mother wrote to me on a postcard from this very Temple of Karnak, until I had actually stood there in the great hall. Some years later, I had the wonderful experience of standing before what I had doubted could truly exist. I was completely overwhelmed. Inside the temple I overheard a guide saying that a hundred men could stand on the capital of one of the colossal columns. The Temple of Karnak is the most outstanding among a vast complex of monumental buildings. Before leaving this place, Heroditus' "City of a Hundred Gates," I had experienced an aura of transcendent order and dignity and pre-eminent appreciation for the creators of this most sublime architecture.

However commanding their architecture may be, another aspect of the Egyptians' genius is clearly seen in art independent of scale. In their sculpture, with equal care and grace, they rendered works from the smallest to the mightiest. Much of this sculpture's religious significance is lost for us; still, the timeless quality of these masterpieces remains — and is the reason they remain as renderings of life as it was and what it aspired to be. Today, we experience this art, if not quite as directly, perhaps more profoundly than did the original viewers, and in these intervening thousands of years what has not changed is the pleasure of fine line and form.

Egyptian sculpture has endured for five thousand years and could endure for thousands more. Yet, preservation becomes a concern in an age where human whims may cut short most valued existence. Thinking of this and of providing exposition, enlightenment, and enjoyment for a readership, I discussed with my mother, Emily Wells Brown, an idea for a book on Egyptian sculpture. Having a lifelong interest in art and being the one in whose house I had first learned of the marvels of Egypt, she unhesitantly offered to support such a project. I am most deeply grateful to her for this, as are, perhaps, in a measure, those who will delight in the pages that follow.

I want to thank John Kyle for helping to initiate this project and his dedicated staff for the ensuing fine and original work.

I offer my deep gratitude to Edna Russmann and David Finn, both gifted in their fields, for agreeing to undertake this difficult task and bringing it to fine fruition.

I would like to offer my great appreciation to the Organization of Egyptian Antiquities, especially the chairman and the many staff members whose cooperation has made possible this praise to the genius of ancient Egypt.

Joan B. Winter

November 11, 1988

Author's Preface

MAINLY THROUGH SERENDIPITY, I found myself in Egypt in 1966 on an extended visit. Knowing little of the country or its past, I wandered into the Egyptian Museum — and into another world. Crammed with exhibits, dusty, and almost empty of visitors, the museum in those days resembled nothing so much as antiquity's attic. I was fascinated; and, as I gradually came to know and love the unique, historically resonant land that had produced these treasures as just one part of its long story, the course of my life was changed. When I came home, it was to study ancient Egypt, particularly its art — the statues and other works that had so impressed me in the museum. Since then, as a lecturer, teacher, and museum curator, I have often wished that there were some way to recapitulate for others the immediacy with which I first encountered the art of ancient Egypt: a book, perhaps, that would present Egyptian sculpture, not as history or illustration, but for its own sake. Then Joan and William Winter went to Egypt and, having had, in the museum, an experience rather like mine, returned with the idea of supporting just such a book.

Nonetheless, our decision to restrict this book to sculpture in Egypt, and almost entirely to examples in the Egyptian Museum, was based on more than just our par-

ticular fascination with the place. Though sculpture and other pharaonic remains have been shipped abroad since at least the Roman Conquest, two thousand years ago, so that brilliant examples can be found in most of the great museums of Europe and America, Egypt is still unparalleled as the repository of its heritage. And despite the steady and welcome creation of local museums — such as the Luxor Museum, from which a few of our selections are drawn — the Egyptian Museum remains the great central repository of ancient art in Egypt. Today, few statues still stand in or near their original locations, but these are invaluable in providing at least some sense of their spatial and architectural setting, and we have also included some of the best of them.

More than most books of photographs with text, this was a true collaboration. In his preface, David Finn has described the way in which we proceeded. Working together was a pleasure, enriched for both of us by our very different experiences with and approaches to sculpture. Since mine was the task of choosing the statues, I was curious to know how David would react to them. He did, in fact, reject one of my choices: a strange, marvelous Old Kingdom figure that is unfortunately — I must admit — battered nearly to a hulk. However, it didn't surprise me in the least when he, like so many before him, succumbed to the allure of Nefertiti.

In order to give a fair idea of the variety of Egyptian style and its changes over time, I have attempted to include examples of the best from every period. Many readers will find that they prefer some periods or styles to others — as do I. Certain very familiar statues had to be included: they deserve their fame. For many of them, David Finn's vision may provide fresh insights. However, most of the selections are, in my view, much less familiar than they deserve to be, and a few are almost entirely unknown, even to specialists. To do justice to the subject in the available space, it was necessary to limit ourselves to major works in stone or wood. This meant the exclusion not only of some fine statuettes in gold and other metals but also of a whole array of lively or attractive little figures, created as servant statues or as parts of cosmetic vessels, jewelry, or other types of minor arts.

The text is not intended as an art history, or even a systematic analysis of Egyptian sculpture. It is a celebration of certain specific statues, and I have tried to describe what I find most attractive or intriguing in each. The factual matter is as accurate as I could make it. I have not shrunk from theorizing or even speculating, when I think such exercises may be fruitful; I have, however, tried to make it very clear when I go beyond the facts. A certain

amount of general historical background is included, but this has been kept to a minimum. The reader who wants further information will find at the back of the book a bibliography covering more general, as well as more specialized, publications.

Many people have helped to make this book possible. First and foremost, I join David Finn in thanking Mrs. Lutcher Brown and Dr. and Mrs. William C. Winter, who initiated the project and have steadfastly supported it throughout. In Egypt, photography was possible through the kind permission of the Egyptian Antiquities Organization, then under the direction of Dr. Ahmed Kadry; and the courtesy and cooperation of my esteemed colleague, Dr. Mohammed Saleh, former Director of the Egyptian Museum; Dr. Mohamed el Saghir, General Director for Southern Upper Egypt; and Mrs. Madeleine Yassa, Director of the Luxor Museum. My thanks also to Dr. Paul Walker, formerly Executive Director of the American Research Center in Egypt, and, in the Center's Cairo office, Dr. Richard Verdery, then Cairo Director, as well as my friend and colleague, Ms. May Trad, whose enthusiasm and efficiency surmounted so many problems. We warmly appreciate the unfailing helpfulness and enthusiasm of John H. Kyle, Director of the University of Texas Press, Barbara N. Spielman, Managing Editor, George Lenox, Associate Director and Designer, and their staff.

Edna R. Russmann

Photographer's Preface

I WANT TO EXPRESS my appreciation and gratitude for the inspiration and support of the late Mrs. Lutcher Brown and Dr. and Mrs. William C. Winter of San Antonio, Texas, whose deep love for the wonders of ancient Egyptian sculpture was responsible for the initial conception and ultimate publication of this volume. The Winters and the University of Texas Press provided the aegis under which Edna Russmann, or Ann, as she is known to her friends, and I were able to collaborate in the selection, photography, and exposition of the finest ancient sculptures in Egypt: Cairo and Luxor.

It proved to be a wonderful collaboration. While I had photographed and published the works of many of the great sculptors of Europe — Donatello, Ghiberti, Michelangelo, Canova, Cellini, Giambologna, Sluter, Henry Moore — I had little knowledge of or experience with the art of ancient Egypt. With Ann's help, I learned enough about the different periods of Egyptian civilization to understand something of the stylistic trends. And, under her guidance, I was able to photograph in the course of two unforgettable trips to Egypt the marvelous works she designated.

There are legends about the difficulty of photographing works of art in Egyptian museums, and I was apprehensive about the problems I might encounter in the course of my work. However, my fears proved to be completely groundless, mostly because of the extraordinary help and guidance I was able to get from Ms. May Trad of the American Research Center in Egypt. She was indefatigable in overcoming all the obstacles to my project, and as a result I received the most remarkable cooperation from the staffs of the Cairo and Luxor museums, who accommodated every request I made for lighting, ladders, background paper, and other facilities.

The project would not have been possible without the support of my granddaughter, Rachel Bloomgarden, who accompanied my wife and me on our trips. With hundreds of photographs to take for the book, Rachel helped me work out a schedule for each day's work. Her careful planning proved to be invaluable and she became a most dependable assistant on this and subsequent photographic projects.

As I focused my camera on these outstanding works, their superb sculptural qualities were a constant source of amazement. My purpose was to explore the aesthetic qualities of the forms rather than record their historic significance, and I found solidity, grace, delicacy, subtlety, power, humanity, and often exquisite beauty in the faces and figures I photographed.

The smaller works, which were for the most part taken out of display cases, where they stood virtually unnoticed among scores of other sculptures, proved to be monumental in character when viewed under strong photographic lights, and I marveled at Ann Russmann's sharp eye in making her selections. The larger works had all the qualities of great sculptures and revealed inspired combinations and undulations of form when photographed from different angles. It wasn't necessary for me to understand their historical backgrounds to appreciate their fine aesthetic qualities, although later it was a revelation to read Ann Russmann's fine interpretive text, which provides an insightful perspective for each of the works.

Perhaps the most exciting moment for me came on my second trip when, by chance, I was able to photograph the portrait head of Nefertiti with her glass case removed. The first time I had seen her I was told, apologetically, that it was impossible to remove the case. In the circumstances, I did the best I could and, even then, I found her regal beauty spellbinding. But a few months later, when I returned, I learned that arrangements had been made to remove the case in order to clean the glass. I rushed to the gallery to watch the procedure and, to my delight, was

given permission to photograph her in the open air for a few moments. I managed to do so from all angles and, using my lights carefully, felt that I was able to reveal the full majesty of her magnificent features. A year or so later, I happened to be in Berlin where I had a chance to examine the more famous portrait of Nefertiti and came to the conclusion that, although the latter is more colorful and has the benefit of that unforgettable headpiece, the sculptor of the Cairo portrait was a greater master than his Berlin counterpart.

I couldn't have succeeded in the project without the flexibility and precision of my Hasselblad camera. With four lenses (50 mm, 80 mm, 250 mm, and 500 mm), two extension tubes, and several proxar lenses, I was able to photograph details of the smallest objects, manage my way around crowded display cases, and focus large sculptures situated many feet off the ground. My Polaroid magazine attachment was invaluable since frequently I discovered that the correct exposure was different from what my spot meter told me, and test prints were more reliable guides to composition than was the naked eye.

All told, I took well over two thousand photographs of the works selected by Ann Russmann, and when they were processed she and I carefully reviewed each one to judge its merits in revealing the quality of the sculpture. This, in itself, was an adventure since it gave us a chance to combine Ann's knowledge of the works and my photographic eye for sculptural values. Although we didn't want to preempt George Lenox's design of the book, we also indicated which photographs we would like to see large and those we thought could be smaller. I also gave Ann a complete set of my black-and-white contact prints to have in front of her as she worked on her text.

The treasures in the Cairo and Luxor museums are unquestionably among the greatest sculptures ever created, and having an opportunity to photograph them proved to be an experience of a lifetime. I hope that I have succeeded in my task well enough to give readers the benefit of that experience through the photographs published in this volume. A full appreciation of these magnificent works will result, however, when the reader combines Ann Russmann's textual interpretations with the photographic images.

David Finn

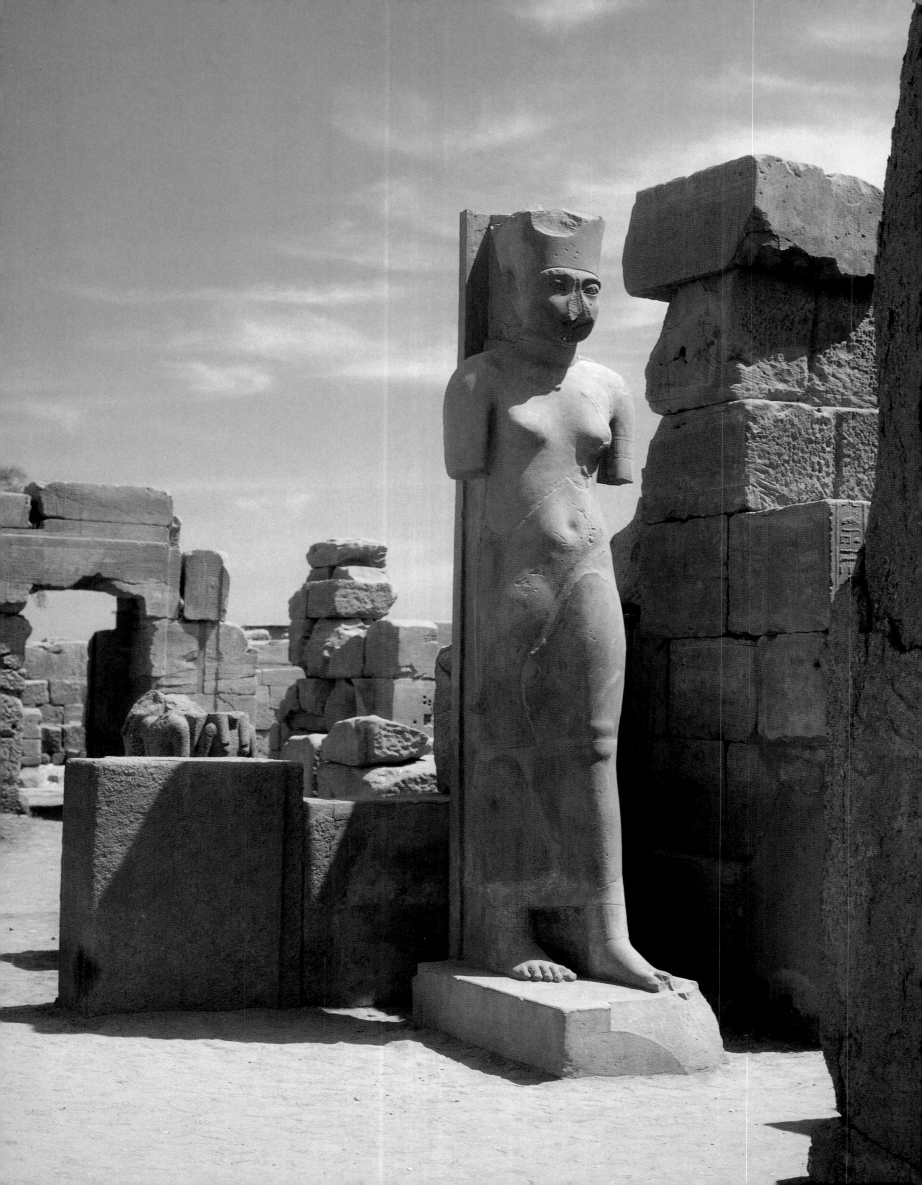

Egyptian Sculpture

Amunet, the consort of Amun
see also p. 135

Chapter 1 The Art of Egyptian Sculpture

THE SCULPTURE of ancient Egypt seldom receives the appreciation and recognition as art that its qualities deserve. Many museums number one or more very fine Egyptian statues among their collections, and the really great museums possess great ones; but they seem almost to be hidden behind an invisible screen of false expectations and bored inattention. Bewildered by a daunting parade of kings and dynasties, distracted by such fascinating but bizarre manifestations as mummies and animal-headed gods, discouraged by such repressively neutral descriptions as "artifact" and by such belittling clichés as "Egyptian art is all alike," a viewer can too easily miss — or even be afraid to look for — the riches right in front of our eyes. And that is a pity, because Egyptian sculpture offers great attractions, including a sympathetic and often memorable vision of the human form, and the pleasures of perfectly mastered technique.

It is sometimes suggested that ancient Egyptians had no true art, because they had no concept of art as such. Certainly, they had no word that can be translated as "art," although they did have terms to designate sculpture and the other arts. All of these things were made for a purpose, and it was in terms of their purpose that the language defined them. Art was a function of religion — but it was most certainly art.

One sign of this is the fact that the Egyptians appreciated their own art. It is incorrect to say that Egyptian sculpture was not made to be seen by human eyes. No one who approaches the temple of Abu Simbel, under the impassive, inexorable gaze of the four gigantic statues of Ramesses the Great carved into its façade, can miss their message: one is meant to feel puny and full of awe. Even in the tombs, where most statues might be walled up in statue chambers or tucked away underground near the mummy, one or more were often on view in the chapel, to be visited by the funerary priests or the family when they came to make their offerings. Statues within temples were accessible to priests and to anyone else permitted in the sacred precincts. As time passed, more and more sculpture was placed in the more public parts of temples, in front of temples, and even on the façades of tombs.

The constant emulation or outright copying of older statues shows that they were observed and admired. From the New Kingdom, there is even evidence of connoisseurship — or at least a kind of tourist enthusiasm — on the part of people who visited old tombs in order to view their decorations. Like later tourists, they wrote on the walls, leaving their names and often a remark that they found the object of their excursion "more beautiful than anything."

Perhaps the clearest sign of the Egyptians' appreciation of their art is the constant correlation between the most exalted patronage and the finest works — not just the best crafted but also the loveliest and most moving. Such a connection is commonplace enough throughout human history, but we must not take it for granted with the Egyptians. It shows, for one thing, that the great sculpture ateliers must have sought and attracted the most talented artists, even in this society so devoted to handing down professions from father to son. And, given the immense distances of time and custom that separate them from us, it is reassuring to find that the most informed Egyptian taste so often agrees with our own.

This does not mean, of course, that Egyptian ideas about sculpture were identical with ours. Far from it. An Egyptian statue was not a mere representation. For a private person, it was a means by which he or she could exist forever. For a god or a king, it was a manifestation that might itself be an object of worship. Egyptian sculpture was functional. From its function, it derived a significance so immediate and profound that it is probably beyond our full comprehension — especially since we cannot ourselves share the underlying magical beliefs. If an Egyptian statue had been properly made and animated by the correct rituals, it was truly capable of possessing life. This belief was most vivid and literal during the earlier, more primitive ages of their history, but it never entirely disappeared. We see evidence of it every time we find that a statue has been "blinded" by damage to its eyes, or "killed" by the deliberate destruction of its nose, to cut off the "breath of life" ⟦63⟧. Belief of this nature and intensity cannot but have influenced the very forms the Egyptians gave their statues. It was undoubtedly a major factor in the perennial tendency to idealization — but it must also, somehow, have governed the appearance in almost every period of what look very like portraits.

In order truly to appreciate the richness of Egyptian sculpture, therefore, it is necessary to operate on two levels. We must encourage and deepen our personal perceptions, but at the same time we should try to learn as much as we can of what the Egyptians themselves intended and

achieved. We can, for example, better admire the superb workmanship of a stone figure if we know how simple were the tools and how laborious the methods with which it was made. We may appreciate it even more, if we know that this particular piece is a supreme example in an era of splendid achievement — or, conversely, that it stands alone in a time of clumsy or declining work. We may find certain poses [such as 72] attractive or awkward, but we can judge them better if we know just what the figure is supposed to be doing, and why. We may be intrigued to learn that a charming but foppishly elegant fellow was a cavalry officer in a military age [48]. For those who succumb to the lure of Egyptian sculpture, it is often this interplay between the familiar and the strange or surprising that lies at the root of their fascination.

For many reasons — not the least of them the fact that they produced so very much — the Egyptians have left behind a huge legacy of things they made, including a significant number of very fine works of sculpture. Inevitably, however, a vastly greater quantity of lesser statuary is also preserved. The mediocrity, pathetic clumsiness, and occasional plain awfulness of run-of-the-mill Egyptian sculpture testify that the Egyptians were inept, careless, competent, and brilliant in about the same measure as all other human beings. Even the least of these figures is full of interest, of course, and many are attractive. But they do not represent the real achievements of Egyptian sculpture.

From early in prehistoric times, Egyptians fashioned little anthropoid figures, mainly in terra-cotta and bone; somewhat later, perhaps, they also began to carve them in wood. Wooden statuary was to remain important through most of Egyptian history. But sculpture did not really come into its own in Egypt until it also began to be made in stone.

When Egyptian craftsmen began the fashioning of stone sculpture, they already controlled the necessary technology, gained from several centuries of experience in the virtuoso carving of ornate, thin-walled stone vessels. These highly developed skills help to explain why the "archaic" stage of sculpture was relatively short. Even very early stone statues show a high degree of proficiency [1]. The main tasks of the earliest sculptors were to establish suitable poses and other conventions and to teach themselves how to credibly render the human form in three dimensions.

They seem to have started by drawing very heavily on images already established in two-dimensional monuments, like the reliefs on the Narmer Palette, made at the beginning of the First Dynasty. Two of the earliest statue

poses, which represent the figure standing or seated on a chair or stool, were already standard for relief representations of kings and tomb owners. Adapting the highly stylized forms of Egyptian two-dimensional art to figures in the round was not, however, accomplished without some difficulties. Much of the anatomical clumsiness of early statues like [[1]] and [[2]] occurs in just those areas — such as the transition from shoulders to neck — that are least naturalistically handled in Egyptian reliefs [[as on the very much later relief figures on the base of 89]].

The fact that the Egyptians wrote with pictures — hieroglyphs — profoundly influenced every aspect of their art. The distinction between sign and picture, so basic to our way of looking at things, was ambiguous in Egyptian painting and relief. Seated and standing figures, for example, were drawn to represent real people, but they appeared in virtually identical forms as hieroglyphs. Even a statue was regarded, at least in early times, as in some sense a three-dimensional hieroglyph. This is very clear on many Old Kingdom statues, where the owner's name, written on the base, lacks the final hieroglyph: a "determinative" sign placed at the end of personal names, in the shape of a human figure. It was unnecessary on the statue, which itself served as the determinative sign.

The interconnection among hieroglyphs, two-dimensional representations, and sculpture also helps to explain one of the basic characteristics of the Egyptian standing male statue: the fact that the left foot is almost always advanced. In the normal direction of hieroglyphic writing, from right to left, the signs must face to the right. This preference for rightward-facing figures is reflected in reliefs and paintings, where (unless subject to other considerations, such as symmetry) the most important figure invariably faces right. The far leg, on the side away from the viewer, is shown forward, even if the subject is not in motion, in order to make it visible. And so it was done on standing statues. If a two-dimensional figure had its arm raised, to hold a tall walking stick, for example, it would be the far arm — the left on a rightward-facing figure — in order to obscure the rest of the body as little as possible. Statues shown holding such staffs grasp them with the left hand [[9, 17]].

No doubt these conventions were also influenced by other factors. Apparently, most people do tend to stride out with the left foot. Right-handed men may actually have tended to carry their walking sticks in their left hands. Women are usually shown in statuary with both feet sedately together; this was probably a realistic interpretation of what appears as a compromise in reliefs and

paintings, where a woman's far foot is partially visible, just slightly in front of her near foot.

It is a gross oversimplification to suggest that the "squareness" of Egyptian sculpture was due to the stone-carvers' inability to break free from the rectangularity of the blocks with which they started. No doubt an ancient sculptor (like a modern one) tended to think of his raw material as squared-off blocks. But the "squareness" might better be described as self-containment, heaviness, density — and this is deliberate. The firm, closed silhouette and the base that anchors it so solidly to the ground show that there is no intent, in an Egyptian stone statue, to disguise the nature of the hard, unyielding medium, which was chosen precisely for its permanence.

Verisimilitude was provided by the paint, which covered the carved surfaces with a simulation of natural color. The colors the Egyptians used do not strike us as especially naturalistic; yet there is something strangely lifelike in the effect of those few statues where the paint is still fully preserved [[4]]. But even paint could be dispensed with, at least on some kinds of stone. As early as the Old Kingdom, sculptors began to leave unpainted many statues made of granite, contenting themselves with merely pointing up such details as the hair and eyes with black and white. It is possible that they had decided the reddish or grayish color of the stone was a sufficient approximation of skin tones. But they must also have been responding to the nature of this hard stone, the surfaces of which could be enhanced by polishing. Limestone, the stone first used extensively for sculpture, is soft and easier to work, but it could never be polished to a gloss. Until quite a late date [[63, 71]], limestone statues were always fully painted.

We usually do not know why a particular stone was used for any given figure. There is some evidence that, at least in the Old Kingdom, people preferred to have their tomb statues made in a variety of stones and woods, perhaps to take the fullest possible advantage of the virtues of all materials. In the temples, hard stones were most often used, in part, no doubt, for practical reasons. Reddish stones like quartzite may sometimes have been chosen for their similarity to skin color, but the color of this stone may also have invoked solar symbolism.

Egyptian stone sculpture generally avoids the use of pierced openings and projecting elements. Projections, which would have rendered a statue needlessly vulnerable to damage, were avoided without much trouble in the static formal poses, which held the body straight and facing front, the arms close to the sides. There was, however, one considerable problem. Gods, kings, and officials alike

seem to have carried staffs, batons, flails, and other wand-like instruments as signs of their status, and even their identity. Often they held them against the body; these implements could be represented in relief [[29, 60]]. However, this was an awkward solution for objects that in reality stood partly away from the body, like ceremonial fans [[see 63]]; for other badges of office, it didn't work at all. The typical Old Kingdom official seems to have gone about equipped with a long staff in one hand and a slender baton held horizontally in the other. On his stone statues, these long slender status symbols were denied him, replaced by a nondescript little rolled handkerchief — a practical object with the further virtue that it could be almost entirely enclosed within the fist.

Holes were avoided by the simple device of leaving a fill in the spaces between the limbs, between the body and the back pillar, and elsewhere. These flat, recessed areas are known by the modern term "negative space." The name seems suitable, because on some statues negative space is painted black, to signify that it does not exist. Negative space was not in any way the result of technical difficulties in carving stone. The spectacular openwork on thin-walled stone vessels made in the First Dynasty and even before shows that, if sculptors had wished to pierce holes in their statues, they could certainly have done so. Now and then, in fact, they did [[14]]. But they clearly preferred the solidity of negative space, and its use is almost universal on Egyptian stone figures. In the New Kingdom and Late Period, its larger surfaces, especially the space behind the advanced leg, were frequently employed for inscriptions and reliefs.

Of all the conventions peculiar to the sculpture of ancient Egypt, perhaps the most peculiar — and the most mysterious — is the back pillar, that rectangular shaft which covers much of the back of standing figures, and of many statues in other poses. No satisfactory explanation has been offered for this feature. It cannot be a primitive holdover, for it is not found on archaic statues [[like 1–3]]. It is not a reinforcing element, for many back pillars reach only to the top of the shoulders, leaving the most vulnerable parts of the statue, the neck and head, unprotected. In later periods, it was important as a vehicle for inscriptions, but it was not originally intended for this purpose: early examples of back pillars are blank, even though there are inscriptions on the base. If the feature had a symbolic function, it seems curious that its appearances are so inconsistent: standing figures almost always have a back pillar, but seated scribe statues very seldom do before the Late Period. A few statue types, such as the block

statue, are rarely given one in some periods, almost always in others. Seated statues may or may not have it; sometimes the chair back is extended upward to take its place ⟦4 is an exaggerated example of this⟧. The shape and height of a back pillar are roughly consistent within any given period, but variations are frequent. Often, for example, it is widened to extend beyond the figure on either side, in a kind of back slab. Sometimes the back pillar seems architectural. On a few Old Kingdom limestone statues, the back pillar and the base are painted pink with gray and white spots to imitate granite. New Kingdom figures tend to stand well away from their back pillars, to which they are connected by a thick negative space.

Whatever its meaning, the back pillar was an integral part of the statue. It is often represented on Egyptian drawings of statues, and it lasted as long as Egyptian sculpture was made. From late in the Ptolemaic Period, there are even a few figures in almost pure Hellenistic style, but with back pillars — presumably to certify them as Egyptian.

As we might expect from craftsmen so attuned to the nature of their materials, Egyptian wooden sculpture differs in small but significant ways from that in stone. Though they do have bases, wood statues are rarely encumbered by a back pillar, and almost never are the natural openings plugged up with negative space. These figures hold their appropriate implements in the accustomed manner ⟦9, 17⟧. Their poses and proportions may be virtually the same as those of their stone counterparts, but they look lighter, slimmer, livelier.

Since hard woods had to be imported, and even the poorer local products were usually available only in small pieces, the sculptor in wood had to make his figures piecemeal. The arms, the fronts of the feet, and the base were almost always made separately and pegged to the body. Anything the statue carried was carved as a separate little model. A wooden statue might even be given real miniature jewelry ⟦52⟧ or wrapped in a piece of linen as if it were cloaked.

The little doll-like figures of the Middle and New Kingdoms tend to be best preserved ⟦24, 25, 48, 52⟧, but many life-sized wooden statues were made during the Old Kingdom ⟦9⟧, most of which have been lost, over the millennia, to termites and bonfires. To judge from what has survived, wood statues seem to have been made mostly for tombs, where they would have been safer from accidental damage than in the temples.

Whatever its material, an Egyptian statue almost never makes any concessions or allusions to its actual

size. Many have been disconcerted by their first view of an Egyptian statue with which they are familiar from photographs. With a slight shock, they find it to be very much larger, or tinier, than they had assumed. The Egyptian sculptor thought in terms of human scale; theoretically, you look each statue in the eye, although actually doing so is more often than not physically impossible. The sculptor made strikingly few concessions, even to the practical problems of viewing very large works. Anyone who has visited Abu Simbel, and gazed up at the colossal seated figures of Ramesses II, probably remembers them as squat, and all knees. These effects could have been mitigated, at least to some extent, by proportionally enlarging the upper bodies and heads, to counter the diminishing perspective as we look up. But distortion in the service of visual illusion was not the Egyptian way.

If we admit that the Egyptians produced art, then we have to call the men who made it artists, although they worked to rules and conventions that seem to us inflexible and burdensome in the extreme. It is not likely that the Egyptian sculptor, a product of his own conservative society, saw things that way. He had very likely been born into his profession and started his apprenticeship while still a child, beginning with the simplest and humblest tasks and advancing through the rough work of early stages to the fine carving and finishing of a statue. He did not work alone, but as part of a team. If he was successful, he would find himself in charge of a workshop, planning the work, supervising his team, very likely putting on the finishing touches as only he could do them. His social standing, if not exalted, was comfortable. If he reached the top, as king's sculptor, he was a man of considerable importance. He may be anonymous to us, but he was certainly known to his contemporaries.

But none of this tells us of the pride and mastery of the artist at work. For that, we must go to the works themselves — to the masterpieces that simply would not exist if the sculptors had been mere craftsmen, if they had felt stifled by the rules that governed their work, if they had not exploited their imaginations as well as their skills. The absolutely perfect placement of the falcon behind Chephren's head [6], the smug bonhomie of the Sheikh el Beled [9], the artful drama in the face of Sesostris III [26], the perfection of beauty that is Nefertiti [55], the perfect dignity of an anonymous old man in a cloak [88]: all these and many others show the creativity of a true artist, the shared humanity that can span millennia, to link the perceptions and sympathies of cultures as different as Egypt's and our own.

Chapter 2 The First Great Period

The Old Kingdom

Dynasties 3–8

(CA. 2649–2134 B.C.)

Archaic Sculpture, Dynasties 2 and 3
(CA. 2770–2575 B.C.)

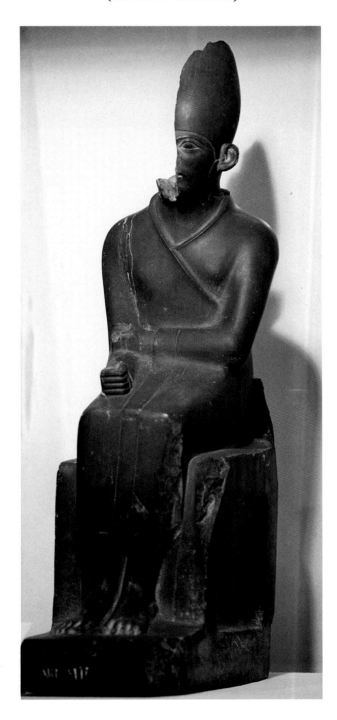

⟦ 1 ⟧

King Khasekhem
DYNASTY 2, CA. 2650 B.C.
GRAYWACKE; HT. 56 CM

THE EXTENT of Egypt's early achievement in sculpture can be seen in the seated figure of the Second Dynasty king Khasekhem ⟦1⟧, carved in a greenish graywacke and, despite the loss of one side of his head, remarkably well preserved. Along with a similar but more fragmentary figure of the same king in white limestone, this is one of the most ancient datable statues in the world, possibly the earliest to represent a known historical personage. Technically, the stone carving is very skillful; the sculptor has shown a fine sense for the beauty of the stone, which he has polished to a soft, semimatte luster.

Khasekhem wears the tall White Crown of Upper Egypt and is wrapped in a cloak or robe, the edges of which stand stiffly away from the neck. The garment resembles one worn by later kings during the *heb sed,* a ceremony of royal renewal. The king's throne is a plain, low-backed chair. It stands on a base incised with tiny figures of enemies, rather crudely but vividly portrayed in the tumbled attitudes of violent death, literally under the weight of the royal power.

In profile, the king's posture appears slumped, or bowed by age. His shoulders are rounded in a manner uncharacteristic of later royal figures. The effect is emphasized by the forward thrust of his thick neck; this may in part be deliberate, but it also shows some awkwardness in connecting the slightly oversized head with the torso. These marks of clumsiness or uncertainty, in so accomplished an example of stonecarving, are signs of its archaic style, as are the large, staring eye and the position of the left hand in front of the torso.

Though less than half of Khasekhem's face has been preserved, its fine and rather subtle detail deserves a close look. The eye is large and stylized, but the sculptor has taken great care to convey the roundness of the eyeball within its socket and even the minute droop of the corner of the upper lid over the lower. The flesh of cheek and jaw is sparely but quite naturalistically modeled, especially under the eye and in the slight bunching of flesh at the corner of the mouth. This sensitive but restrained treatment of the face prefigures, to an astonishing degree, the

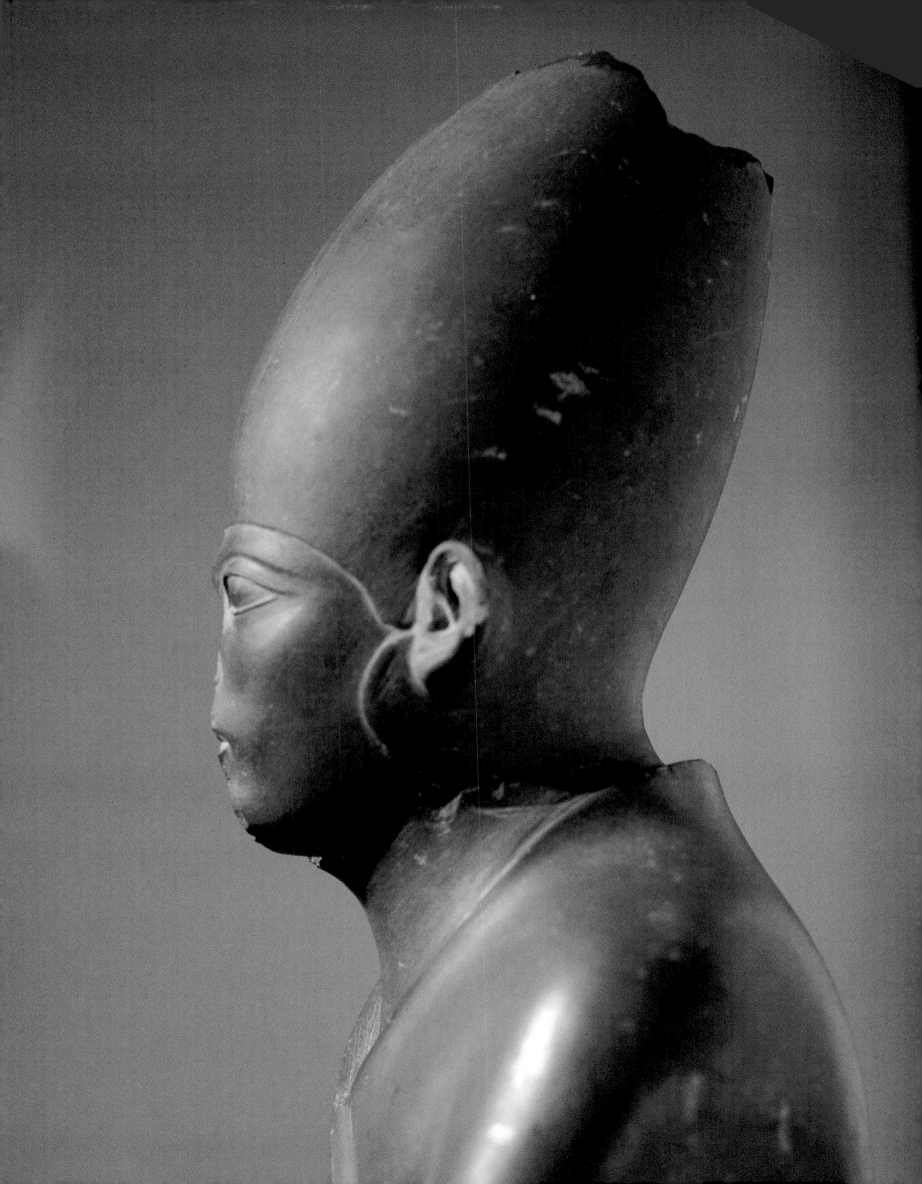

style and techniques of the great classic works of the Old Kingdom, some two centuries later ⟦6⟧.

Some of the same naturalism appears in the modeling of the king's feet. The rest of him, however, including his hands and ear, has been treated much more summarily. Here is already the tendency, so marked in later Egyptian sculpture of all periods, to concentrate attention and detail in certain areas of the statue and to simplify everything else. The strongly rectilinear effect of Khasekhem's statue in its front view may, therefore, already be the

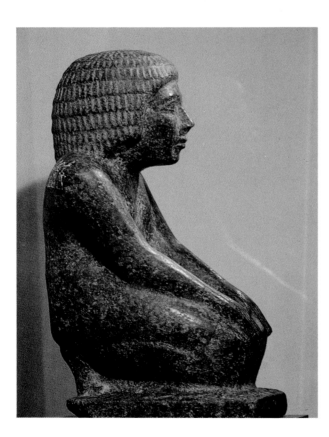

⟦ 2 ⟧

The funerary priest Hetepdief
DYNASTY 3, CA. 2649–2575 B.C.
RED GRANITE; HT. 39 CM

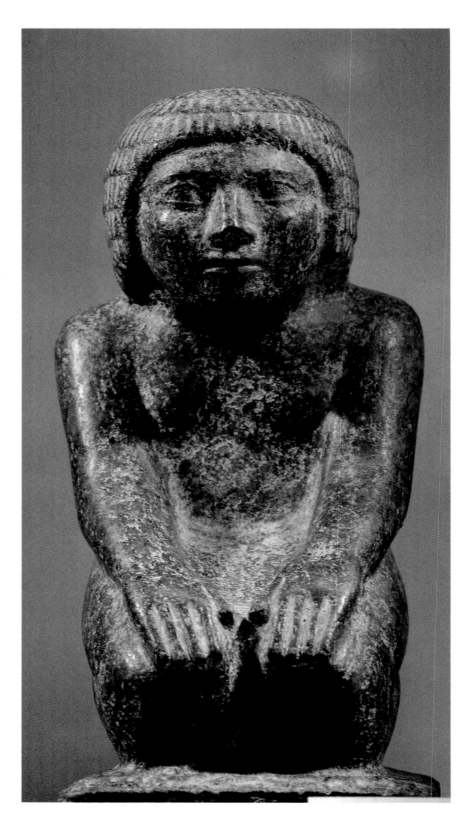

product, not of a primitive, but of a quite sophisticated taste. However, there is a "stony" quality to this figure, a kind of subordination to its material, that will not be found on statues made even a century later [[3]]. A comparable effect may be found in the archaic statuary of Greece and other cultures.

A counterpart to the earliest identifiable royal statuary of Khasekhem is the small kneeling statue of a man named Hetepdief, probably the first named statue of an Egyptian private individual [[2]]. It was carved somewhat later, most likely during the Third Dynasty. Hetepdief's name is inscribed on the base of the statue. On the back of his right shoulder are the names of the first three kings of the Second Dynasty. Apparently Hetepdief acted as funerary priest of their cults, and it is in this capacity that he is represented, in the kneeling pose of a worshipper.

Ordinarily, one would expect to see artistic progress over the generations separating this statue from Khasekhem's seated figure, but the carving of the priest's image is technically inferior to the earlier work, and its relative crudeness gives it a more primitive aspect. Hetepdief's head is noticeably too large for his body and seems to hang too low and forward on the shoulders. The sculptor has evaded the problem of getting the neck right by hiding it with the curls of the headdress. The figure seems still partly embedded in its stone matrix: facial features show a minimum of detail, and the limbs, their angularity reflecting the original stone block, are not fully differentiated at the front of the torso.

There are at least two obvious reasons for this apparent backsliding. First, Hetepdief had his statue carved in red granite, much harder and far more laborious to carve with primitive tools than Khasekhem's graywacke or the soft white limestone of much early sculpture. Second, Hetepdief was not a king, and he may not have had access to the royal atelier. In later periods of Egyptian art, there is often a noticeable difference between the quality of statuary carved for the king and his intimates and that produced by the secondary workshops catering to less-favored individuals. A similar social stratification of art is to be found in many cultures.

Since it is kneeling, Hetepdief's statue was probably not made for his tomb. Like many people, the Egyptians considered kneeling an attitude of submission — suitable in the presence of one's lord or one's god but hardly appropriate in one's own tomb. It would seem that Hetepdief had been allowed the honor of placing his statue in a temple, a privilege not generally available to nonroyal individuals until a thousand years later. For all its simplicity — or perhaps because of it — the little figure, with

its solemn, rapt gaze, is an eloquent expression of humility and hope in the presence of the divine.

The limestone seated figure of Djoser, a king of the Third Dynasty [[3]], represents the culmination of the archaic style in Egyptian sculpture. Djoser's tomb is the Step Pyramid at Saqqara, the first monumental stone structure in the world. This life-sized statue was placed at the base of the pyramid's north side, in a little stone room. This was the *serdab,* the closed statue room where Djoser, through his image, was to maintain contact with the world of the living, hearing the prayers of his funerary priests just outside, smelling the incense of their rites and the aroma of the food offerings, with which he would be magically nourished. When archaeologists unearthed the statue, it still sat in the *serdab,* facing two little circular holes carved in the north wall, its contact point with the world. Only the damage to the head, caused by tomb robbers intent on gouging out the precious gold and crystal of the inlaid eyes, serves as a reminder that it had ever been disturbed during its four and a half millennia staring out from that little room.

Like his pyramid, Djoser's statue expresses the forceful energy of a culture just beginning to realize its creative powers. Here is a confidence still raw and almost brutal in its determination to surpass — to prove its strength in achieving what had literally never been done before. Djoser's figure is commanding and yet very down to earth. The simplicity of his throne, the gesture of one fist clenched on his breast, and his wrapped garment with its stiffened upper edge are all in the archaic tradition [[see 1]]. But the stern set of his features and the leonine majesty of the large wig and pleated headcloth are the work of a sculptor who not only was a master of representing the human form but also possessed an eye for psychological effect. A modern viewer, prompted to some extent by the cavernous shadows of the empty eye sockets, may be reminded of Shakespeare's King Lear. Though fanciful, this comparison is curiously apt. For all their differences, the play and the statue share a somber, brooding quality. Each reflects, in its own way, the human loneliness of supreme royal power.

The paint of Djoser's statue is badly worn, probably by erosion from windblown sand after his *serdab* chamber lost its roof, while it was filling up with the sand that preserved the figure unseen until modern times. The traces of color show that the white stone was painted to simulate the colors of life. The linen of the king's robe and headcloth is white. His skin is the dark ocher red conventional for men. The coarse strands of the heavy wig are black, as is the long, wavy beard. Apparently, this is

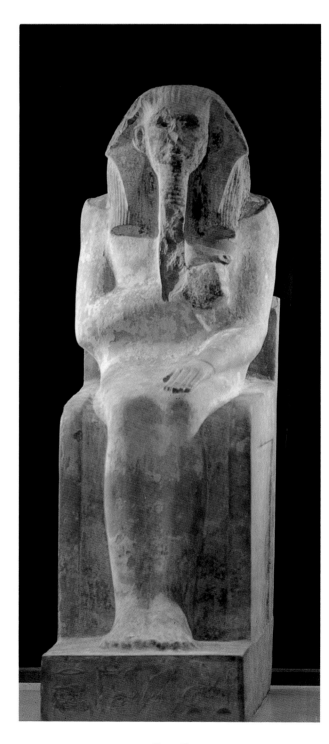

[[3]]

King Djoser
DYNASTY 3, CA. 2630–2611 B.C.
PAINTED LIMESTONE; HT. 135 CM

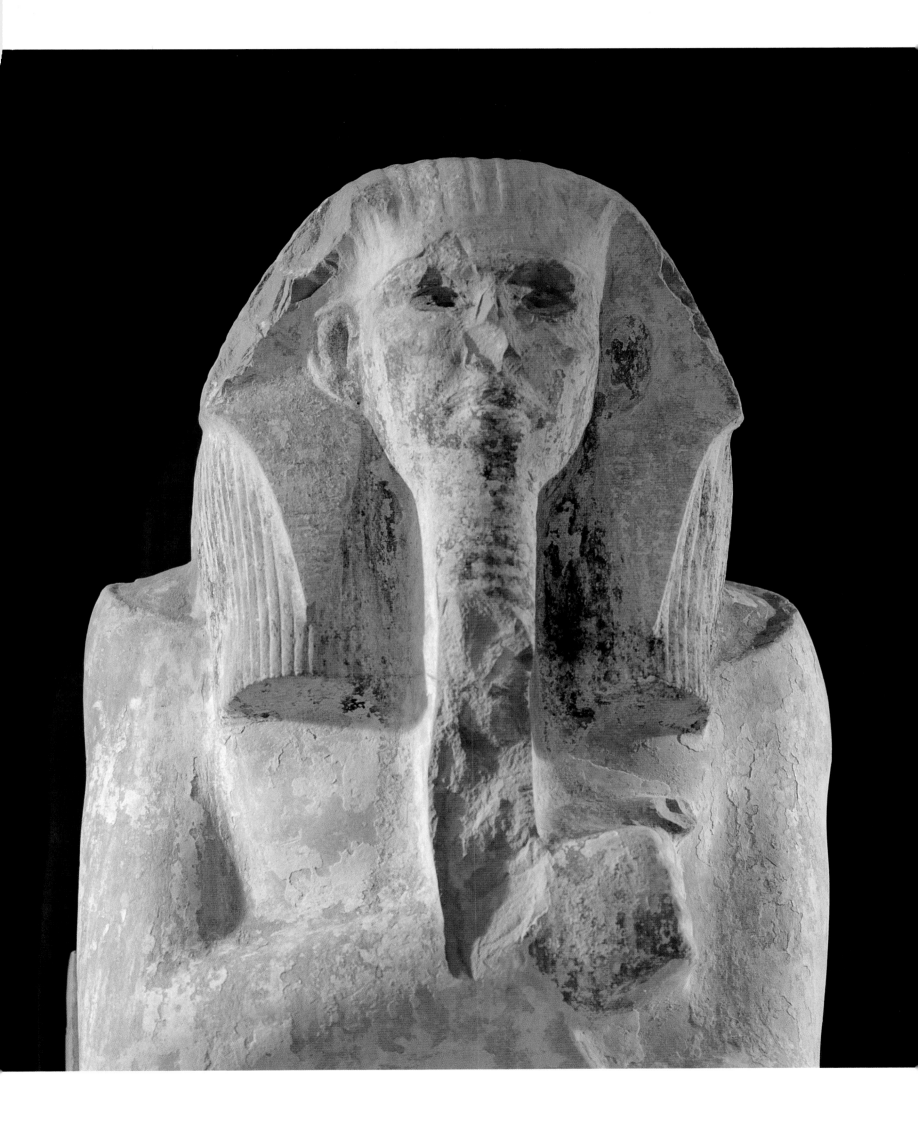

already a false beard, tied on for ceremonial appearances as in later times, for a painted strap can be seen on the sides of the cheeks, running up to the ear. Certainly his own, however, is Djoser's small black moustache. Moustaches are rare in most Egyptian art, but in the Third and Fourth Dynasties, they seem to have been cultivated by a few kings and other great men ⟦4⟧.

Not only Djoser's moustache but his other facial features as well may give us a fair idea of how this man actually looked. In the underground passages of the Step Pyramid, several relief representations of the king show a similar heavy face, with the same slightly prognathous lower jaw. For perhaps the first time in history, we can recognize at least an official, possibly a real, likeness of an individual.

But the identity of the statue in Egyptian eyes — its capacity to be a body for Djoser's spirit and no other — was primarily due to the magical rites performed over it when it was installed in the *serdab* (and even while it was being made) and to the inscription on the front of the base. Reading from right to left, this gives two of his most important titles: "King of Upper Egypt [the reedy plant above the half loaf of bread] and of Lower Egypt [the bee and the other half loaf]" and "Two Ladies," referring to the goddesses Nekhbit of Upper Egypt and Wadjet of Lower Egypt, in the form of a vulture and a cobra. The last four signs spell one of his names, Netjerykhet. The carefully carved hieroglyphs are more than a mere label, for they bring to the statue the power of the word and confer identity by naming it. Rarely does an intact, completed Egyptian statue lack at least the name of the person it represents.

The Fourth Dynasty
(CA. 2575–2465 B.C.)

The Third Dynasty can be considered the dawn of the Old Kingdom, the first great epoch of ancient Egyptian history, which lasted through the Sixth Dynasty. (For further details, see the Chronology at the back of this book.) As Djoser's statue demonstrates, the considerable achievements of this dynasty marked a turning point from the strong but still immature art of the Archaic Period to the fully developed style of the Fourth Dynasty.

However, royal patronage does not explain the single most remarkable aspect of Fourth Dynasty sculpture — its greatness. This is unquestionably one of the supreme periods in Egyptian sculpture, probably one of the major sculptural periods in world history. Just as the impressive but tentative form of the Step Pyramid was now superseded by the vast glistening slopes of the true pyramids, so the powerful but heavy forms of archaic sculpture, like Djoser's statue, gave way to the perfection of a

style that was at once simple but elegant, restrained but expressive: a truly classical style, one that was to leave its mark on Egyptian art for all time to come. It is important to remember that all this was happening for the very first time. The Egyptians had no precedents or models anywhere in the world for what they achieved in the century around 2500 B.C. This most conservative of peoples reveals itself, in this period, as one of the most creative.

The first stage of this Fourth Dynasty development has fortunately been preserved for us in a pair of life-size statues representing the "King's Son" Rahotep and his wife Nofret [[4]]. Walled inside their great tomb at Meidum, near a pyramid built for King Snefru, the first king of the Fourth Dynasty, or his predecessor, the couple's statues somehow escaped the attentions of tomb robbers. When found in 1871, they were almost exactly as they had been when they were sealed away, almost 4,500 years before.

The virtually complete preservation of the paint on these two figures and the retention of their inlaid eyes offer our best clue to how other large painted statues, such as Djoser's [[3]] and Ka-aper's [[9]], originally looked. There is nothing subtle about the colors. The strong, rich mineral pigments are laid on in conventional tones: reddish ocher colors the youthful body of the man, while yellow serves to indicate the paler skin of his more housebound

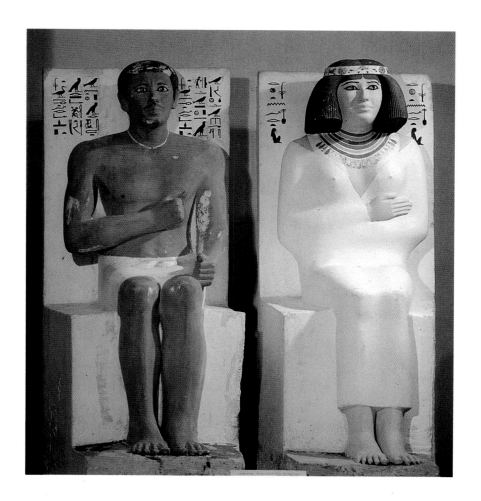

[[4]]
Rahotep and his wife Nofret
DYNASTY 4, CA. 2575–2551 B.C.
PAINTED LIMESTONE; HTS. 120 CM, 118 CM

wife. Though the painting is not naturalistic, these bright figures have an almost eerily lifelike quality, intensified by the extraordinary effect of their inlaid eyes. Each eye is a piece of rock crystal, with the iris and white rendered in paint on the flat back and a hole drilled in the center and filled with black to make the pupil. The front surface, curved and highly polished, simulates a human cornea. Each eye was framed in a thin strip of metal before being fastened into the eyesocket. This kind of inlaid eye must have been very costly — tomb robbers invariably ripped them out when they had a chance. Its effect is remarkably like that of a living eye.

Compared with Djoser's figure, Rahotep and his wife show considerably more finesse. For the first time, we see heads that look exactly the right size for their bodies and that sit with perfect naturalness on the shoulders. Instead of the king's simple chair, the pair sit on unadorned blocks, with the backs extended to the height of their heads. This high back may be an early step toward the back pillar. It provides an admirable frame for the figure and — even more important — a place for the identifying name and titles, right beside the head.

In many ways, these statues still reflect the past: in their pose, for example, with hand on chest, and especially in their grave, sober expressions. Rahotep wears a simple short kilt and a white neck cord strung with a tubular bead and an amulet, which seems to represent a turtle. Like Djoser, he sports a little moustache; otherwise, his strong, handsome features are very simply rendered. Yet he exudes intensity in the taut, tapering planes of his cheeks and the intent, far-seeing gaze of his eyes. The sculptor has enhanced and defined the concentration of his expression with just one detail, a series of little vertical furrows over the brow. Rahotep frowns, preoccupied with eternity.

Nofret's name means "The Beautiful One." Modern taste may doubt whether she entirely deserves the compliment. On her plump face, high seriousness produces a rather spoiled, sullen look — there is no point in speculating, so many millennia later, whether the sculptor really intended this. Nofret is most tastefully and elegantly dressed. The pristine whiteness of her garments, a cloak wrapped over a shoulder-strapped dress, half conceals most of her body but discloses the young, pretty breasts. Her jewelry is gorgeous. The large beaded collar was a standard accessory. Worn by both men and women, it provided a splash of color to relieve the whiteness of their linen clothing. Nofret's wig is short and very full, contrasting with her own finer hair, which is shown in low relief on her forehead. The headdress is held in place by

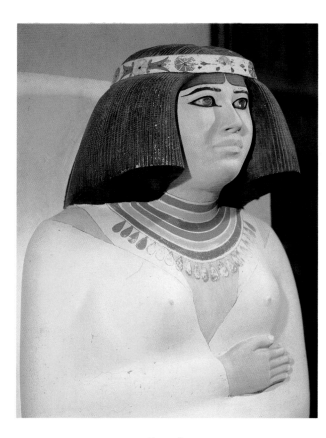

〚 4 〛

Nofret, detail

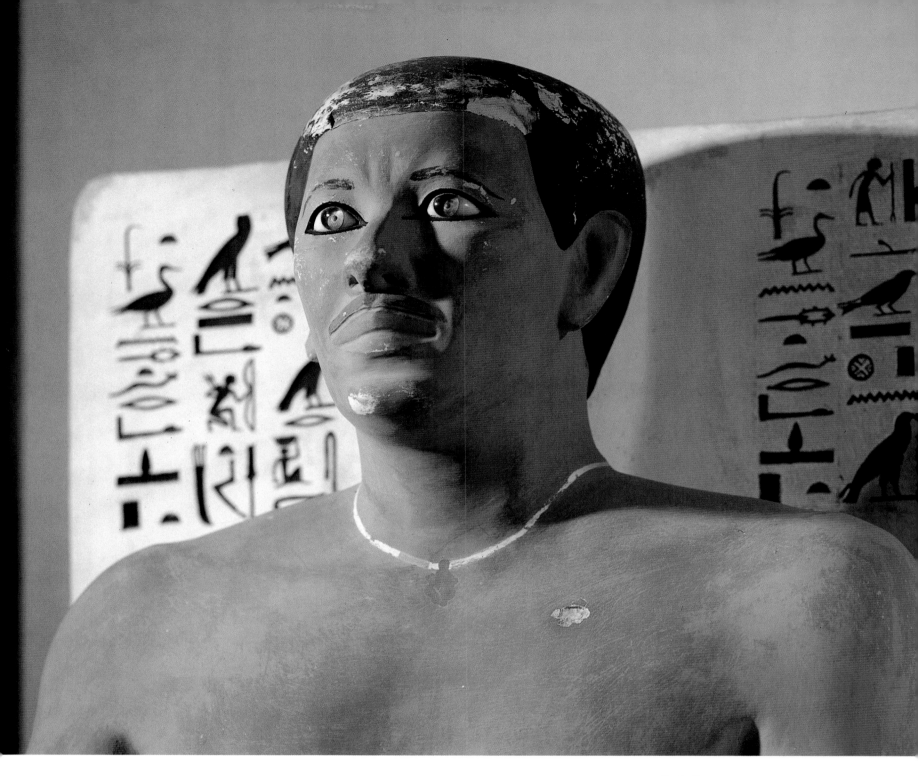

[4]

Rahotep, detail

an exquisite diadem. There are actual examples of such diadems made for royal women, of gold inlaid with carnelian and turquoise. Nofret's, however, is painted white, suggesting that hers was silver, which in this period was even more precious than gold.

In their tombs west of the Great Pyramid, some of King Cheops' favorites were provided with a curious limestone head. This head was not placed in a statue room above ground but apparently at the entrance to the underground burial chamber. Offering nothing of value to even the greediest ancient tomb robber, these heads have had a high survival rate. Nevertheless, they are few in number — only about thirty — because they seem to have been made almost exclusively for the Cheops court.

Very little sculpture survives from Cheops' reign.

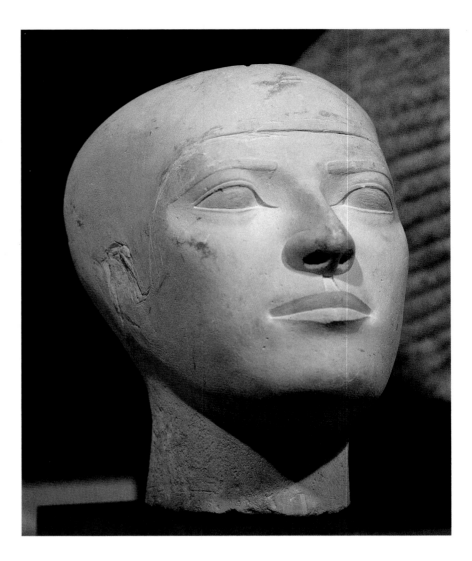

⟦ 5 ⟧
Reserve head
DYNASTY 4, CA. 2551–2528 B.C.
LIMESTONE; HT. 19.5 CM

The fascination and wonder aroused by his Great Pyramid, from the time it was built, brought thieves as well as tourists. Together with its surrounding tombs, this pyramid is one of the most thoroughly plundered monuments in the world. Cheops' two funerary temples have disappeared and with them all but a few small fragments of the statues they contained. Without the heads, we would know very little about the sophistication of the sculpture made during his reign.

The heads are not broken from complete statues. The bottoms of their rather long necks were smoothed flat, so that they stand without support. They are among the most mysterious of all Egyptian sculpture. The usual modern term for them, "reserve heads," is based on a theory that they were intended as a spare part, in case of damage to the head of the official statue or of the mummy itself. But this idea is unsatisfactory for a number of reasons, including the fact that almost every one of the heads had been crudely reworked or deliberately mutilated *before* it was placed in the tomb. Another hypothesis, that they were sculptors' models, establishing a person's official likeness for the production of his statuary, founders on the fact that these tombs seem to have contained no

more than one or two statues — not enough to justify such a prototype.

Whatever their purpose, the heads provide a sort of portrait gallery of Cheops' intimates. Unfortunately, the repeated savaging of these tombs by ancient looters obliterated even the names of some of their occupants. The prince for whom this head ⟦5⟧ was made is one of the anonymous ones; about all we can say of him is that his tomb contained no provision for a wife.

Like all the reserve heads, this one is life-size and has short-cropped hair, with only the hairline indicated. Over the forehead, the line is firm and thick, almost like a cap. Toward the temples, however, it starts to degenerate, and at the sides of the head the hairline is just crudely and indecisively scratched. Additional scratched lines, especially around the sideburns, look childishly careless and inept. The head has no ears, though a slight depression on one side suggests that ears might once have been contemplated. These damages do not affect the face, although they form an odd contrast with its beautifully carved and finished features. Almost all reserve heads share this unexplained combination of fine work on the face with omissions and mutilations in the area of the hair and ears.

Feature for feature, the face has a good deal in common with the face of Chephren ⟦6⟧. There is also a resemblance to Rahotep ⟦4⟧, presumably a member of the same family, two or three generations back. But the reserve head has an entirely different expression from the earlier work. By the time of Cheops and the Great Pyramid, the soberness that Rahotep's statue had inherited from archaic sculpture like that of Djoser had given way to a look of serenity and infinite confidence. This prince's face, though it seems to share the family features, is too ideal to be considered a true portrait of an individual. As an ideal, however, it is among the noblest human images carved in stone.

Idealism and nobility permeate every aspect of the seated life-size figure of King Chephren, builder of the second pyramid at Giza ⟦6⟧. Like the figure of King Djoser ⟦3⟧, this is a funerary statue, but it is quite different in spirit. It was not designed for a simple *serdab* but for a funerary temple. Not surprisingly, it is more godlike.

The distinctive mottled stone — often called Chephren diorite, because it is best known from this statue — had been shipped some seven hundred miles down the Nile from the royal quarries beyond Egypt's southern border. It is a very hard stone, and it has been carved with superb fluency. The perfect proportions of head and body, the subtly modulated curves of the torso, the fine crisp outlines of the mouth and eye are a technical achievement

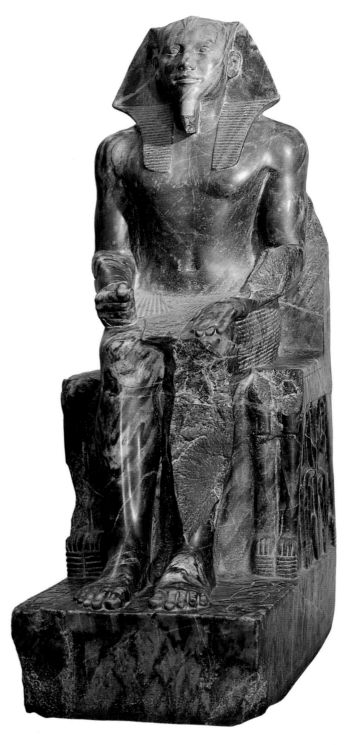

⟦ 6 ⟧

King Chephren
DYNASTY 4, CA. 2520–2494 B.C.
GNEISS (CHEPHREN DIORITE); HT. 168 CM

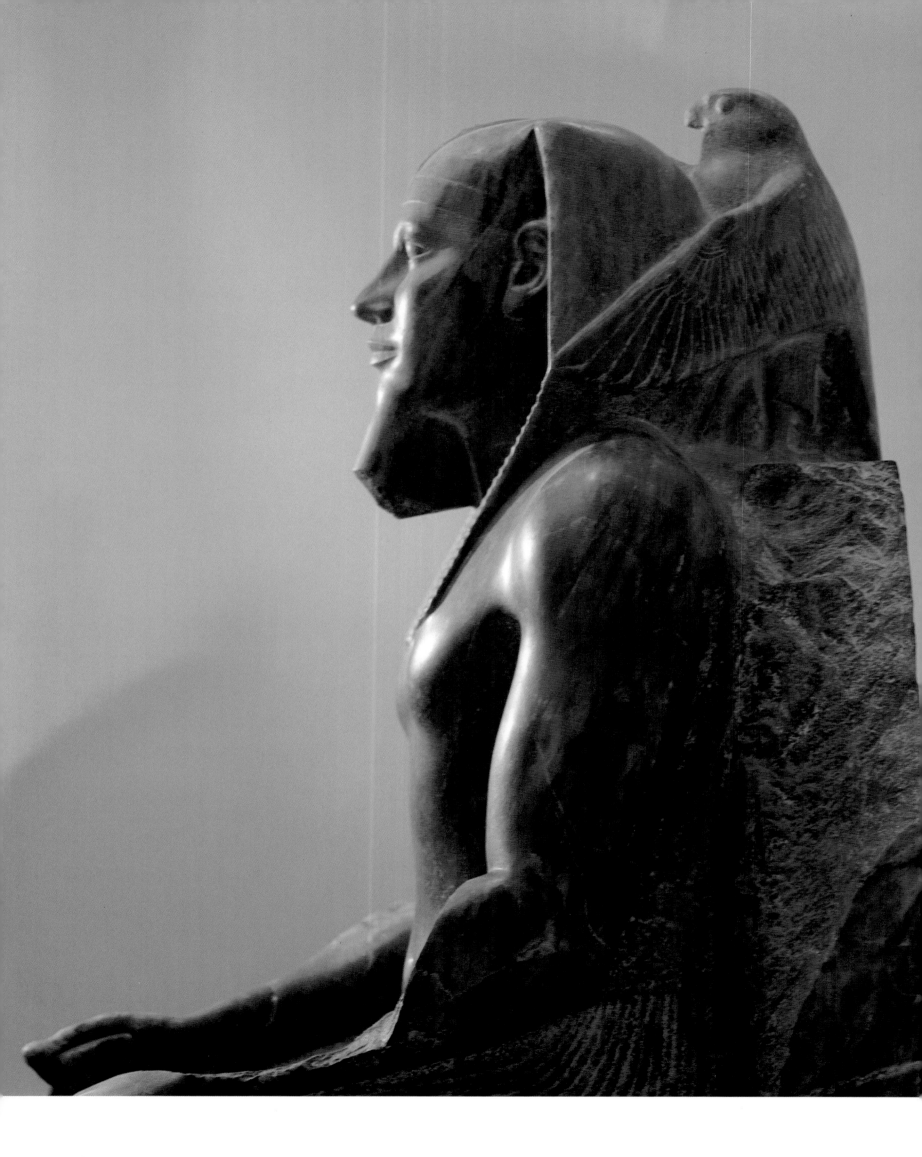

that may sometimes have been equaled in ancient Egyptian sculpture, but never surpassed.

Chephren's lion throne was probably copied from a real piece of royal furniture. In fact, a similar throne, made a thousand years later, was found in the tomb of Tutankhamun. Each side consists of the very stylized body of a lion, its legs forming the legs of the chair and its disproportionately small head at the front of the seat. The space between the legs is filled with a heraldic design — the plants of Upper and Lower Egypt knotted around the hieroglyphic sign for unification — symbolizing the union of Egypt under the power of the king.

The low back of the throne supports an imaginary structure, a back pillar that serves as support for the figure of a falcon, whose wings embrace the back of the king's headcloth. The falcon is Horus, the pre-eminent god of kingship. Its pose is beautifully emblematic of Horus' relationship to the king, protecting his mortal part and personifying the divinity of his royal role.

Seen from the front, the statue loses some of its distinction, becoming simply the figure of a handsome man in royal garb. Here, fully developed for the first time, are the regalia of an Egyptian king. The headcloth worn by Djoser [3] now covers the entire head and frames the face. On its front is the uraeus cobra of kingship. A false beard is fastened to the point of the chin. A simple pleated kilt is Chephren's only garment; his strong muscular chest and arms are enhanced by his erect but comfortable pose, one hand relaxed on his thigh and the other clenched in a fist.

In profile, the mystical and yet somehow natural union of man and falcon — the bird's beak and the sweep of its wing echoed in the lines of the king's straight nose, beard, and headcloth — expresses better than words can describe the concept of a king at once human and divine, placed between gods and men. The statue was found near Chephren's pyramid, in a pit in his Valley Temple. Presumably, its original place was in one of the statue emplacements still clearly visible in the main hall of this building. To judge from the placing of these rectangular spaces, it would have been this side view of the statue that first presented itself to a visitor entering the statue hall.

Mycerinus, the son of Chephren, built a much smaller pyramid at Giza, but his funerary temples preserved a quantity of his sculpture. One of them shows the king between the goddess Hathor and a personification of the nome (district) of Thebes [7]. Though close enough to touch shoulders, the three figures gaze ahead, apparently oblivious to their companions, connected only tenuously by the back slab that frames them all — and by the resem-

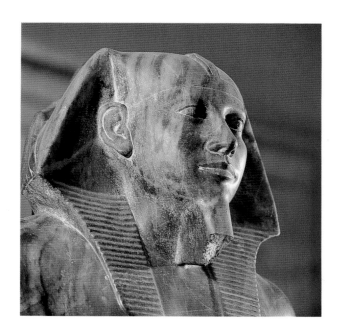

[6]
detail

blance of their features and their identical striding stance. They have the look of three individuals intent on a single goal. And this, indeed, is the main purpose of the statue: to show the king on equal — almost family — terms with one of the great deities and with the spirit of his land.

Egyptian sculpture representing two or more people almost always has the appearance of separate but similar statues that happen to be carved in the same piece of stone. Whether family groups or, as here, a mixture of real and mythical figures, they stare independently ahead, joined at most by an arm around the shoulders, a hand on the arm [[14]]. Close relationship is revealed only in their proximity and in their similarity — almost always, in an Egyptian group statue, the faces are very much alike. The lack of interrelationship among the figures in groups is often cited as a failing of Egyptian sculpture — and so it may be, in our terms. It is not difficult, however, to understand how the Egyptians' insistence on order and clarity, their love of symmetry and preference for well-established, simple poses, led them to consider a series of discrete but harmoniously balanced figures as the most suitable and most beautiful arrangement for any group.

Mycerinus had a series of these triads, each showing him with Hathor and a different local deity. No two of them are exactly alike. Sometimes the goddess is in the middle, sometimes she is seated. Always her head and the king's are on about the same level, whether she is standing or sitting down. In the latter case, of course, the result is that she is much bigger than the king. Here, she is just slightly shorter, the height of a mortal woman. The relative sizes of Egyptian figures were apt to be determined more by their importance than by natural appearance. It is interesting and significant, therefore, that the king, a mortal god, could slightly overtop one of the greatest deities. The nome figure's emblem equals the height of the other two figures, but he himself is very much shorter — literally a demigod.

Mycerinus wears the White Crown. His face may be somewhat less noble and handsome than his father Chephren's [[6]], but his features are more distinctive. His statues all show a full-cheeked face, with rather bulging eyes, a knobby chin, a fleshy, faintly bulbous nose, and — when the paint is preserved — a moustache like King Djoser's [[3]] or Rahotep's [[4]]. Here again is a definite individual likeness, which presumably reflected the king's actual appearance. Both the divine figures look very like him. This is to be expected in a group statue; but, in any case, representations of gods almost always have the features of the reigning king. He was, after all, the only model available on earth.

[[7]]

King Mycerinus with the goddess Hathor
and the personification of Thebes
DYNASTY 4, CA. 2490–2472 B.C.
GRAYWACKE; HT. 93 CM

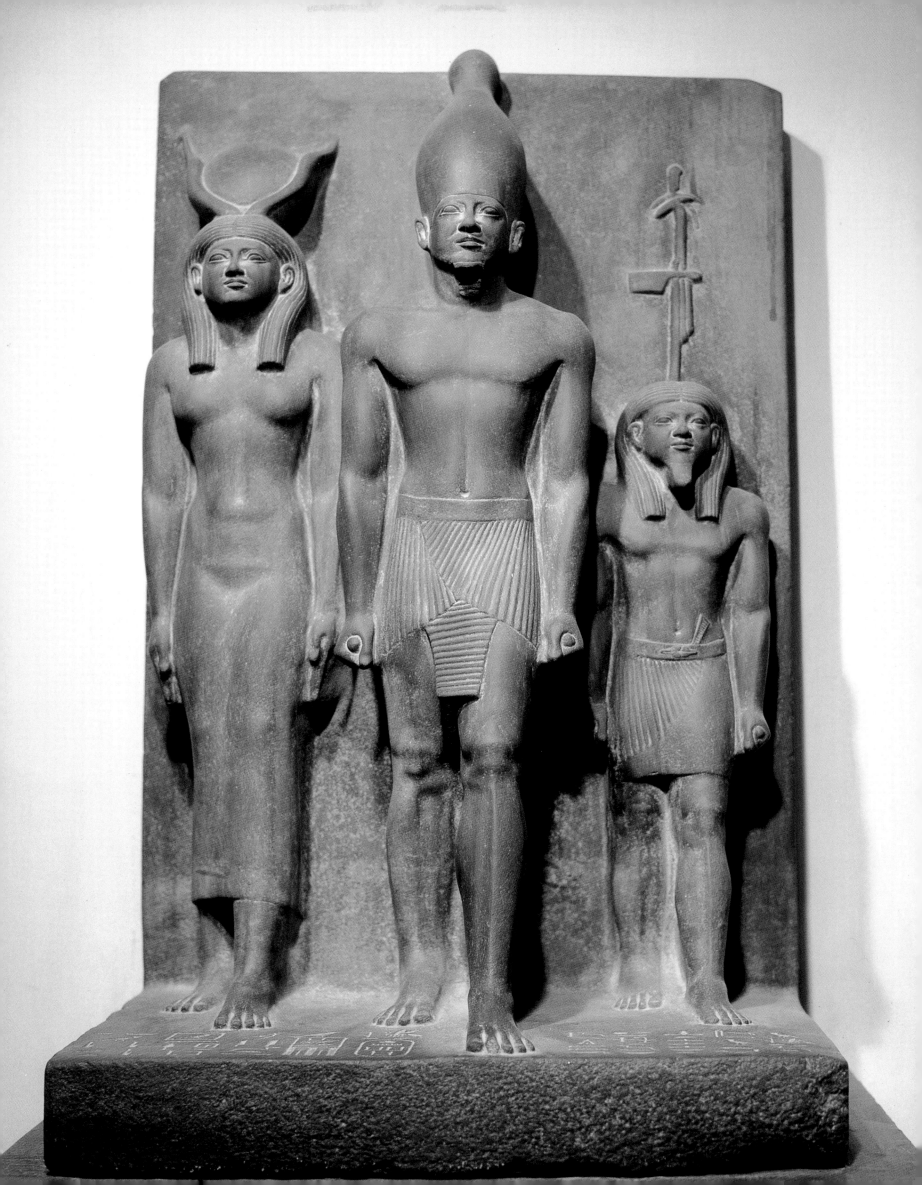

Hathor is identified by the inscription and by her distinctive headdress. Her long wig is surmounted by cow horns and a sun disk, emblematic of two of her most important roles. As a source of protection and sustenance, she is often represented as a cow [[86]], and she stands in close filial relationship to the sun god Re. Her body represents the feminine ideal of the Old Kingdom, with full but firm breasts, taut stomach, and long, narrow hips. The Middle Kingdom woman may have had a more elegant form [[24]] and New Kingdom fashions were often more lush [[63]], but this slim, strong, almost athletic-looking body has an appealing, surprisingly modern look. The shoulder straps of her implausibly tight dress would have been added in paint, but the garment is little more than a token concession to modesty.

The Fifth Dynasty
(CA. 2465–2323 B.C.)

The ruling family of the Fifth Dynasty was apparently related to the Fourth through the female line. Userkaf, the first king of this dynasty, built a temple to the sun god. There, in 1957, was found a greenish stone head, slightly under life-size [[8]]. The most portraitlike of all Fifth Dynasty royal heads, it bears an interesting resemblance to the likeness of King Mycerinus [[7]], just a generation or two earlier. Userkaf has the same round cheeks, bulging around the nostrils and over the upper jaw, a similarly blunt, fleshy nose, and a broad, firm mouth. The head is not just a copy of earlier statues, however, for this king has a rounder, fuller, slightly receding chin, and his eyes slant downward from the nose, a peculiarity rather rare in life and extremely unusual in Egyptian sculpture. The eyes are enhanced by long "cosmetic lines" drawn from the outer corners, and the ends of the eyebrows have also been extended to balance them. This eye makeup, used by both men and women, is frequently indicated on Egyptian statues, sometimes with black paint but often, as here, in low relief.

Userkaf's crown is the Red Crown of Lower Egypt, the counterpart to the White Crown of Upper Egypt [[see 1, 7]]. The tall vertical element that rose from the back has been broken off, but the sweep and majesty of the main part are well preserved. We do not know what this or the other tall crowns were made of, but so imposing a superstructure must have demanded a rather careful balance, even though it was held on as securely as possible with tabs that practically encircled the ears.

As the Old Kingdom continued in the Fifth Dynasty, Egypt's prosperity and civil order encouraged the growth of economic and social complexity. The king was still the highest authority and controlled the greatest power, but he and his family could no longer oversee

opposite page

[[7]]

detail

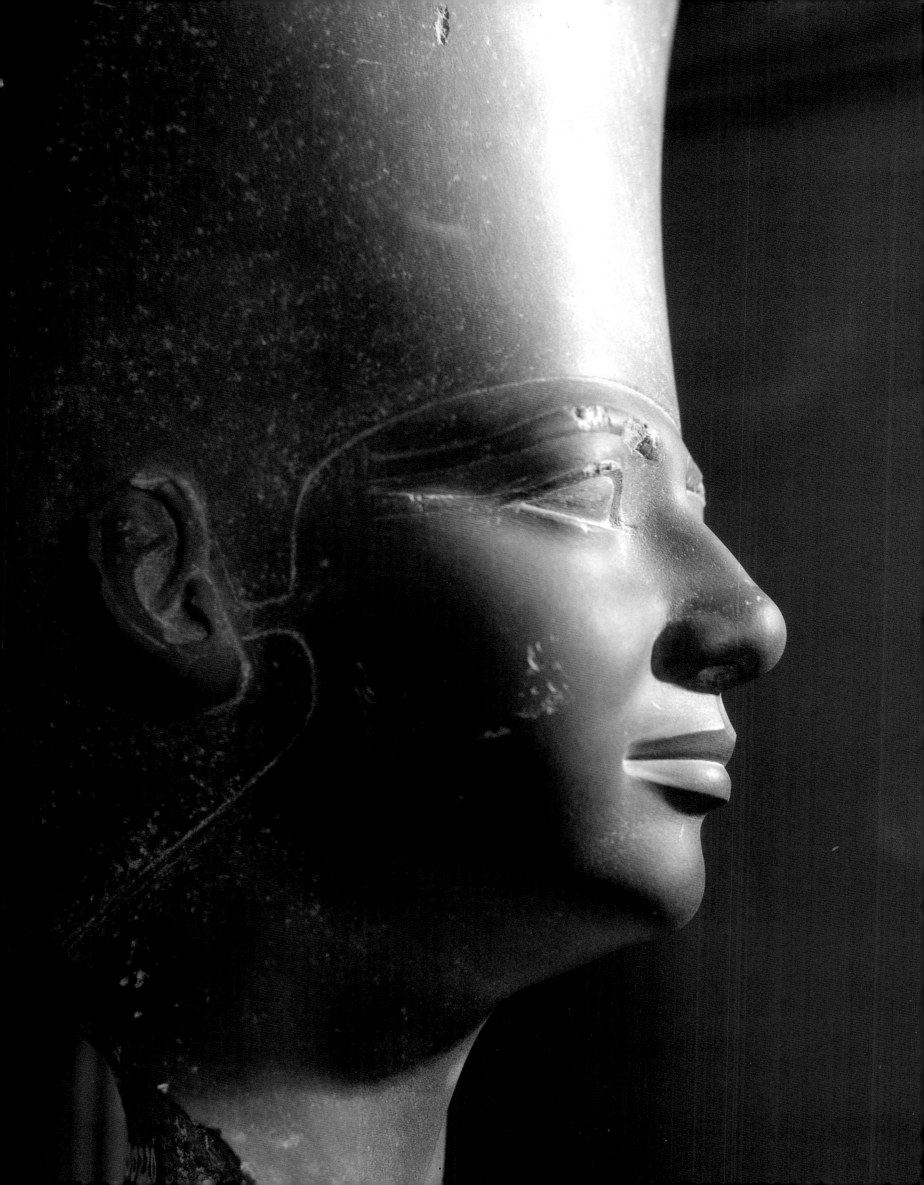

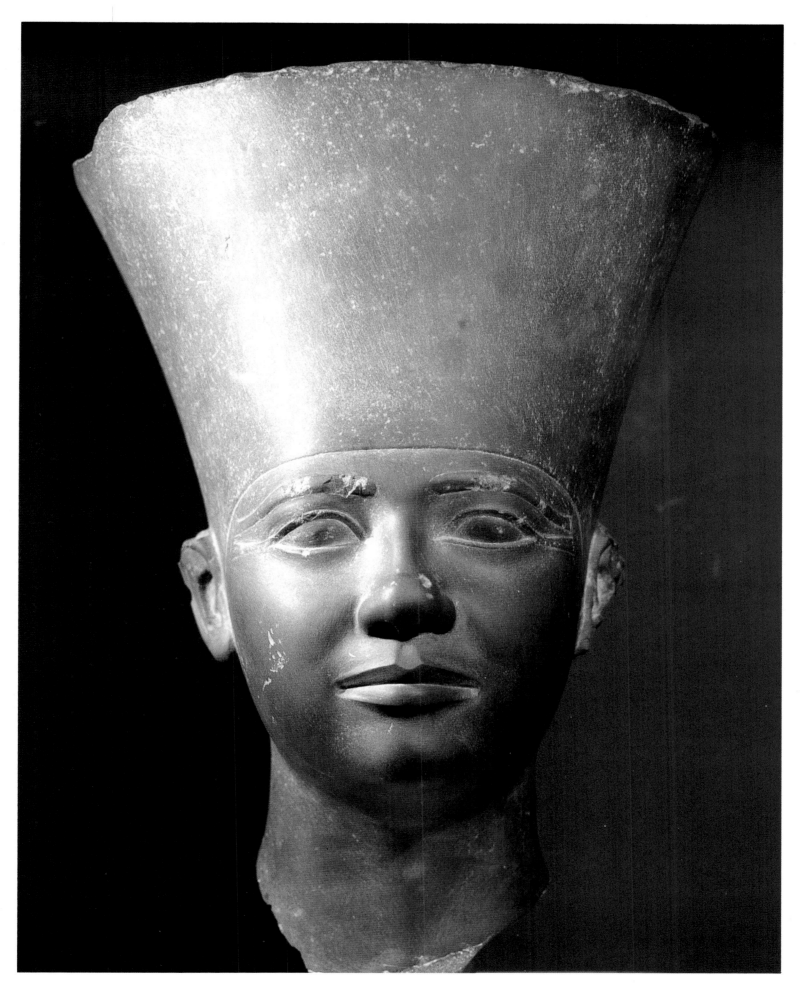

〚 8 〛

Head of King Userkaf
DYNASTY 5, CA. 2465–2458 B.C.
GRAYWACKE; HT. 38 CM

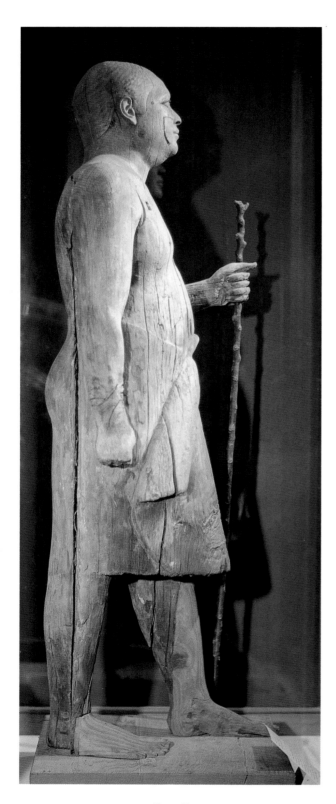

⟦ 9 ⟧

The "Sheikh el Beled"
DYNASTY 5, CA. 2465–2400 B.C.
PAINTED WOOD; HT. 110 CM

every aspect of the administration. Offices expanded and bureaucrats, both secular and priestly, multiplied. There was some upward social mobility, the nature and degree of which are almost impossible to assess. It is clear, however, that through the Fifth Dynasty and into the Sixth an increasing number of men were able to climb the Egyptian equivalent of the corporate ladder. This had important artistic consequences, because one concomitant of success was the ability to provide oneself with a tomb and the statues — sometimes, a lot — to put in it.

Sculptors rose to the challenge. Many more workshops came into existence to cater to officials and priests. If more of this Fifth Dynasty sculpture were preserved, we could probably learn to distinguish the individual workshops, even though we could not name the masters. It is usually quite easy to distinguish the style of a statue made for — and presumably near — the Giza necropolis from one made for Saqqara, just a few miles away. As ordering statues became less a matter of privilege than a commercial transaction, many more statues were made than in the Fourth Dynasty. The majority were quite small, conventional, competent, and mediocre. Enough examples fall so far below this standard, however, as to suggest that even an inept craftsman could find customers, if his prices were sufficiently low.

But very fine statues were also made, especially in the early Fifth Dynasty, when Fourth Dynasty traditions of life-size, portrait features and high quality were still strong. A good example is the wooden statue of Ka-aper ⟦9⟧. When it was excavated in his tomb, the Egyptian workmen — so the story goes — burst into gleeful and perhaps slightly malicious laughter, insisting that the portly dignitary was the very image of their local sheikh. Ever since, the statue has borne the nickname "Sheikh el Beled," or village headman, a fitting tribute to its lifelike quality and its air of stately self-importance.

Shown in the fullness of success, still vigorous under the weight of authority and prosperity, Ka-aper's middle-aged figure looks both naturalistic and individual, from his close-cropped hair, receding at the temples, down to his pudgy ankles and feet. His crystal eyes, like those of Rahotep and Nofret ⟦4⟧, greatly enliven his face and enhance his expression of confidence and determined benevolence. The longish kilt, suitable to his dignity and semisedentary lifestyle, is wrapped comfortably under his paunch. Ka-aper once held an official baton in his right hand and in his left a tall walking stick, another badge of rank — which became indispensable as its owner grew stouter and shorter of breath. These implements are still preserved on the figure of Meryre-haishitef ⟦17⟧. Ka-aper's

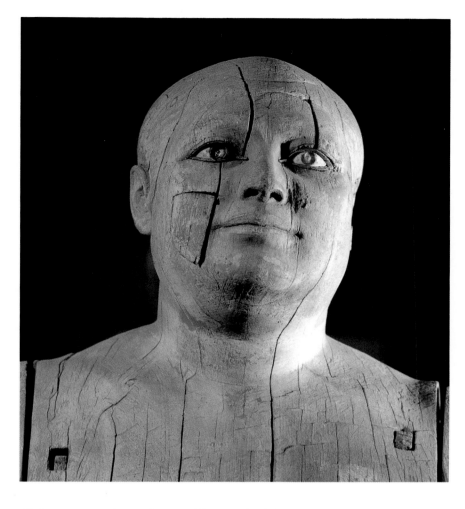

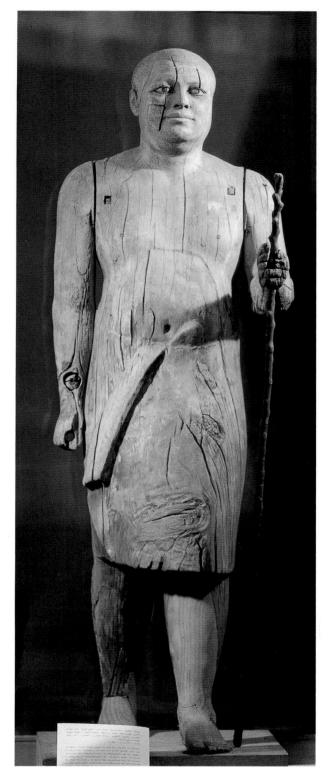

did not survive; the staff now held by his statue is a modern restoration.

If Ka-aper's figure had been carved in stone, his staff and baton would have been omitted. Like most wooden statues, this one is unencumbered by a back pillar or negative space. As usual in wood-poor Egypt, the arms were made separately and pegged to the body. Though now they are clearly visible, the joins would have been hidden when the statue was new by the paint that once covered it.

It is easy to imagine Ka-aper, at the height of his career, looking very much like this. At a time when bureaucracy was still a fairly new development, this middle-level bureaucrat is startlingly vivid in his complacency and pride. The sculptor has achieved just what was wanted — a statement of worldly success, with little acknowledgment of the negative aspects of age and physical decline. To the extent that it is a portrait, the statue is flattering and idealized. In fact, it is an ideal of mature success, which the ancient Egyptians found almost as attractive as the prime of young adulthood. Officials often provided themselves with tomb statues representing both of these desirable ages. Understandably, however, the youthful version was always much more popular, and we can be quite certain that Ka-aper had seen to it that he was represented at least once as a handsome young man.

Scientific examination of mummies has shown that the ancient Egyptians, as we would expect, suffered the full human range of congenital and acquired disabilities. But the subjects of Old Kingdom statues, whether represented in the prime of youth or in ostentatiously well-fed maturity, are physically perfect. The disfigurements and disabilities of earthly life could apparently be eliminated from the hereafter, by omitting them from one's images. In the very rare cases where a statue shows physical abnormality, the probability is therefore strong that, like excess weight in middle age, the disability was considered to be somehow advantageous to the person represented.

This was certainly true of a man named Khnumhotep, who was a dwarf. His limestone statue ⟦10⟧, half the size of life, represents his condition with such accuracy that it can be diagnosed. Khnumhotep's elongated skull, stocky body, and tiny limbs indicate that he was born with achondroplastic dwarfism. His face, far less distinctive than his body, gives little indication even of the man's age; but his slightly receding hairline and the knee-length formal kilt with its starched front panel suggest that he, like the Sheikh el Beled ⟦9⟧, is represented in middle age. The fact that he was able to commission such a statue demonstrates his worldly success, which probably was due not just to his abilities but also to his physique. Their very rarity and conspicuousness seem to have aided dwarfs to attain positions of responsibility.

Funerary statues of the Old Kingdom, whether royal or private, show their subjects in dignified postures: standing, seated on a chair, or tailorwise on the ground in the respected pose of the scribe. The little limestone figure of a man named Kaemqed ⟦11⟧ would seem at first glance to be an exception. He kneels quite humbly, his hands clasped in his lap. The inscription on the base explains his stance, for it identifies him as a funerary priest, like the much earlier Hetepdief ⟦2⟧.

The tomb in which Kaemqed's statue was placed was not his own. It belonged to a man whose funerary cult he served. The arrangements — in the form of a legal contract, sometimes inscribed on a tomb wall — would have been made while both men were alive; in addition, Kaemqed was allowed a statue, which was placed alongside those of the tomb owner and his family. This was undoubtedly a great favor to Kaemqed. However, it was not pure philanthropy on the part of his employer, who thus magically gained the eternal services of a priest.

A comparison of Kaemqed's figure with the archaic kneeling Hetepdief ⟦2⟧ shows vividly how far Egyptian sculpture had come in about two hundred years in representing the human body. Both men kneel passively, their

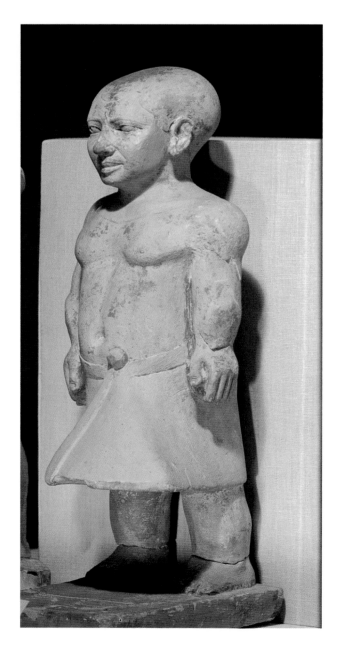

⟦ 10 ⟧

Khnumhotep, a dwarf
DYNASTY 5, CA. 2465–2323 B.C.
PAINTED LIMESTONE; HT. 46 CM

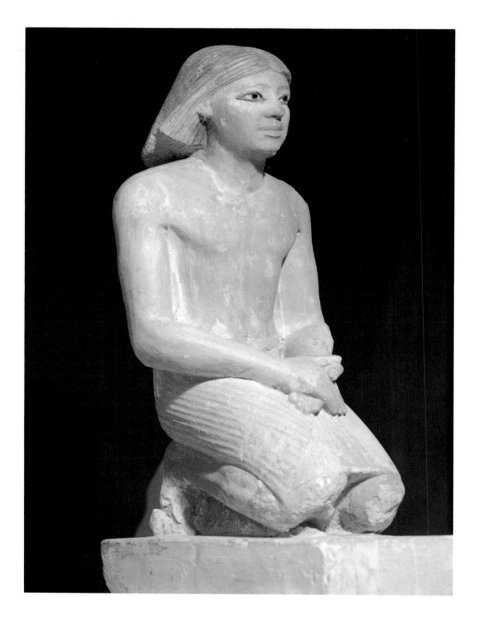

〚 11 〛
The funerary priest Kaemqed
DYNASTY 5, CA. 2465–2323 B.C.
PAINTED LIMESTONE; HT. 43 CM

hands at rest. But while Hetepdief seems to crane forward, his expression solemn and intent, Kaemqed's back is straight and his shoulders relaxed. He smiles slightly, serene and confident. This change is too great to be explained as just a different or more fluent style. From some period early in the Fourth Dynasty, probably soon after the statues of Rahotep and Nofret were made 〚4〛, there was a change in the spirit of Egyptian sculpture that must have been connected with a change in religious attitudes or belief. We may never understand it, but its evidence is clear in the images.

Kaemqed's face bears a strong resemblance to the face of the dwarf Khnumhotep 〚10〛. This is merely a stylistic similarity, due to the fact that both statues were made at Saqqara at about the same time. It shows that neither face can be considered a portrait. The priest's inlaid eyes are a simpler, cheaper type than those of Rahotep and Nofret 〚4〛 or the Sheikh el Beled 〚9〛. They consist of polished black stone disks set between pieces of white stone. There is no crystal to reflect light and glisten

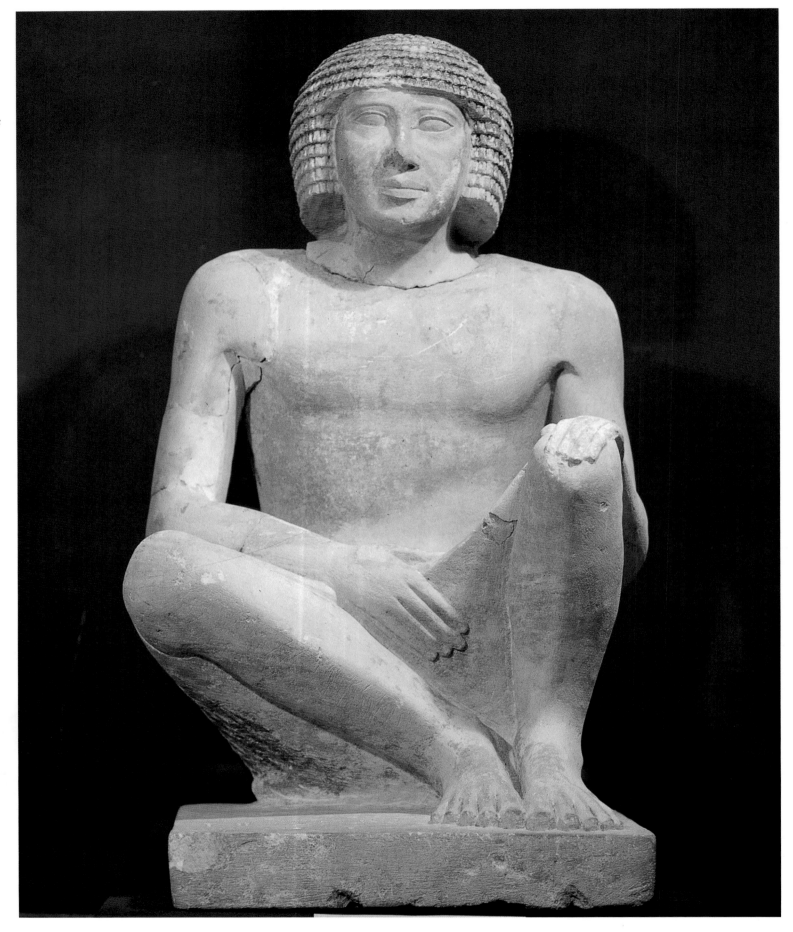

〚 12 〛

The physician Nyankhre
DYNASTY 5, CA. 2465–2323 B.C.
PAINTED LIMESTONE; HT. 70 CM

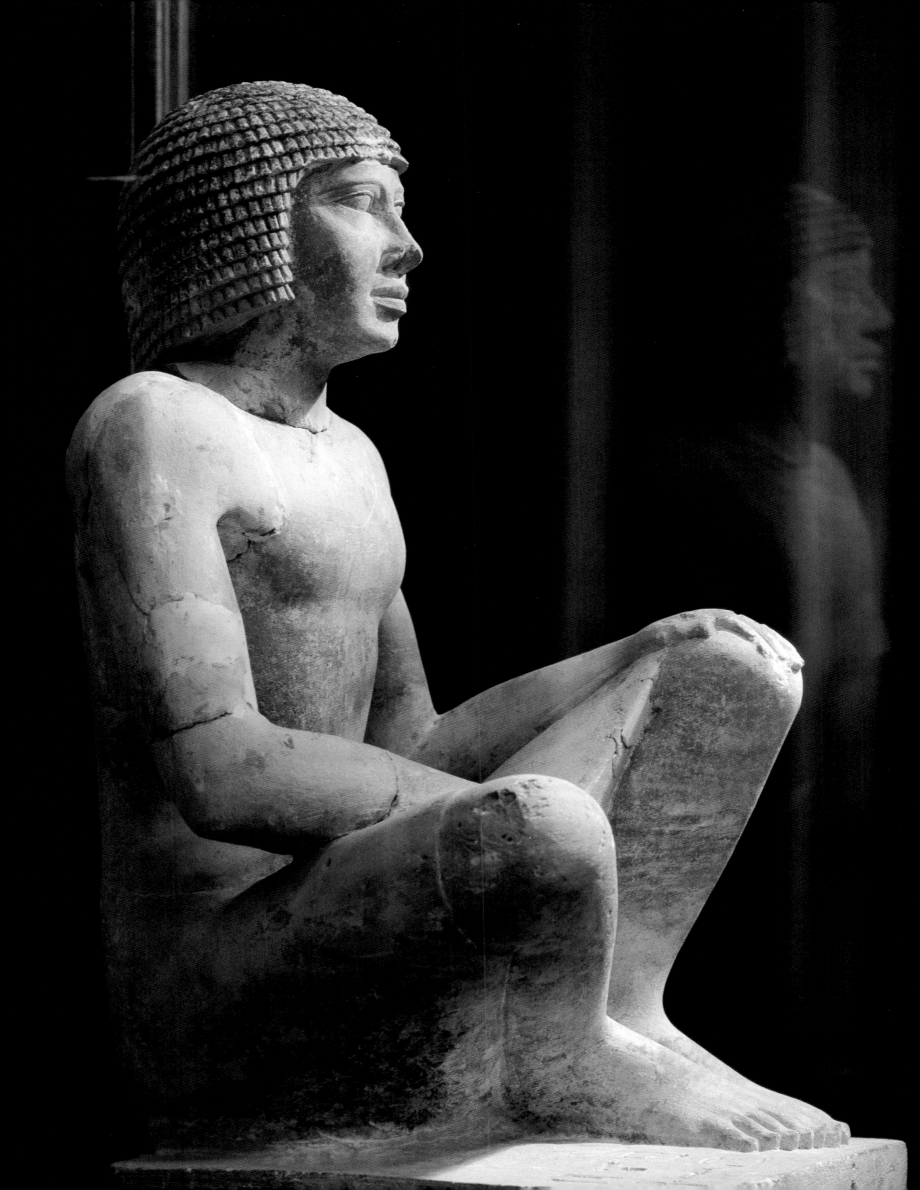

like a real eye. The copper rims, once narrow and reddish like the painted skin, have corroded because of salts in the stone and have turned into thick greenish crusts. On the front of Kaemqed's short kilt with its pleated flap are four painted strands of beads on tasseled cords. This ornament, suspended from the front of the belt, is not necessary to a funerary priest's ceremonial costume; it may have been an insignia of another of his jobs, some mark of his rank or social class — or just a valued adornment that he wanted to keep with him forever.

In the relatively simple world of the Old Kingdom, it was not necessarily considered beneath the dignity of important people to be seen sitting on the ground. This was especially true of scribes, whose connection with the written word made their crosslegged pose not only respectable but also prestigious [see 16, 50, 83]. More rarely, a man may be shown sitting comfortably with one knee (usually the left one) raised, the other leg flexed and resting flat on the ground [see 82]. The statue of a man named Nyankhre shows this pose in a variant that may be unique: his left knee is raised in the usual way, but the right flops out at a peculiar angle; both feet are flat on the ground [12]. It is hard to imagine that most men would be comfortable in this position for very long, and it has been suggested that the sculptor was trying here to indicate that Nyankhre had a deformed right leg. The leg itself, however, looks perfectly normal. Moreover, it would be highly unorthodox — and against the statue's purpose — to represent a physical peculiarity that was not in some way advantageous or prestigious. We should probably take Nyankhre's statue for what it seems to be, the portrayal of a man relaxed and at ease, as close to casual as any ancient dignitary could permit himself to be. This excellent sculptor may even have been inventing or experimenting with a new pose. If so, he or one of his colleagues quite soon realized that the diagonal leg looked unstable and too strikingly asymmetrical. Only when sculptors began to show this leg resting on the ground did the pose find some favor.

The face of Nyankhre's statue is not particularly striking. A closer look, however, reveals individualistic qualities in the long face, with its firm jaw and highly placed, close-set eyes. Though not a portrait, neither is this face a stock model. Such hints of individuality within a handsome, conventional, idealized face can often be found in Egyptian sculpture of good quality. We are never likely to know how much these nuances were due to the subject's human desire to recognize himself in his sculptured image or how much they may have been the artistic expression of a skilled and ambitious sculptor.

Nyankhre was a supervising physician. According to the Greek historian Herodotus, who visited Egypt a little after 450 B.C., Egyptian medicine was very advanced. Even in this period, two thousand years before Herodotus, there were medical specialties and — as Nyankhre shows — medical bureaucracies. Socially, he was probably at the middle level of the professional classes. It is interesting that he was able to acquire a statue of such quality and size, about two-thirds life-size.

The name inscribed on a tomb statue was usually preceded by the owner's professional and honorary titles, as many as he could muster — or, at least, as many as the scribe could fit into the available space. Since the name comes last, it usually appears at the bottom of the statue, whether the inscription is confined to the base [[for example, 3]] or runs down a back pillar [[as on 39]]. An inevitable and often frustrating consequence of this arrangement is that many of the most interesting statue fragments, fine heads or busts, are anonymous, their identities lost when they were parted from their lower bodies. Occasionally, a scholar with a sharp eye and a detective's instinct has succeeded in matching up an anonymous bust with its base, to reunite the owner's name and his likeness. Such restorations must usually be made with photographs, since the two parts almost invariably turn out to be widely separated, often in museums on different continents. And they are rare: most fragmentary statues are doomed to remain incomplete, the missing parts smashed to bits or damaged beyond recognition.

Among the most tantalizing of such anonymous figures is the limestone bust of a man found at Giza [[13]]. It was excavated in a Fifth Dynasty tomb, but even its archaeological context is of only limited help, because the tomb had been seriously disturbed by ancient looters and the bust was in rubble thrown into one of the burial shafts. It might have been made for the owner of this tomb, a man named Khuwiwer, but could easily have been carted over from another tomb, even from a tomb long plundered and vandalized by the time this shaft was being filled to seal off a new burial. Archaeology is often vague just when we desire more precise information.

Though only a sliver of the torso survived the blow that separated this bust from its body, the softly pendulous form of the right breast, sagging over a roll of flesh beneath, leaves no doubt that this, like Ka-aper, the Sheikh el Beled [[9]], is a man of obesity and middle years. But this man's fat, though less abundant than Ka-aper's, seems more subject to gravity. The soft slopes of the flesh suggest that this torso showed the relaxation of a seated pose, very likely the crosslegged position of a scribe.

[[13]]

Bust of a man
DYNASTY 5, CA. 2465–2323 B.C. OR EARLIER
LIMESTONE; HT. 34 CM

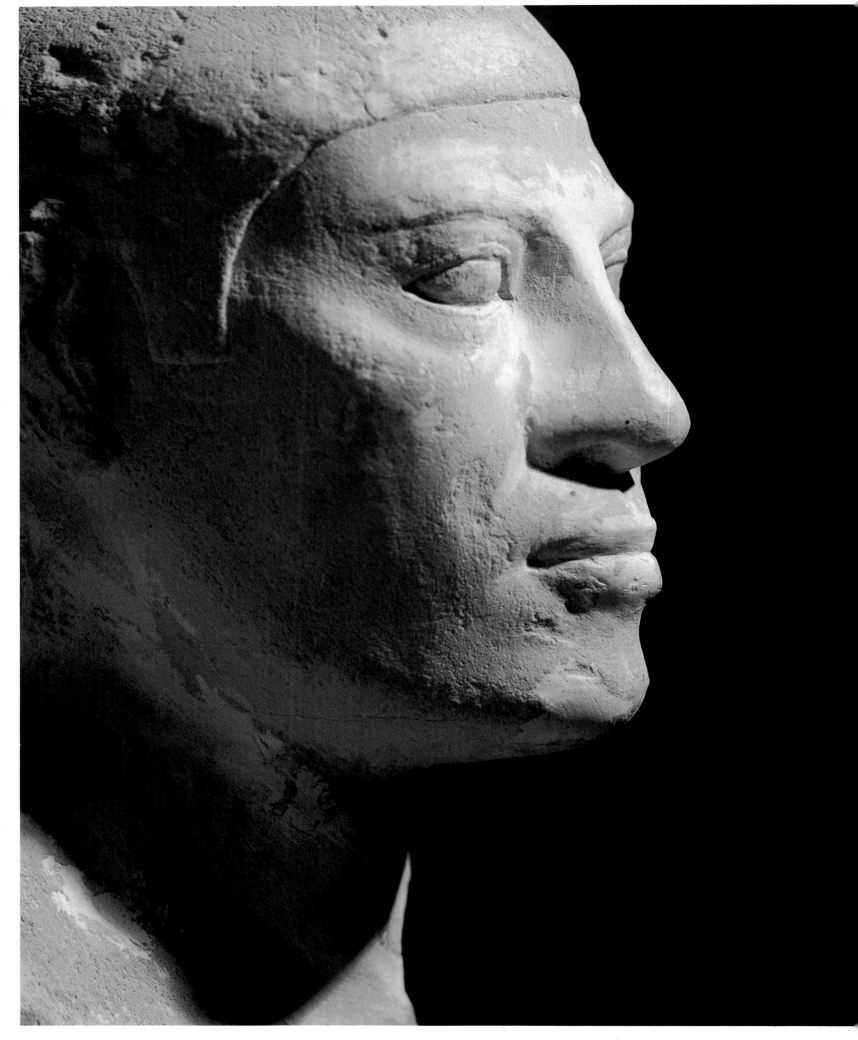

The softness of the man's body forms a striking contrast to the roughhewn quality of his bold, craggy face. Here every feature is individual, from the small eyes that, like the brows above them, tilt upward at the outer ends to the straight but broad nose and the massive, undershot jaw. It is a face that looks accustomed to authority and not hesitant to use it. The sense of strong character, built into the very structure of this face, is very different from Nyankhre [[12]], where individuality is only suggested by the slight alteration of conventional features. It is more uncompromisingly individual than even the comfortably arrogant Ka-aper [[9]]. Though it wound up broken and discarded in a late Fifth Dynasty tomb, the statue could well have been made for a contemporary of Ka-aper or even slightly earlier, in the last years of the Fourth Dynasty.

Like Khnumhotep [[10]], the dwarf Seneb (his name means "The Healthy One") made no effort to disguise his unusual physique. When he commissioned a tomb statuette of himself with his family — all, apparently of normal size — he presented his sculptor with a rare challenge [[14]]. To be sure, the problem of integrating so unusual a figure into a standard family grouping may have been less awkward for an Egyptian artist than for most. He would have been used to apportioning the relative sizes of figures according to their importance rather than their appearance [[see 7]] and was adept at making the most of artistic conventions, such as the preference for isocephaly [[keeping different heads at the same height — compare 7]]. Nonetheless, someone has clearly given thought to the composition of this statuette: it shows ingenuity and considerable tact.

Seneb and his wife sit side by side like any other married couple, staring straight ahead in the shared separateness of Egyptian groups [[compare 7, 38]]. As the woman often does on such statues, she embraces her husband. This is a demonstration of their conjugal relationship, but it also shows that he is the recipient of attention in this his statue, made for his tomb. Seneb's sturdy torso has been enlarged, to put his head and shoulders on the same level with his wife's. The shortness of his arms is mitigated by bending them across his chest, with the stubby hands clasped in an unusual but appropriate gesture. The disproportionately large head and face seem suitable to his condition but also serve the more important purpose of making him the largest, guaranteeing his dominance of the composition. Seneb's little legs are folded under him, in the manner of a scribe [[compare 83]]. Where a pair of normal legs would be, the sculptor has had the charming idea of placing the two children.

opposite page

[[13]]

detail

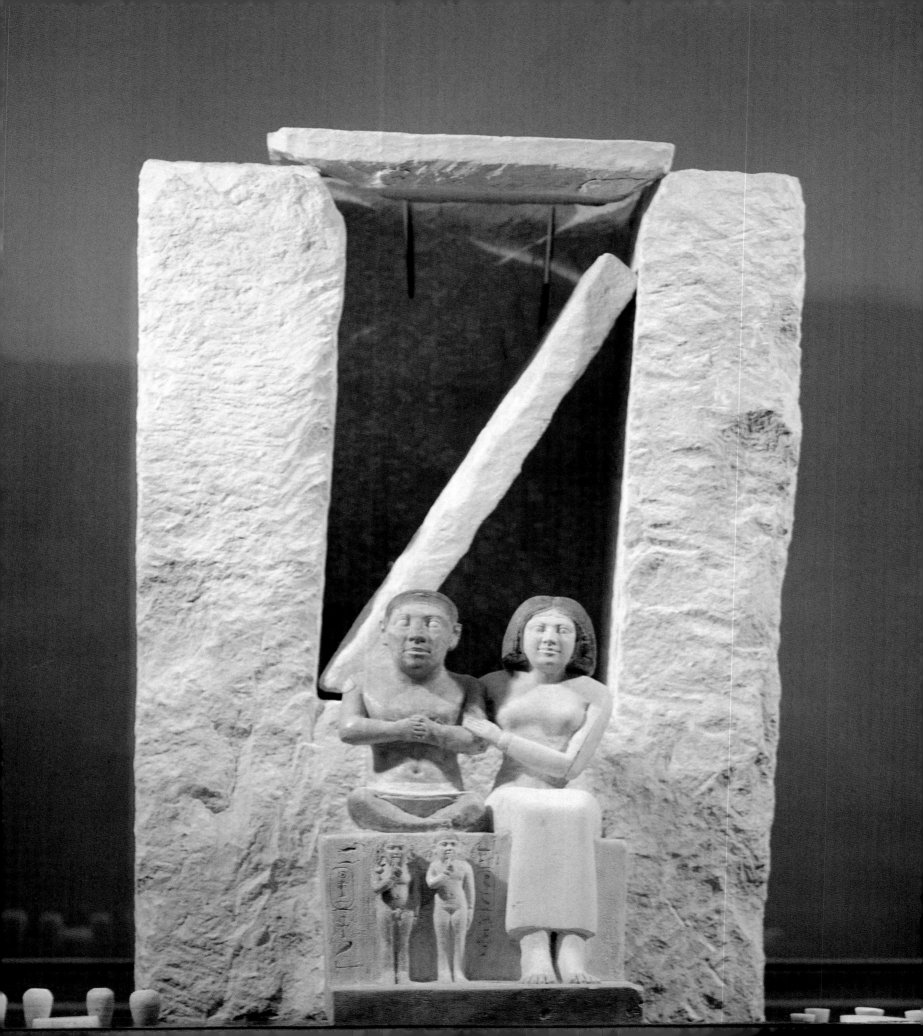

As is usual with Egyptian representations of children, these infants look only vaguely juvenile. The boy's round tummy and the girl's flat chest are the only anatomical suggestions of their age. Details of this kind were really unnecessary: since the children were included as offspring, their physical ages were immaterial. Someday they would grow up — conceivably, when this statue was made, they were already adult. Childhood was their family status in their father's tomb, and this was best indicated by conventional signs: diminutive size, nakedness, the boy's sidelock of youth, the forefinger held to the lips in the Egyptian equivalent of thumbsucking.

The unusual requirements of Seneb's statue demanded special attention from its sculptor and may have inspired him to extra care. He has added a fancy touch by cutting away all the stone between the couple's bodies, leaving them as free as if they were carved in wood. Another suggestion that this statue was something special is the rough little limestone box which now stands behind it. When it was found in Seneb's tomb, the statue was shut up in this box, protected in its own little shrine.

opposite page and detail above

⟦ 14 ⟧
Seneb and his family
DYNASTY 5, CA. 2465–2323 B.C.
PAINTED LIMESTONE; HT. 33 CM

Late Old Kingdom

Late Dynasty 5–Dynasty 6
(CA. 2400–2152 B.C.)

The style of Old Kingdom sculpture, as created by the Fourth Dynasty and carried on into the Fifth, was perfectly suited to Egyptian funerary beliefs. Perhaps no other society has ever managed to convey so well the serene assurance of the true believer in an eternal future beyond — and better than — life on earth. Its ideal of nobility and beauty in the human form has never been surpassed. Yet, for all its idealism, Old Kingdom style at its best could incorporate features of individual portraiture, the marks of aging, even physical deformities with the flexibility of a great and living art form.

As time passed, however, conventional usage dulled the richness of the style and reduced its capacities. Sculpture became more repetitive, the brilliant exceptions fewer. By the time this well-preserved statue of a standing king ⟦15⟧ was carved, the Fourth Dynasty was a hundred-year-old memory, kept alive by legends and by the towering reminders of its giant pyramids. Egypt was still well organized and prosperous, but in art it seemed to have settled for a comfortable repetition of the past. Thus, when the base that probably had his name on it was lost from this statue, the king it represented became totally anonymous,

because his pleasant, undistinguished face is the corporate face of all kings of about his time. Traditionally, historians have called him Tety, the first king of the Sixth Dynasty, but recently the plausible suggestion was made that he may represent Menkauhor, a late Fifth Dynasty king, since the statue was found near the ruins of what was probably his small pyramid.

The prototype of this face, with its plump features and placidly confident expression, is easy to find. If we turn back to the likeness of Userkaf, the first king of the Fifth Dynasty [[8]], we see the same round cheeks and fleshy nose, small eyes, and heavy brows. But the individuality in Userkaf's downward-slanted eyes and full, knobbed chin is missing altogether from the stolid, rather lumpish features of the later king. Even more distant is the sublime nobility of a Chephren [[6]]. The present must differ from the past in any society, no matter how traditionbound; even the most reverent imitator will introduce changes. Unthinking repetition usually means change for the worse.

Small changes in the body of this statue make it quite different from past models, as we can see by looking back to the Fourth Dynasty king Mycerinus [[7]]. Identical in costume and pose, the anonymous king seems at first glance to have been copied directly from some such statue. Though equally muscular, however, his figure is fleshier through the torso. The abdomen bulges, discreetly, but enough to push the belt of the kilt down below it in a slight curve. The shoulders are not quite as broad or straight. By comparison, Mycerinus seems to be taking a deep breath, throwing back his shoulders, and holding in his stomach. The tautness of his body makes the later figure look rather slack.

Even at the time the anonymous king's figure was being carved, a new spirit and a new style were beginning to emerge in Egyptian sculpture. A major change was in process, which by the end of the Old Kingdom had transformed the representation of the human figure. The beginnings of this change appear in the wooden statue of an administrative official named Mitry [[16]], found in his tomb at Saqqara with other wooden sculpture of himself and his household.

When complete, Mitry's figure sat crosslegged on the ground, in the normal working posture of a scribe. His short kilt, stretched tight across his lap, made a table for the papyrus scroll he was reading. Although the lower part of the statue is now lost, Mitry's hands still hold the rolled ends of his document, on which he appears to be concentrating with controlled intensity. He looks straight ahead, but his long neck is craned forward, as if he has

opposite page

[[15]]

Standing king
LATE DYNASTY 5/EARLY 6, CA. 2396–2291 B.C.
RED GRANITE; HT. 74 CM

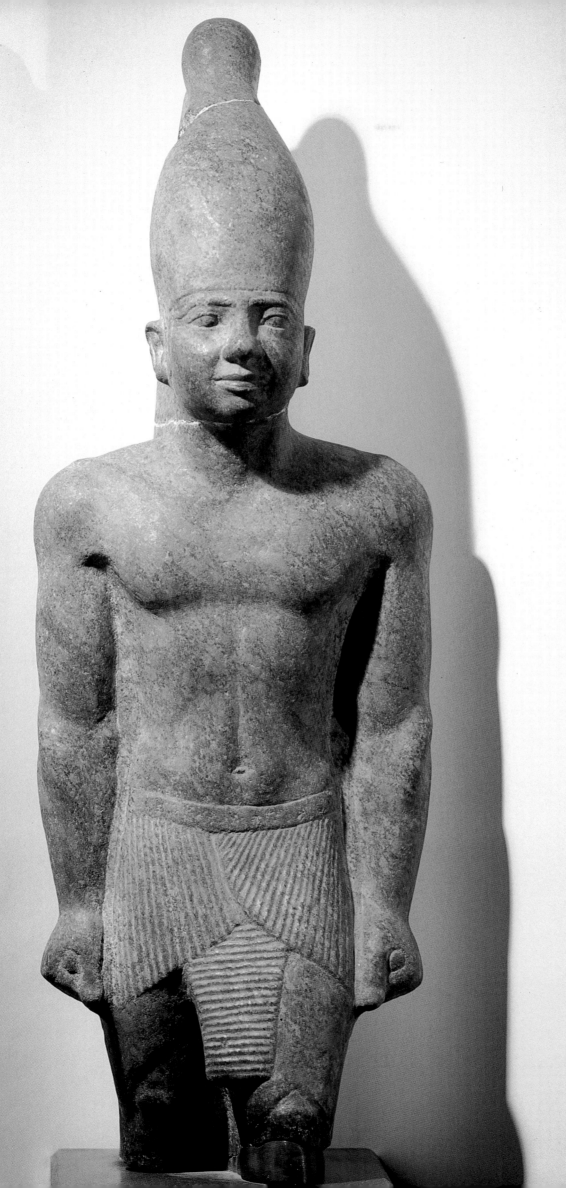

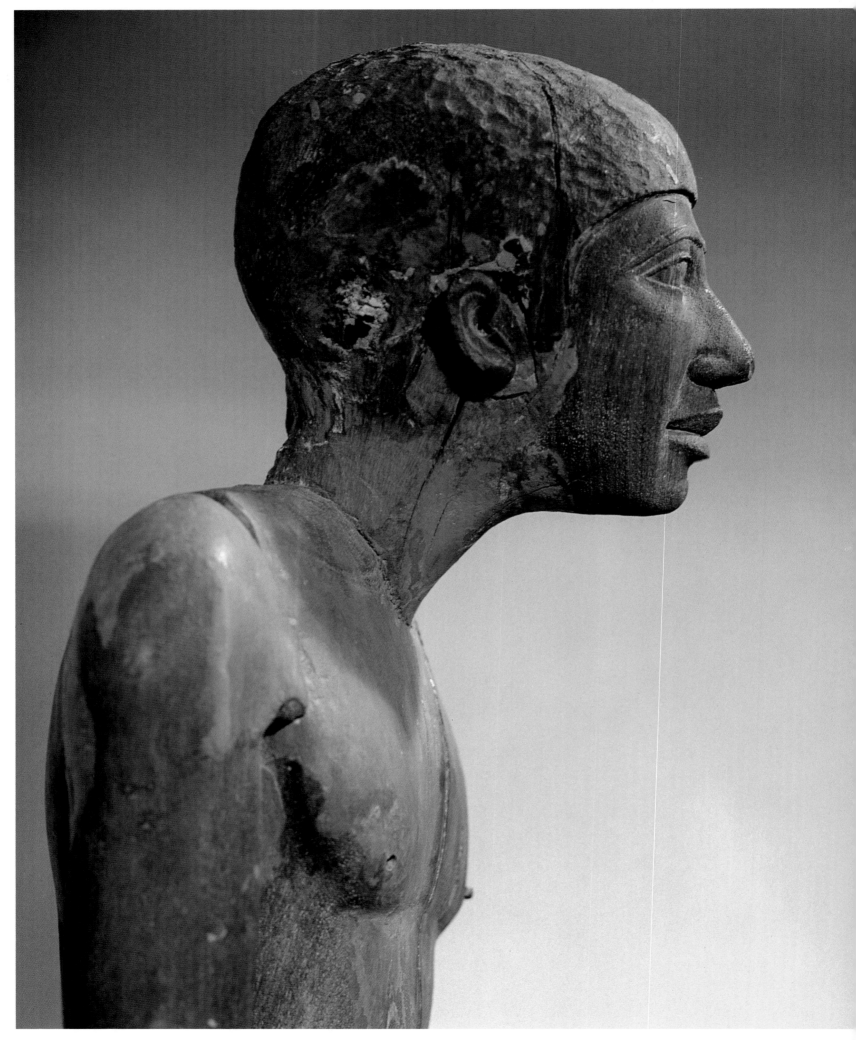

just lifted his eyes from the writing. His large mouth looks as if it is about to open with a question or a criticism.

Mitry's alert expression seems a world away from the blandness of the anonymous standing king ⟦15⟧. Yet the statues both came from Saqqara and cannot be too widely separated in time. The two men may even have been contemporaries. Nor are the basic forms and proportions of the statues so very different. In Mitry's case, however, the sculptor has carried out a whole series of slight exaggerations, with dramatic effect. The eyes, wide and rounded, seem to stare. The thick lips are everted, so that they appear to be parting. The neck forms a tense angle with the narrow, attenuated torso. There is almost no suggestion of muscle in the long, spindly arms. All of these details are new to Egyptian sculpture. Almost every one constitutes a rejection of the naturalism achieved earlier and still apparent in the royal statue. What Mitry's figure has lost in realistic detail, however, it has gained in expressiveness and animation.

Of the eleven statues found in Mitry's tomb, more than half were in the older, more naturalistic style. Only two or three, besides ⟦16⟧, point the way toward the new style. But these expressive features were quickly developed and dominated Egyptian sculpture through the long Sixth Dynasty and beyond, into the troubled times that followed the fall of the Old Kingdom. Most of these late Old Kingdom statues are small and have, to our eyes, a doll-like quality, with wasp waists and skinny limbs, great staring eyes, and thick lips set in a curious grimace. They are seldom recognized as the products of a new and distinctive style: usually they are ignored or relegated to a short discussion of "the decline of Old Kingdom art." But, whatever they may reflect of a changing spirit or new ideas about funerary representations, these late Old Kingdom statues were certainly a deliberate step away from an ancient, moribund style to one that better satisfied the tastes and beliefs of the time. At their best, they have a vigor and beauty all their own. One of the finest is the nude standing figure of a man named Meryre-haishitef ⟦17⟧.

The statue is one of three wooden representations of Meryre-haishitef found in his tomb. They had not been placed in a statue chamber but in the shaft leading down to his burial chamber: perhaps in an effort to protect them, perhaps so they would be closer to his mummified body, or for religious reasons unclear to us. All three statues, of which this is the finest, show their subject nude. This nakedness is unusual but by no means unique. Although nudity was usually reserved for the representations, in tomb reliefs, of manual laborers hard at work, a

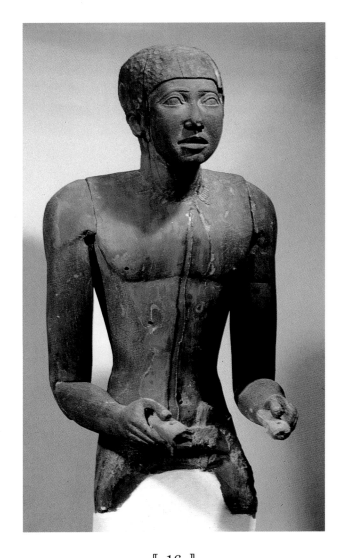

⟦ 16 ⟧

Bust of Mitry as a scribe
LATE DYNASTY 5/EARLY 6, CA. 2400–2250 B.C.
WOOD; HT. 47 CM

few tomb owners of the Old Kingdom included at least one naked figure among their tomb statues. We do not know why. It seems remarkable, however, that Meryre-haishitef should have provided himself with nude representations only, for a man's costume was one sign of his rank.

Since this is a wooden statue, Meryre-haishitef has no back pillar, and the spaces between his limbs are open. Despite his undress, he stands in formal pose, left leg advanced, his long staff in his left hand, the baton of authority in his right. There is presence in the determined set of his facial features. The black and white paint on the large, slightly slanted eyes gives an almost hypnotic quality to his fixed gaze, which is reinforced by the tautness of his full lips. The expressiveness of Meryre-haishitef's face and the firmness of his pose form a telling contrast with his willowy body, delicate and vulnerable looking — not just in its nakedness but also in the softness of its long, narrow torso and unmuscular limbs. There is something very humanly appealing in this neat little figure, fragile and unafraid.

Meryre-haishitef was buried near where he had lived, in the cemetery of Herakleopolis, an important town well south of the capital Memphis and out of its orbit. This is the first statue of a private man, in this book, to have come from some place other than the great Memphite royal cemeteries of Meidum, Giza, and Saqqara. It signals another new development in Egypt as the Old Kingdom drew to its close. With the decline of centralized government during the Sixth Dynasty came a rise in the power and prestige of provincial centers. Men could now make important careers in their home towns, and they began to build their tombs nearby. As Egypt fell into the civil wars and general disorder of the First Intermediate Period, the royal workshops around Memphis could no longer provide a national standard of artistic quality or style. Local craftsmen with scant knowledge of the great tradition and sometimes, it seems, with little technical training took over the making of tombs and tomb statues. Their efforts are often charming in their naïveté and sometimes comically clumsy. In a negative way, they reflect the direct relationship between Egyptian art and politics: without the patronage of a strong central regime, artistic continuity, sophistication, and even technical skill seem to have rapidly degenerated.

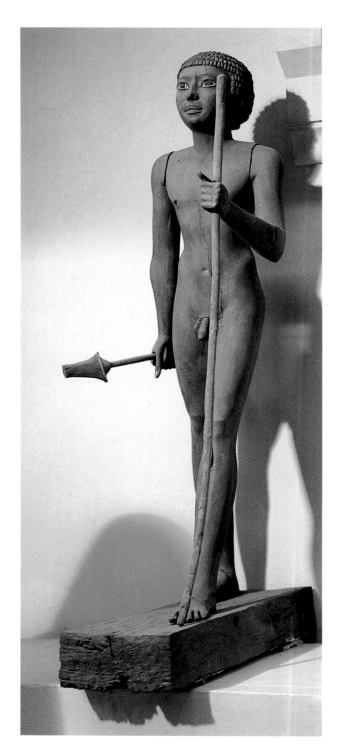

〖 17 〗

Meryre-haishetef in the nude
DYNASTY 6, CA. 2246–2152 B.C.
WOOD; HT. 66 CM

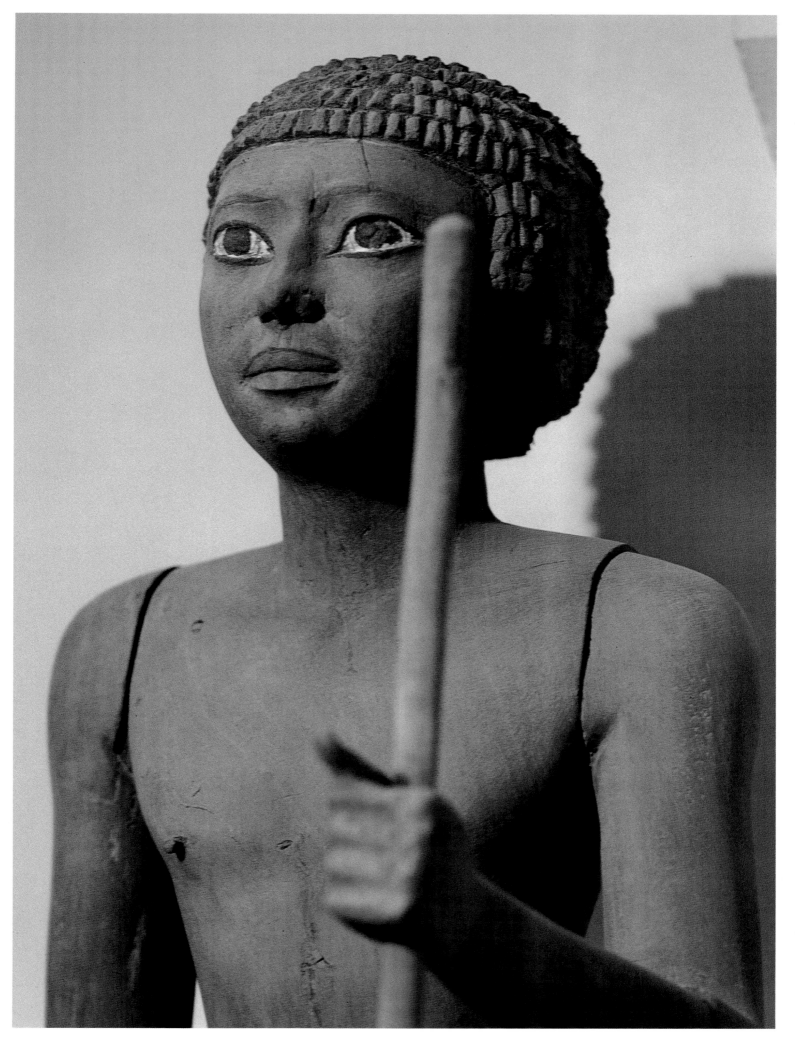

Chapter 3 The Classic Period

The Middle Kingdom

Dynasties 11–13
(CA. 2134–1633 B.C.)

IN ALL THE ARTS, the Middle Kingdom was a classic age. Its literature was so polished in expression, so rich and varied in content, that the forms and even the language in which it was expressed remained the standard of literate expression for centuries thereafter. Its minor arts, such as cosmetic objects and especially jewelry, include some of the most exquisitely designed and superbly crafted objects ever made. Middle Kingdom painting survives mainly as pathetic scraps and worn shadows of its original splendor, but the greatest modern authority on Egyptian painting considered it the finest this culture ever produced. The beautiful relief carvings of the period often served as models for later Egyptian artists when they sought subtlety and elegance of expression. In technical mastery and stylistic fluency, Middle Kingdom sculpture was the equal of these other arts. In originality and profundity, it may have surpassed them all.

The sculptural production of the Middle Kingdom was very large, partly because many more statues were made for temples. Figures of the gods, which seem to have been rare in the Old Kingdom, became ever more common, and private people now began to place statues of themselves in temples, as well as in their tombs. Along with the royal centers and funerary complexes, therefore, the great temples came to have major sculptural ateliers. How these were organized, and under whose auspices, is very unclear; but they must have played a prime role in the dissemination of high artistic standards. Middle Kingdom sculpture certainly includes the usual human proportion of mediocre work. Taken all in all, however, the level of excellence is remarkably high. Throughout the land, statues of admirable quality were made, even for quite modest members of society.

Inventiveness was manifested in many ways. Sculptors worked increasingly in hard stones, such as granite, and achieved virtuoso results with extremely hard materials like quartzite. They created new statue types and adapted old ones to new purposes and ideas. They designed works with an eye to psychological effect, and they expressed complex purposes in a beautiful, flexible, often understated style. Most interesting to us, perhaps, with

our focus on individuals and their psychology, was their approach to rendering the human face. Through most of this period, but especially in the five or six decades around the end of the Twelfth Dynasty and the beginning of the Thirteenth, sculptors of the Middle Kingdom created hauntingly distinctive statues. The best of these may with some justice be called portraits, for they give us convincing renderings of highly individual faces, scored by age and heavy with an attitude toward life that — even if we cannot fully understand it — strikes us with the full impact of personality and mood.

The Eleventh Dynasty
(CA. 2134–1991 B.C.)

The Middle Kingdom was really inaugurated by Mentuhotep II, who, from his family seat at Thebes in the south, succeeded in extending his control over all of Egypt, about 2040 B.C. This king and his peers knew that the reunification marked the beginning of a new era. Since they were Egyptians, however, they saw it as a re-establishment of the historic union of the Two Lands, and they tried in many ways to revive and emulate the glorious past. In sculpture, as in architecture and relief, the evocation and even imitation of Old Kingdom characteristics are often quite apparent.

But Egypt of the Middle Kingdom had changed too much to simply repeat the patterns of the Old. One of the most important consequences of the breakdown of a centralized royal regime and the attendant civil disorders and economic hardships at the end of the Old Kingdom had been a resurgence of the great provincial centers. Their districts, called nomes, were more ancient than Egypt itself. With the emergence of a centralized state, the nomes had provided a structure for the organization of local administration. But they also served as a focus for the persistence of local customs, traditions, and dialects. Not surprisingly, any lessening of royal authority encouraged the emergence of regional variations in many aspects of the culture. Without the standardizing influences of the royal studios, provincial workshops developed along their own stylistic lines, doubtless encouraged in many cases by the patronage of ambitious local families, like that of Mentuhotep.

It is not unusual to see visitors to the Egyptian Museum stop in their tracks when they come upon the life-sized seated statue of King Mentuhotep II [[18]]. The inscrutable mask of his face, the almost abstract blockiness of his seated form, the strange disproportion of oversized legs and feet, the glimmer of the worn but bold and simple colors give this figure an eerie power, not unlike what we sometimes feel in the presence of primitive works of art.

However, the impression of a naïve or archaic quality in the stylized power of this statue is misleading.

What we see here—the simplified forms, the great hypnotic eyes, the full, taut-looking lips—is the heritage of late Old Kingdom style as it had evolved into a local artistic tradition at Thebes, Mentuhotep's home and the site of his tomb.

Howard Carter, who was later to discover the tomb of Tutankhamun, stumbled on the statue in front of Mentuhotep's funerary temple at Deir el Bahri, across the river from Luxor. More precisely, the archaeologist's horse stumbled in loose ground over its hiding place while carrying him home one evening in 1899. Horse and rider took a fall. Investigating, Carter found a sealed chamber that contained offerings and a nameless, empty coffin. The tomb's only occupant was the stone figure, which lay beside the coffin, wrapped in a linen shroud.

The exact meaning and function of the buried statue are still mysterious. Whether it was the object of a special cult or merely a substitute placed there when Mentuhotep decided to abandon this tomb chamber and build another nearby, it is an image of the king, wearing the Red Crown of Lower (northern) Egypt ⟦like 8⟧ and a short ceremonial robe ⟦like 1⟧. But his artificial beard is the narrow, curled beard of a god, and his arms are crossed over his chest, in the pose of Osiris, the prototypical dead king and Lord of the Underworld, who thus holds his emblems, a crook and a flail. Any pharaoh, dead and properly buried, was identified with Osiris, and a royal funerary temple would include statues of the king as Osiris, with the crook and flail. Here, however, the mixture of earthly and divine elements is much more ambiguous. Even more than its Osirian pose and the unusual circumstances of its burial, the disconcerting power of this figure suggests a mystical incarnation of the god in the king.

The statue's enigmatic nature makes it impossible to definitely answer a tantalizing question raised by the black color of its skin: whether Mentuhotep was related to the darker-skinned peoples whose ancient homes lay along the Nile south of Egypt. These people had fought and traded with Egypt and in many ways shared its culture since far back in prehistoric times. They were constantly emigrating from their poor, arid lands into the richer north. Some of Mentuhotep's wives were apparently black skinned, but for him there is little evidence, apart from this one statue. As far as they are preserved, his other representations show him with the dark red skin of the ethnic Egyptian male. Osiris, however, was sometimes represented with a black skin to signify his association with the life-giving Nile. Into the river his body had been thrown, according to myth, and through it he pro-

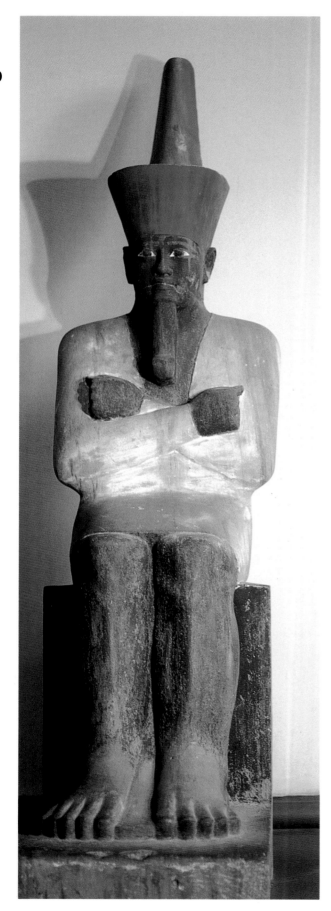

50

⟦ 18 ⟧

King Mentuhotep II
DYNASTY 11, CA. 2061–2010 B.C.
PAINTED SANDSTONE; HT. 138 CM

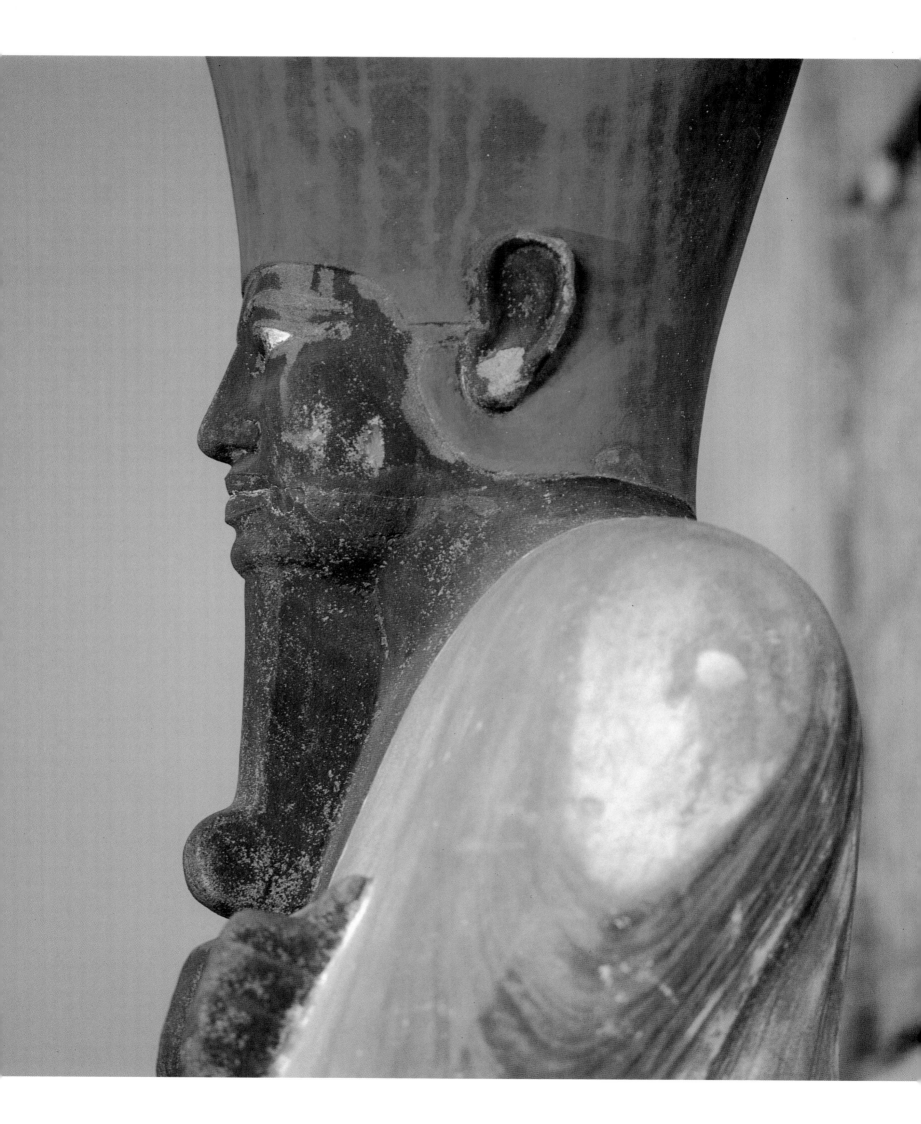

vided the fertilizing, resurrecting power of the rich black silt brought by the annual floods. The blackness of this statue, therefore, may well be the symbolic blackness of life eternally renewed, not the real color of a living man.

The Twelfth Dynasty
(CA. 1991–1783 B.C.)

The founder of the Twelfth Dynasty, Amenemhat I, shifted the royal residence back to the north. By now, Thebes had acquired a special prestige, which much later events were to reaffirm (see Chapter 4). The area of Memphis, however, regained its strategic role as the center of government when Amenemhat established his new residence city not far away. He called his foundation Itjet-tawy. Its general location is known, but its actual remains have not yet been found.

Amenemhat and his successor built their pyramids near Itjet-tawy, and their officials clustered their tombs around them. Saqqara, the ancient burial ground on the desert cliff overlooking Memphis, had lost status since the end of the Old Kingdom, but some men of the Middle Kingdom continued to be buried there, especially those whose profession included service at the Saqqara pyramids. Some of the old royal funerary cults there were still active, despite political change and the lapse of time. One of these men, Hetep, was a priest of the Sixth Dynasty king Tety, and he built his tomb near Tety's pyramid. In it were found two very similar statues of Hetep, one in white limestone and the other, better preserved, in dark granite 〚19〛. They are among the oddest-looking statues ever made in ancient Egypt, but their subject is clear: Hetep squatting in the depths of his sedan chair.

An actual sedan chair of the Old Kingdom was found in the tomb of King Cheops' mother, beside the Great Pyramid. It is of wood trimmed with gold, and its shape is that of an ordinary chair with arms and a back. Instead of legs, however, it rests on two long poles by which teams of bearers could carry it about. There is no footrest: the owner had to squat, with her feet on the front of the seat. Though cramped and probably bumpy, this conveyance was evidently the most comfortable and prestigious mode of overland travel available in its day. In several Old Kingdom tombs, the wall reliefs show officials in their sedan chairs, knees in the air, surveying the world from shoulder height. Looking at the rows of the bearers' legs, no doubt trained to move in synchronization, it is easy to understand the probable source of one Egyptian word for this vehicle: the centipede, that weirdly coordinated creature. Hetep's chair lacks the projecting carrying poles, and the back has been heightened and rounded to frame his head. Otherwise, it and the crouched posture of its occupant are quite true to life.

〚 19 〛

Hetep in sedan chair
DYNASTY 12, CA. 1991–1926 B.C.
GRANITE; HT. 73.7 CM

But Hetep's figure does not look so much fitted into a low, cramped space as embedded in a solid cube, from which his head and limbs are only partially free. Some scholars have suggested that he is literally embedded: that the statue is a symbolic representation of Hetep emerging from the matrix of his coffin — or, alternatively, the primeval hill of creation — into the afterlife. But, although it was often idealized or enriched with symbolic details, the Egyptian tomb statue was essentially an earthbound image — the representative on earth of the departed spirit, the primary link with its mortal remains and the magical agent through which it received the necessary offerings. It would have been inappropriate and pointless to show the part of one's being that had actually left this world. Moreover, neither coffins nor the mounds of creation in reliefs and paintings bear much resemblance to the cube that encloses Hetep. It is simply a special kind of chair, one that forced its user into a crouching position. The stony solidity of the statue is really an overabundance of negative space, possibly the result of the sculptor's caution or uncertainty in carrying out an unusual assignment.

Indeed, this sculptor, by training or temperament, was better suited to traditional themes. He has given Hetep the intently expressive features — wide, staring eyes and tautly grimacing full lips — of the late Old King-

dom sculptural style [[see 17]]. The similarity is so strong, in fact, as to cast some doubt on the originality of this statue and to make one suspect that it might actually have imitated an earlier statue from one of the nearby Old Kingdom tombs. Whatever its explanation, the old-fashioned style gives this figure a provincial look, which is somewhat disconcerting to find at Saqqara, formerly (and again in later periods) one of the great centers of Egyptian sculpture.

It was at the court of the fledgling Twelfth Dynasty that royal studios began the remarkable new developments that were to characterize art for the rest of the Middle Kingdom. Amenemhat I and his son Sesostris I built pyramid complexes, complete with cemeteries for their families and followers near their residence city, at a site now known as Lisht. Working within visiting distance of the Old Kingdom pyramids at Giza and Saqqara, the sculptors of Lisht seem to have been most impressed by the suavity and naturalism of the ancient monuments. They did not set out to copy the older works but used them for both reference and inspiration in forming their new style.

The sculpture of Sesostris I shows a range of variations that suggest considerable experimentation with the royal image. There is no standard likeness for this king. At Karnak, under the lingering influence of Eleventh Dynasty Theban style [[see 18]], his features range from mask-like [[20]] to blandly beneficent [[21]]. At Lisht, relief and sculpture show strikingly individual but bewilderingly different representations. Ironically, the finest and most convincingly naturalistic of all Sesostris' statues seem to have no direct connection with him at all. They are a pair of wooden statuettes, virtually identical except for their crowns. One wears the Red Crown of Lower Egypt, the other the White Crown of Upper Egypt [[22]].

These mysterious images were found at Lisht in 1915 by an expedition from the Metropolitan Museum of Art in New York. The archaeologists were excavating the pyramid of Sesostris I, but they did not find the statuettes in the king's funerary precinct. The figures were discovered in a little chamber within the thick mud-brick wall surrounding the tomb of the dignitary Imhotep, whose high offices had procured him an imposing tomb just northeast of Sesostris' pyramid. They had been deliberately immured, together with a cult object of the funerary god Anubis, apparently as part of Imhotep's burial. It is probable that they had played a magical role during the great official's funerary rites. A few Middle Kingdom reliefs depicting funerals of private persons show a pair of statuettes with royal crowns being carried, with the grave goods, in procession to the tomb, Apparently,

[[20]]

Osiride statue of King Sesostris I, detail
DYNASTY 12, CA. 1971–1926 B.C.
PAINTED LIMESTONE; HT. 158 CM

when the services were over, this pair was secreted in the tomb's periphery, hidden protectors of Imhotep's funerary domain.

Though he wears a White Crown, the symbolism of this figure is not strictly royal. His kilt is not an orthodox royal kilt. Instead of a royal emblem or staff, he carries a crook (not, however, the crook of Osiris). He had a beard, but nothing is left of it except the hole under the chin where it was attached. Very likely it was the narrow, plaited beard of a god [see 43].

As enigmatic as this figure and its pair may be, it is clear that they are products of a royal atelier: the king's gift to Imhotep or one of the perquisites available to a man of his rank, along with his large and advantageously sited tomb. Since a deity or semidivine magical figure would bear the features of the king [see 7, 30], it is reasonable to consider this statuette a likeness of Sesostris I.

The base, the fronts of the feet, and the arms of the statuette were made of separate pieces of wood. The body is trim and well proportioned but slighter and less muscular than a royal figure of the Old Kingdom. As with other figures of Sesostris I [see 21], the torso is softly modeled, the ribcage is clearly indicated, and the belly is a little fleshy. Compared to the tautly bifurcated upper body of King Mycerinus [7], this torso may seem slack; but, beside it, the earlier figure looks surprisingly mannered.

For all its soft naturalism, the body is much more idealized than is the face, which gives the impression of a real individual, even though no single feature is very distinctive. Its character derives from a slight discrepancy between the spaciousness of the upper half, with its low but broad forehead, large eyes, and straight, rather fleshy nose, and the short, compressed lower half, in which nose, chin, and bulging cheeks all seem to crowd in upon the wide mouth. The mouth holds its own, though, in a firmly set horizontal, which animates the entire figure with an expression of almost stubborn determination.

In their statues, Egyptian women tend to look healthy and capable. Though fully feminine, theirs was usually a sober, rather sturdy charm [7, 14, 41, 47, 71, 85]. Twice in Egyptian history, however, women's images achieved a haunting beauty. Nefertiti and other great ladies of the late Eighteenth Dynasty, glamorous and poised, aloof but seductive, have a compelling loveliness that sometimes seems surprisingly modern [55, 63]. Less well known, perhaps, are the beautiful women of the Middle Kingdom — not so sensual, more quietly elegant, infinitely appealing. The head from a small wooden figure of such a woman was found near the pyramid of Amenemhat I at Lisht [23]. We do not know who she was,

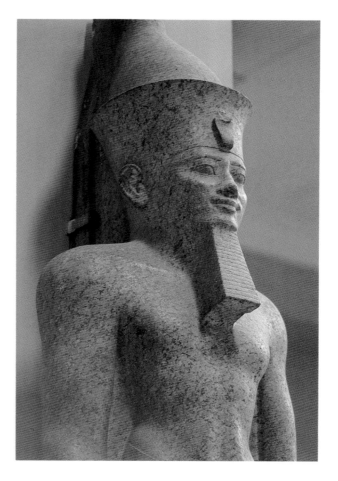

[21]
Colossal statue of King Sesostris I, detail
DYNASTY 12, CA. 1971–1926 B.C.
GRANITE; HT. 310 CM

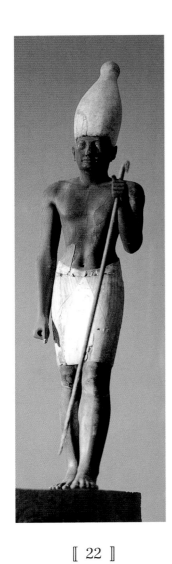

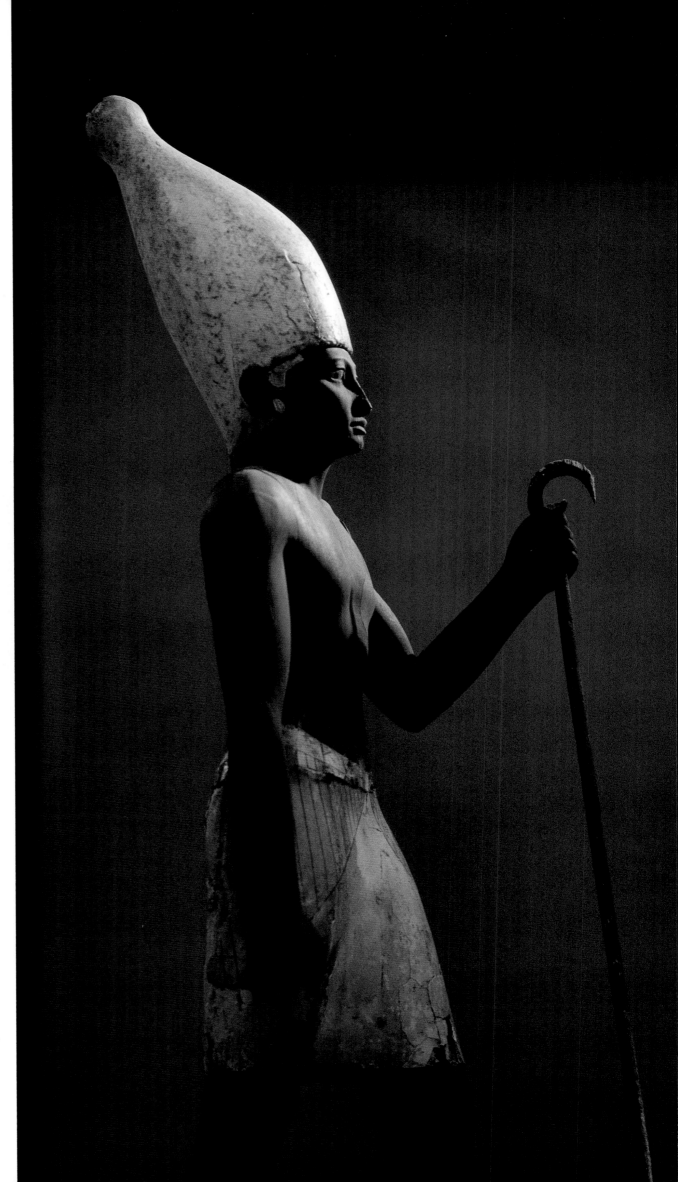

⟦ 22 ⟧

King Sesostris I
DYNASTY 12, CA. 1971–1926 B.C.
PAINTED WOOD; HT. 56 CM

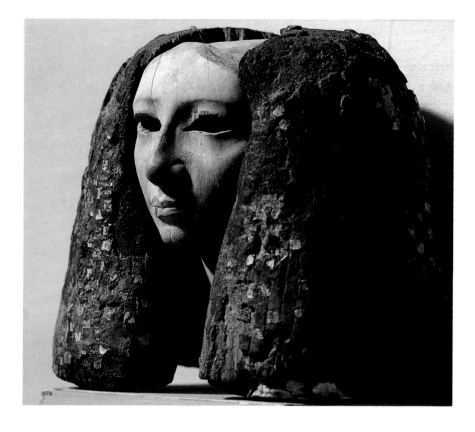

〚 23 〛
Head of a woman
DYNASTY 12, CA. 1991–1926 B.C.
WOOD, PAINTED AND GILDED; HT. 10.5 CM

but the provenance and the exquisite quality of her once elaborate statue leave little doubt that she was a prominent member of the court, quite possibly a queen or a princess.

As with many composite statues 〚see 55〛, this one was assembled from materials that approximated the natural colors of the substances they depicted. Dark wood was used for the heavy masses of the wig. The hair was then painted black and overlaid with little squares of gold leaf, meant to simulate small golden bands, which were slipped up over the individual tresses to form a glittering checkerboard pattern. Faded paint indicating the woman's own hair can be seen on her forehead. Her headdress, quite likely a crown of some kind, has been lost.

Carved in a paler wood, not unlike the color of feminine skin, the delicate little face looks almost waiflike in the mass of its formal coiffure. Inlaid eyes, now lost, would have increased the force of her gaze. Without them, her expression seems tender and sweet. Though girlish and even pampered in appearance, this is not the face of a child. Faint lines around and down from the nostrils and a certain firmness in the set of the softly curved lips create an air of gentle but disciplined graciousness, characteristic of the finest Middle Kingdom female sculpture.

The bodies of Middle Kingdom women, as portrayed in their statues, have a stylized elegance as svelte, as sophisticated — and as difficult to attain — as any high fashion of our own century. The wooden statuette of an unknown woman — her name is lost, along with the base,

which like the feet and arms had been made separately—incorporates this new standard of beauty ⟦24⟧. It is easy to compare her form with earlier models, because the mode of dress remained almost the same: a tube of cloth, supported by two broad straps over the shoulders and breasts.

Compared with the feminine ideal of the Old Kingdom ⟦see 7⟧, this woman looks more graceful but much less athletic. Her breasts are smaller, her long torso narrower. Though it tapers to a small waist, the line is so smooth, and the corresponding swell of the hips so gradual, that the actual waistline seems less nipped in than on the older type. The explicit (and rather primitive) delineation of abdominal and genital areas has given way to a mere suggestion of the pubic triangle. The hips themselves are as narrow as on any Old Kingdom woman, but the long, slow curves continue outward as they descend, reaching their greatest width at mid-thigh. For all her slimness, this figure would look decidedly bottom-heavy if the contours were not so smooth and controlled and if the heaviness of the upper leg had not been balanced by a slightly greater length of leg. In side view, the breasts appear almost to be flattened by their confining straps, while the rest of the body is long, straight, and very narrow. Only the sharply protruding buttocks break the almost schematically flat profile.

Her stylish form and the simple, classical cut of her dress proclaim this woman an Egyptian aristocrat, with the taste and wealth to commission a tomb statuette of the best quality, complete with expensive inlaid eyes and eyebrows. Though much of the inlay is lost, blue rims still frame the eyes, like lavishly applied cosmetics. But there are also unusual features about this little figure that give her an exotic, cosmopolitan quality.

Her face is not the delicate oval of most Middle Kingdom women ⟦see 23⟧; it is unusually broad and rather square of jaw, with suggestions of fleshy ridges at the sides of the nose. In Egyptian art, these traits were frequently used to portray the darker-skinned people to the south, the Nubians. Nubian women were often shown wearing their hair in a short round crop, like that on this statuette. Her facial form and hairdo make it very likely that the woman represented here was of foreign extraction, one of the many Nubians who moved into Egypt during the Middle Kingdom.

Though the style of her dress is traditionally Egyptian, it is not made of the plain white linen almost universally worn by Egyptians but from a gorgeously colored, patterned fabric. The long skirt is covered with vertical rows of white meanders, or squared-off spirals, alternat-

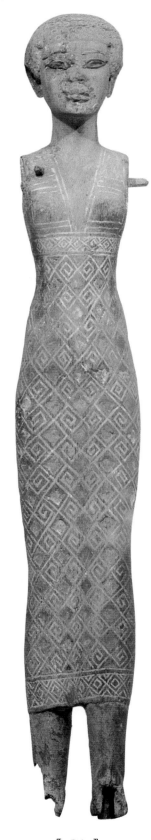

⟦ 24 ⟧

Standing woman
DYNASTY 12, CA. 1971–1878 B.C.
WOOD, PAINTED AND INLAID; HT. 22 CM

ing with orange and blue lozenges. Narrow bands of a smaller lozenge design edge the top and hem. These patterns were carved before being colored, and their texture, combined with the rectilinearity of the design, gives the effect of a rather heavy woven fabric. The dress looks as if it had been cut from something like a blanket or light rug with woven borders.

Most probably, this cloth was not Egyptian. Both the designs and the colors have a foreign look, and their like is not to be found on other representations of Middle Kingdom garments or on surviving examples of Egyptian fabric. Nor is it Nubian: the colorful garments of Nubian women, as represented by the Egyptians, look nothing like this. If the cloth of this dress was imported, it must have come from the Minoans, who invented so many variations on spiral designs. Very similar meander and lozenge patterns appear on the painted ceilings of some richly decorated Middle Kingdom tombs. A foreign inspiration for these ceiling designs has often been suggested, and they could well have been copied from textiles like this.

The woman's statuette ⟦24⟧ was a tomb statue. Life-sized stone statues continued to be made for tombs throughout the Middle Kingdom ⟦19⟧. But the late Old Kingdom practice of placing small wooden figures closer to the mummy ⟦17⟧, sometimes even inside the coffin, also remained popular. These little Middle Kingdom figures are often sensitively modeled, with the charm of an understated sophistication. Such a one is the wooden statuette of Hepkem, from his tomb at Meir in Middle Egypt, one of the strong provincial centers of the early Middle Kingdom ⟦25⟧.

There is a modest, rather chaste quality about this pale, monochromatic little figure. His whiteness is in part an undercoat applied rather unevenly to the whole figure and partly a second coat more carefully painted over the areas that were usually white: the whites of his eyes, his fingernails, the kilt, and a band or strap that runs diagonally from high on the right shoulder down under the left breast. The areas of bare skin should normally have been painted the standard reddish brown of Egyptian male representations. There are smears of this color on the body and definite traces of it in the corners of the mouth, but this basic part of the paint job seems somehow to have been scanted. If Hepkem were his proper color, the use of black to indicate the darker skin of his nipples would seem less schematic and the yellow color of his shaven scalp would be, not darker than the rest of him, but naturalistically pale. The stubble of his sprouting hair is indicated as rows of little black dots, an affectation of

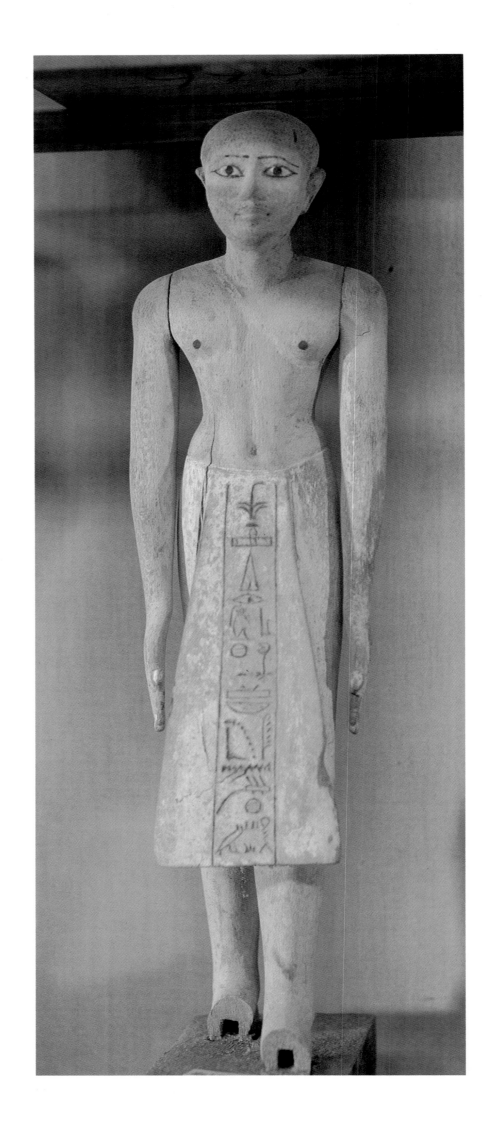

〚 25 〛
Standing Hepkem
DYNASTY 12, CA. 1971–1878 B.C.
PAINTED WOOD; HT. 32 CM

realism found on a number of Middle Kingdom wooden statuettes.

More unusual are the paint traces that show that Hepkem once sported a moustache and, apparently, some kind of beard. Occasionally shown in the Old Kingdom [see 3, 4], moustaches were very rarely depicted in later times. And a beard that covered more than the point of the chin was in most cases an indication of careless grooming. This dapper little creature seems, therefore, to have taken an individualistic approach to his appearance. There is evidence that Egyptian men might abstain from shaving when they were in mourning, but so sad a period was not likely to be commemorated on a tomb statue.

Hepkem's body has the slender, delicate softness characteristic of the Middle Kingdom, with round pectorals and a nipped-in waist [22, 27]. His only adornment is the elegantly drawn inscription in cursive hieroglyphs, which spell out a short offering prayer in his name to Osiris. It occupies the stiff front panel of his skirt, as if the garment had been designed for the purpose of being written on. The arms, base, and fronts of the feet were, as usual, made separately; the latter have been lost.

The doll-like charm of Hepkem's figure [25] and of the two women [23, 24] is typical of much sculpture made during the middle of the Twelfth Dynasty. Beneath this easy, accomplished style, however, ran a current of invention and experimentation. It surfaces most obviously in the development of new types of statues [see 31, 32, 33]. The interest in a rather stern sort of individuality, already apparent in the reign of Sesostris I [22], can be seen in an occasional heaviness and dourness of feature. Even giving these developments their fullest possible due, however, it is hard to account for the sudden appearance of highly individualistic, expressive faces on two of the last kings of the dynasty. Father and son, they present very different features and quite different expressions.

The face of the father, Sesostris III, is among the most memorable in all sculpture. The magnificent head from a colossal red granite statute of Sesostris III in the Luxor Museum [26] shows his noble but idiosyncratic features: deep-set eyes, shrouded by drooping lids; the trace of a jutting nose like a falcon's beak; a thin, tight little cupid's bow of a mouth. Years of frowning, fatigue, and willfulness seem to have worn the skin over the bony countenance into a pattern of diagonal folds and furrows. It is worth looking closely at these downward lines to see how artfully they are placed — how gracefully, in a series of not quite parallel stages, they repeat the diagonal droop of the lids and the sharply rising line of the lips. It does seem odd, though, when we consider that Sesostris was

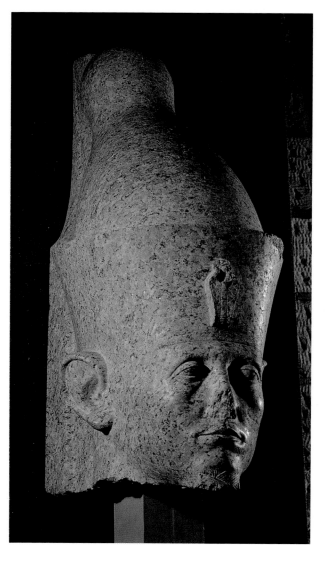

[26]

Head of King Sesostris III
DYNASTY 12, CA. 1878–1841 B.C.
RED GRANITE; HT. 80 CM

one of the strongest and most successful kings of his line, that his face, so carefully and sensitively worked, should show no sign of pride or satisfaction.

Amenemhat III
(CA. 1844–1797 B.C.)

Despite the marks of passing years on the head of Sesostris III ⟦26⟧, it would be difficult to suggest a specific age for this face. A few representations of him look rather more elderly, and a very few seem to show a younger man. For the most part, however, the statues of Sesostris III summarize the indeterminate decades between youth and old age, with features apparently shaped as much by mood as by years. The case is different with his son, Amenemhat III. In the statues of this king — more, perhaps, than with any other ancient Egyptian — we seem to see the major stages of his life: proud but wary youth; robust, stern maturity; weary and disillusioned age.

A life-sized seated statue of Amenemhat III was found at the site of his pyramid at Hawara, in the Fayum ⟦27⟧. The king's low-backed throne has the simplicity of a god's throne, rather than the symbolic ornaments of a royal seat ⟦compare the throne of Chephren, 6⟧. Carved on either side, in sunk relief, is the kind of image only the Egyptians could contrive with their picture writing, in which image and text blend into a readable emblem. On the king's left side, illustrated here, the center of the vignette is a tall hieroglyph, which reads "unification." It refers to a central fact of Egyptian kingship, the unification of Upper and Lower Egypt. This meaning is symbolically enriched by the fat figures, personifications of fecundity, who bind the sign with the papyrus of the north (on the right) and the unidentified lilylike plant emblematic of the south (on the left). The unification sign also supports a column of text, which gives titles and one of the names of Amenemhat III: "The Good God, Lord of the Two Lands, Nymaatre." In this central column of inscription the hieroglyphs face left, the same direction as the profile of the man they identify. Three columns of text on either side are oriented in the same direction as the divine figures below, who are saying them. "Words spoken by the northern land" on the right and "by the southern land" on the left bespeak for Amenemhat III "every good thing which is in . . . , all life, stability, and power under . . ." These identical pairs of blessings (the two outer columns on each side) do not have the concluding "northern land" and "southern land" written out again. It is not necessary, because these are supplied (not just symbolized, but actually written) by the figures below, whose plants are also writings of "north" and "south." The beauty and economy of the Egyptian system are evident. At a glance, a

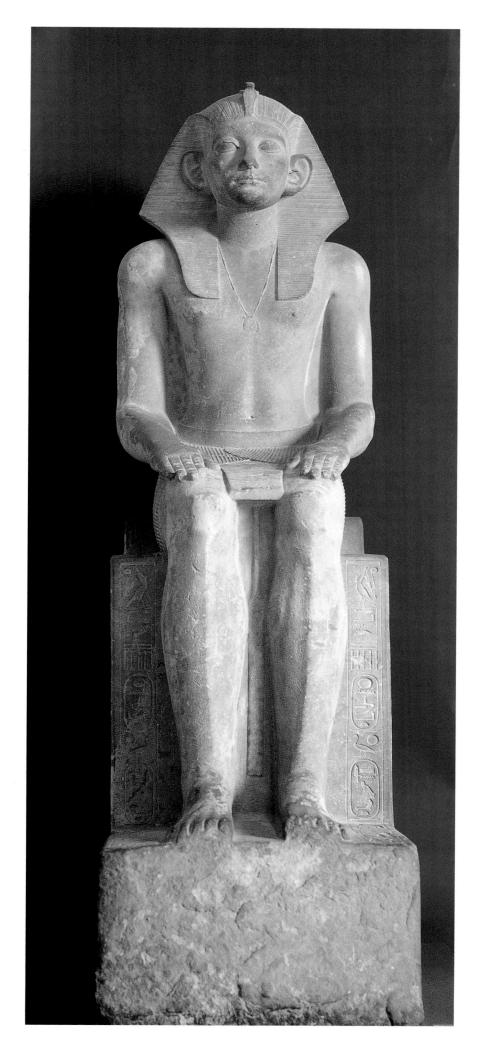

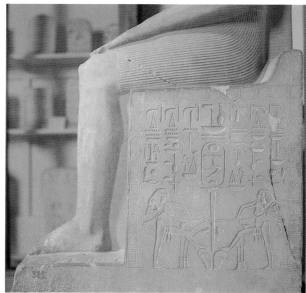

〚 27 〛

Seated King Amenemhat III
DYNASTY 12, CA. 1844–1797 B.C.
LIMESTONE; HT. 160 CM

literate person could absorb a message, full of nuances and associations, which, with our method of writing, requires cumbersome circumlocution.

Amenemhat III wears the traditional pleated kilt and the royal bull's tail, shown in relief between his legs. Instead of a collar necklace, he wears a beaded cord from which is suspended a curious amulet, perhaps a little double pouch for charms or magic potions. This particular amulet is one of the minor mysteries of Egyptian art. Not only was its representation confined almost entirely to the later Middle Kingdom (although it was to appear again some twelve hundred years later, on sculpture and relief made in imitation of Middle Kingdom works), but it also was very frequently worn by kings. Almost never, in any other period, were adult Egyptian kings shown wearing amulets or other ornaments not specifically royal.

The uraeus cobra, for once almost perfectly preserved, flares its hood at the forehead of Amenemhat's *nemes* headcloth, which, in its starched magnificence, seems to push his ears forward almost to right angles with his face. The ears are enormous. On the whole, the Egyptians seem to have favored big ears, and also big feet. Certain periods, however, carried this preference to unrealistic proportions. Eleventh Dynasty sculpture often shows hugely exaggerated feet [see 18], while elephantine ears were popular throughout the Middle Kingdom. We have no way of knowing whether distortions of this kind had any symbolic significance, or whether they were just peculiar fashions of their time.

The king's stocky forelegs are well muscled, but the rest of his body, like those of his ancestors [see 22], seems slight and, in the faint, fleshy diagonal lines of the torso, rather soft. It is a young-looking body, and it fits his distinctive but youthful face.

From written records, we know that Amenemhat III was the son of Sesostris III [26]. If we had only their representations to go by, it would be hard to judge whether they were even related. In contrast to the deep-set, hooded eyes of his father, the younger man's eyes are large and slightly exophthalmic, with shallower, fleshier sockets. A broader span separates his knobby cheekbones, and his mouth is fuller (though it will thin with age). The lips look as if they are held closed only by a slight but awkward thrust of the fleshy little chin, as if the upper and lower jaws were out of alignment. The conformation lends the face a tense, uncomfortable look, which has been observed to bear a curious resemblance to portraits of George Washington, whom we know to have suffered from ill-fitting false teeth. For better or for worse, Amenemhat's teeth were his own.

Perhaps it is mainly this tension of the mouth and jaw, combined with the wide, bulging eyes, but there is something meager about this face, a quality of reserve bordering on suspicion. This modern interpretation may not be what the sculptor intended, but it is worth considering for two reasons. Like his father, and some representations of earlier members of his dynasty, Amenemhat III had a countenance almost devoid of any suggestion of godlike amiability or benevolence, one that, as far as we can tell, is wholly human in its submission to mortal life. Unlike his forebears, however — unlike anyone, in fact, whose images are preserved in Egyptian art — Amenemhat's expression varies, along with the changes of age.

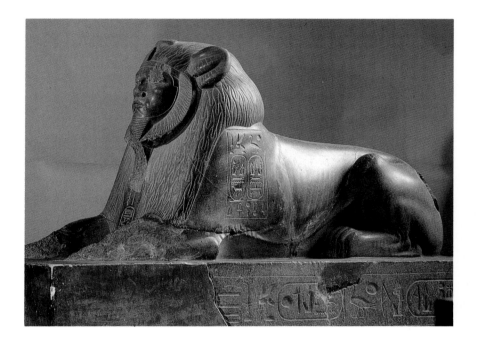

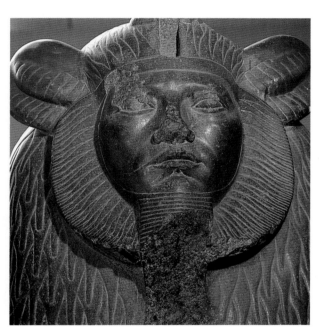

[[28]]

King Amenemhat III as a sphinx
DYNASTY 12, CA. 1844–1797 B.C.
GRANITE; HT. 150 CM, LENGTH 236 CM

A coarser, fleshier, more mature version of Amenemhat's face was used to dramatic effect on certain of his statues; on a monumental sphinx, for example, one of a series found at Tanis in the eastern Nile Delta [[28]]. Of this massive creature, fully leonine except for the king's face, his royal uraeus (now broken), and false beard [[compare 37]], there can be little question that the features are meant to inspire awe and perhaps even fear. We do not know the original location of this sphinx and its companions: they had been usurped through reinscription by several later kings and moved at least once. But such ponderous objects were probably not moved very far. It has been suggested that Amenemhat III placed these sphinxes somewhere along the eastern Delta border, as vivid reminders to incoming Asiatics of his implacable might. If so, they would be among the oldest recognizable examples of sculpture deliberately designed, at least in part, for propaganda effect.

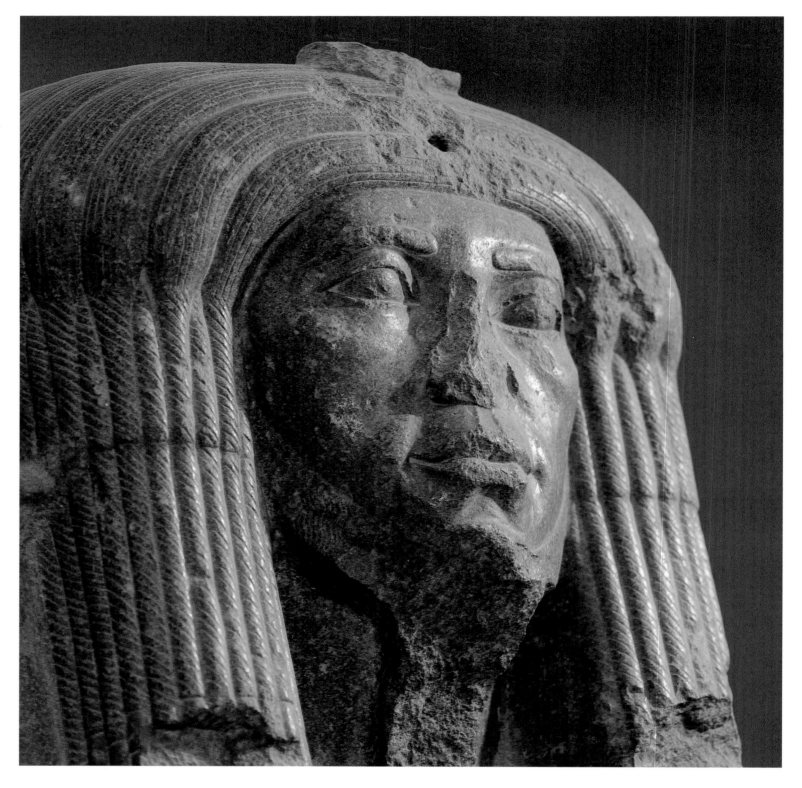

The sphinx's face reappears on an enigmatic bust from a standing royal statue [[29]]. Its broad, stiff wig, like the mane of the sphinx, makes an unnatural frame for the face, which intensifies the harsh, almost brutal expression. With its thick, coarse tresses laid across the head like ropes and bound or twisted at the sides into stiffly pendant bundles, this headdress is strikingly barbaric. It looks like a survival from prehistoric times, and indeed it might be: one or two statues made around the First Dynasty have quite similar hairdos, though they do not seem to be royal. Here, royalty is attested by the uraeus, the body

of which loops back up over the crown of the king's head. The front part of the snake was made separately — probably of metal, to judge from the small size of the attachment hole over the forehead.

All of the regalia on this figure is either unusual or unique. The long royal beard (broken away but quite recognizable from its traces), known from a multitude of representations to be artificial, here seems to grow out of a wispy fringe along the jaw. Like the wig, it gives the strong impression of being a throwback to some primitive age when such beards were real — not mere symbols, but emanations of the virile power of the chief.

A clue to the nature of this unusual representation may be found in the king's costume. He wears the skin of a leopard or panther, slung across his back so that the head and one paw hang over his shoulders and held in place by a strap across the chest. This, too, is a very ancient dress; but, unlike the wig and the natural-looking beard, it had not disappeared from use. The leopard pelt was the Egyptian religious garment par excellence, worn by priests, by sons performing funerary rites for their parents, and, on occasion, by kings. Here, too, however, the representation is ostentatiously archaic, for the fan-shaped end of the chestband knot, which hangs down on Amenemhat's left breast, is a very early form that had become obsolete during the Old Kingdom. Over it is worn a *menit* necklace, more often the emblem of a juvenile god or the equipment of a priestess [see 60, 63]. Against each shoulder rests a thin pole, which terminates in the head of a falcon. All this gear suggests that Amenemhat is shown as a priest performing some special role. But the nature of the rite — even which god was being served — is unknown.

The face of the bust, less fleshy than the sphinx's face, is modeled with greater detail. It is all bumps and hollows, from the faint bony ridge between the eyebrows to the widespaced knobs of the cheekbones, the short diagonals of the various folds and creases, the long slope of the ridged philtrum, and the bulging pockets beside the full, pursed lips. The prognathous set of the lower jaw is more pronounced than on the younger face of Amenemhat III [27]. It seems to have forced out a pair of fleshy ridges, which form an inverted V over the knob of the chin. These ridges, which look so naturalistic and so much the result of his slight deformity, are characteristic of the mature-looking representations of Amenemhat III; they also appear below the mouth of the sphinx [28].

The somber, barbaric power of this statue (and the coincidental similarity of its undershot jaw) is oddly reminiscent of the still quite archaic figure of King Djoser [3]. Since so many elements of the bust — wig, facial hair, cos-

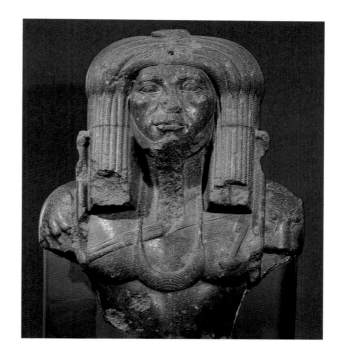

[29]

King Amenemhat III as a priest
DYNASTY 12, CA. 1844–1797 B.C.
GRAY GRANITE; HT. 100 CM

tume — evoke a past that was just coming to an end in Djoser's time, one is tempted to wonder whether the almost brutal expression on this face of Amenemhat III might be a deliberate attempt to simulate the rough majesty of early sculpture like Djoser's, in the infinitely more sophisticated Middle Kingdom.

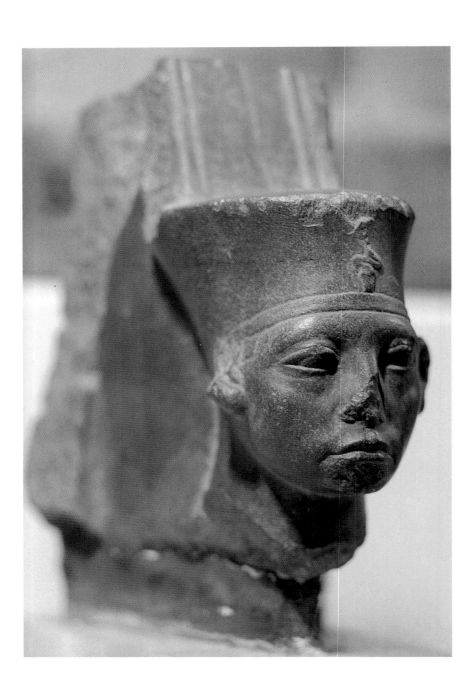

⟦ 30 ⟧

Head of the god Amun
DYNASTY 12, CA. 1844–1797 B.C.
GRAYWACKE; HT. 18 CM

The same features, more aged and worn, make a small head with a tall crown one of the most expressive images of Amenemhat III ⟦30⟧. Around his characteristically long, slightly bulging, widely spaced eyes, the lids are now heavy and fleshy. Physical or mental fatigue is suggested by slight vertical creases in the center of the heavy brow and deep notches beside the ill-fitting lower lip, which seems to be drawn up so firmly as to flatten the

contour of the entire mouth. The fleshiness of the repre-
sentations of his prime has melted away, leaving only
little sagging pouches. The round face has reverted to the
shape of his youthful likeness ⟦27⟧, although a lifetime of
cares and disillusionment seems to separate the two.

Although the head has the features of Amenemhat
III, its headdress of two tall plumes resting on a flaring
cylindrical crown is not royal. It is the crown of the god
Amun ⟦see 61⟧. It is not surprising — indeed, it was only to
be expected — that a deity should be visualized with the
features of the living god on earth ⟦see 7, 60, 61⟧. It seems
strange, however, that an Egyptian god should look so de-
jectedly mortal. We are a long way from understanding
why Amenemhat III, his father, and a very few other
Egyptian kings should have chosen so to emphasize the
material, evanescent aspect of their being and even to
project it onto their gods.

The gods were not the only ones affected by the
representations of Sesostris III and Amenemhat III. Their
likenesses also inspired many "portrait statues" of the late
Middle Kingdom. These often memorable statues of pri-
vate men (and a few women) can look very individu-
alistic. But the melancholy in their expressions and usu-
ally some of their individual features derive from the
sculpture of these two kings. However, these late Middle
Kingdom portrait statues go beyond the traditional Egyp-
tian habit of imitating the likeness of a reigning king.
Many of them were made after the lifetimes of the two
rulers, during the short reigns that brought the Twelfth
Dynasty to a close and in the following Thirteenth Dy-
nasty. It was a remarkable phenomenon, especially since
it persisted under kings who themselves were represented
with much more idealized faces ⟦see 35⟧. Whether it hon-
ored the memory of two very strong pharaohs, whether it
signaled a new perception of the role of private sculpture,
or whether the moody, distinctive features seemed some-
how appropriate to the spirit of the times, we do not know.

On one of these statues, a life-sized seated figure
from Karnak, the expression is almost apprehensively in-
tent ⟦31⟧. It was probably carved in the Thirteenth Dy-
nasty, some years after the death of Amenemhat III; but
its broadly hewn features, the large, heavy-lidded eyes,
the knobby protrusions of the cheekbones — even the sug-
gestion of an uncomfortable fit to the lower jaw — are all
reminiscent of that king's sculpture ⟦see 27–30⟧.

The intensity of the figure's face is enhanced by his
pose. Wrapped in a cloak, his left hand flat on his breast
in a gesture of worship, he seems passive — submissive in
a manner new to Egyptian sculpture. This cloaked form

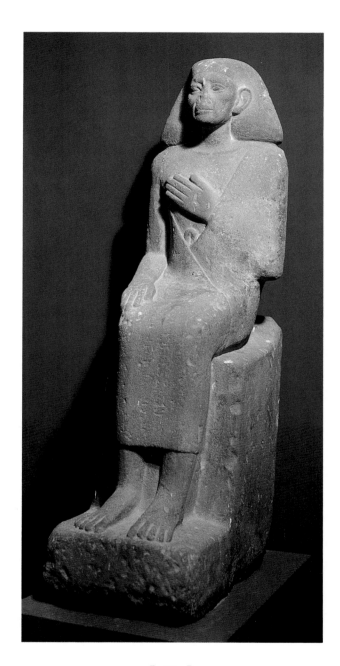

⟦ 31 ⟧
Seated cloaked man
DYNASTY 13, CA. 1783–1633 B.C.
SANDSTONE; HT. 90 CM

is one of several new statue types introduced during the Twelfth Dynasty. Others include figures sitting on the ground ⟦32⟧ and — one of the great inventions of the Middle Kingdom — that peculiarly and quintessentially Egyptian form, the block statue, discussed at length in Chapter 6 ⟦see 74, 75⟧. Following the initial burst of creativity that established Egyptian sculpture at the beginning of the Old Kingdom (see Chapter 2), no other period added so many types to the repertory of Egyptian sculpture as did the Middle Kingdom.

Not all of its innovations were successful. The sedan chair statue made for Hetep ⟦19⟧ seems to have had no appeal. Egyptians might have rejected this pose for its clumsiness. More likely, however, they decided that it added nothing essential to the varieties of tomb statuary already available. The successful new statue types of the Middle Kingdom were created primarily in response to a new circumstance: for the first time since the early dynastic period ⟦see 2⟧, private individuals began to place statues of themselves in the temples of the gods, breaking what seems to have been a royal monopoly of this privilege.

Temple statues did not replace tomb sculpture. Their purpose was to open an auxiliary channel for obtaining the offerings needed in the afterlife. Bitter experience had taught the Egyptians how fragile were even the most carefully laid and lavishly funded plans for eternal offerings in the tomb. Temples were more reliable, especially since their rituals included the practice of "reversion offerings," by which the food, drink, and other good things offered to the cult statues were reoffered to the other statues on the premises. Lesser gods, kings, royal family, and private people got their turn in order of importance. The system is typically Egyptian in its odd but elegant logic and the pragmatic good sense of its economics. Since the statues participated by magic and in spirit only, there was bound to be plenty to go around, until the last stop — when the priests and their dependents took material possession.

Unlike tomb sculpture, temple statues had to withstand ages of exposure in relatively public locations. Most often, they were carved in a hard stone, such as granite, and were given compact shapes to make them as invulnerable as possible to ordinary wear and accidents. The new statue forms of the Middle Kingdom were admirably suited to these practical considerations. But the real source of their popularity was their suitability to the altered function of a private statue that stood in a temple rather than in a tomb. Far from being the major focus and expression of a funerary cult, the temple statue was a minor

participant, present by sufferance and relying on the charity of the gods and their officiants. The modesty and sometimes almost stoical passivity in the stance of these cloaked figures, and those seated modestly on the ground, are no accident. Theirs are the poses of waiting.

The frequency of somber or aged countenances on Middle Kingdom temple statues — once royal likenesses created the precedent — raises the suspicion that in this period such a face seemed particularly appropriate for a guest in the god's house. Specifications for temple statues, as with those for the tomb, seem to have been left largely to the owners (or their sculptors). Many opted for the more traditional standing and seated poses for their temple representations [[see 33]]. Others placed statues of temple type in their tombs.

Nonetheless, the temple statue differed profoundly from the tomb figure in ways that affected the very foundations of Egyptian sculpture. Its sheer physical distance from the tomb and mummy inevitably weakened the ancient belief in a magical identity between image and subject. The owner's spirit could not "live" in it in so immediate a way as in statues housed in the tomb, near his mummy. Although it retained a magical relationship with the person it represented, the temple statue came increasingly to serve a memorial function. This change in spirit is signaled to some extent by the ever more lengthy statue inscriptions, designed to inform passing strangers in the temple of the identity of the deceased and to solicit offerings. The slowly growing perception of a statue as an independent entity underlies the New Kingdom cults devoted to certain statues, distinct from the kings they represented [[see 44]]. In the end, temple statues superseded tomb statues — but that took a very long time (see Chapter 6).

The life-sized quartzite statue of one Khentykhety-emsaef-seneb was found in a necropolis area. It may have been a tomb statue, but it has the appearance of one made for a temple [[32]]. Khentykhetyemsaef-seneb — his long appellation includes a name within a name and means "Khentykhetyemsaef [whoever he was] is healthy [or alive]" — sits on the ground with his legs crossed, like a scribe [[see 50]]. But he is not acting the scribe: his hands rest passively on his thighs, and his body is swathed in a long, typically Middle Kingdom skirt like a bath sheet, wrapped beneath his breast, with one corner tucked under and the other poking out. His rather sunken chest and bulging abdomen suggest the maturity that is also reflected in his face, where features from both Sesostris III and Amenemhat III are combined. The vertical worry

[[32]]
Khentykhetyemsaef-seneb
DYNASTY 12/13, CA. 1844–1633 B.C.
SANDSTONE; HT. 105 CM

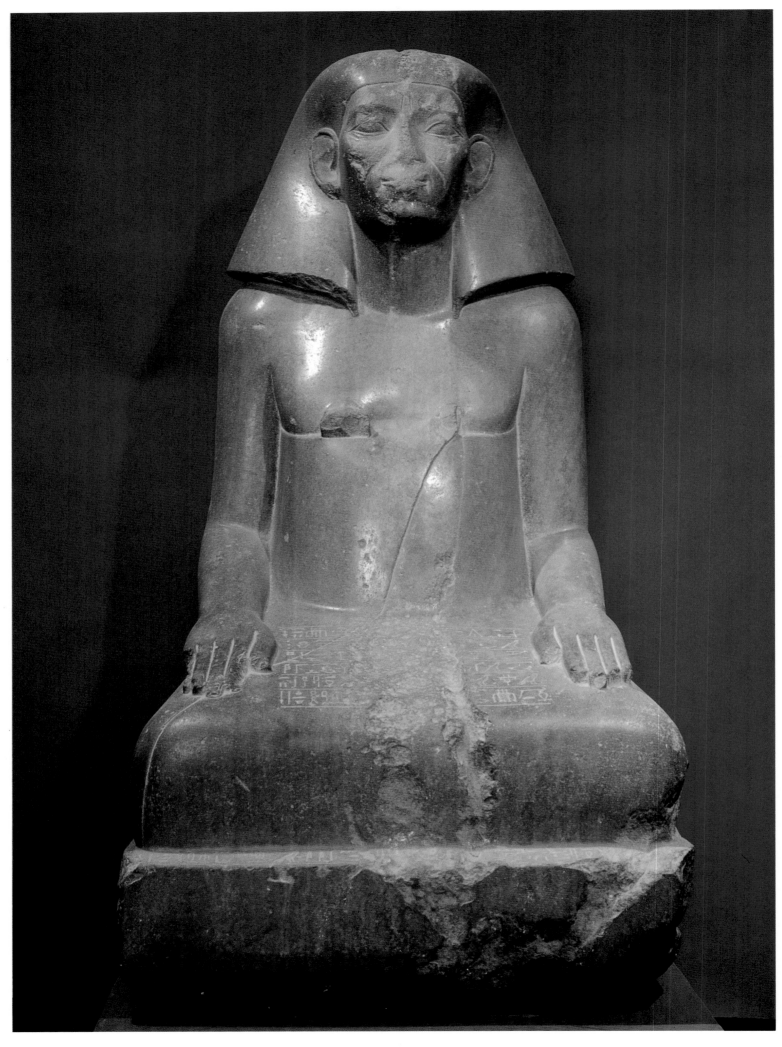

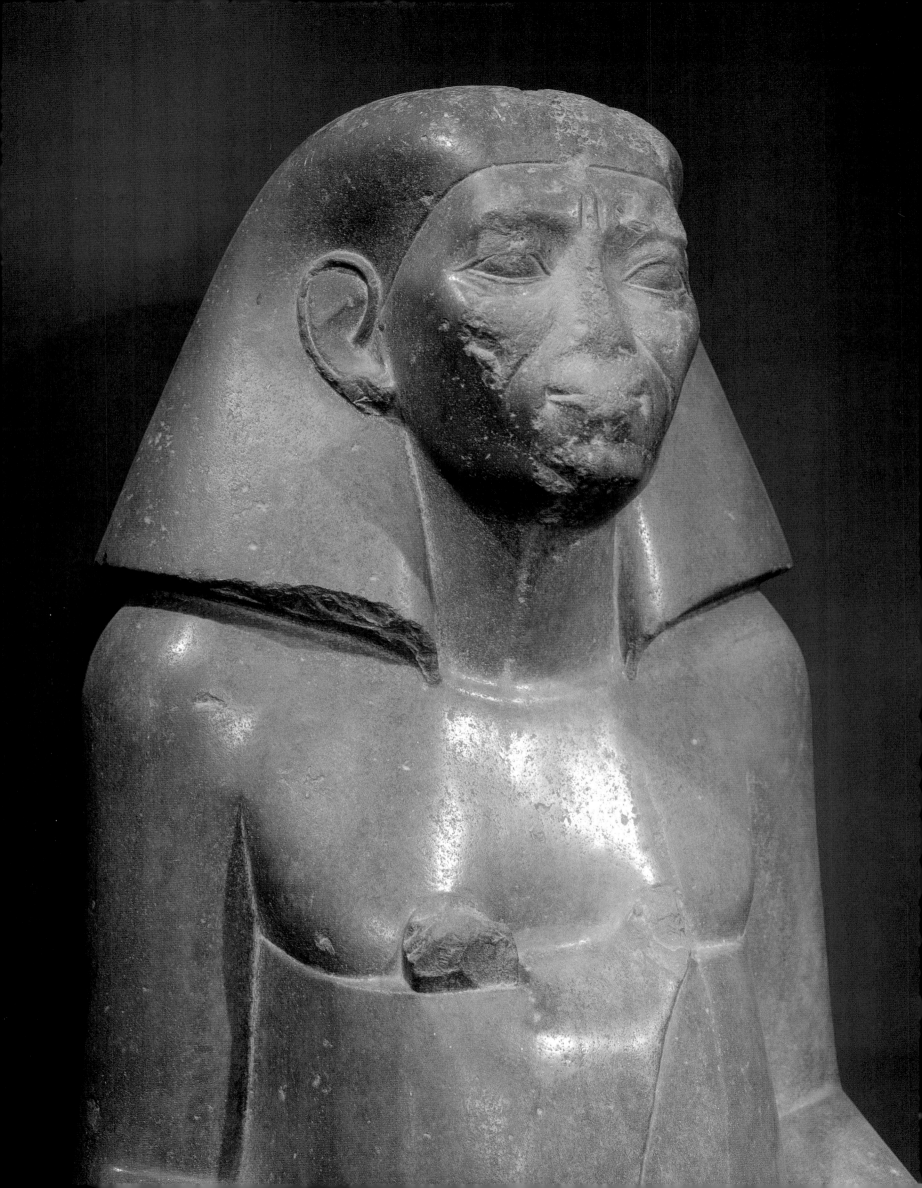

lines between the brows derive from certain represen-
tations of Sesostris III; the wide-spaced eyes and un-
comfortable mouth suggest Amenemhat III. In a manner
typical of many late Middle Kingdom portraits, these
borrowed features are combined with a lantern jaw, the
hint of a double chin, and an ambivalent expression all
Khentykhetyemsaef-seneb's own.

Among the finest and subtlest of late Middle King-
dom portrait statues is the seated figure of a man named
Sikaherka [33]. This statue, found at Karnak, was defi-
nitely a temple figure, but it follows the old, traditional
type of seated pose. Sikaherka's hands, however, lie open,
palm down on his lap, showing the passivity appropriate
to a temple figure; an Old Kingdom tomb statue in this
pose would normally have had one fist clenched, in a
minute but significant display of muscular tension.

Sikaherka's long, front-wrapped skirt and the
smooth-surfaced wig that falls to points over his collar-
bone, just like those worn by Khentykhetyemsaef-seneb,
are innovations of the Middle Kingdom that were seldom
represented later. When one or both appear on a statue of
the New Kingdom [see 51] or Late Period, it is a sure sig-
nal of self-conscious archaism.

The antecedents of these facial features are obvious
enough: a furrowed forehead; heavy, fleshy eyelids; a con-
spicuously firm set to the mouth. But a comparison of this
statue with the two previous ones leaves little doubt that
Sikaherka's sculptor was an unusually resourceful and
subtle artist, a master of understated effects. Sikaherka's
wrinkles are shallow, almost invisible in dim light. His
eyes are small and the mouth little more than a set of
horizontal lines, except for a slight prominence of the
lower lip. The nose and the tapering planes of the rather
long face seem unexceptional. But these features have
been so softly delineated and so organically combined that
their total effect is far more individual and lifelike than
the blatantly expressive faces of Khentykhetyemsaef-seneb
[32] and the anonymous cloaked man [31].

The ancient Egyptians thought of the individual as
a complex of physical and spiritual elements. The living
body housed a set of intangible, immortal factors, includ-
ing the person's name. Some of the spiritual components
correspond roughly with our notions of soul, spirit, and
intellect. Perhaps the most important, however, was the
ka, a kind of "double," born with the individual, dwelling
in one throughout life but possessed of an independent
force. During life, one depended on the *ka* for health and
strength. In death, the *ka* assumed a kind of dominance.
Funerary formulas bespeak offerings "for the *ka* of" the
deceased; and it seems to have been the *ka* that inhabited

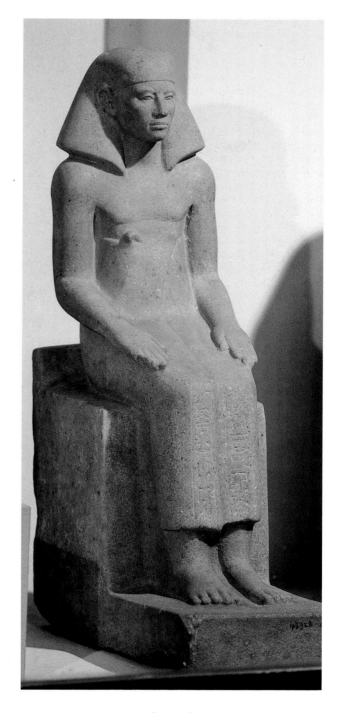

[33]

Sikaherka
DYNASTY 13, CA. 1783–1633 B.C.
QUARTZITE; HT. 65 CM

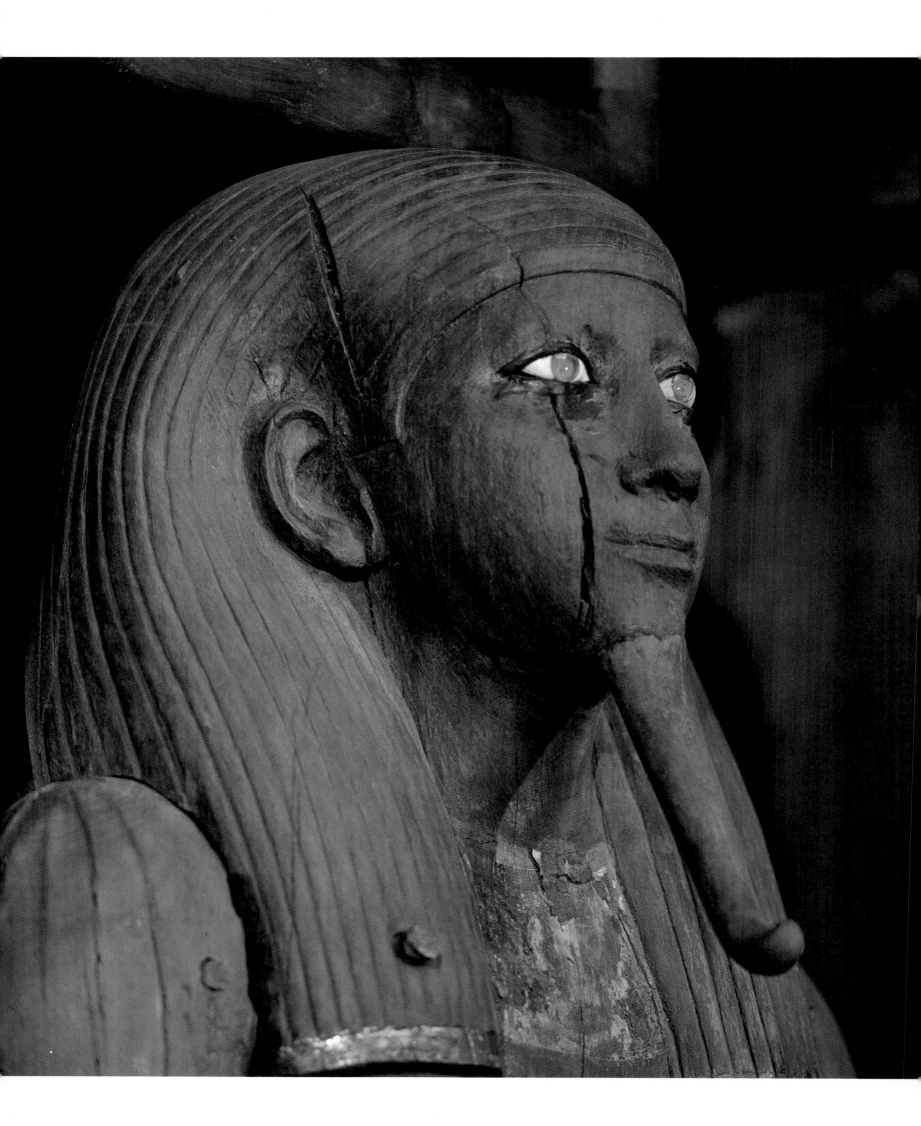

the tomb statue. The emphasis on this ageless and immortal element of the individual may explain in part the strong tendency toward idealization in so much Egyptian art.

Two-dimensional representations of the king often show his *ka,* a much smaller figure standing behind him. On its head is not a crown but the hieroglyphic sign for the word *ka:* a pair of upraised arms. That same sign on the head of a sizable wooden figure found in the modest tomb of one Hor — an obscure king of the Thirteenth Dynasty — identifies it as a statue of the king's *ka* [[34]].

Though different in almost every respect from the seated Osirian statue of King Mentuhotep [[18]], this figure is similar in conveying a sense of uncanny, superhuman spirituality. The *ka* of a dead king was more divine than human. Like the cult statue of a god, this figure stood in its own wooden shrine, which still partly encloses it in the museum. It wears the long straight wig and the plaited, clubbed beard of divinity. Originally, it would have presented a far more colorful appearance, for the skin was painted and gold leaf was applied liberally, not just on the ends of the wig, the collar necklace, and the kilt but on the eyebrows, nipples, fingernails, and toenails as well. The flesh of the gods, as Egyptian texts tell us, is gold.

Though the figure appears nude, it was once minimally clothed in a penis sheath, suspended from a gilded belt [[for the representation of one worn by a god, see 43]]. This primitive garment must also have been made of gold. Like the implements once held by the *ka,* it has disappeared; two holes in the center of the lower abdomen show where it was wrenched away. Fortunately, we still have the wonderful inlaid eyes (the right one, along with the beard and the *ka* emblem, is restored), which derive their lifelike glitter from the transparency of their rock crystal irises. They animate the rapt face with an otherworldly radiance.

When this statue was carved, the great days of the Middle Kingdom were past; Egypt was falling into political and economic decline. But the slight, youthful figure is as finely proportioned and crafted as work from the heyday of the Twelfth Dynasty [[see 22]]. The face, however, is impassive and ageless, its expressiveness concentrated in the luminous eyes. There is just enough individuality in the long curves of the cheeks and the thin lips to raise

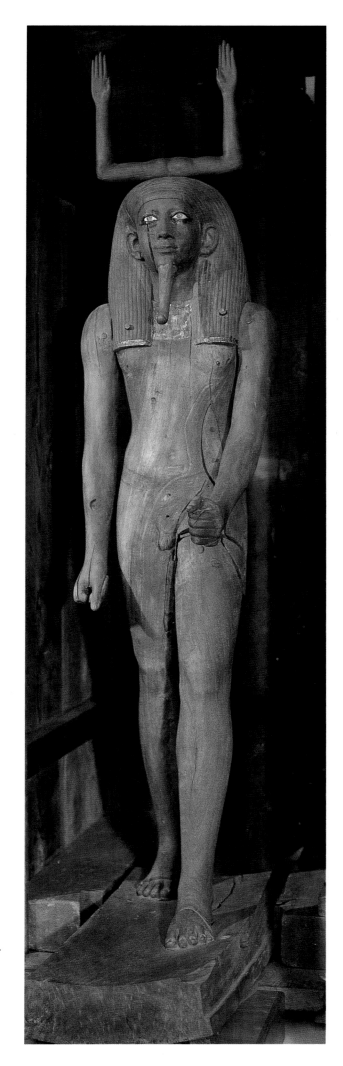

[[34]]

***Ka* statue of King Hor**
DYNASTY 13, CA. 1783 – 1633 B.C.
WOOD, INLAID EYES OF BRONZE AND STONE,
TRACES OF PAINT AND GILDING; HT. 170 CM

77

the question whether this spirit figure is at all a likeness of the living King Hor. It seems appropriate that it should be, but it is hard to draw conclusions, since we have neither a statue of this king nor a *ka* statue of anyone else. In any case, the idealization of its features constitutes a rejection of the somber naturalism of Sesostris III and Amenemhat III.

As the Middle Kingdom ended, Egyptian sculpture was changing again. Perhaps this was due in part to the re-emergence of strong provincial workshops, at Abydos, at Elephantine, and in the Theban area, as central royal control once more began to fail. As at the end of the Old Kingdom [see 17], sculptors — or their patrons — began to reject naturalism, with its Middle Kingdom components of age and mood. A new idealizing style seems to have developed, first in royal sculpture, while many private persons still carried on the tradition of portraiture [see 31, 32, 33]. But even in the royal statues, traces remain of the features of Sesostris III and Amenemhat III.

The colossal head of an unknown Thirteenth Dynasty king with a White Crown, found at Medamud (near Thebes), is a striking example of the simultaneous rejection and continued influence of late Twelfth Dynasty royal style [35]. It does not look in the least like Sesostris III [see 26], but the fleshy brow and the heavy upper lids owe a great deal to his representations, and so does the thin but shapely upper lip. An even more direct debt to representations of Sesostris III is the vertical groove down the center of the forehead. This feature is so unusual in Egyptian art that it must derive from the more naturalistic furrow often shown on the earlier king's forehead.

Here, the furrow calls attention to the king's large eyes and combines with the slight upward curl of the mouth to make the face look alert, if a bit quizzical. Much of its power, however, comes from the strong geometry of its underlying structure. The features are contained within a rather flattened front plane, which tapers like a wedge to the straight edge of the chin. At the sides, it breaks rather abruptly to the flat cheeks, which taper less strongly to a large, square jaw. There is just enough modeling of naturalistic fleshy detail, under the eyes and beside the nose and mouth, to avoid harshness — and, incidentally, to show that this sculptor's effects are deliberate, not the result of naïveté, carelessness, or insufficient skill.

This last Middle Kingdom style was short-lived. Soon enough, it fell victim to the troubles of the Second Intermediate Period, when Egypt was humiliated by foreign domination. Like the style that arose at the end of the Old Kingdom [see 17], it was deprived of the conditions necessary for further development.

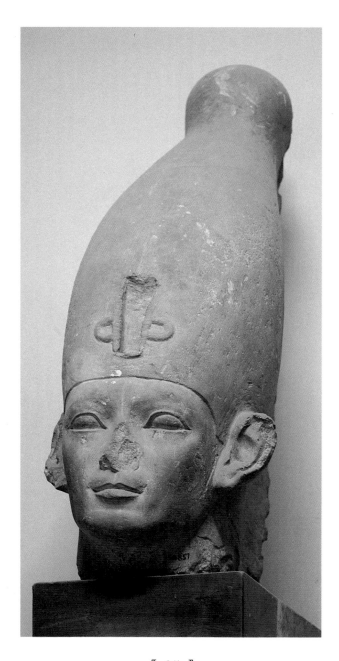

[[35]]

Head of a king
DYNASTY 13, CA. 1783–1633 B.C.
LIMESTONE; HT. 83 CM

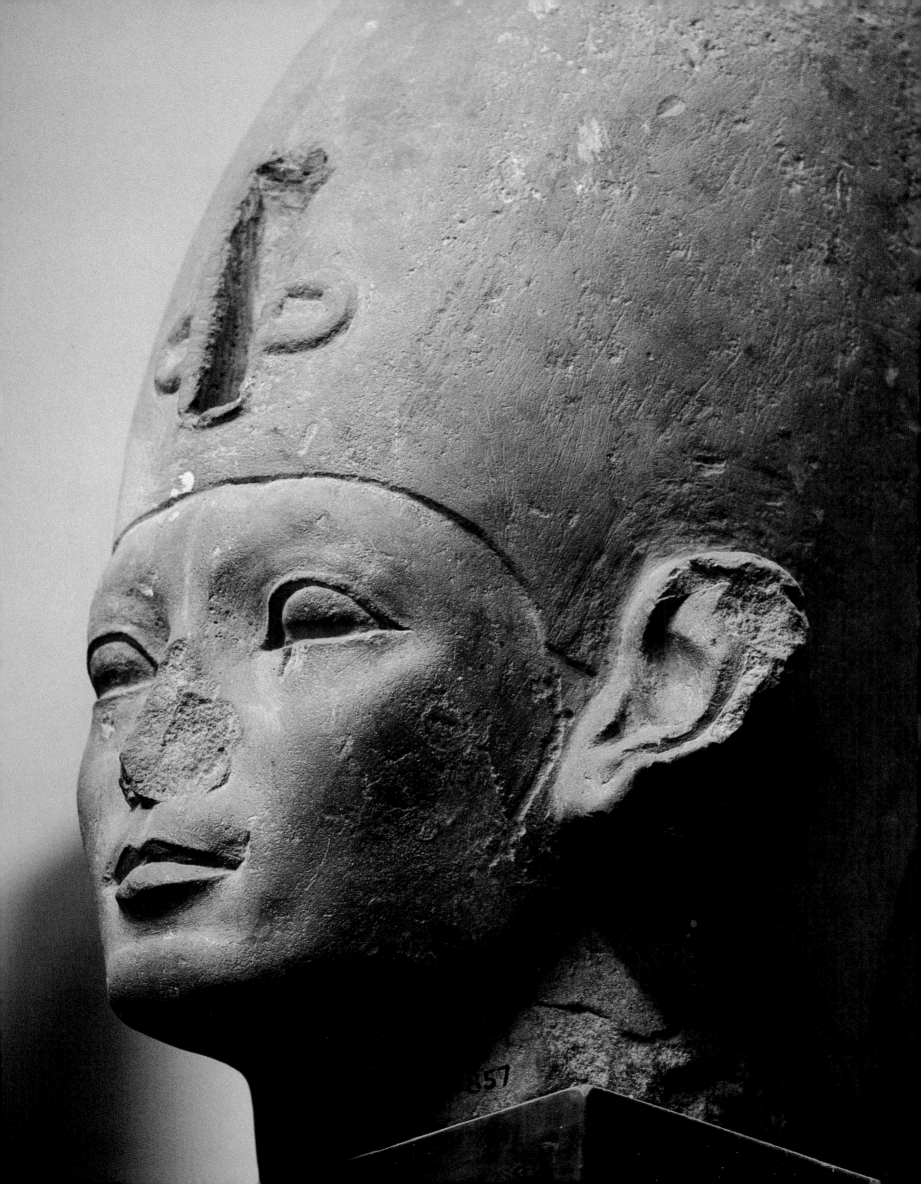

Chapter 4 Creation of an Empire

The Early New Kingdom

Dynasty 18
THROUGH THE REIGN OF AMENHOTEP III
(CA. 1550–1353 B.C.)

THE NEW KINGDOM began with a historical repetition. For a second time, Egypt was reunified and restored to strength by a prince of Thebes. But unlike King Mentuhotep, some five centuries earlier (see Chapter 3), Ahmose, the founder of the Eighteenth Dynasty, had to wrest his kingship from foreign rulers. For several generations, his family had battled valiantly but unsuccessfully against the Hyksos rulers. Finally, Ahmose carried the campaign to their stronghold in the eastern Nile Delta and drove them from the country, ridding Egypt of its humiliating subjugation.

This aggressive start set the tone for the period that older histories of Egypt often refer to as the Empire. Several of the great New Kingdom pharaohs were soldiers and leaders of men. Under Tuthmosis III [see 39, 40] and his successors, Egyptian military might made it the dominant power over much of the ancient Near East, as well as the lands to the south. Egypt became the greatest empire of its day, and this new role had enormous cultural consequences. A military aristocracy with unprecedented prestige, intensified contacts with foreign civilizations, wealth pouring in as tribute or from increased trade: these are a few of the factors that shaped New Kingdom society and had a direct bearing on its art.

The Theban kings of the Eighteenth Dynasty set the seal of ascendancy on their city. Thebes reached its zenith in the New Kingdom. Amun, originally a local god, became the closest thing to a state god that Egypt ever knew. His vast temple complex at Karnak and his smaller Luxor temple, both within ancient Thebes, testify how much of the new imperial wealth was poured into the glorification of the city and its god. Huge amounts were spent on the royal funerary establishments: the immense underground tombs in the Valley of the Kings and elaborate funerary temples, of which Deir el Bahri, the Ramesseum, and Medinet Habu are only a small remnant. And most of these structures were filled with sculpture.

The re-establishment of a strong, centralized royal power gave rise to a new artistic tradition. The first reigns of the Eighteenth Dynasty show some interesting parallels to the early Middle Kingdom (see Chapter 3). The art-

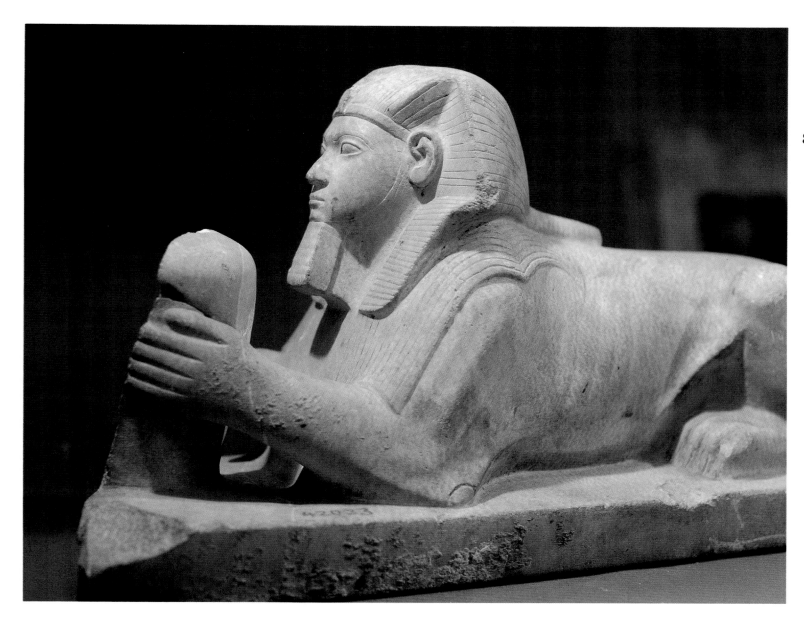

ists of Ahmose's reign, like those of the Eleventh Dynasty ⟦see 18⟧, mostly carried on with the local style, producing vigorous but undeniably provincial work. The reign of his successor, Amenhotep I, like the early Twelfth Dynasty at Lisht ⟦see 22, 23⟧, saw both experimentation and renewed sophistication, which produced some memorable royal representations.

Amenhotep I is one of those pharaohs whose representations, although they vary considerably in detail, seem to show a single underlying reality. It is his face that looks out from a small alabaster statue and identifies it as his ⟦36⟧. The face is not particularly handsome. The forehead is low and broad; the eyes bulge a bit; the small straight nose has a tense little flare at the nostrils. The round cheeks bear their fullness so low, around the jaws and pursed little mouth, that Amenhotep looks almost as if his mouth were full of water. His narrow, knobby chin shows just the hint of a cleft above the wavy hair of his artificial royal beard.

⟦ 36 ⟧

Amenhotep I as a sphinx
DYNASTY 18, CA. 1525–1504 B.C.
ALABASTER (CALCITE); HT. 22 CM, LENGTH 43.5 CM

Amenhotep is represented as a sphinx. This inspired combination of a king's head with a lion's body, to signify divinely royal might and majesty, was an Egyptian invention of the early Old Kingdom. One of the first, the enormous Great Sphinx of Giza, was carved out of desert bedrock to represent King Chephren [see 6], whose pyramid stands behind it. Usually, a sphinx lies peacefully recumbent, but its body is massive, with muscular shoulders, a ribcage like a barrel, and hindquarters ready to spring. A human head on this body, if it is not to look ridiculous, must be disproportionately large. The Egyptians perceived this, and they also realized that the royal pleated headcloth, the *nemes,* gave needed width to the head, framing it in a setting not unlike a mane. Most sphinxes, including the Great Sphinx and this one, wear the *nemes.*

It seems hardly possible to improve on the basic concept of the sphinx, and the Egyptians seldom tried. One of the few successful variations, of which this sphinx may be the earliest sculptural example, was to give it human hands. The hands have been amalgamated into the animal body by making them as pawlike as possible. Set on forelimbs that are leonine in almost every respect, the palms were as broad as the pads of paws, although they terminated in a thumb and four fingers. One of the hands is now broken away, and the other has lost the tips of its fingers. Presumably they were tipped with fingernails, not claws.

A human-handed sphinx had the advantage of being able to make a gesture or hold an object. Amenhotep's sphinx held a ceremonial vessel, which he offered to a god. This statuette was not made as an object of devotion in its own right, but as an auxiliary to the divine cult image. Egyptian temples were full of small royal statues, in poses of offering or worship [see 39, 72], which embodied the king's role as chief worshiper and only intermediary with the gods. The intended recipient of Amenhotep's offering in this case was probably Amun, since this is one of the statues found in the Karnak Cachette.

The Karnak Cachette

The Cachette (sometimes called the Favissa) was a huge pit dug in one of the courtyards of Karnak temple, probably around 300 B.C., when major restorations were underway. Into it were thrown statues and other temple objects, the accumulation of centuries, which were taking up needed room. In fact, the Cachette was a sacred dump. Its contents were not deposited with any great care, but their burial in holy ground shows a continued respect for the spiritual presence of predecessors who were very long dead and, for the most part, long forgotten. Similar depos-

its have been found under a number of Egyptian temples, but none has approached the size of the Karnak Cachette. Clearing it required three years of excavation, from 1903 to 1906, under conditions of considerable difficulty and extreme discomfort. The pit, over ten meters deep, was continually filling up with ground water, in which the workmen found themselves literally "fishing for statues." When they were done, they had brought up over 1,700 objects, including some 750 stone statues made for Karnak temple, almost all of them dating from the New Kingdom or later. From this point on, a large percentage of the sculpture in this book will be Cachette statues. (This provenance will sometimes be mentioned in the text; it is systematically recorded in the documentation at the end of the book.) It is hard to imagine what our understanding of Egyptian sculpture would be without this extraordinary find. But so much material from a single site also carries the danger of distorting our overall view: because of the Karnak Cachette (and other rich finds in this area), we tend to look at Egyptian sculpture, of the New Kingdom and later, through Theban eyes.

Like kings, royal women could be portrayed as sphinxes. In this respect, there is nothing unusual about the limestone sphinx of a woman named Hatshepsut ⟦37⟧. This, however, is the famous Hatshepsut, the woman who ruled as king. When the fourth king of the dynasty, Tuthmosis II, died, he left a widow who was also his sister, Hatshepsut, and an heir, his only son, Tuthmosis III, born to a secondary, nonroyal wife. At first, Hatshepsut acted as regent for her nephew-stepson, who was still a child. Soon, however, she called herself his co-ruler, and finally she took over, representing herself as sole king of Egypt. Hatshepsut's extraordinary career may have shocked modern historians more than it did the ancient Egyptians. The facts that she retained power for twenty years without open opposition and, even more, that the boy Tuthmosis III not only survived but also was given command of the army when he became old enough suggest that her motives were loftier than mere greed or personal ambition. Some scholars now believe that Hatshepsut's assumption of power was in response to a real political or dynastic crisis.

As priest and as mortal god, pharaoh was by definition a man. Thus Hatshepsut, when she is represented as king, is usually shown with a masculine body and costume, and many inscriptions refer to her as male. Of course, nobody was fooled by this fiction; there seems to have been ambivalence, or even confusion, about how far it should be carried. On this sphinx, the inscription

Hatshepsut
(CA. 1473–1458 B.C.)

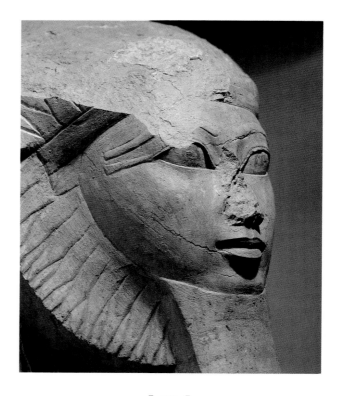

⟦ 37 ⟧
detail

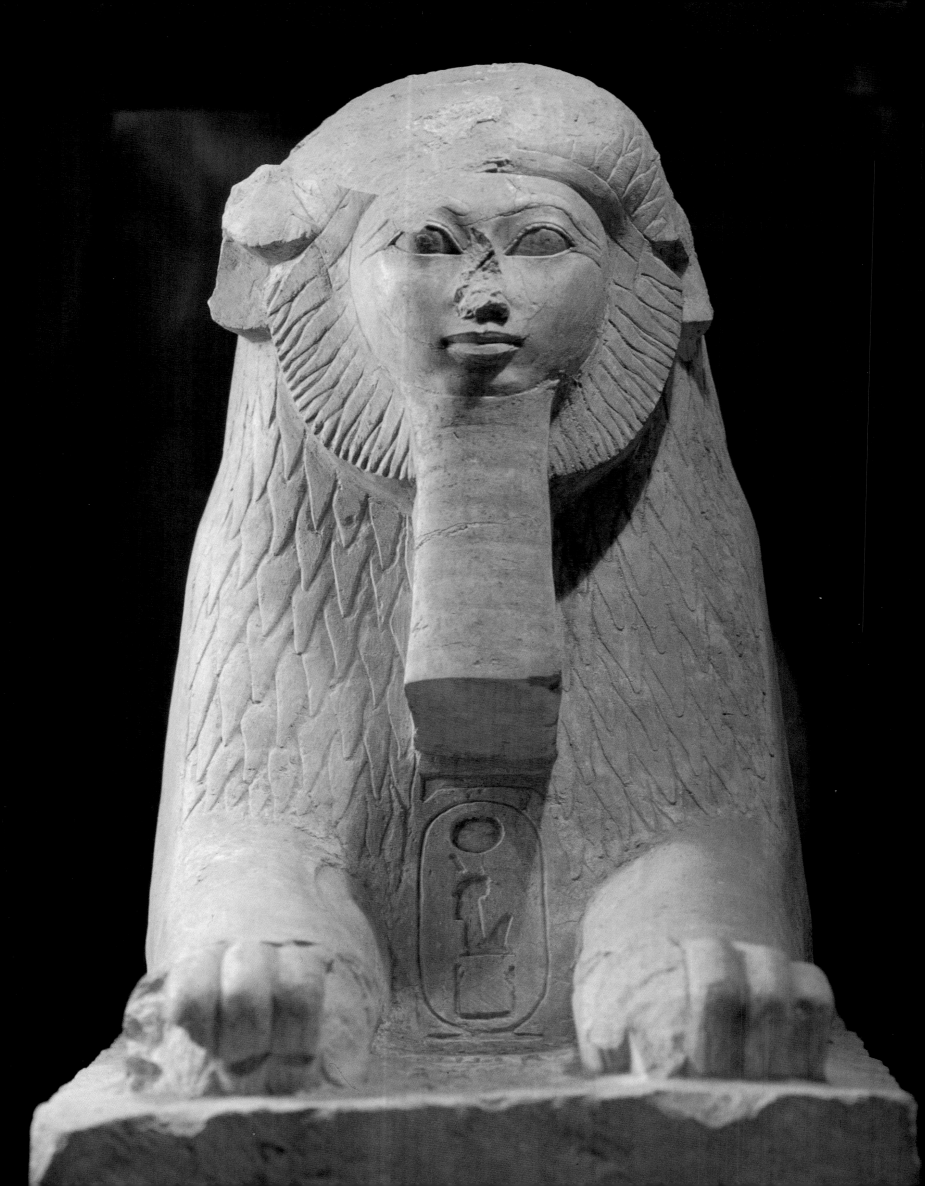

beneath the kingly false beard and between the paws reads: "Maatkare [another name of Hatshepsut], beloved of Amun, may *he* be given life forever." A companion sphinx in the Metropolitan Museum, an almost identical twin to this, reads: "Maatkare, beloved of Amun, may *she* be given life forever."

The lion's body looks masculine. Its chest is covered by a full mane, the shaggy hair stylized into a flame pattern. Instead of a king's pleated *nemes* headcloth ⟦as on 36 and 64⟧, the face is framed by a lion's ruff and large leonine ears. Besides the face, only the false beard, tied on with a strap running along the inside of the ruff, is human.

In the Middle Kingdom, the superleonine quality of the maned sphinx had been exploited to awesome and forbidding effect ⟦see 28⟧. Here, the symbolism is more subtle. Deliberate ambiguities in the carving and painting of the head and mane give this sphinx an abstract, metaphorical quality rare in Egyptian sculpture. Although the animal body is an appropriate tawny yellow, the ruff and mane have been painted blue, the same color as the beard. In Egyptian painting, blue was often substituted for black, especially in the representation of hair ⟦see 71⟧. To Egyptian eyes, therefore, the whole head would have appeared to be humanized, as if mane and ruff were an enormous wig or some strange version of a *nemes* headdress (which was usually painted blue and yellow). The impression of a headdress is enhanced by the yellow band that runs across the forehead under the now largely destroyed uraeus, just like the yellow frontlet of a *nemes*. In back, the mane tapers down to a thick little tail, like a braid or the queue at the back of this headdress ⟦compare 36⟧. This highly stylized blend of animal and royal imagery makes a perfect setting for the piquant, feminine-looking mask that is Hatshepsut's face.

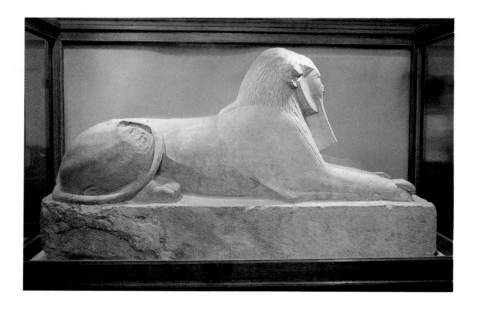

⟦ 37 ⟧

Queen Hatshepsut as a sphinx
DYNASTY 18, CA. 1473–1458 B.C.
PAINTED LIMESTONE; HT. 62 CM, LENGTH 108 CM

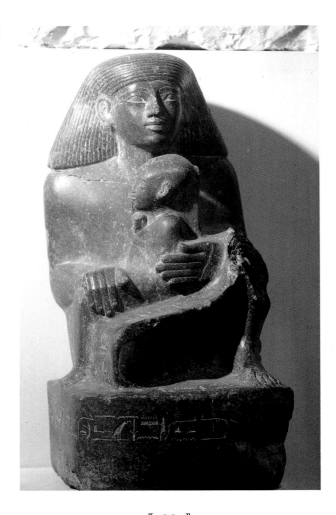

⟦ 38 ⟧

Senenmut with the Princess Neferure
DYNASTY 18, CA. 1473–1458 B.C.
GRANITE; HT. 60 CM

It is a face of smooth, undifferentiated planes and elegant, almost hieroglyphic features. Only a few of Hatshepsut's most finely worked statues show the marked taper of this delicate oval face and the angular quirk in the arch of the eyebrows. Reaching their peak well beyond the central axis of each eye, the brows appear to be a little raised, giving the queen a sophisticated expression, a look almost of detached amusement.

This sphinx was one of many statues placed in Hatshepsut's funerary temple at Deir el Bahri in western Thebes. After her death, Tuthmosis III took power, claiming to have been king all along — as indeed, theoretically, he was — and enjoyed a long reign on his own. Toward the end of it, he ordered the eradication of Hatshepsut's names and images. The Deir el Bahri statues were smashed and buried in a pit. This *damnatio memoriae* was efficiently carried out, but — in the very long run — it had exactly the opposite effect. Hidden and forgotten, the broken statues lay almost undisturbed until archaeologists from the Metropolitan Museum of Art found them in the 1920s. Today, restored and exhibited in Cairo and New York, they are among the best known of all Egyptian royal sculpture. As in the case of Akhenaten's statues ⟦see 53⟧, the destruction of her images served, ironically, to preserve them for a distant posterity.

Hatshepsut's foremost official, Senenmut, held many offices, but some of the most important involved his stewardship of her daughter by Tuthmosis II, the princess Neferure. So prestigious was this responsibility — and, perhaps, so efficacious, in its proximity to the mysteries of royalty, for his own prospects in the afterlife — that Senenmut commissioned a number of statues showing him with the child. In this one ⟦38⟧, the sculptor has used the standard pose of a man sitting on the ground with one knee raised ⟦see 82⟧. The little girl is perched on the downward slope of Senenmut's lap, as if it were a low-backed chair. In the statue's inscriptions, Senenmut is called Neferure's nurse. For this title, the choice of pose was extremely clever, because, although it was based on a well-known type of male statue, the adaptation created a composition with a quite different symbolic significance. Representations of women nursing infants often show them sitting on the ground in exactly this pose. The baby lies across the woman's lap, with its head supported at the breast by her raised knee. So characteristic was this little group that it could be used as a hieroglyph for writing the word "nurse." Senenmut's statue, therefore, provides a graphic version of his most exalted — and doubtless largely honorary — title, in much the way that early statues served as hieroglyphic determinatives for their own inscriptions.

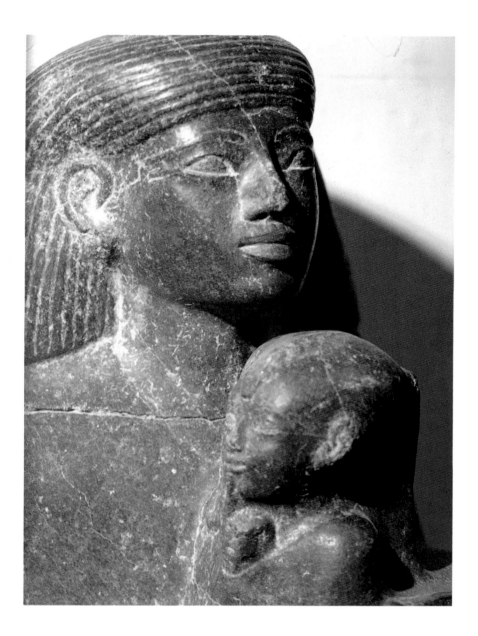

As with almost all Egyptian statue groups, the two figures seem to have little connection beyond their proximity [[compare 7]]. Senenmut stares straight out over Neferure's head. Her little figure, facing to his right, gazes forward, apparently oblivious to his presence. Their separateness is emphasized by the back pillar behind her head and neck, as if Senenmut held a statue, not a child. In a sense, what he really holds *is* an image: the sign of his high responsibility and trust. This is further emphasized by the one link connecting the two: his huge flat hands, which hold and shield her small body in a gesture both gentle and firmly protective.

Senenmut's face is blunter and fuller than that of Hatshepsut's sphinx [[37]], but his idealized features are basically the same, especially the flat, seemingly lidless almond eyes, their slight tilt emphasized by the contrasting downward slant of drawn-out eyebrows and cosmetic lines. His simple shoulder-length hairdo, the strands of which cross over the top of the head without any indication of a part, is probably a wig. He wears a knee-length

kilt and over that some kind of shawl, which covers all of his upper body except his right hand and the fingers of the left.

Neferure is swaddled in a garment from which only her right hand emerges to touch her mouth, in the emblematic gesture of childhood [[see 14]]. The sidelock of youth hangs down on the right side of her head. To certify her royalty, a uraeus cobra raises its hood at her forehead. With almost comical incongruity, its body slithers its undulating curves over the top of her shaven skull.

The representations of both Senenmut [[38]] and his ruler, Hatshepsut [[37]], are idealized almost to impersonality. The highest power and responsibility are conveyed with understated gestures and rather subtle symbolism. They are like three-dimensional hieroglyphs, not just in their poses, but in many details, such as the simplified outlines of their flat, almond eyes. Their style is characteristic of what we may call the Tuthmoside style, which first appeared under Hatshepsut's father, Tuthmosis I, reached its peak under Tuthmosis III, and remained dominant until some point in the reign of that king's grandson, Tuthmosis IV. The deliberately simplified idealism of Tuthmoside style may strike us as bland or artificial, but it is a remarkably strong and consistent style and very distinctive. For the Egyptians, it was perhaps the most satisfactory and successful form of idealism ever created, the most perfect expression of what they considered essential and immortal in the human image. It was to be extremely influential. The Tuthmoside style was a major factor in the development of Ramesside style [[see 71]], and it dominated the art of the Third Intermediate Period [[72–75]]. Even after the passage of eight centuries, its influence can still be discerned in the equally distinctive and idealized style of the Saite Period [[see 83]].

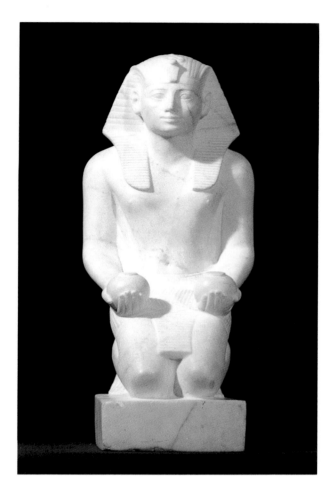

[[39]]
King Tuthmosis III kneeling
DYNASTY 18, CA. 1479–1425 B.C.
WHITE STONE; HT. 26.5 CM

Tuthmosis III
(CA. 1479–1425 B.C.)

An important factor in the appeal of Tuthmoside style for later generations was its association with the great conqueror, Tuthmosis III. It seems ironic that this indomitable warrior should be portrayed with such a slender form and delicate, smiling features — so like those of his aunt, Hatshepsut, who had initially supplanted him and whose images he eventually sought to destroy. It is likely, of course, that two such close relatives had a family resemblance. But the strength of the style they shared tends to make them almost identical.

A pristine little figure of Tuthmosis III is a case in point [[39]]. Compared to the overtly symbolic figure of Hatshepsut's sphinx [[37]], Tuthmosis looks natural and even comfortable in his kneeling pose, his hands resting on his thighs and holding two round offering pots. Un-

trammeled by an artificial frame of lion mane and cere-monial beard, the face is softer and more smiling. But the features are almost the same in their shapes and even their proportions. This face seems a little fuller and blunter, and the eyebrows follow a flatter, more regular curve, with no suggestion of Hatshepsut's quirky, sophisticated rise. Though minute, these variations are fairly consistent on Tuthmosis' images, and they may be intended to give his face a slightly more masculine aspect. But the differences are so small that, if Tuthmosis' name were not inscribed on the back pillar, it would be virtually impossible to be sure which of the two was represented here. The slight, soft-looking body seems that of a boy, not a man. It is the same body given to Hatshepsut on the statues where she is represented as king, and its willowy slenderness almost seems more suitable to her than to the leader of men who conquered most of the known world.

A king would kneel only before a god. Like the sphinx of Amenhotep I [36], therefore, this is an attendant figure. The globular offering jars, called *nu*, would have held milk or wine, which, according to the inscription on the back pillar, Tuthmosis was offering to Amun.

There is an adventure in this little figure's past, if only we could know it. Everything about it — its high quality and the lovely marblelike stone in which it is carved — indicates that it was a gift of some importance, destined for a major sanctuary or chapel of Amun. But excavators found it near the modest village of Deir el Medina, in circumstances indicating that it had been deliberately hidden in antiquity. Whoever cached the figure, whether from greed or in reverence, had valued it highly. Thanks in large part to his care, it has been almost perfectly preserved.

About twenty statues of Tuthmosis III have survived, but only one of them hints even faintly at a personal likeness. That is a standing figure, slightly under life size [40]. The delicately traced hieroglyphic forms of the eyes and brows on this statue, the pleasant, unremarkable contours of the rather small mouth, and the unaggressive forms of the slim body are the very ideal of the Tuthmoside style, which is reflected also in its elegance of silhouette, especially if one completes in imagination the upward sweeping lines of the now broken White Crown.

Nonetheless, for all its stylized formality, there are hints in this figure of a real and powerful man. Though far from the taut muscularity of an Old Kingdom king [see 7], the body is sturdier and more manly than most figures in Tuthmoside style. At the cap of each broad shoulder, there is even a faint suggestion of the stylized triple ridges by which the Egyptians indicated the deltoid muscle. A

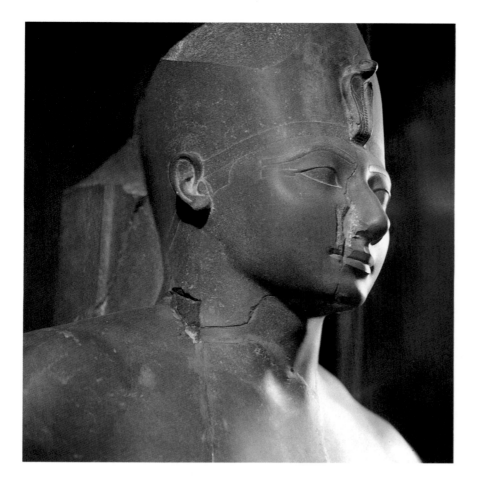

thick neck, with a bit of an Adam's apple, and an incipient double chin in the fleshy lower face suggest a man of mature years. Most telling, however, is the nose. On this one statue, Tuthmosis appears with an exaggerated version of the sharp, aquiline nose of his family. The large, hooked, rather fleshy beak of this face has the individual look of a real person. It seems also to characterize the forceful, energetic personality of one of the most successful of all pharaohs.

Tuthmosis III dedicated a seated figure of his mother, Isis, in Karnak temple ⟦41⟧. This gift, which was probably posthumous, was a signal honor, since, apart from queens and goddesses, statues of women were not ordinarily placed in the temples ⟦see 73⟧. However, it was more than a simple gesture of filial piety, for it probably had political overtones as well. Isis wears the headdress of highest royalty: a round platform, which once supported two tall plumes. At her brow are the uraeus cobras of a queen. These are the regalia that Hatshepsut would have worn as Great Wife of Tuthmosis II. It is unlikely that Isis, a minor and presumably nonroyal wife, actually wore them, at least not before her son finally came into power. In this statue, Tuthmosis exalted his mother — and through her, himself and his heirs.

Not surprisingly, the headdress has been given great emphasis. The heaviness of the wig is emphasized by the

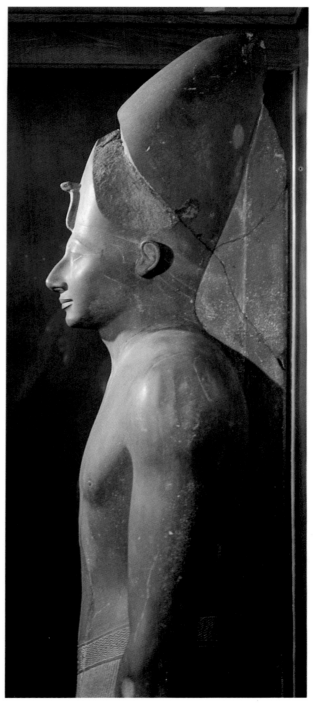

⟦ 40 ⟧

King Tuthmosis III standing, detail
DYNASTY 18, CA. 1479–1425 B.C.
GRAYWACKE; HT. 200 CM

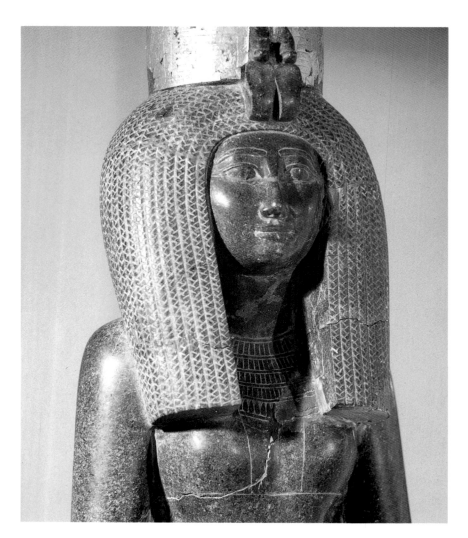

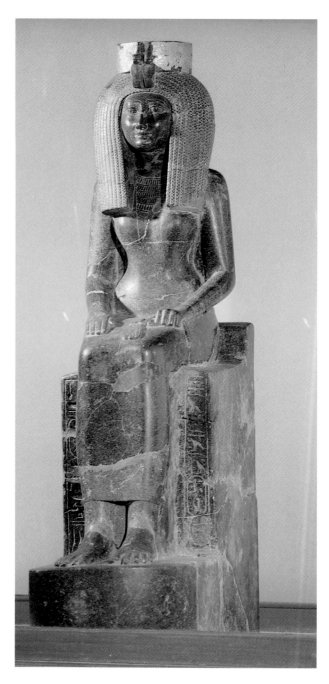

〚 41 〛
Queen Isis, mother of King Tuthmosis III
DYNASTY 18, CA. 1479–1425 B.C.
GRANITE; HT. 98.5 CM

insistent pattern of the coarse-looking tresses. Atop it, as on a cushion, rests the large cylinder of the crown platform. The towering feathers of the superstructure were probably made of gold, or of gilded bronze. Gold leaf still covers the cylinder, and traces of gold can also be seen on the queen's jewelry. There is no sign of paint on this statue. When it was new, the gold must have glittered dramatically against the dark gleam of the polished gray granite. Her dainty, patrician Tuthmoside face suits this iconic figure, monument to a woman who achieved immortality in her offspring.

When the firmly established custom of imitating the king's likeness 〚see 7〛 coincides with an unusually well defined style like the Tuthmoside, we might expect that statues of private persons would all look alike. Certainly, by the time of Tuthmosis III, there was a marked similarity among most statues. Such a period was naturally also a time of high standards of training and technical skill, and it might be predicted that this combination of facile technique and rigid conventionality would produce only slick, lifeless work. Instead, when we look beyond the clichés of the Tuthmoside style, we find beauty and freshness, if not much originality. What we would regard

as crippling strictures on creativity were, for the Egyptian artist, simply the natural boundaries of his culture. However firmly they contained him, they did not make him feel inhibited or restricted. But they did, perhaps, encourage him to concentrate on refined effects and subtle details. A case in point is the kneeling figure of a man named Djehuty [42].

Like many men of the Tuthmoside period, Djehuty — whether from pride, piety, or as a mark of royal favor — bears on his right shoulder and breast, like tattoos, the names of his ruler, Tuthmosis III. But even without these handy date stamps, there could be little doubt that the statue was made about this time. Djehuty's almond eyes and formless but faintly smiling mouth are found on many statues of Tuthmosis III [compare 39]. The elegantly obtrusive penciling above and around the eyes follows prescribed forms: even the contrast between the tilt of the eyes and the downward slant of the cosmetic lines can be found on royal statues [see 37]. The rather flat, tapering face and the unmuscular body are quintessentially Tuthmoside in form.

No one would mistake this for a portrait of Djehuty. Even his gently marcelled dandy's wig, each tress ending in a careful corkscrew twist, and the foppish little chin beard are strictly a la mode. They are early symptoms of a growing taste in this dynasty for opulence and personal adornment — the rewards, no doubt, of imperial wealth. Yet, although every element is a formula, specified and ideal, the statue has freshness, derived in large part from an intriguing set of understated oppositions. It is humble but erect, modish but circumspect, retiring but utterly confident. As an object, it is quite beautiful. We cannot know how conscious this sculptor may have been of everything he was putting into the statue, but it is important that we recognize that he was engaged with it as an artist, taking pleasure in his medium and satisfaction in his mastery.

Like Hetepdief [2], Djehuty is represented kneeling. After its early appearance, this unequivocally submissive pose had become rare in Egyptian sculpture. It was hardly suitable for the owner of a tomb; in the Old and Middle Kingdoms, therefore, the pose was confined to subordinates [see 11] — and to kings, in their role as priest. In the Eighteenth Dynasty, however, it was adopted again by private persons, primarily for their temple statues, and was to become one of the most popular and enduring of statue types, the New Kingdom's major contribution to this repertory. Egyptian kneeling figures of the New Kingdom and later usually hold something: the figure of a god or an offering. The large rectangular object held by

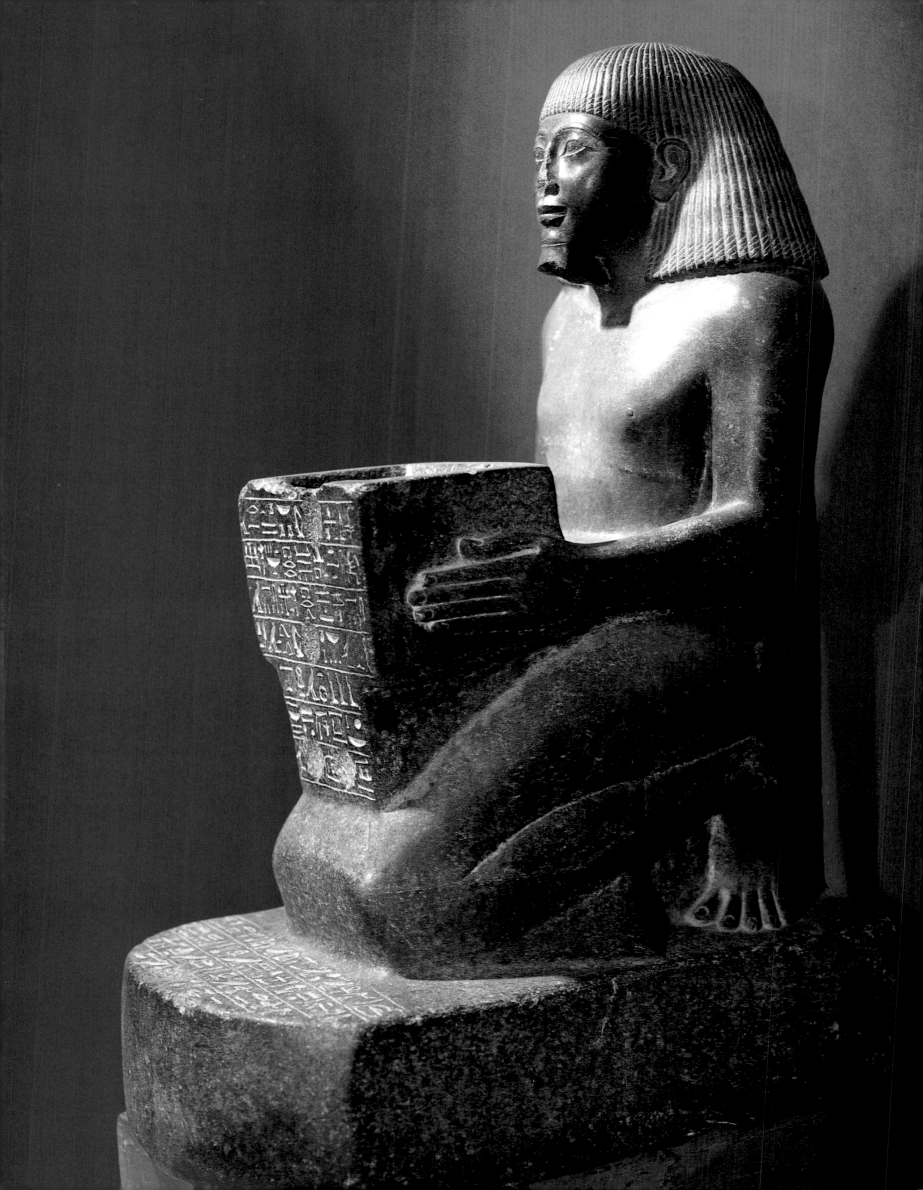

Djehuty is too nondescript to identify with certainty. The depression in the top might be an offering basin, but it could have held a separate statuette of one or more deities, such as Amun and the goddess Renenutet, who are named in the offering prayer on its front.

In contrast to the scarcity of divine statues from the Old and Middle Kingdoms [see 7, 30], the gods are well represented in New Kingdom sculpture. From the middle of the Eighteenth Dynasty on, their statues seem to increase in number, size, and importance. One reason for this development is suggested by a standing figure of an enigmatic, oddly dressed male deity [43]. The inscription shows that it was made in mid-dynasty, during the reign of Amenhotep II, making it one of the earliest large divine statues still in existence. It stood over seven feet, from its base to the top of its tall headdress. It could have stood in a sanctuary, but its size and the architectural quality of its broad back pillar suggest that it was intended for a larger, more open setting, such as a hall or courtyard, a place where it would have been visible to worshippers who were denied access to the inner area of the sanctuary. In this statue, we may see the early stages of two developments that profoundly changed Egyptian religious belief and practice in the later New Kingdom: a more personal relationship of individuals with the gods they worshipped and the increasingly important role of statues as objects of worship.

The impersonal idealization and almost sexless beauty of the Tuthmoside style seem particularly appropriate for representing the divine in human form. Despite the damage this figure has suffered, including the loss of its inlaid eyebrows and the pupil of one eye, it retains much of its original grace. A curiously beatific quality, a blend of openness and inexpressiveness, makes it a plausible image of a supernatural being. As usual in this style [compare 40], carved detail has been kept to a minimum. But where it is used, it is exploited both for its own beauty and to enliven the larger surfaces of the figure, in the plaiting of the divine beard (now mostly broken away) and in the god's single garment, a penis sheath held in place by a knotted belt.

One of the most primitive of all male costumes, the penis sheath had been worn at the dawn of Egyptian history. By the New Kingdom, certain neighboring peoples, especially those of the Libyan desert, may still have worn it, but in the Nile Valley it survived only as the costume of a few gods and spirits [see 34]. Here, the sculptor has given the sheath its ancient, traditional shape. Looking closely, however, one can see that he had no idea what it was really made of. Nor does he seem very clear about just

opposite page

[42]

Djehuty kneeling with altar
DYNASTY 18, CA. 1479–1425 B.C.
GRANITE; HT. 84 CM

opposite page and detail

⟦ 43 ⟧

Standing god
DYNASTY 18, CA. 1427–1401 B.C.
LIMESTONE; HT. 235 CM

how it was fastened to the belt. His concern was to fashion a lovely, exotic garment fit for a god; the play of the striped surfaces against the smooth curves of the thighs and stomach is very pleasant to see.

But it is not much help in identifying the god, whom the inscription names only as "Tall of Feathers" — the two plumes on his head — and "Lord of the Atef," a plumed crown. Both these epithets are unspecific. Since the statue was found at Karnak, it may represent some special manifestation of Amun, especially since his usual crown, tall and plumed, caused him to be often called "Tall of Feathers."

For all its conquests and wealth, and notwithstanding the strange political episode of Hatshepsut's reign ⟦see 37⟧, Egypt through the first half of the Eighteenth Dynasty seems a very stable society. From our distant perspective, it looks almost as if the Egyptians had achieved the timeless, harmonious certainty they had always sought. The idealized forms of their sculpture in this period, changing so little from one generation to the next, seem an expression of perfection — or at least of perfect self-satisfaction, the successful denial of change.

But human life is never so simple. By the middle of the dynasty, Egypt was on the brink of upheaval, less from political than from spiritual causes. The currents of change that were to burst forth so spectacularly in the Amarna Period (see Chapter 5) were already beginning to stir, at least two generations before. Early intimations of the religious innovations of Akhenaten can already be seen in certain inscriptions from the time of his grandfather, Tuthmosis IV. And the coming changes were also foreshadowed in the arts, particularly in the representations of Tuthmosis IV himself. In most of his surviving statues, Tuthmosis looks very like his forebears, sharing their aquiline features and impassive, impersonal expression. But it is quite another likeness we see on another statue, a colossal standing figure made late in his reign ⟦44⟧.

Glancing up at this statue, which towers over them at the foot of a stairway in the Egyptian Museum, most visitors will notice only the tall column of the body and pay little attention to the distant head. Those who look more closely, however, will wonder why this impressive figure has received so little attention. For here is not only a new sort of royal face. It is one that, with its slanted, catlike eyes, low, full cheeks, and rather long jaw, seems already to contain the germ of the striking likenesses of both Tuthmosis' son, Amenhotep III ⟦see 45⟧, and his grandson, Akhenaten ⟦53⟧.

Is it possible that, with new genetic stock added over the generations, the "family" look had actually changed? Certain recent studies of the royal mummies of this dynasty suggest that some such change did take place. As always with Egyptian art, however, much more was involved than simple physical reality. It hardly seems coincidental that Tuthmosis' new style of likeness should have emerged at about the same time that we begin to find references to the sun disk Aten as a divine entity and suggestions of a changing role of the king.

When discovered at Karnak, the statue was in pieces, some of which were never found. The legs, from knee to ankle, are modern restorations, and only traces remain of the standard that Tuthmosis once held in front of him. The religious symbol marks the king in his ancient role as main priest and intercessor with the gods. But the statue itself was apparently set up in one of the more public areas of Karnak temple, where it could be viewed — and prayed to — by faithful subjects. Indeed, it may well have had its own name and, therefore, its own personality and its own cult. It marks the beginning of an exaltation of the king to new divine heights, which was to lead to Akhenaten — and to survive him. Ramesses II, in the following dynasty, also had statues of himself with their own

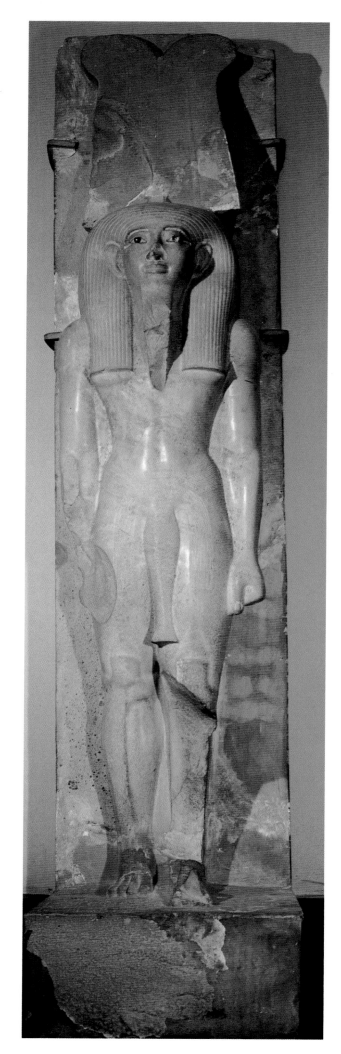

names and special cults. There are even relief representations that show him worshipping his own statues.

The pyramids and the Great Sphinx at Giza testify how very early in their history the Egyptians achieved mastery of the colossal (see Chapter 2). They frequently represented their kings in statues far larger than life ⟦see 21⟧. But it was Amenhotep III who seems first to have made the truly gigantic a hallmark of royal sculpture. His immense funerary temple on the West Bank of Thebes, across the river from Luxor temple, is today little more than a bare field. Two battered giants are still in place, however, before the long-vanished gateway: the seated images of Amenhotep III now usually known as the Colossi of Memnon.

This temple contained another gigantic statue, some seven meters tall, which showed the king with his Great Queen Tiye and several of their daughters. This statue had been smashed to bits. Reassembled in the Egyptian Museum, it now fills most of the far end of the great central court ⟦45⟧. It may well be the largest statue inside any museum. Since not all the pieces were found, parts of the statue had to be reconstructed. These restorations were deliberately carried out in a color slightly different from the original stone, so that the viewer can tell at a glance what is ancient and what is not. (On the black-and-white photographs, the restorations appear as lighter patches.)

The royal pair sit side by side, Tiye with her arm around her husband like any good Egyptian wife ⟦see 14⟧. Three princesses stand in front of the throne, but only the central one, Henettaneb, is well preserved. She is the eldest and is therefore shown as larger than her two sisters, but even she barely reaches the height of her parents' knees. So extreme a disproportion in size, to indicate relative importance, had been common practice in the Old Kingdom ⟦see 14⟧. Over the millennia, this had been softened by a tendency toward more natural proportions. For his colossi, however, Amenhotep III reverted to the old custom and even exaggerated it. Still, Henettaneb had nothing to complain of: though diminutive in terms of the entire statue, her figure is over life-size.

The princess and her mother both wear heavy enveloping wigs, topped by flat cylindrical platforms ⟦see 41⟧. The queen's crown still bears its decoration of cartouches, inscribed alternately with the two most important names of her husband: Nebmaatre Amenhotep. Tiye also wears the most ancient headdress of an Egyptian queen, the vulture cap, which fits down over the wig, its feathers lightly incised like the tresses of hair. The vulture's head (its beak now lost) rears above her brow, flanked by two uraeus cobras. Thus the queen embodies

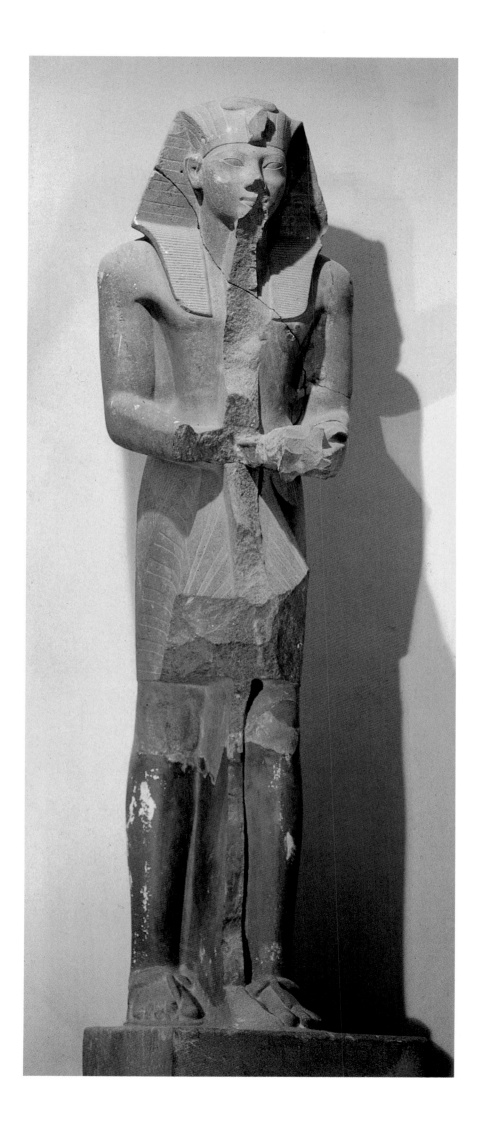

King Tuthmosis IV with a standard
DYNASTY 18, CA. 1401–1391 B.C.
QUARTZITE; HT. 280 CM

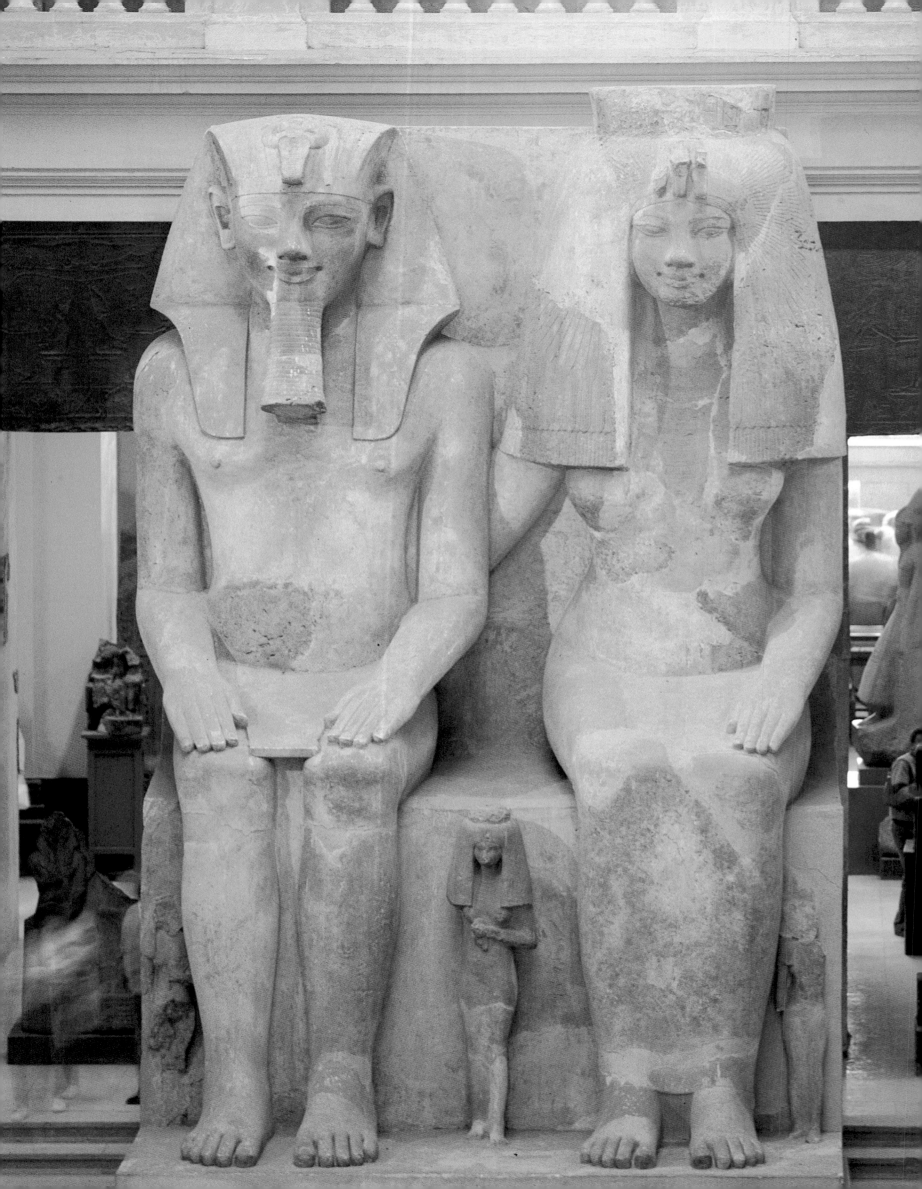

both of the great protective goddesses, the vulture Nekhbet of Upper Egypt and the cobra Wadjet of Lower Egypt.

By all the evidence, Tiye had a forceful and energetic personality, and on some of her statues her likeness is distinctively individual. Here, however, she is represented in a more traditional way: her face is a slightly feminized version of the king's.

There is no mistaking the face of Amenhotep III. We have seen its forerunner on the remarkable statue of his father ⟦44⟧. But this childishly rounded face, its long eyes accentuated by thick but elegantly arched brows and the widely smiling mouth, the upper lip unusually full and thickening to a little bulge at the center, is almost always recognizable, whether borne by the king, his queen, or his loyal subjects. As so often before in Egyptian art, the likeness of this king characterized the style of its time.

On this statue, the royal features are simplified and exaggerated — as in the broad bands rimming the eyes — to give the effect almost of a mask. A much smaller statue, in the Luxor Museum, renders the same face in a softer, more naturalistic way ⟦46⟧. Here we seem to see a boy who looks slight and fragile beside the large, grotesque seated figure at his side. It is the crocodile-headed god Sobek, who extends toward him the sign of life (*ankh*).

However, this juvenile appearance cannot be taken literally. Except for a very few made at the end of his life (or even posthumously), all representations of Amenhotep III, whether stylized or naturalistic in aspect, show a youthful cast of countenance. Some of those that look most babyish must, on the basis of iconographic or inscriptional evidence, have been carved after the king had reigned for at least thirty years.

Amenhotep III's reign was a period of luxury and considerable ostentation, and this is reflected in the statues of his subjects. The statuette of a couple named Khaemwaset and Menena shows a charming pair of fashion plates ⟦47⟧. Khaemwaset's short-sleeved shirt and long pleated skirt are anchored by a pleated sash, draped and tucked with infinite care, so that one fringed, fanned-out end hangs down like a little apron. The exact form of Menena's costume is a little vague. It is not clear whether the folds of material covering her bent arm are part of her dress or (more likely) a separate shawl of a lighter fabric. But her jewels seem to be reproduced with exactitude: a two-strand choker over a large collar necklace, rosette-shaped breastpieces, a pair of bracelets, and at least one armlet.

Both of their elaborate wigs are very much in the fashion of the day. His double wig, with its checkerboard of little curls framing the face, had been approved mas-

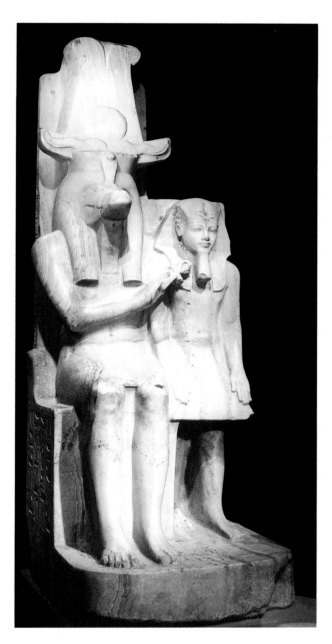

⟦ 46 ⟧
King Amenhotep III with the god Sobek
DYNASTY 18, CA. 1391–1353 B.C.
ALABASTER (CALCITE); HT. 256.5 CM

opposite page

⟦ 45 ⟧
King Amenhotep III and Queen Tiye
DYNASTY 18, CA. 1391–1353 B.C.
LIMESTONE; HT. 700 CM

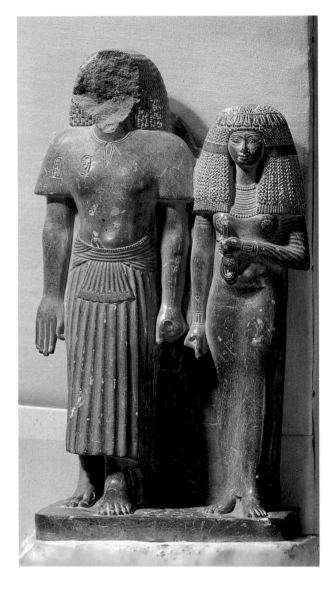

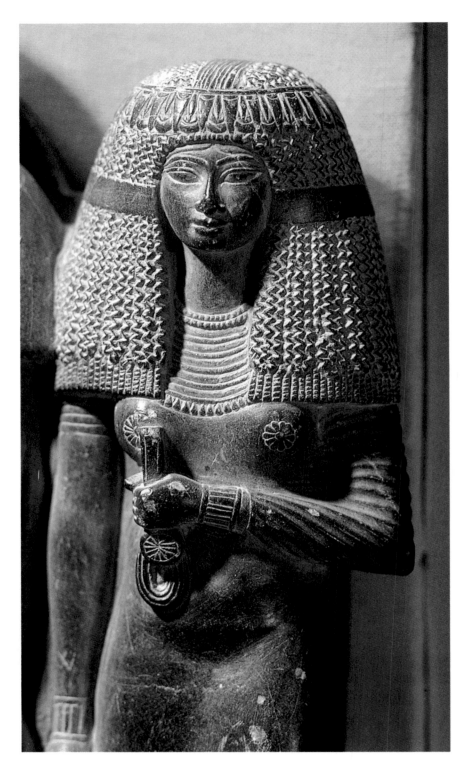

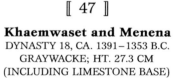

[[47]]

Khaemwaset and Menena
DYNASTY 18, CA. 1391–1353 B.C.
GRAYWACKE; HT. 27.3 CM
(INCLUDING LIMESTONE BASE)

culine formal wear for a couple of generations. Her massive, enveloping wig was a newer style, currently popular with both royal and private women [[see 45]]. The queen placed a crown on hers. Ladies like Menena added a floral diadem and decorative bands at ear level, which probably also served to keep the masses of hair away from the face. Like an Old Kingdom woman [[4, 14]] — but rather exceptional for her time — Menena allows her own hair to show at the forehead, its fineness no doubt forming a piquant contrast with the coarse, stiff artificial tresses.

This pair, who dedicated their statue in a temple in the Delta city of Bubastis, were not of the highest social

rank. Khaemwaset was a military man, a Chief of Archers. His wife, like many women of good family, served in the local temple, as a Chantress of the goddess Bastet. In token of her status, she holds the *menit* necklace used as a rattle in religious ceremonies 《see 63》. Since it was not common for women to appear in temple statuary 《see 73》, it may be significant that Menena is represented as so much shorter than her husband. Although the difference in height does not look unnatural, it may be intended to emphasize that she is under his protection.

On his right arm and chest, Khaemwaset bears the cartouches of Amenhotep III. Even without them, it would be easy to attribute the statue to this reign, for Menena's round, sloe-eyed face is a version of Amenhotep's stylized likenesses. Had it been preserved, her husband's face would undoubtedly have looked very much the same.

The Royal Scribe and Chief of the King's Stables Tjay, whose lovely wooden statuette was found at Saqqara, also had his features cast in the likeness of the king 《48》. In this case, however, the resemblance is to the more naturalistic versions, such as 《46》. The round softness of Tjay's face finds a counterpart in his figure, which in profile looks quite thick through the middle and sports the beginning of a paunch. Again, Tjay is emulating his king. As his reign progressed, Amenhotep III seems increasingly to have been represented with a plump, unathletic-looking physique. Some have seen this as another aspect of his deliberately childlike appearance. To others, it prefigures the anatomical exaggerations of Akhenaten 《see 53》. It may also have been a tactful reference to the king's increasing obesity, for three statues and a relief representation, all of which seem to have been made very late in his reign, show Amenhotep III as a fat man.

This statuette was probably made later in Amenhotep's reign than that of Khaemwaset and his wife 《47》. Although the two men's costumes are almost the same, Tjay's floppy-sleeved shirt and the hip-hugging breadth of his sash are even more foppishly elegant. His necklace, four heavy strands of gold disks, undoubtedly represents a real possession worn with particular pride, for this type of jewelry was an award from the king, the equivalent of a medal.

For the lover of ancient art, the lure of fragments can be dangerously seductive. It is not just that, shorn of its exotic hairdo or costume, an isolated face or limb may beguile us with a false modernity. Most ancient statues are more or less broken, and this makes it all too easy to forget that the Egyptians almost always conceived sculpture as a representation of the full human form. Today, we are very used to half-length statues, heads, and even

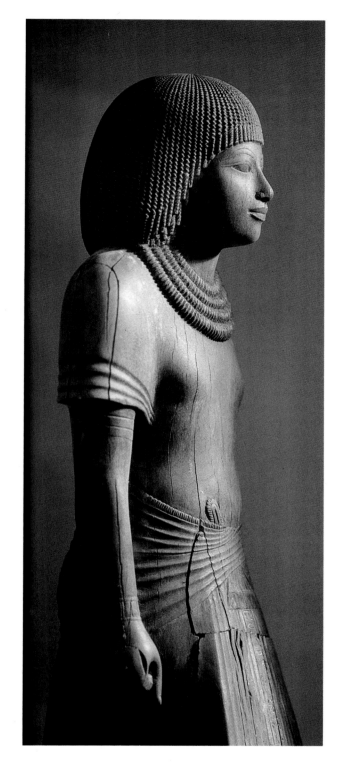

103

《 48 》

Tjay
DYNASTY 18, CA. 1391–1353 B.C.
EBONY; HT. 58 CM

faces, which were created as complete, independent works. For an Egyptian sculptor, however, the whole aesthetic balance of a statue, its proportions, its variations on the themes of naturalism and idealism, were always conceived in terms of the full head and body. Exceptions are rare, and they are always special cases [see 5, 58].

A fragment, however, can serve quite wonderfully to focus the attention. And so, although we have tried for the most part to choose statues complete enough at least to remind us of their original wholeness, we have also included this strong, gracious, anonymous little face [49].

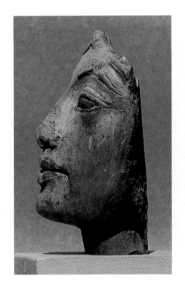 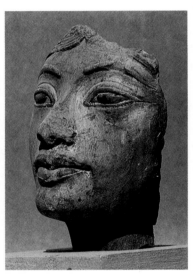 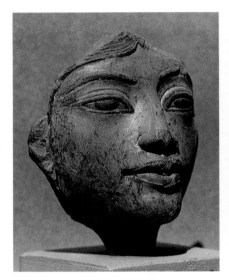 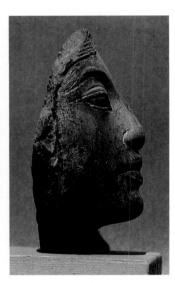

[49]

Face of a man
DYNASTY 18, CA. 1391–1353 B.C.
DARK STONE; HT. 8.5 CM

It is an Amenhotep III face. The mouth is just like his, even the bulbous little droop of the upper lip. The eyes are his, including the broad bands of cosmetic rimming them. Even the incised line that divides the upper and lower parts of the upper eyelid was invented for Amenhotep III and can be found on many of his statues [such as 46]. But there is no trace here of a crown or uraeus. The face does not, therefore, represent the king.

The subject of this statue was probably a man. The remnant of a full, center-parted hairdo on his right temple indicates a type of wig most often found on New Kingdom statues of scribes; it was associated, apparently, with that bureaucratic profession. This man was very likely an official, therefore, or a military officer of administrative bent.

Though shorn of its identity and its trappings, the face retains a vivid presence. Despite all the mannerisms of a very specialized style, it seems to look us in the eye with uncompromising directness. Its strength is as important as its elegance. This is not the portrait of an individual. It is an individual face from a remarkable era, a product of the Egyptian genius for infusing convention with genuinely felt spontaneity and life.

One of the most remarkable men of the New Kingdom is usually referred to as Amenhotep son of Hapu, to distinguish him from the many other Amenhoteps of his day. From obscure and probably humble origins in the Nile Delta, this man became one of the foremost officials of Amenhotep III, apparently the most respected. What we know of the man's career indicates great organizational and administrative abilities, but there must have been much more to him than that. Amenhotep III acknowledged his extraordinary services or special qualities by granting him the signal honor of a small funerary temple of royal type, beside the king's own. After his death, Amenhotep's legend continued to grow until, in the Late Period, he was venerated as a god.

Several well-preserved statues of Amenhotep son of Hapu show his command of patronage, as a holder of high office, and indicate a discerning taste. They suggest an interesting and perhaps original turn of mind. These statues are among the finest products of this lavishly productive era. One, from a pair of almost identical life-sized statues found at Karnak, shows him as a seated scribe ⟦50⟧. This type of statue, invented in the Old Kingdom to represent education and competence ⟦see 16⟧, had always had great prestige. But Amenhotep, by choosing the pose for two such important statues, may have given it a renewed luster. For the next century or more, Egypt's most powerful notables often favored the pose of a scribe for some of their most important life-sized statues, destined for the greatest temples.

The scribe sits crosslegged on the ground, the front of his kilt stretched taut, to serve as a table for the partly unrolled papyrus in his lap. Amenhotep carries his writing kit slung over his left shoulder: the palette, with its disks of red and black pigment, hangs down on his chest; the little water pot is suspended in back on the other end of the strap. His right hand is poised to hold a brush pen; his head is bowed over his work.

In keeping with his businesslike pose, Amenhotep's costume is simple. The cartouches of the king are blazoned on his right shoulder and breast, but he wears no jewelry at all. The only overt sign of his rank is the fashionable, waved and curled double wig. He is ripe in years and experience, for his sagging breast and the folds of flesh below are the conventional indications of middle age ⟦see 9⟧.

The face is ageless. With its artfully arched and tapered brows and full, carefully outlined mouth, it comprises yet another set of features imitating Amenhotep III ⟦see 46⟧. However, the sculptor has skillfully utilized the dip of the head and the downward cast of the eyes to in-

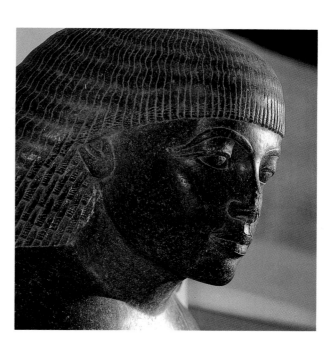

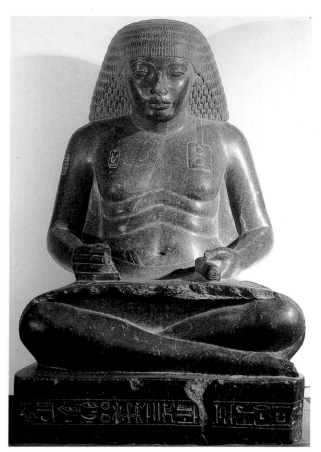

⟦ 50 ⟧

Amenhotep son of Hapu as a scribe
DYNASTY 18, CA. 1391–1353 B.C.
GRANITE; HT. 128 CM

fuse the handsome but orthodox face with a sense of intelligence and thoughtful concentration.

The schematic rendering of the thick fat folds on the torso of Amenhotep's scribe statue is very like the way this feature was depicted on portly figures of the Middle Kingdom. Others of his statues incorporate even closer imitations of Middle Kingdom characteristics, which could easily have been observed on old statues, many probably still in place within Karnak temple. A standing statue of Amenhotep shows him with a wig and a stiff, openhanded stance, both characteristic of Middle Kingdom sculpture but long obsolete by his time. And the finest of all his statues — one of the masterpieces of Egyptian sculpture — derives much of its effect from a striking, purposeful application of archaism based on the Middle Kingdom 〚51〛.

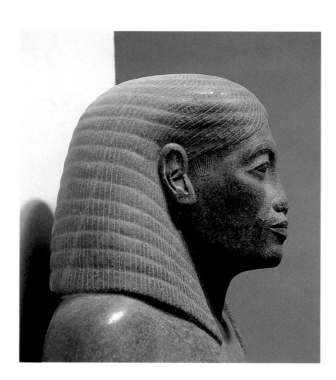

〚 51 〛

Amenhotep son of Hapu as an old man
DYNASTY 18, CA. 1391–1353 B.C.
GRANITE; HT. 142 CM

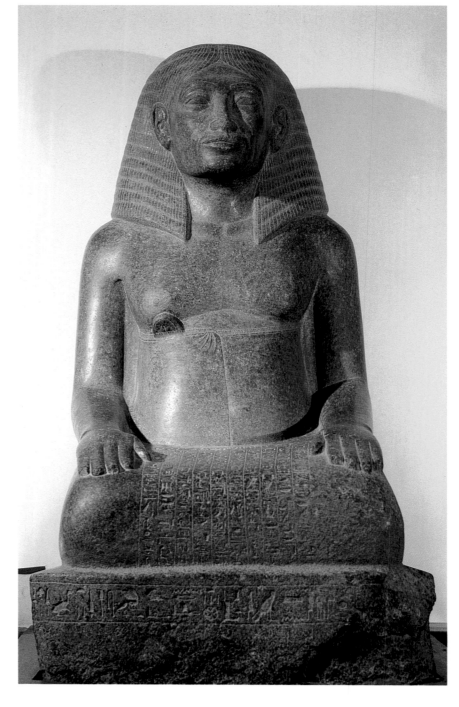

Like Amenhotep's scribe statues [[50]], this life-sized figure of the great man, also from Karnak, shows him seated on the ground. Here, however, his hands rest passively on his thighs, and his crossed legs are entirely covered by a long skirt, wrapped high under his breast. The pose, the garment, and the wig with its pointed front ends are not just Middle Kingdom types; they have been reproduced with such fidelity that they would seem to have been modeled on a single, specific statue, one very like [[32]] in this book. In Amenhotep's time, such a statue would have been about four hundred years old. Like [[32]] and most late Middle Kingdom statues of this type, it probably had an old-looking face — and Amenhotep son of Hapu is also shown here as a man of advanced years.

There is an oddness to Amenhotep's face, which has its own history. At some point in antiquity, the nose was smashed — probably with malice, to kill the statue [[see 63]]. Then, at an undeterminable but still ancient time, it was restored. A skilled hand cut down the broken area to re-create a straight, though unnaturally flat, nose. The restorer seems also to have re-emphasized the lines around the nostrils, and he smoothed down the surfaces of the adjacent cheeks and upper lip. He made no effort to repolish the face or otherwise disguise his work. His intent was not aesthetic but pious: by providing a nose with which the statue could "breathe" again, he had restored it to life.

Damaged royal monuments were sometimes restored by later kings, but — apart from recarving the names of gods erased during the Amarna Period (see Chapter 5) — such solicitude was rarely extended to the memorials of private individuals. Almost certainly, the person who tried to reanimate this statue was prompted to his good deed by reading, in the hieroglyphic inscription, that it was an image of the venerated, and perhaps already deified, Amenhotep son of Hapu.

The inscription yields another interesting fact: in it, Amenhotep tells us that he had reached the age of eighty years. This is not mere boasting. As one rich in years and with wisdom to match, he offers the reader his spiritual help in the afterworld — in return for recitation of the offering prayers he needs for his eternal sustenance. The marks of age in his face emphasize Amenhotep's claim. He or his sculptor may even have calculated that its singular appearance, in a time of uniformly idealized sculpture, would be a useful device to catch the attention of potential prayer givers. Inscriptions on other New Kingdom temple statues often attempt to attract passersby and persuade them to pray for them — "it's only breath," as some of them say.

108

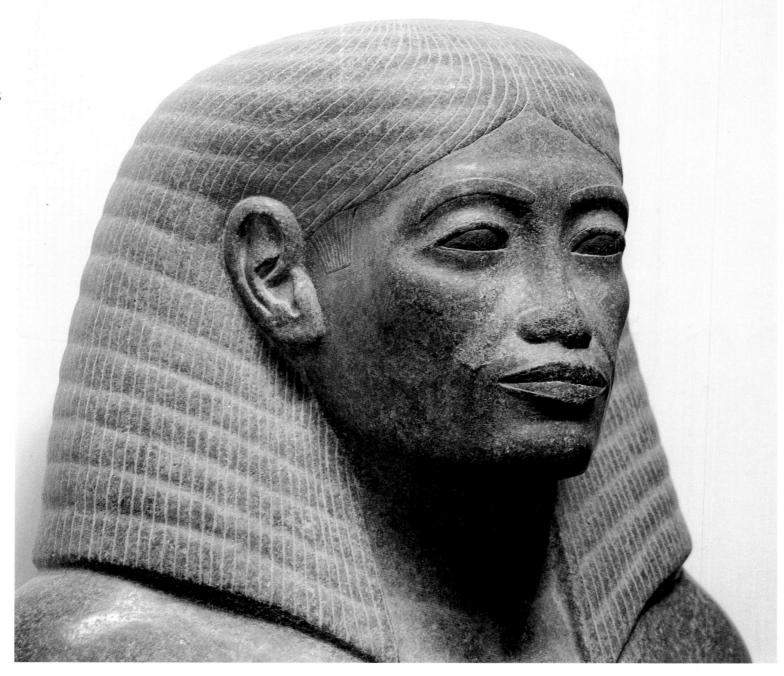

⟦ 51 ⟧
detail

With its unusual reference to age, the text shows that this statue was conceived as special; undoubtedly, Amenhotep son of Hapu chose for it the most distinguished sculptor available. And he chose well. Great technical facility and an unerring eye underlie the perfect proportions and convincing simplicity with which this artist re-created a statue of ancient type. But his great achievement is in the face, where he has managed to evoke a Middle Kingdom type of aged countenance, to modify this with the suave elegance of his own day, and, within this stylistic interplay, to create a handsome, memorably distinctive image, with a strong sense of personality.

Middle Kingdom sculpture is suggested in the statue's heavily lidded eyes. This type of eye had virtually

disappeared since the emergence of the Tuthmoside style, with its flat, hieroglyphic rendering [see 37]. Though they differ in several details, these eyes are unmistakably reminiscent of the hooded eyes on Sesostris III and other late Middle Kingdom aged faces [see 26]. The eyebrows, on the other hand, have all the artifice, and very nearly the shape, of brows popularized by Amenhotep III [see 48]. The Middle Kingdom wig has been refined and updated, with a center part and wavy locks gracefully arranged along the temples. With almost incongruous elegance, it frames a high forehead divided by a prominent horizontal ridge. It would be hard to find a precedent in Egyptian sculpture for this striking, naturalistic-looking feature, so suggestive of both age and intelligence.

The thoughtful, intellectual forehead and eyes are balanced by thin, rather ascetic cheeks, marked by the diagonal furrows the Egyptians had always used to suggest age [as on 26], and a firm, square chin. The firmness is intensified by the line of the mouth, where an Amenhotep III type of fullness is combined with a tense pursing of the lips, sometimes found on Middle Kingdom statues [see 27], to marvelous psychological effect. His lips a little thinned by age and tightened by resolution, the great man seems almost about to speak. His face is unmistakably that of one long accustomed to making decisions and rendering judgments.

The Egyptians loved to write about wise men. Here, at least once, they succeeded in portraying one. Amenhotep son of Hapu has none of the grimness or wearied resignation that we sense in the aged faces of the Middle Kingdom [see 26, 29, 30]. Even less is there the harsh look of command, seen occasionally in the Old Kingdom [see 3] and often in the Late Period [see 78, 79]. This man looks as if he recognizes truth and is not afraid to live with it.

Can the statue be considered a true portrait of an unusual man in his last years? From what we know, we can at least see how hard it is to answer such a question. For whatever reason, Amenhotep or his sculptor had rejected much in the ideals and fashions of their own day, turning to a sterner, totally obsolete style of the distant past. This was manipulated to produce an image that looks intensely individual — but by no means as elderly as the eighty years claimed in the inscription.

Finally, the expression of this face and certain of its details, especially in the eyes, bear a prophetic resemblance to portraits of the later Amarna Period, such as the head of Nefertiti [see 55]. For all its retrospective quality, this statue of Amenhotep son of Hapu stands at a turning point — may, indeed, have been a turning point — between

the major styles of its era. No other example of Egyptian sculpture demonstrates so well the stylistic complexities underlying the more sophisticated works of this ancient civilization. And, as the restoration shows, the statue long continued to draw attention and respect. Indeed, it may not be too fanciful to wonder whether the posthumous reputation of Amenhotep son of Hapu and his eventual deification were to some extent inspired by this magisterial image.

Late in her life, Amenhotep III's queen, Tiye, seems to have spent much of her time at a palace near the entrance to the Fayum, a site now known as Medinet Gurob. Her husband may already have been dead; her son, Akhenaten, was pursuing his strange career in his new city at Amarna (see Chapter 5). Statuary found in the badly destroyed remains of the palace, and in tombs nearby, shows a strange blend of Amenhotep III and Amarna styles, almost as if the old queen were trying to combine the best of two eras.

An intact tomb, discovered in the vicinity of the palace, contained two mummies and their grave goods. In one of the coffins was a cosmetic vessel inscribed with the names of Nebmaatre (Amenhotep III) and Tiye. Near the head of this mummy lay a little wooden figure, less than six inches tall [[52]]. Its base bears the name Tama, presumably the name of the deceased.

Tama's round face, big eyes, and full mouth are a late, summary rendering of the Amenhotep III face. The pouty droop to the lips probably imitates certain representations of Tiye. However, Tama's hairdo — a short round wig embellished by a rather flamboyant version of the sidelock of youth [[see 14]] — is one popularized by the Amarna princesses. Her body also has an Amarna look in the droop of the little breasts and the bulge of the abdomen [[see 62]].

The arms are connected to the body in an irregular way, suggesting that they were covered by a shoulder cape or shawl [[as worn by 63]]. But the only parts defined by paint are her eyes, her mouth, and her wig. There is a strip of gilding on the sidelock, but Tama was not content with this simulation of jewelry. She decked her figure with gold stud earrings (only one is still in place) and a gold necklace, over which she hung a doubled strand of little beads.

This is by no means the only tomb statue of a woman to be ornamented with real jewelry. Usually, however, there is just a string or two of beads. Charming little Tama seems to have had her priorities firmly in order. A true Egyptian believer, she was determined to carry her material treasures with her into the afterlife.

Tama
DYNASTY 18, CA. 1360–1350 B.C.
WOOD WITH PAINT, GILDING, SEPARATE JEWELRY;
HT. 14.2 CM

Chapter 5 Revolution and Aftermath

Akhenaten and the Amarna Period

(CA. 1353–1335 B.C.)

AKHENATEN, king of Egypt: in all the ancient world — in all of history, perhaps — he was unique. Few periods have attracted so much attention as his reign, called the Amarna Period after the modern name for his capital. Only the young Tutankhamun, heir to the aftermath of the Amarna Period and probably Akhenaten's son, is more familiar to us; and his fame is entirely due to the sensational discovery of his nearly intact tomb in 1922.

Many of Akhenaten's "new" ideas were already in the air during his childhood, and even earlier. Nevertheless, this heir to one of the most tradition-bound societies of all time must be recognized as a true original and a genuine revolutionary. Not only did he attempt to suppress the worship of most Egyptian gods in favor of the sun, which he called simply Aten, "sun disk." He also had his universal deity represented in no familiar human or mostly human shape but as the disk itself, emitting its life-giving rays from high overhead. Aten looks more like the hieroglyphic sign for "sun" than like any divine image familiar to the Egyptians.

Akhenaten was not really, as many modern writers have liked to think, the first monotheist. To be sure, he worshipped only the Aten. But for his subjects he provided other objects of worship: himself and his wife and daughters. Far more than at any time in Egypt's past, the king, son of the Aten, was god on earth.

The vital interdependence between Egyptian art and beliefs was never more clearly demonstrated than in the Amarna Period. When Akhenaten changed the religion, he changed artistic style almost as radically. These two aspects of his reform were carried on simultaneously, and he personally supervised both. Akhenaten could not have separated the two; it probably did not occur to him even to try.

In the first years of his reign, Amenhotep IV, as he was originally called, began to construct a series of temples just to the east of Amun's Karnak precinct. During the reaction that followed his death, these temples were dismantled. Their blocks were reused as the hidden cores of new constructions, built to the glory of Amun. To Akhenaten's successors, this method of disposing of his

temples may have seemed a fitting tribute to the victory of traditional religion over the repudiated cult. They retained the blocks within the sacred area — as old statues were later to be buried in the Karnak Cachette — because they were too holy to be subjected to desecration. The cult was heretical, but the Aten — the sun disk — was visibly the manifestation of the sun god Re. It was fitting that these stones form the foundations of structures dedicated to Amun-Re.

Colossal statues of Akhenaten himself were another matter. They were toppled from their places and buried, more or less shattered, where they fell. Thus it happened that, like the buried statue fragments of Hatshepsut [[see 37]], they remained hidden, free of further damage, until they were uncovered by French excavators working for the Egyptian Antiquities Organization in the mid-1920s.

One of the best preserved of these Karnak colossi stands about ten feet high, from the top of its tall double crown to the break at knee level [[53]]. The left arm is gone, and considerable restoration was necessary where the head had been knocked off the shoulders. The face, however, is intact; even traces of the paint that once covered the white limestone remain, especially on the eyes, which seem still to survey a universe from between their slitted lids.

This is Akhenaten as we usually picture him, the disturbing image that has become inextricably linked with his strange history. Our interest in the man increases our fascination with the strangeness of his representations. But they in turn exert a subtle influence on our ideas about his reign.

Almost everyone reacts strongly to this statue. Many experience a curious, uncomfortable mixture of repulsion and attraction. It is not easy to explain the almost charismatic presence of so grotesque a figure, whose every feature is distorted or deformed. The face and neck are gaunt and elongated. The lids seem to droop over narrowed, slanted eyes. The arrogance of their remote gaze is reinforced by a long patrician sliver of a nose. But thick, pouting, sensuous lips seem to be held closed only by conscious effort. Overlarge as it is, this mouth is dwarfed by a chin of monstrous length and pendulosity, on which the false royal beard looks less like a hanging attachment than a prop to shore it up. It is not difficult to imagine this face as that of a fanatic, or even one deranged.

If the face is strange, the representation of Akhenaten's anatomy is almost shocking. The scrawny neck, the starkly protruding collarbones, puny arms and shoulders, and pigeon breast suggest an aged man or one wasted by chronic disease. Below the high, nipped waist, how-

[[53]]
Colossal statue of King Akhenaten
DYNASTY 18, CA. 1353–1350 B.C.
LIMESTONE; HT. 310 CM

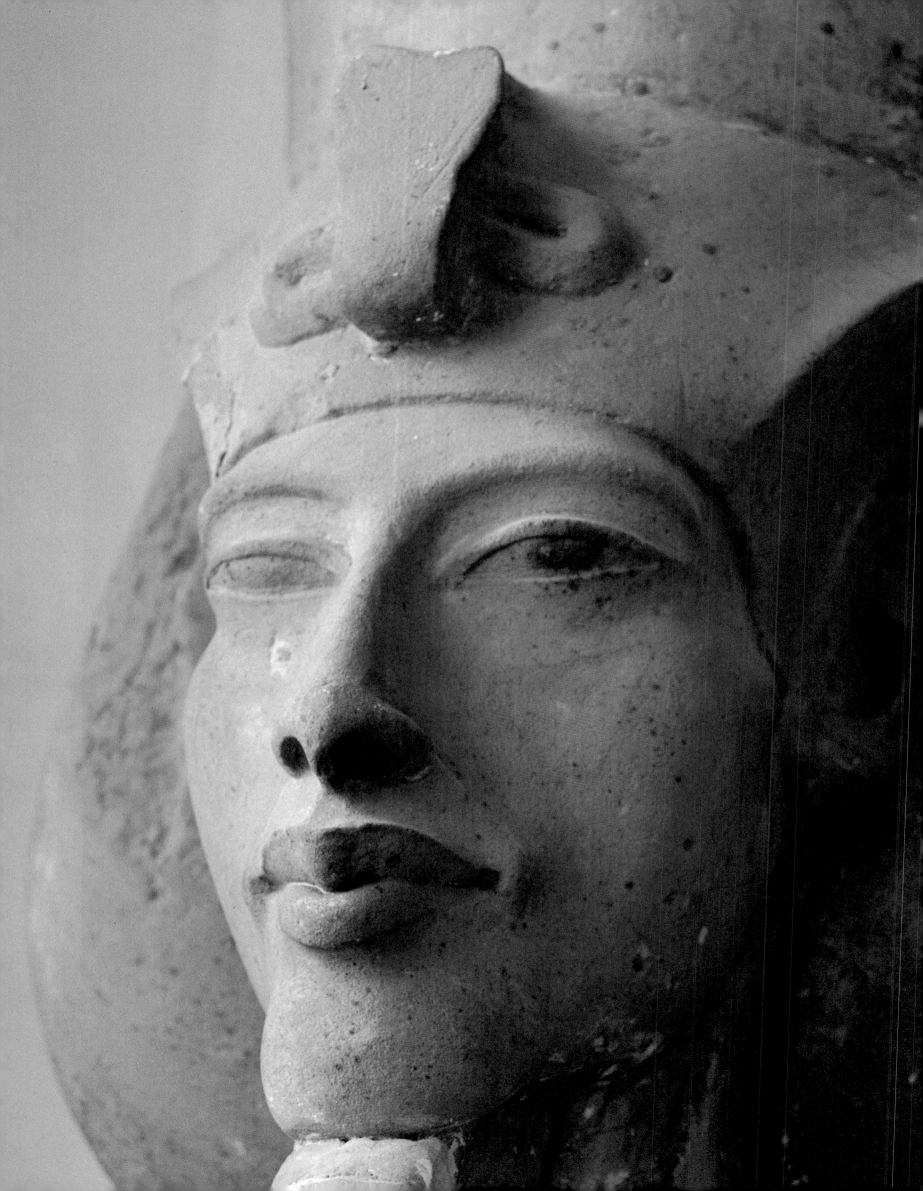

ever, the king's body balloons. His pleated kilt cannot contain the flaccid paunch, the weight of which flattens not only the navel but also the front of the broad belt over which it hangs. Behind, the buttocks protrude even more. But fattest of all are the enormous, bulging, womanly thighs. Of all the anomalies of this figure, the unmistakably female look of Akhenaten's lower body is the most disconcerting. Small wonder that so many have attempted to explain it. No one has yet succeeded, however, and it is unlikely that anyone ever will.

Certain medical disorders can cause adiposity in the lower body, together with excessive elongation in the neck and parts of the skull. Studying this and other representations of Akhenaten, a number of doctors have offered diagnoses of Akhenaten's probable illness, syndrome, or deficiency. It would be fascinating if we could know what, literally, ailed the man. Unfortunately, the doctors do not agree with each other, nor do their diagnoses fit the scant but reasonably well established facts known about Akhenaten's life. For example, most of the proposed ailments would render the sufferer impotent. However, Akhenaten almost certainly fathered six daughters and at least one son, Tutankhamun.

The real problem is that diagnoses of this kind are based on false premises. They arise from modern perceptions and preoccupations — from scientifically oriented curiosity and from our irresistible tendency to assume that distinctive features must, like a photograph, mirror an actual appearance. Akhenaten's concerns, of course, were entirely different. In departing radically from the styles of all earlier royal representations, statues like this were visible, calculated manifestations of his departures from traditional belief. We can be sure that this figure somehow embodies his concept of his own majesty and divinity. It is a fair guess that Akhenaten really looked odd and that he possessed these physical characteristics to some degree. Since his mummy was apparently destroyed not long after burial, we will probably never know for sure. But whatever their relation to his actual appearance, this statue and the other representations of Akhenaten at Karnak are deliberately unrealistic. They are exaggerations, abstractions, designed on the king's orders, to suit his purposes. The evidence is unequivocal.

In the first place, we know that this, like all the Karnak statues, was made early in Akhenaten's reign, before his fifth year, when he abandoned work at Karnak. From that time on, he devoted all his resources to the construction and decoration of his new capital at Amarna. As time passed, however, sculptural style at Amarna softened, and so did the appearance of Akhenaten. His odd

opposite page

⟦ 53 ⟧

detail

features were still represented, but in a manner that seems far more sympathetic, attractive — "normal." A head of the king, found in the vicinity of Amarna, shows how he was portrayed in these later years ⟦54⟧. At first sight, this sensitive, rather melancholy face seems utterly unlike its Karnak forerunner ⟦53⟧. But the features are all recognizably there: the narrowed, slanting, heavy-lidded eyes; the thick, drooping lips; the long bony line of the jaw ending in an oversized knob of a chin; the scrawny neck. Had Akhenaten suffered from any of the catastrophic illnesses that might fit the "symptoms" of his early statues, he would not have become this attractive as he aged.

The artificiality of Akhenaten's early style is also demonstrated by the representations of his wife Nefertiti and their daughters. Even more than in earlier periods of Egyptian art, they are images of the king. Nefertiti cannot have shared any of the exotic diseases postulated for her husband (most of them, indeed, are restricted to men), but her early statues and reliefs show this queen of legendary beauty as a slightly more female but equally grotesque twin of her husband, with his long, gaunt, slit-eyed face and scraggy neck, a pigeon breast scarcely fuller than his, and hips and thighs obese even for a woman. The hauntingly beautiful heads by which we remember her are all products of the lovelier later style at Amarna ⟦see 55⟧.

Amarna, the new city roughly midway between Memphis and Thebes, was entirely Akhenaten's creation. He called it Akhetaten and filled it with temples for the Aten and palaces for his family. The place was so dependent on him, and so identified with his cult, that it virtually died with him. His followers and the craftsmen he had employed packed up everything of value and moved on. The site was more or less abandoned. Left behind in its ruins were the worthless mementos of the discredited king and his cult; this "junk," found by modern excavators at the site, includes some of the finest and most intriguing of all ancient Egyptian sculpture.

For the most part, these later statues found at Amarna have a sophisticated naturalism that sometimes seems almost eerily modern. They must reflect changes in Akhenaten's beliefs or attitudes, even though they seem to have been made in an atmosphere of increasing fanaticism and religious intolerance, during the king's last years. The majority of the Amarna statues are so attractive that one suspects they include a good deal of suave flattery. But many seem to have the faces of individuals. Nefertiti's sculpture at Amarna, though it still bears a family likeness to her husband's, is as recognizable as it is beautiful.

Nefertiti's name means "The Beautiful One Is Come." Thousands of years after her death, her beauty is

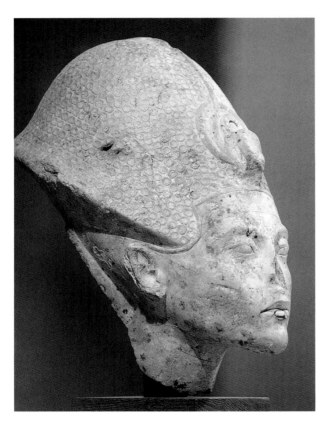

⟦ 54 ⟧

Head of King Akhenaten
DYNASTY 18, CA. 1348–1335 B.C.
LIMESTONE; HT. 24.5 CM

a living legend, based on actual representations of an unforgettable face. The most famous of these is a head in Berlin, where her chiseled features and elegant long neck are balanced by the sweep of her tall cylindrical blue crown. But there are many who share my own belief that a life-sized head in quartzite is the loveliest of Nefertiti's portraits and — perhaps because it was never finished — the most poignant [55].

There can be no doubt that it is Nefertiti who is represented here. The broad, calm arch of the brow; the gracefully modulated cheekbones and the strong but feminine chin; the perfect nose; the intriguing tilt of the slightly hooded, patrician eyes; the clearcut line of the lips, full and generous but with stubborn little folds at the corners — these belong to Akhenaten's queen, alone of all women.

Her famous head in Berlin has the cool gemlike perfection of high fashion. This face, though just as regal, is softer and more tender. The rough patches on the cheeks and the painted black guidelines under the eyes and above the lips indicate that the sculptor intended to work on it further, fining it down a bit more. His central guideline, dividing the face vertically, is also still in place. Very rarely in Egyptian sculpture are we allowed so vivid a glimpse of the hand of a great master, perfecting his work. We wonder why, at this stage, he paused to paint the eyebrows and eyelids and to redden the lips. Perhaps the queen herself was coming to inspect his progress to date. Perhaps he knew that for some reason he would never be able to complete the head. Conceivably, he was simply carried away by the beauty of his creation. Unanswerable questions like these arise irresistibly when we confront the finest of the Amarna works, so strong is their sense of living personalities, of both the artist and his royal subjects. This indefinable quality of transcending skill and beauty and touching life itself is unique, in all the ancient world, to the art of Amarna.

From its beginning, Egyptian sculpture had followed humankind's vision of itself along two paths, idealism and naturalism. The paths were separate. Even the greatest of earlier Egyptian statues succeed as expressions of either the immortal or the recognizable in human form. But at Amarna, for a few years, one or two sculptors of genius in that revolutionary environment managed to fuse the age-old opposites with a brilliance that has seldom been equaled, and never surpassed. Nefertiti's portraits are their crowning achievement. Her beauty is the beauty of absolute perfection. Yet it is so vividly alive that one feels one has somewhere seen this face, if only for a moment — or in a dream.

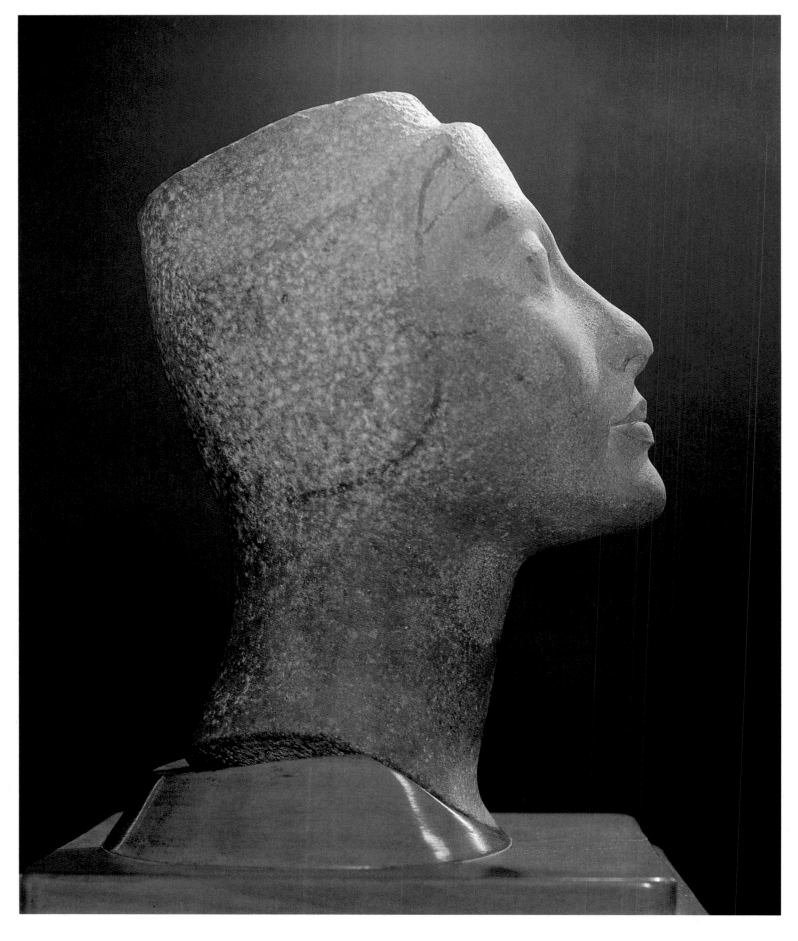

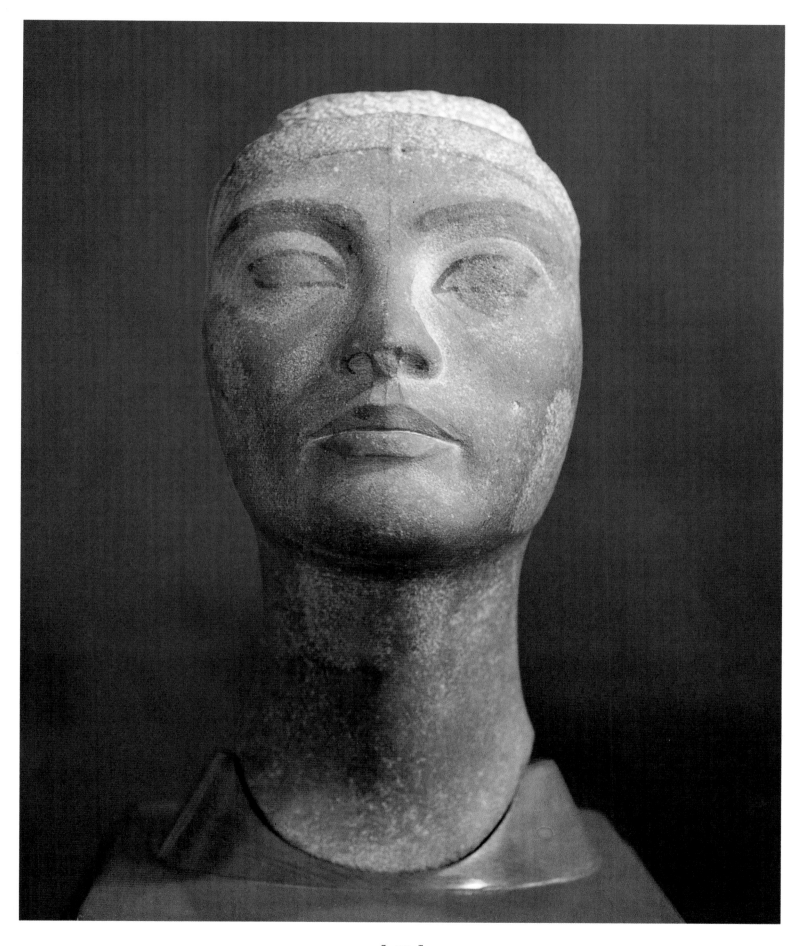

⟦ 55 ⟧
Unfinished head of Queen Nefertiti
DYNASTY 18, CA. 1348–1335 B.C.
QUARTZITE; HT. 35.5 CM

see also frontispiece

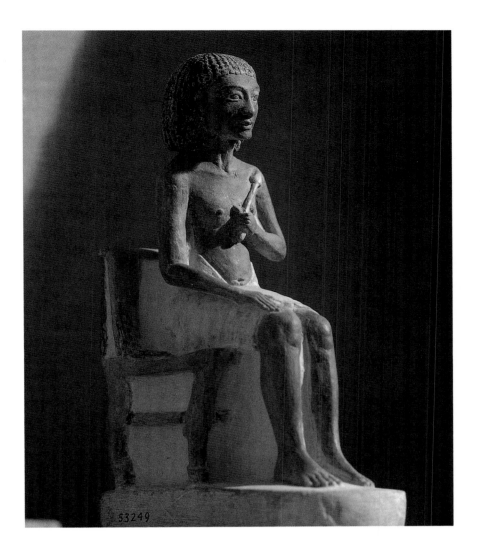

⟦ 56 ⟧

Elderly man of Amarna
DYNASTY 18, CA. 1348–1335 B.C.
PAINTED LIMESTONE; HT. 18.4 CM

The head was being made for a composite statue. The quartzite of the finished face would have been polished to the pale, tawny glow of the queen's skin and fitted on to shoulders covered by a collar necklace, perhaps of real gold and jewels. The body, in its linen dress, might have been made of the whitest limestone or alabaster, and the hands and feet of quartzite. The headdress, which would have fitted over the tang on top of the head, must have been intended to cover the ears, since they have not been indicated. It would not have been her tall blue crown, therefore, but a long wig in some black or blueblack material. A towering queen's headdress would have been set on top, fashioned in gold or gilded metal. Composite statues, assembled from parts made of appropriately colored materials, were very popular in the Amarna Period; many bits and pieces of others have survived.

There are very few statues of the private individuals who followed their king to Amarna, so few that it seems such expressions were restricted or even prohibited. One of the rare exceptions is a little painted limestone figure of a seated man, found in one of the houses at Amarna ⟦56⟧. The figure lacks any indication of its identity. It might represent a forebear of the householder, who commissioned the little image to venerate his memory in a small

domestic shrine. Or it could be the owner himself, an old-fashioned courtier who could not bring himself to forego the immortality conferred by a representation in stone.

Whoever he was, this man's statuette shares the king's features in their earlier, more exaggerated form: long nose and jaw, sinewy neck and bony shoulders, sagging breast, flabby paunch, and large thighs. He is no beauty. Unlike the king's features, however, these suggest neither deformity nor ill health. Akhenaten's peculiarities have been plausibly modified — one might almost say subverted — into the well-established lineaments of Egyptian old age. The main departures from the royal face, especially the strong lines down from the nose and mouth and the thinner lips, derive from traditional conventions for representing age [see 30].

The man's pose is equally conventional. He sits erect, on a chair so carefully carved and painted that one can see that it is made of two kinds of wood. So straight is his back that white-painted negative space is required to connect him to the chair back. His right hand rests flat on his thigh; in his left hand he holds a traditional — and religiously neutral — lotus bud.

The sculptor who carved this little figure — probably moonlighting from his work on the royal projects — was no great artist. Nonetheless, he managed rather cleverly to produce a work that was impeccably Amarna in style yet traditional in its rendering of dignified old age. Whoever commissioned the statuette, whether for himself or to honor someone else, received the perfect expression of his desire to insert an ancient, personal concern into the grandiose structure of his king's new religion.

Nefertiti's unfinished head [55] was found in a sculptor's studio at Amarna. Archaeologists uncovered at least two such abandoned studios still containing models and work in progress. Besides recognizable representations of the immediate royal family, these include plaster studies of several elderly men and women whose identities are quite unknown. These anonymous players on the Amarna stage increase our curiosity about who wielded the power during the city's heyday and in the aftermath of Akhenaten's death. The mystery is deepened by a striking little royal head about which nothing is known, except that its style is the style of Amarna [57].

Like the head of Nefertiti [55], this much smaller work was intended for a composite statue, this one with inlaid eyes. The neck may have fitted into the top of a collar necklace, since it ends in an oblique plane, descending from back to front. (This line has encouraged the mounting of the head at an incorrect angle, so that it appears to gaze upward, contrary to Egyptian practice.)

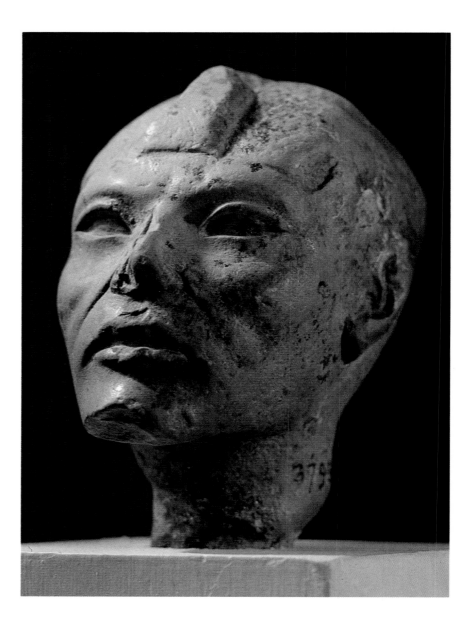

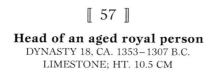
⟦ 57 ⟧

Head of an aged royal person
DYNASTY 18, CA. 1353–1307 B.C.
LIMESTONE; HT. 10.5 CM

A crown would have been placed on the unpolished, incomplete skull. A projection has been deliberately left on the front of the head. Although rather broad, it can only be explained as the support for a uraeus; thus, the head must represent royalty in old age.

As a depiction of age, it is both subtle and penetrating, with a reserved quality reminiscent of some of the late Middle Kingdom heads of aged kings ⟦see 30⟧. Here, however, the expression, though wearied, lacks the Middle Kingdom sense of disillusion or sad disdain. The modeling is softer; there is a more vivid sense of tired flesh, stretched over knobby cheekbones and sagging into pronounced creases beside the nostrils and mouth. The lips are indicated so delicately that it is hard to see their distinctive contours. And they are slightly parted, an expressive touch suggested in other Amarna statues but almost unimaginable for a royal figure in any other period of Egyptian art.

The head is usually assumed to be masculine and, by a process of elimination, assigned to Ay, the elderly

royal relative who ruled briefly after Tutankhamun's premature death terminated the direct family line. But it is so purely Amarna, in its delicate but unflinching naturalism, that it is hard to imagine its being made after a decade of the more idealized style of Tutankhamun's reign ⟦see 58–62⟧. Some have suggested, therefore, that the head was made earlier for Ay at Amarna, where he was among the most prominent of the courtiers. After he became king, according to this theory, the statue was updated. The original headdress was cut back, in preparation for the addition of a suitable crown and uraeus. This seems plausible. But since we are already speculating, there is another possibility.

Could this head represent an elderly woman? A small wooden head in West Berlin shows Akhenaten's mother, Queen Tiye, in her later years, with features strikingly similar to these, including the fine bones of the tapering jaw and chin, the slightly slanted, rather narrow eyes, and especially the broad flat curves of the distinctive upper lip. Like many queens of the New Kingdom ⟦see 41, 71⟧, Tiye often wore a double uraeus at her brow ⟦see 45, a representation of her in youth⟧. The unusual breadth of the projection here at the forehead might have been intended to accommodate the greater width of the two cobras.

The face of the Berlin Tiye is somewhat younger, with more prominent lids, a sprightlier arch to the brows, and a more feminine delicacy of feature — as well as a more truculent expression. We know, however, that Tiye survived her husband and lived on well into her son's reign, making at least one trip to Amarna. One can imagine the autocratic dowager queen on her state visit, looking very much like this and being unsparingly commemorated by an Amarna sculptor.

The riddle of the head will probably never be solved. From all this speculation, however, emerges one small but salient point: male or female, the mouth most closely resembles the mouth of Tiye. Ay, the Amarna relative and partisan who ended his days as king of Egypt, was in all likelihood her brother.

The Post-Amarna Years

Tutankhamun, Ay, Horemheb
(CA. 1333–1307 B.C.)

It says a great deal for the stability of Egypt, the efficiency of its army, and the unquestioned supremacy of its kingship that Akhenaten was able to reign for seventeen years

without, as far as we know, open revolt. We have no information about his death, but nothing suggests that it was unnatural. There are slight signs, however, that an organized counterreformation was getting underway during his last years. The speed with which the reaction took place as soon as the child Tutankhaten came to the throne also suggests that plans had been carefully laid for this event. Within a short time, the boy's name had been changed to Tutankhamun (you don't have to read hieroglyphs to see the significance of that), and he and the court had been moved to Memphis. Akhenaten's city was left behind; his policies were reversed; eventually, he himself was blotted out of the official records.

Tutankhamun
(CA. 1333–1323 B.C.)

This last male twig on the great Eighteenth Dynasty family tree held little interest for historians in the early twentieth century. They concluded quite correctly that he was a mere figurehead for the men managing the counterreformation, several of whom eventually became kings themselves. The only real question concerned his parentage. (There is still disagreement, but most scholars today believe he was the son of Akhenaten by a minor queen.) All that changed, of course, at the end of 1922, when Howard Carter found his tomb in the Valley of the Kings. Today no other figure in all of antiquity is as well known as the boy King Tut.

For all its treasures, Tutankhamun's tomb was not rich in sculpture. The many images of the king found there consist mostly of the mummiform funerary figurines called *shawabti*s and enigmatic magical statuettes in gilded wood, which show the king in various improbable, otherworldly poses. This lack is not the result of his burial being rushed or scanted. Stone funerary sculpture was being made for him in quantity, and some of it had even been finished by the time he died [[59]]. But these belonged in the king's funerary temple, on the other side of the cliffs ringing the Valley of the Kings. Hidden in the valley, the New Kingdom royal tomb was a repository for the belongings most precious to its occupant and, above all, for aids designed to physically or magically protect the all-important mummy—like the magnificent gold mask that covered Tutankhamun's shrouded head.

Not even the mask is more lifelike than a mysterious wooden figure, half-length and armless, found in the tomb [[58]]. No one has yet offered a convincing explanation for this statue, which is life-size and complete as it was made. It can hardly have been, as some have proposed, a dressmaker's dummy or elaborate clothesrack. Egyptian garments were loosely fitted and stored flat.

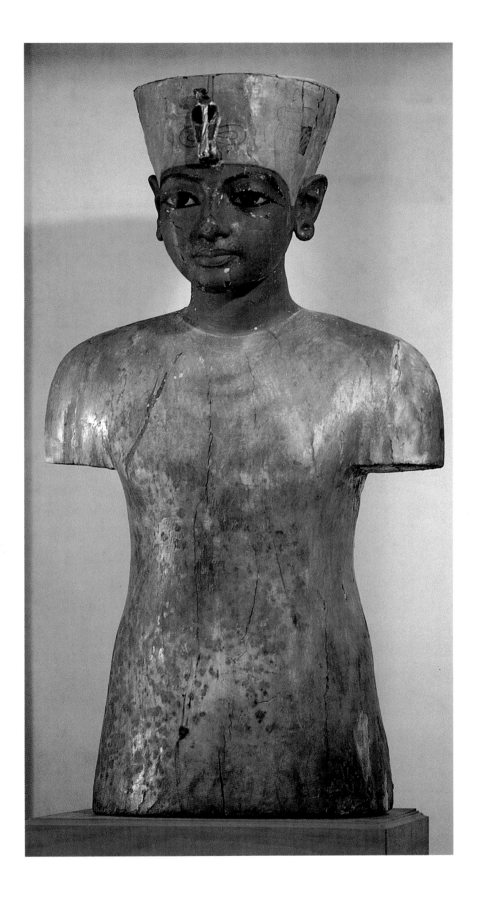

[[58]]
Half-length figure of King Tutankhamun
DYNASTY 18, CA. 1333–1323 B.C.
PAINTED WOOD; HT. 76.5 CM

One clue to the nature of the figure is the unconventional coloring of its crown. Similar in shape to the lower part of a Red Crown [[see 18]], this cylindrical structure is painted yellow, possibly to simulate gold. It is not the crown of a living Egyptian king. Its wearer, therefore, does not represent Tutankhamun as he ruled on earth, but as king in a spiritual or magical sense.

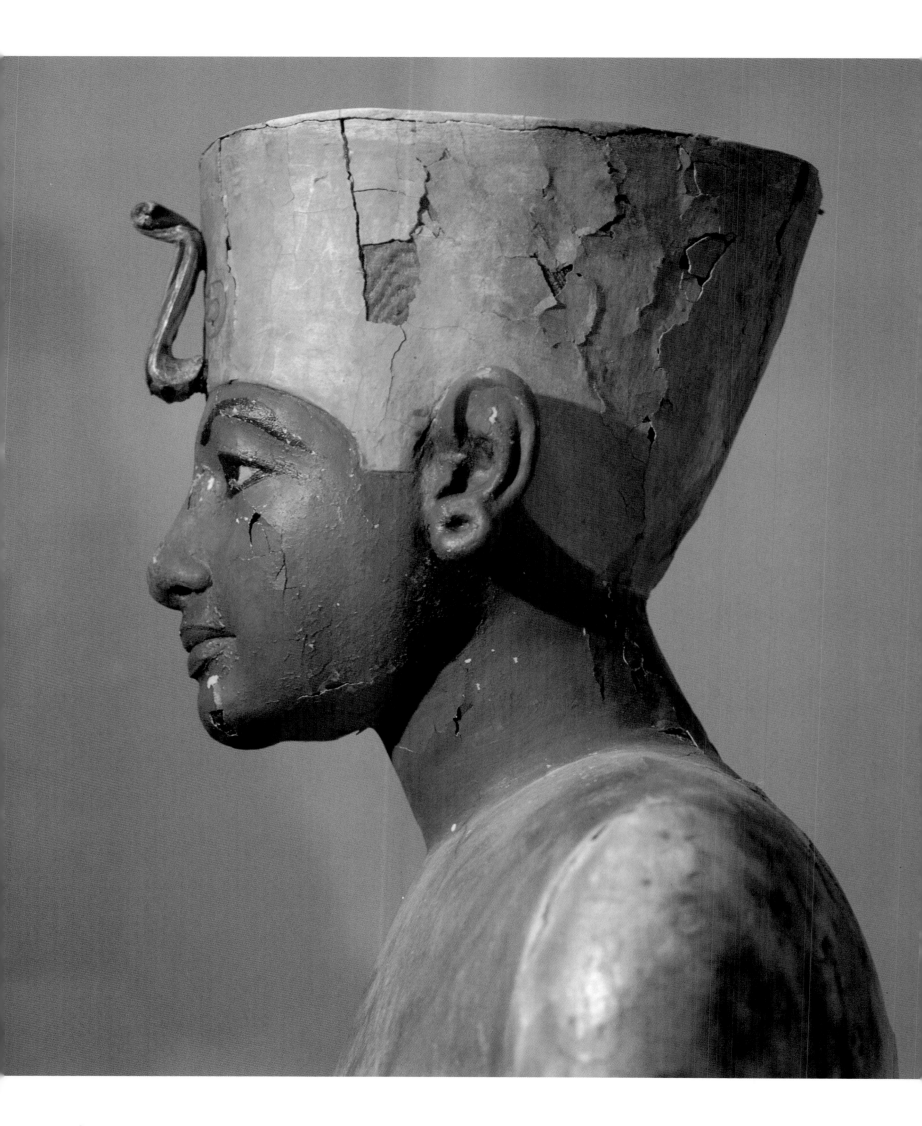

Representations of funerals on the tomb walls of private persons occasionally depict, among the objects being carried to the tomb, a half-length figure wearing a crown. Tutankhamun's is apparently the only surviving example of this effigy, which must have played some specific magical role in the protection or rebirth of the deceased, whether king or commoner. 〚Compare the small royal figures associated with the burial of Imhotep, a great official of the Middle Kingdom; see 22.〛

Like the gold mask, this figure represents a delicately handsome youth with large, almond eyes under artfully arched brows, a fine straight nose with a fleshy, almost retroussé tip, and a full, beautifully formed mouth. This face seems even more boyish, however, with round cheeks and baby fat around the chin. The carefully carved ears stick out a bit. As on the mask, their somewhat enlarged, pierced lobes show the effects of wearing showy, heavy earrings, of a kind actually found in the tomb. This detail carries on an Amarna innovation. Big earrings had been fashionable, for both men and women, for several generations. The earrings themselves are seldom represented on statues 〚see 71〛, but Akhenaten's artists began regularly to show the holes pierced in the lobes. One can be seen on the head of Akhenaten 〚54〛.

Like all the representations of Tutankhamun found in his tomb, the half-length figure owes a strong debt to the soft, attractive style of the later Amarna Period. There is none of the beauty of his stepmother, Nefertiti, but perhaps some of her prettiness, along with the lush features and soft roundness of Akhenaten's face in its later version 〚see 54〛. At the same time, there is more than a hint of the likeness of Tutankhamun's grandfather, Amenhotep III, in the elegantly formal drawing of the eyebrows, the shape of the lips, the boyish chin 〚see 45〛. This may be an example of politics made visible. Tutankhamun's advisers liked to stress the king's closeness to the grandfather he may never have known, the better to forget Akhenaten.

Of course, there may well have been a genuine family likeness. And Tutankhamun may really have had the youthful, ingenuous face we know so well. Nonetheless, deciding on the exact form of his official likeness was probably one of the first and trickiest acts of the new regime. Akhenaten had harnessed art to revolution, for the first time linking specific ideas to a specific style. The counterreformers who were determined to extirpate, in Tutankhamun's name, all of the Amarna unorthodoxies, had to contend with an art politicized, even radicalized, but expressed in a style of extraordinary vitality and appeal. Amarna statues could be smashed or hidden, but Amarna style lived on. As we shall see, it was modified.

opposite page

〚 58 〛

detail

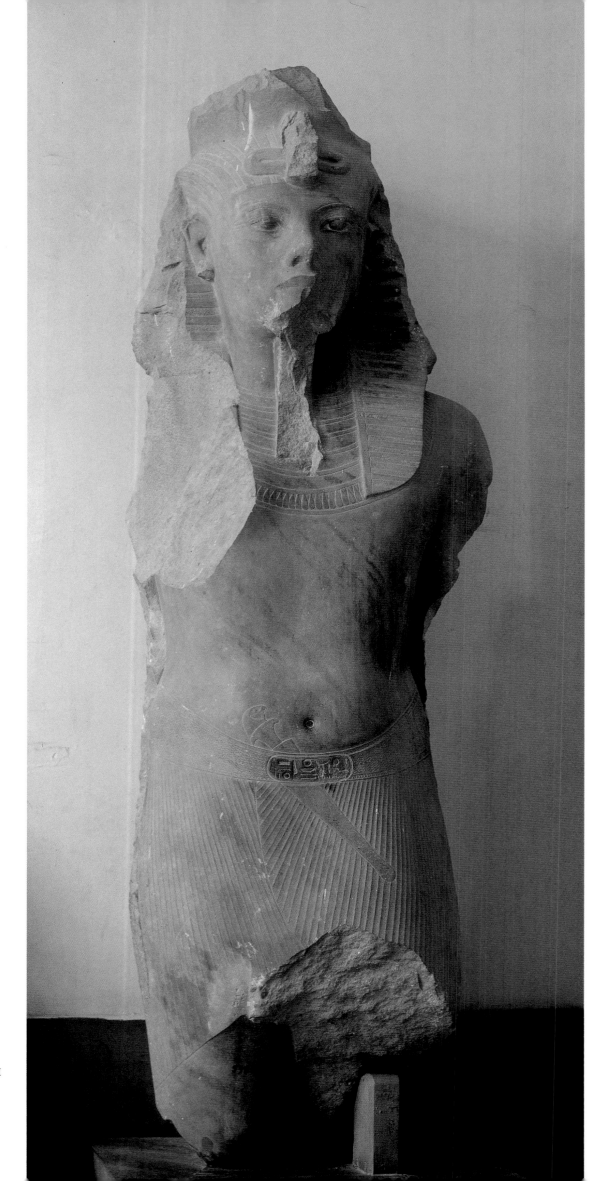

〚 59 〛

**Colossal statue of
King Tutankhamun**
DYNASTY 18, CA. 1333–1323 B.C.
PAINTED QUARTZITE; HT. 285 CM

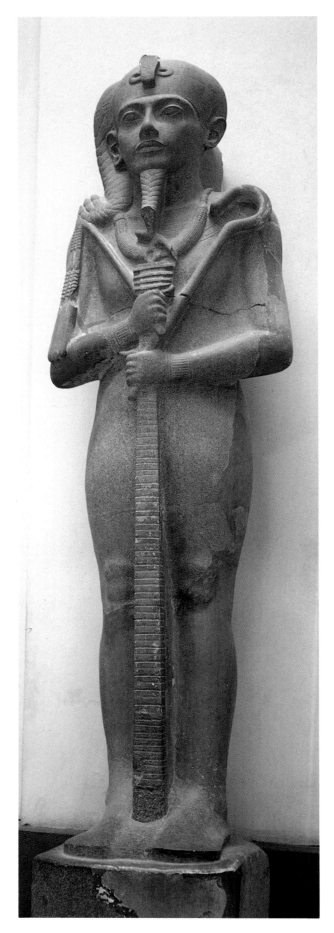

⟦ 60 ⟧
**The god Khonsu with the features
of Tutankhamun**
DYNASTY 18, CA. 1333–1323 B.C.
GRANITE; HT. 252 CM

But post-Amarna style was always recognizably the child of its past, long after the time when the oldest artist trained at Amarna had laid down his tools.

Tutankhamun was a teenager at the time of his death — a man by Egyptian standards, though a young one. His maturity, such as it was, may be expressed in a colossal standing figure made for his funerary temple ⟦59⟧. This face lacks the boyish charm of the half-length statue from Tutankhamun's tomb ⟦58⟧. The cheeks are longer and leaner, the eyes are proportionately smaller. Feature for feature, however, the two representations are almost alike.

The young king is not fat, but his torso looks soft and fleshy. The effect is naturalistic and may even reflect Tutankhamun's immature physique. Nonetheless, the body is a construct, a combination of the slim proportions of earlier royal figures ⟦such as 40⟧ with the unmuscular flabbiness of Akhenaten ⟦53⟧. Amarna style is the source of Tutankhamun's little paunch. Though it has none of the grotesque obesity of his father's distended abdomen, it still seems to press down the front of the belt, giving it the same taper as on Akhenaten's representations.

This statue was to have been one of the most important in Tutankhamun's funerary temple, and the care taken with its details is evident everywhere, from the blue and yellow paint still visible on the *nemes* to the pattern on the belt and the sheathed falcon-headed dagger slipped behind the buckle. The royal name on the buckle, however, reads Horemheb. A careful observer will notice the rough, rather crude look of the right side of this inscription, and guess at least part of what happened. This statue was usurped twice. Tutankhamun's successor, Ay, took it for his own funerary temple, but Ay in turn lost both temple and statue to his successor, Horemheb.

A stela erected in Tutankhamun's name at Karnak tells of the sorry state in which the king found the temple of Amun, and of his pious exertions to make it more glorious than ever. This is, of course, an official statement by the party that set out to erase all evidence of the heretical period. It may not, however, have falsified the extent of the damage inflicted on Karnak at Akhenaten's orders. One telling indicator of extensive restoration at Karnak during Tutankhamun's reign is the large number of divine statues that bear his features. One of the most beautiful of these is an almost complete figure, over life-size, which represents Khonsu. This lunar deity was a child, the son of Amun and his consort Mut. He had his own temple within the Karnak enclosure, and it was under the pavement of its sanctuary that the pieces of this statue were found ⟦60⟧.

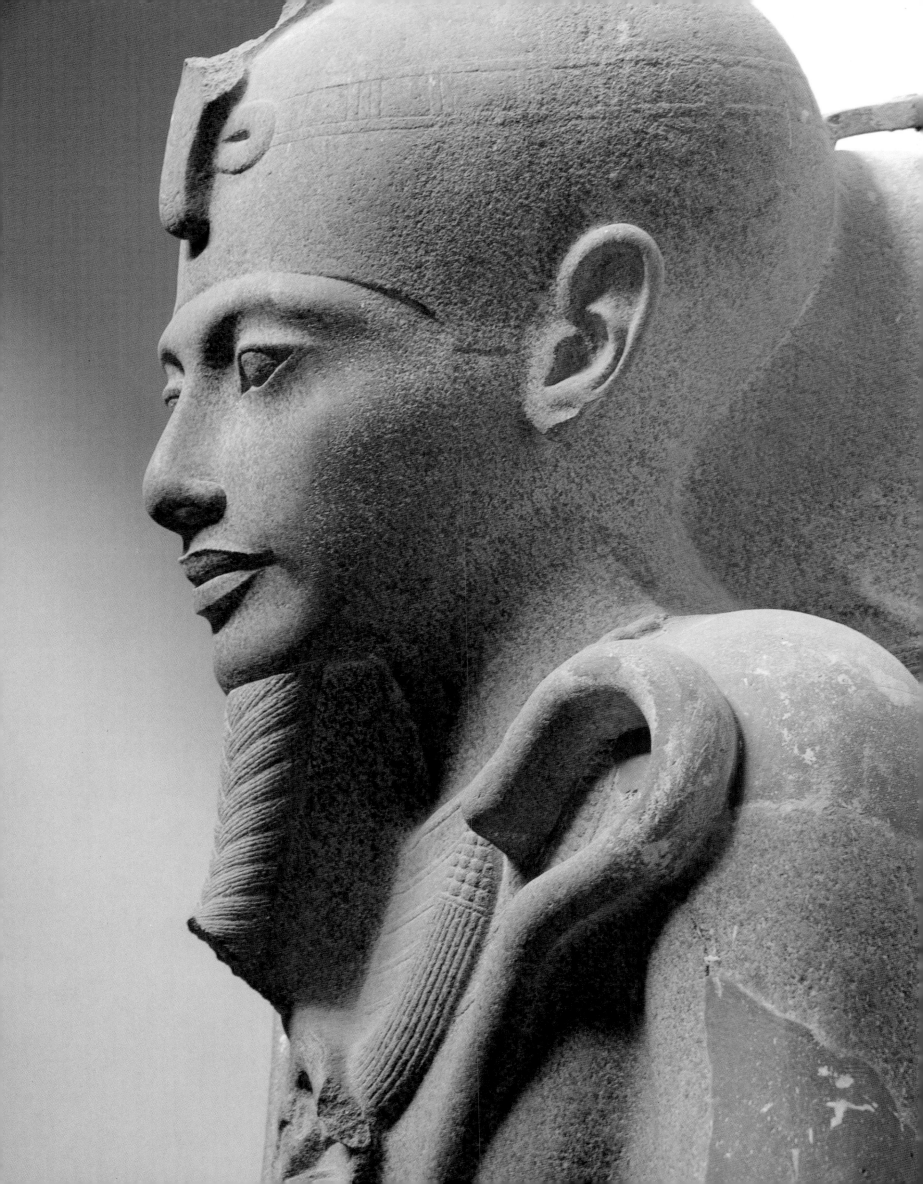

The hieratic simplicity of the young god's mummiform body is broken by a welter of divine insignia. Both hands are required to clutch an Osirian crook and flail and *djed, ankh,* and *was* signs, respectively signifying endurance, life, and power. Over the usual collar necklace, Khonsu wears a thick, many-stranded *menit* necklace, probably to rattle in honor of his mother, Mut. Goddesses seem to have taken pleasure in the rustle and click of its many tiny beads. Khonsu appears to wear a skullcap, or perhaps it is just a schematic demarcation of the hairline on a shaven or cropped skull. Around this, a narrow, ribbonlike diadem supports a uraeus and helps hold in place a luxuriantly thick sidelock of youth [see 14]. Its braided tresses are echoed in the thinner plait of the divine beard [see 43].

Supported on its column of a body and framed by the clutter of divine regalia, the face of the young god is almost unearthly in its loveliness. There is inexpressible sweetness in its exquisitely tapering planes, the full but firm lines of the pursed mouth, and the tranced gaze of the tilted eyes, set deep under strikingly semicircular brows. This withdrawn, dreamy expression is characteristic of many statues made for Tutankhamun and his contemporaries [see 63]. Here one also feels a hint of melancholy, largely the effect of shadows that seem to hollow the eye-sockets and the sides of the cheeks, making the corners of the mouth look more turned down than they are. One of the first Egyptologists to study this statue decided it had the face of a consumptive and deduced that its model (whom he thought was the doughty and long-lived Horemheb) must have suffered from tuberculosis. This is another example of the pitfalls of making diagnoses from works of art.

We now realize that this is a version of the face of Tutankhamun, as it appears in a number of temple statues representing the king and on almost all of the images of gods made in his name. In its juvenile aspect, it seems to stand midway between such childish figures as the half-length figure from his tomb [58] and the youth represented in his funerary colossus [59]. The Amarna heritage is unmistakable in the slight elongation of the skull, the indication of fleshy creases in the front of the neck, the pierced earlobes, the slight drooping of the prominent eyelids—above all, the Nefertiti-like perfection of that beautiful face. Even so, this post-Amarna style is clearly aiming for a more formal, traditional look. The soft, detailed modeling of the flesh has been restrained, and the result is less naturalistic, more stylized, even mannered.

Wandering today through the vast bare courtyards and the maze of roofless halls in Karnak, even an imagina-

tive visitor can hardly envision the priests, temple servants, and worshippers who once thronged and jostled here; the treasures of cult equipment that gleamed half-hidden in the dusky gloom of enclosed inner precincts; the statues that must have crowded every available bit of space. Of those statues that survived into modern times only a few, mostly too large to move, remain in or near their original locations. Among these are a pair of colossal figures, representing Amun and one of his consorts, Amunet 〚61, 62〛. They were found in pieces; most of the god's body was never recovered.

The statues now bear the name of Horemheb as donor, but his inscriptions have clearly replaced another royal name. Looking at the face of the god 〚61〛, it is not difficult to see who inspired his handsome features. We have already seen them on the statue of Khonsu with the face of Tutankhamun 〚60〛. This Amun has a cheerier expression, mostly because his mouth and lower face seem fuller and more relaxed, not unlike the half-length figure from Tutankhamun's tomb 〚58〛.

Amunet 〚62〛 is a goddess with little personality. She was primarily Amun's female counterpart: her name is a feminized form of his. As represented here, she is quite slim, but her figure lacks the firm contours of earlier Egyptian statues of women 〚see 7, 24〛. Her small breasts (mostly modern restorations, but accurately reproduced) are low and rather droopy. Her little round abdomen sags over the fleshy pubic area, and her plump thighs bulge. This physical ripeness derives from Amarna, where Nefertiti's lush, pear-shaped body was the feminine counterpart to her husband's. Like the male bodies of Tutankhamun 〚see 59〛 and the gods made in his likeness, post-Amarna figures of women reverted to earlier traditions of slenderness but still displayed a number of Amarna's anatomical peculiarities, albeit much restrained and modified. The result, as here, is often a soft, even vulnerable, womanly look.

The head of the goddess was found apart from most of the other pieces of these statues. It had received more brutal handling than had the head of Amun. Some iconoclast, with two or more heavy blows, utterly destroyed her nose, mouth, and chin — having first taken the precaution of "blinding" the eyes by pecking at them, so that the goddess could not "see" her attacker 〚compare the damage to 63〛. This mutilation must have been carried out at some point after the cults of the ancient gods had waned. Even then, however, superstition and a residual awe were strong enough to make the vandals fearful of divine retribution.

The combination of dignified reserve, grace, and sensuous charm peculiar to post-Amarna sculpture re-

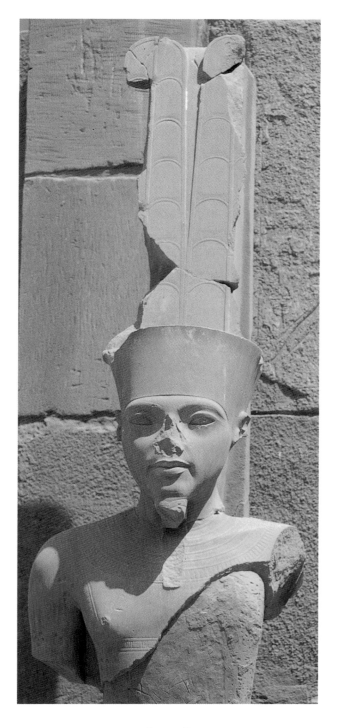

〚 61 〛

**The god Amun with the features
of Tutankhamun**
DYNASTY 18, CA. 1333–1323 B.C.
LIMESTONE; HT. CA. 6 M

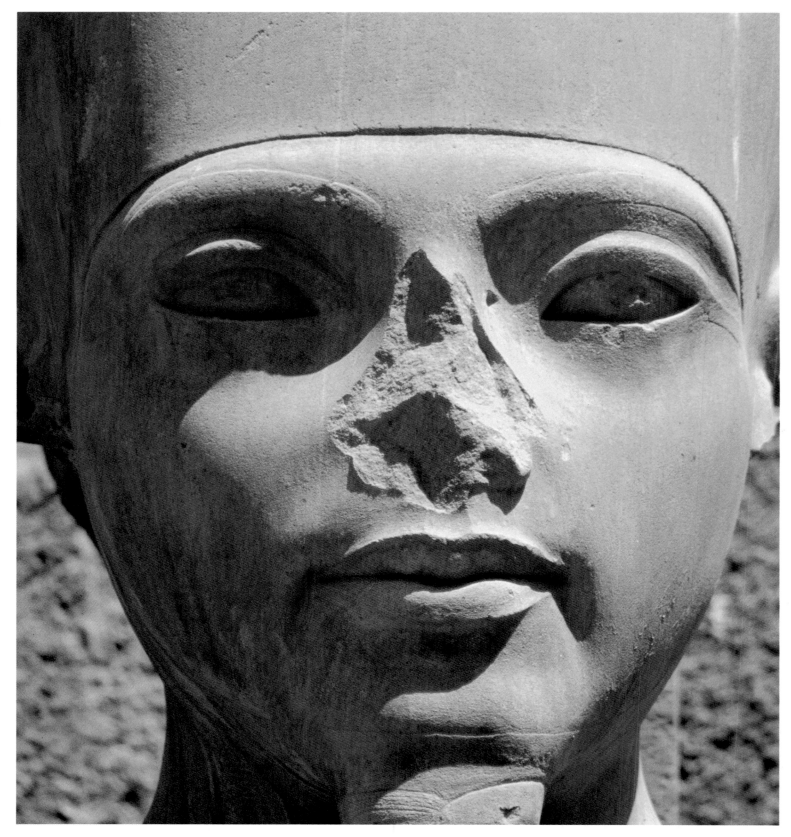

⟦ 61 ⟧
detail

⟦ 62 ⟧
Amunet, the consort of Amun, detail
DYNASTY 18, CA. 1323–1319 B.C.
LIMESTONE; HT. CA. 4 M

see also p. xii

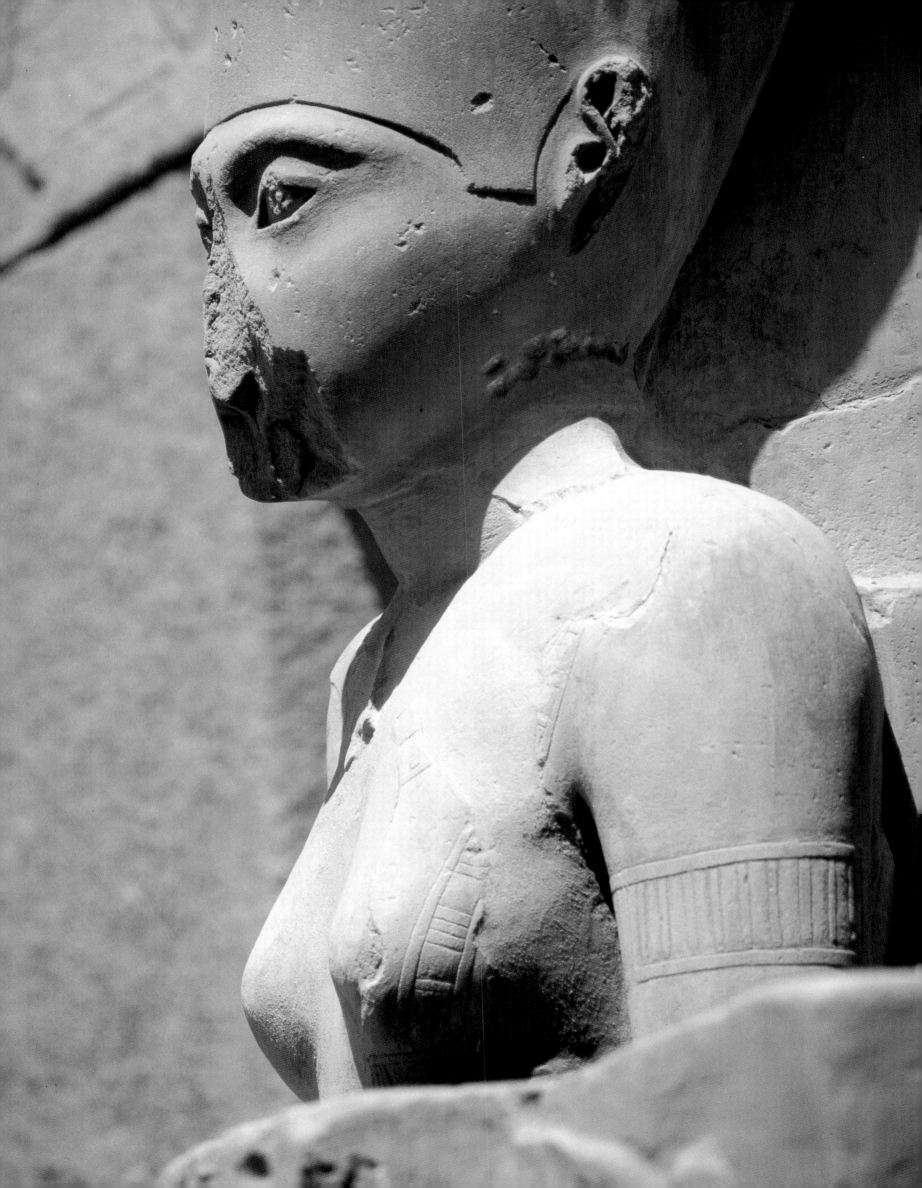

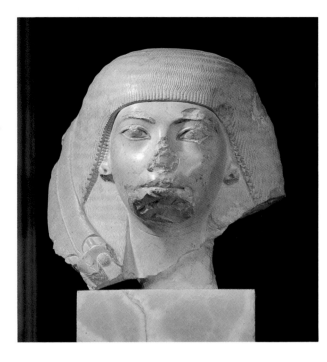

[[63]]

Nakhtmin and his wife
DYNASTY 18, CA. 1323–1319 B.C.
LIMESTONE, PAINTED DETAILS; HTS. 34 CM, 85 CM

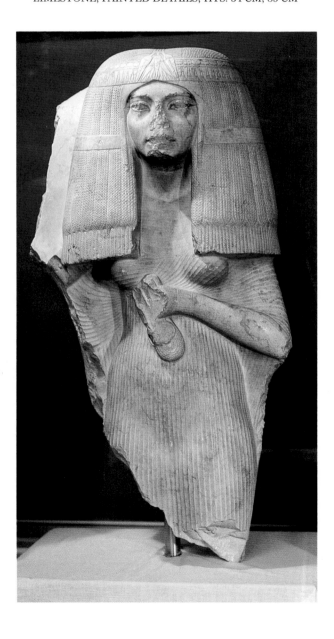

ceived exquisite expression in a masterpiece of which only two fragments have been preserved: the statue of a General Nakhtmin and his wife [[63]]. The Egyptian Museum purchased these pieces in 1897. We do not know where they were found, when and how the statue was destroyed, or what fortunate chance permitted the survival of these two splendid scraps.

Carved in a hard fine limestone with almost the texture of marble, the group must once have shown the general seated, with his head on the same level as that of the smaller standing figure of his wife, whose raised right arm lay on or around his shoulders. The unnatural difference in their sizes, a feature very common in the Old Kingdom, had become rather rare in the sophisticated New Kingdom. Statues of couples made in this period usually show the man the same size or only a realistic bit taller than the woman [[see 47]]. In such representations, however, both of the pair either sit or stand. Once the decision had been made to show Nakhtmin seated and the woman standing at his side, their disparate scales would have been considered necessary, in order to place their heads on a uniform level. This taste for isocephaly — a very Egyptian principle of design — was almost as persistent in Egyptian art as the chaste form of her wifely embrace [[compare 14]].

Although we have little more than his head, it is clear that Nakhtmin wore full formal dress. The fine wavy tresses of his double wig are shown with unusual delicacy. Its upper ends are twisted to form a thick fringe, which falls gracefully over the forehead, half covering his ears and flaring at the sides to reveal the even finer strands of the lappets below. Against his right shoulder, the general held a fan made of a single ostrich plume set into a long holder. The top of the holder, a papyriform umbel between two rosettes, is still preserved. The long wisp of feather is curled around the side of Nakhtmin's wig, to avoid rendering it as a breakable projection.

This statue seems to have been made after the death of Tutankhamun, but the young king's image is the source of Nakhtmin's features. The rounded brows, the tilted eyes with their short but prominent upper lids, the soft but firm full lips, and the almost introverted air of abstraction characteristic of Tutankhamun's sculpture are equally apparent on the face of this high-ranking officer. Some Amarna stylistic details have become mannerisms: the plastically modeled eyelids, the large earring holes, the fleshy creases on the front of the neck.

Traces of paint on Nakhtmin's face indicate that, contrary to the usual Egyptian practice of covering a limestone statue with paint, only certain details had been picked out with color. The eyebrows, irises, and cosmetic

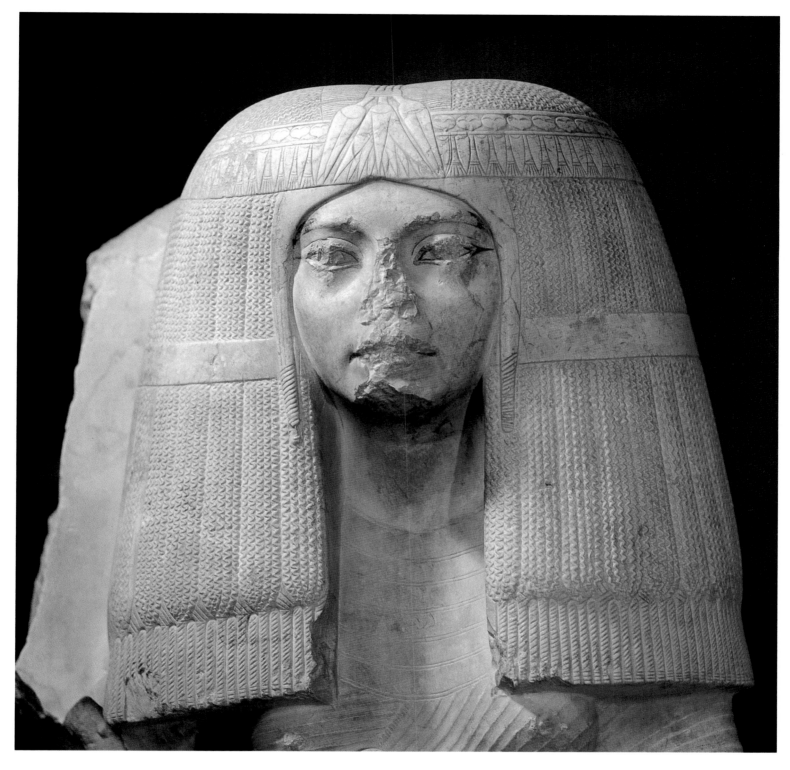

Nakhtmin's wife, detail

lines were painted black, the lips red. Black emphasized the creases on the neck, the folds of the eyelids, and the line between the lips, which ends in two little notches. Black encircles the earholes, which are painted red. This method of selective coloring was not unusual for reddish stones, which could be considered more or less skin color 〚59〛. Shortly before the Amarna Period, fine white limestone began occasionally to be treated this way, as an affectation or simply from appreciation of the creamy beauty of the stone.

For all his beauty, Nakhtmin is an exotic-looking dandy. His wife, however, makes any oddities of style and

costume seem almost irrelevant. She is gorgeous, appealing, expensive looking, with some of Nefertiti's feminine grace, much of Tutankhamun's dreamy softness, and a seductive quality all her own. As with most Egyptian representations of wives, her face is basically a feminized version of her husband. But the sculptor has altered each feature significantly, making the face rounder, the lids heavier and sleepier, the little pads of flesh more noticeable below the eyes, beside the nose, and at the drooping corners of the slightly fuller lips. He has made her not just more feminine but far more individualistic than her husband. Framed by the almost architectural mass of the great formal wig, its elaborate tresses and hairbands lightly traced in relief like stucco ornament, her languorously sensual face is as memorable as a face glimpsed in a window.

The sexuality implied by the face is made explicit in the body. The rounded abdomen and pubis, swelling thighs, and (as seen in profile) plumply prominent buttocks are all inherited from the sculpture of Nefertiti. Even more than on the statue of Amunet [[62]], however, Amarna pudginess has here been streamlined. This woman's high waist and the long curving sweep to a low center of gravity recall the elegance of Middle Kingdom women [[see 24]]. The high-set globes of the breasts are provocatively sexy and, like her other charms, they are showcased in a gown that, for all the elaboration of its fine sharp pleats and capelike top, is a mere gauzy veil. Nakhtmin's wife was doubly fortunate: she lived in the time of a gracefully beautiful style, and she commanded the services of a brilliant sculptor. Whether he saw her this way, or whether he was creating his own ideal of femininity, he gave her something more than beauty. Nakhtmin's wife has a ripe seductiveness without parallel in ancient Egyptian sculpture.

One can't help wondering about this glamorous couple. Her name, written on a missing part of the statue, has been lost. Her only remaining sign of rank is the beaded *menit* necklace — the same kind worn by the god Khonsu [[60]] — which she holds folded in her hand. As a priestess, a rank held by many society women, she would have carried and rattled it in the ceremonies of some goddess.

Of Nakhtmin himself, we know or can deduce a little more. That pretty, inefficient-looking fan of his was a well-defined piece of court equipment. Its depiction on his statue is a strong hint that Nakhtmin was a "Fanbearer on the Right of the King," a title held by certain of the most important nobles, with direct access to the royal person. Along with his name, the surviving bits of inscription on the back of the statue list some of Nakhtmin's other titles: Prince, Royal Scribe, General-in-Chief, and

King's Son . . . , the last title incomplete. This is very annoying, because "King's Son" might indicate a prince of the blood, but it could also have been "King's Son of Kush," the official designation of the king's nonroyal viceroy in the south. Unfortunately, we know of neither a royal prince nor a viceroy of Kush named Nakhtmin at this time. However, Tutankhamun's tomb contained funerary statuettes donated by the Royal Scribe and General Nakhtmin, almost certainly our man. The privilege of making such a gift was, of course, a mark of the highest honor and suggests that Nakhtmin was one of the dignitaries responsible for arranging the royal burial.

Since it gives his military rank as General-in-Chief, this statue was inscribed after Nakhtmin had been promoted, presumably in the reign of Tutankhamun's successor, Ay. It has even been suggested that the elderly, childless Ay, possibly a relative, designated Nakhtmin a King's Son in order to make him his heir. This is an intriguing but unprovable theory. In any case, however high Nakhtmin may have climbed, it is almost certain that he finally fell.

The statue itself provides evidence for his fall. At some point in antiquity, before or during its destruction, both of the faces were subjected to vicious attack. The noses were hammered off, apparently with a small, sharp instrument, to prevent their owners from breathing. The mouths were chipped speechless, and Nakhtmin's wife was "blinded" by repeated blows to the eyes. [Compare the superstitious attack on the eyes of Amunet, 62.] This "killing" of the representations, accompanied by similar mutilations of Nakhtmin's name and titles on the back, was not simple vandalism but a personal attack against Nakhtmin, carried out in the same spirit as the posthumous desecration of the sculpture of Hatshepsut [37]. With our present information, there is no way of knowing whether Nakhtmin was still alive when his statue — and presumably the tomb for which it was made — was savaged. But his fall seems to have coincided with the rise to the kingship of his fellow general and probable rival, Horemheb.

Horemheb may be the king represented on a sphinx at Karnak [64]. Though most of its face is terribly damaged, the generous breadth of its symmetrically arched brows and the droop of the heavy, drowsy-looking lids are enough to convey the curious, beautiful, dreamy but open expression unique in Egyptian sculpture to the reigns of Tutankhamun, Ay, and Horemheb. We may never be entirely certain for which of them this sphinx was carved, not just because of its bad condition but even more because Horemheb so thoroughly usurped the sculpture

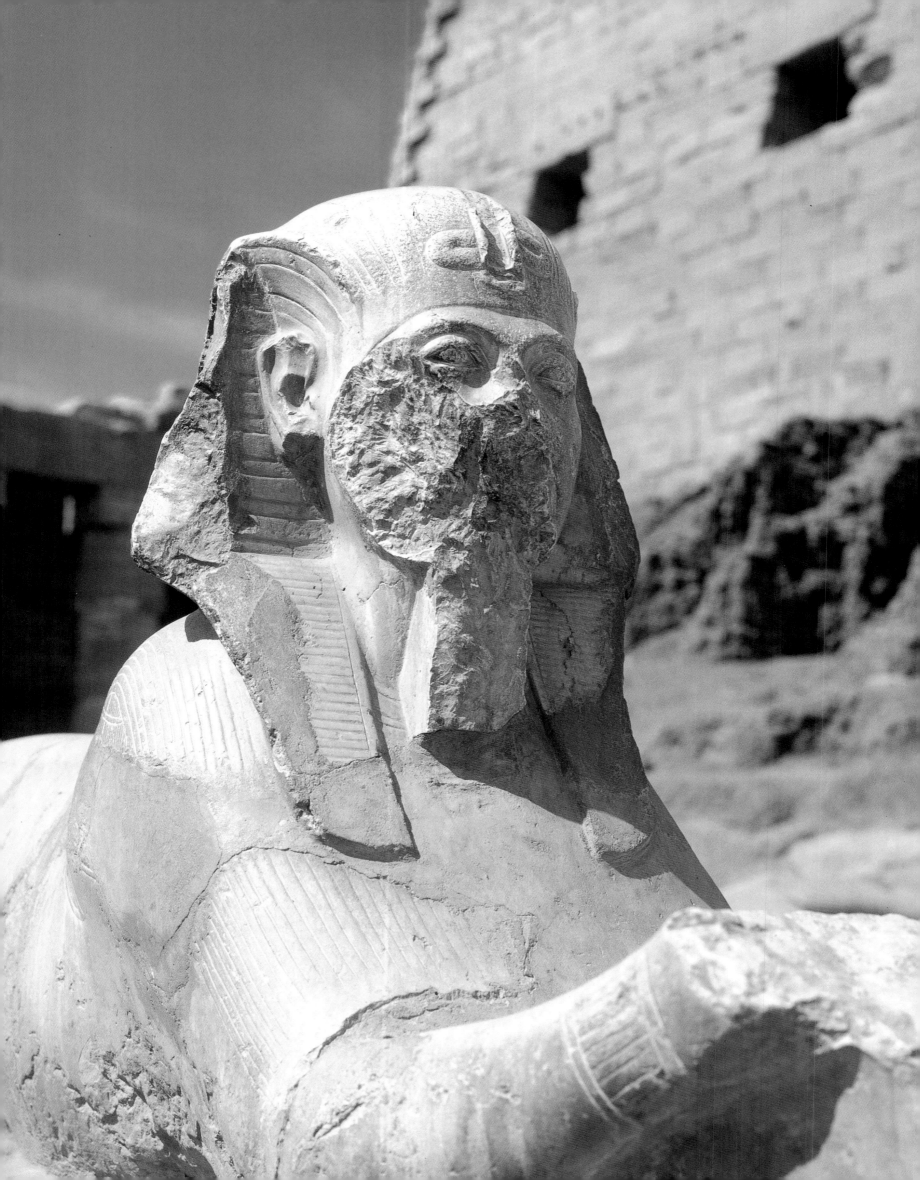

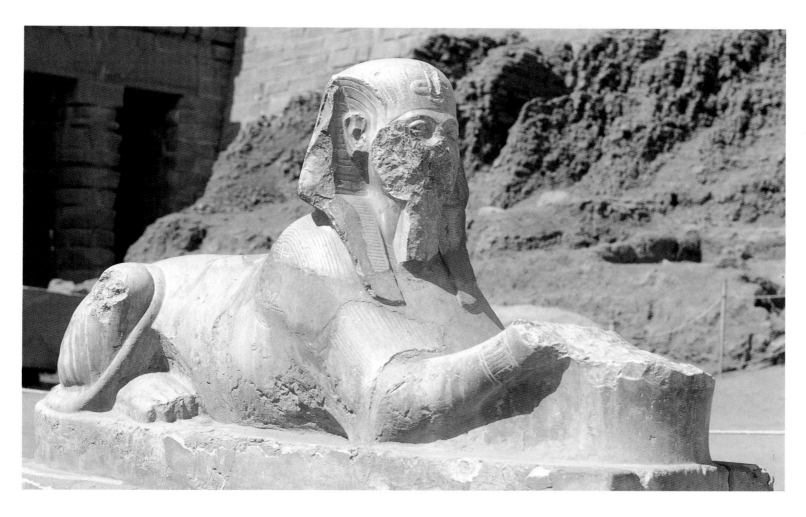

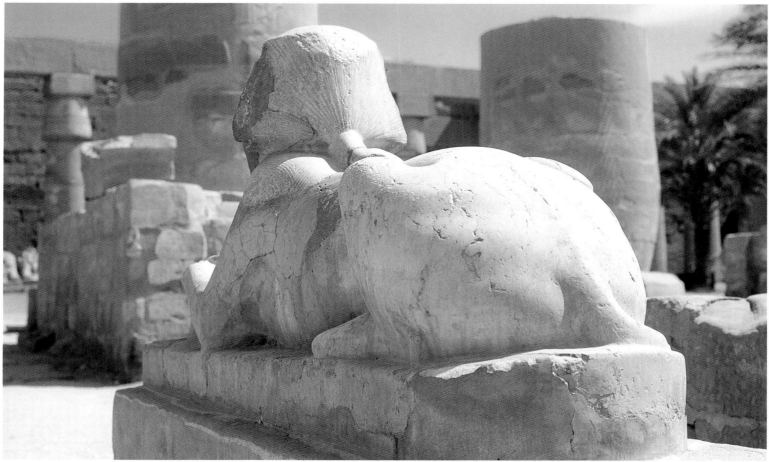

〖 64 〗

Sphinx, probably King Horemheb
DYNASTY 18, CA. 1319–1307 B.C.
LIMESTONE

of his two predecessors [[see 58, 61, 62]] that his own royal likeness — if, indeed, one was developed for him — is obscure.

Horemheb, a powerful and efficient ruler, had good political reasons for his usurpations. He had begun the process of officially forgetting both the Amarna Period and the awkward first years of the restoration. In later times, the regnal years of the nonpersons Akhenaten, Tutankhamun, and Ay were accounted for by crediting them to Horemheb, whose respectable thirteen years of rule were thus lengthened to a fictional forty-seven.

One of the few statues preserved that was actually made during Horemheb's reign is the head from a huge figure of the goddess Mut [[65]]. Her pleasant, rather stolid face shows the likeness of Mutnodjmet, Horemheb's queen. Assuming the woman's face was, as usual, a feminized version of her husband's, we may find a corresponding heaviness of feature on what is left of the sphinx, around the eyes and the long jaw.

Like the sphinx of Amenhotep I from the beginning of the Eighteenth Dynasty [[36]], this sphinx carved at the very end had human forearms and hands with which it held a vessel, perhaps with a lid in the shape of a ram's head emblematic of Amun. Like all fine Egyptian sphinxes, it is an almost seamless join of human and animal, so smoothly accomplished that the sweet, almost lazy remoteness of its gaze seems to agree perfectly with the rippling muscularity of its massive hindquarters. From the back, more beast than man, the creature's royal *nemes* head-cloth almost looks like a particularly well groomed mane.

Like the statues of Amun and Amunet [[61, 62]], the sphinx rests today not far from where it was found at Karnak, in the forecourt of the great temple of Amun. Originally it may have been one of a pair flanking the doorway in the Second Pylon. French excavators working on the long history of this part of the temple have suggested that this sphinx and its companion were reused some 650 years later, when the Twenty-fifth Dynasty king Taharqa built an imposing colonnade in this courtyard. Apparently, a pair of sphinxes just this size occupied tall pedestals at the front. It would by no means have been the first time in ancient Egypt that a usurper suffered usurpation [[see 59]].

The attractive little figure of an anonymous standard-bearer, marvelously well preserved to the bottom of his long kilt, encapsulates the beguiling charm of post-Amarna sculpture [[66]]. The standard resting against his shoulder is religious in nature, a slender pole topped with the head of a goddess. Presumably, it represents a real piece of temple gear, which it was the duty and privilege

[[65]]
Head of the goddess Mut
DYNASTY 18, CA. 1319–1307 B.C.
LIMESTONE; HT. 80 CM

of this man to carry in religious processions or cere-
monies. By depicting it on his statue, he intended to dem-
onstrate both his piety and his claim to special considera-
tion from the goddess and her priests. Originally, it seems,
only the king could be shown handling these sacred ob-
jects [see 29]. Only after the Amarna Period did private
people carry them on their own statues. The standard-
bearer statue thus became one of the few New Kingdom
additions to the repertory of sculptural types; it was to
remain popular for the next century or two. It is a good
example of the constant encroachment by ordinary mor-
tals on royal prerogatives that might somehow enhance
one's position in the afterlife. Along with the even more
popular New Kingdom statues that show men holding
statues of gods or altars, it also reflects a change in reli-
gious attitudes. Following the Amarna Period, people be-
came more demonstrably pious. Many seem to have felt a
very personal relationship with one special god, praying
and offering to him and venerating the objects of his cult.

There is no doubt that the person represented by
this statue is a man. His long double wig, wide-sleeved
shirt, and sarong-wrapped kilt, with its stiffened front
panel, are standard New Kingdom dress wear for men
[see 48]. He was evidently a man of considerable impor-
tance. Not only has he been entrusted with the standard
but, like Tjay in no. 48, he wears the "Gold of Valor" —
strands of disk-shaped beads, awarded by the king as mili-
tary honors or for other service to the realm. But the style
of his time, the fancy dress, the soft-looking body with
its pointy little bosom, and the delicate features of his
Tutankhamun-type face make us think rather of a sweet
young thing than a man of power. It is easy to understand
why other post-Amarna statues very like this one have, in
modern times, so often been mislabeled as women.

This kind of misapprehension should warn us that
there is much about post-Amarna art that we do not
understand. The style looks so untroubled and full of cal-
culated charm that it seems to contradict the reactionary,
revisionist spirit from which it arose. It is even harder,
contemplating the apparent sensitivity and almost passive
serenity of figures like this, to remember that they are the
products of a tense and even dangerous era, when the
obliteration of Amarna was complicated by an unusually
awkward transition between dynasties. Tutankhamun's
death extinguished the royal line of the Eighteenth Dy-
nasty. During the next two decades, the throne was held
by three commoners in succession: Ay, Horemheb, and
Horemheb's hand-picked heir, Ramesses I. In conser-
vative, theocratic Egypt, this series of events was unusual
and potentially catastrophic. For the men involved, there

[66]

Man bearing a standard
DYNASTY 18, CA. 1333–1307 B.C.
BRECCIA; HT. 48 CM

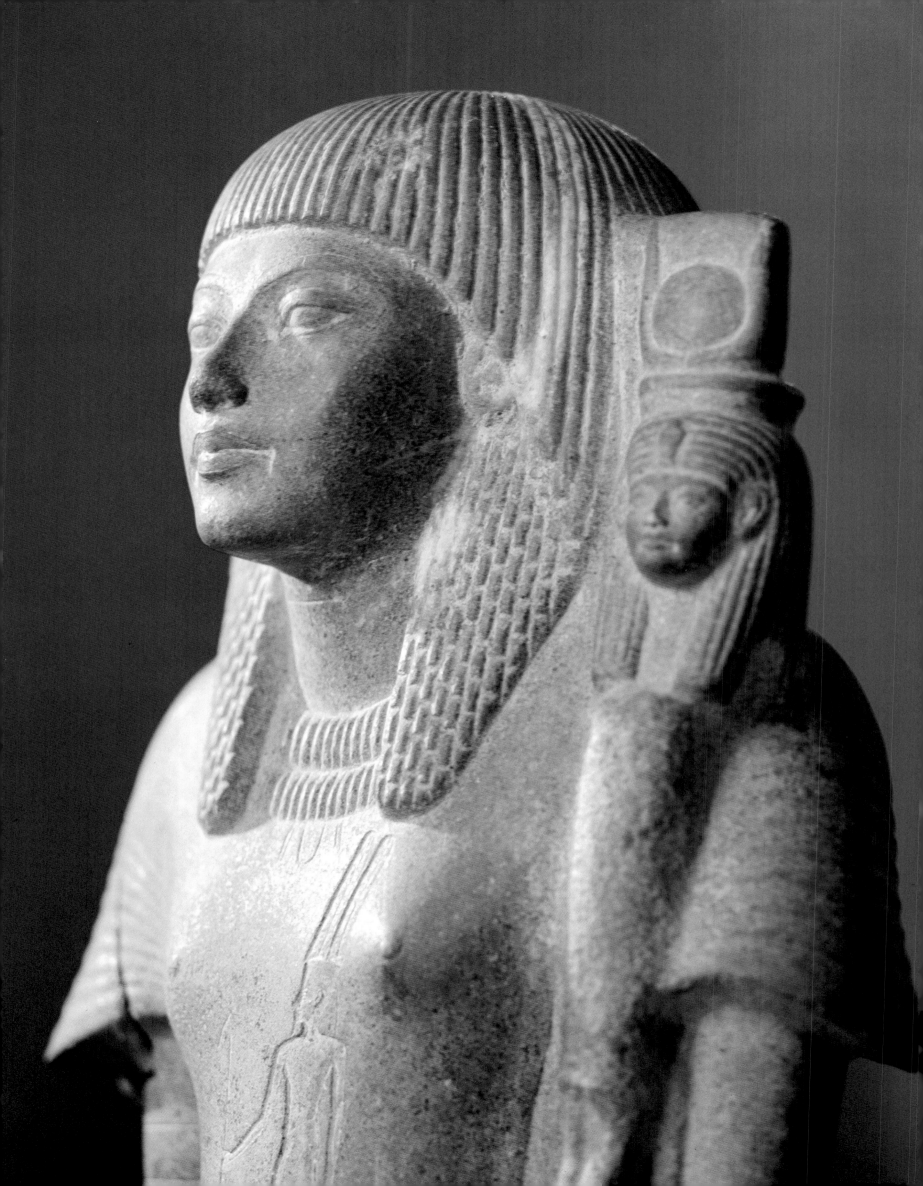

must have been ruthless competition and jockeying for power, of which we have only hints [[see 63]]. In their calm beauty, these statues seem so innocent. But the continued influence of Amarna in their style gives at least a hint of how deeply that heretical episode had jolted Egyptian life and thought.

We are not the first to respond to the attraction of this particular statue. The man for whom it was made is anonymous, not because he failed to have it inscribed with his name, but because he lost it to a usurper some four centuries later. The High Priest Sheshonq, who took it over, was not content, however, just to replace the original inscription with his own. He had the statue updated, as well. Sheshonq lived around 900 B.C., when piety was often demonstrated on statues with images of the gods carved in relief right on the body of the person represented — or at least on the clothing [[see 73]]. So the god Amun was added to the chest of this statue and Osiris on the panel of its kilt. To obtain a smooth surface for the latter, Sheshonq's sculptor had to scrape down the lines of vertical pleats. This erased patch can clearly be seen across the middle section of the panel. The later sculptor was competent but somewhat lackadaisical. Osiris is very nicely carved, but his body extends down past the prepared surface. Around his feet, leftover pleats stand up, like blades of grass.

The Ramesside Period

Dynasties 19 and 20
(CA. 1307–1070 B.C.)

Connoisseurs of Egyptian art are snobbish about the Ramesside Period. They disdain its sculpture as overblown, bombastic, careless, uncouth, vacuous, impersonal, drearily uniform yet inconsistent in style. It is interesting that these faults — which certainly can be found in Ramesside art — are among those most often mentioned by critics of the art of our own time. There is, in fact, a sense in which the sculpture of the Ramesside Period should seem comfortably familiar to us: more than any other period of Egyptian art, it exhibits symptoms of consciousness and of self-consciousness, which we know very well. Consciously, it often seeks to manipulate and even intimidate the viewer with contrived dramatic effects, usually involving huge size. With apparent self-consciousness, it searches for an image to embody its view of itself. Unlike Akhenaten or the early great periods, it never really found one. There is a confusion at the root of

opposite page

[[66]]

detail

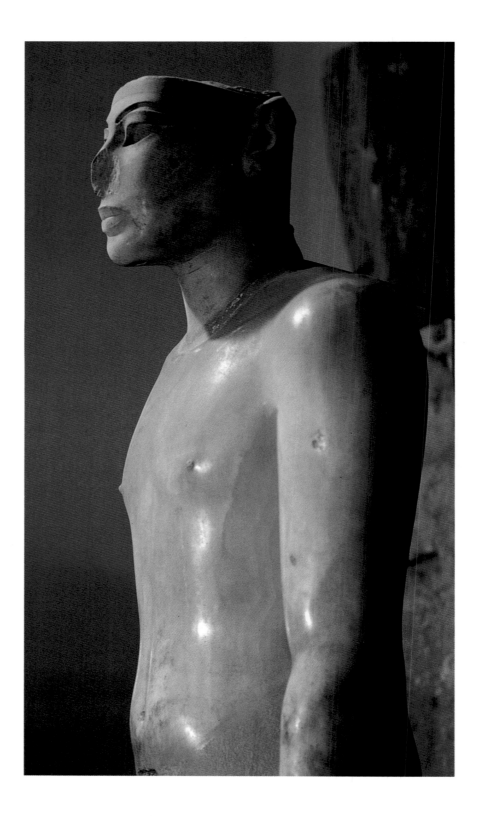

Ramesside art that we should recognize, for it is not un-like our own.

It is still Egyptian art, of course, with its ancient symbolic vocabulary and its certainty of religious and magical purpose. Ramesside sculptors did not invent the use of style for special effects — we have already consid-ered the deliberately awesome effect of a Middle Kingdom sphinx 〚28〛. Nor did they invent gigantism in sculpture. Whoever conceived the Great Sphinx at Giza did that, early in the Old Kingdom, about 2500 B.C. Innovation and change had occurred constantly in Egyptian art, and ex-perimentation is seldom unconscious, even when it cloaks

itself in tradition. But the early Ramessides still felt the aftereffects of Amarna. Sety I, especially, claimed to be starting a new era. By willing oblivion for Akhenaten's era, however, this conservative culture, so committed to repeating its past, placed itself in a strange, awkward position. Or so it seems, at least, in the arts. Sculpture, in particular, tended to vacillate between a modified version of its immediate post-Amarna predecessors — indirectly but recognizably under Amarna influence still — and attempts to revitalize earlier styles, especially those of the venerated Tuthmosis III and Amenhotep III.

These different and contradictory impulses are nowhere more apparent, and perhaps never better resolved, than in a lovely alabaster figure that bears the name of Sety I [[67]]. A composite statue — a type especially popular in the Amarna Period [[see 55, 57]] — it had been dismantled before it was buried in the Karnak Cachette. Though some parts are missing, it is not difficult to imagine how splendid this statue must originally have looked, the head fitted with its royal headdress, the roughly finished surface of the kilt overlaid with a separate material. Cuff-shaped bracelets would have hidden the clumsy holes by which the hands are attached to the arms. Attributes of kingship were inserted into the fists. This was a major cult image of Sety, worthy of the great temple in which it stood. The missing elements, so carefully removed before the figure was laid away, must have been mostly or entirely of gold.

Egyptian alabaster, though yellowish, waxy in texture, and usually heavily veined, has a softness to the eye and a quality of translucence that can marvelously convey the sense of living flesh. In a few examples like the torso of this figure, the sculptor seems to have responded to his material as did the ancient Greeks with their marble, stroking and smoothing his surfaces to the point that they almost seem to be modeled rather than carved. This torso is a beautifully coherent unit, yet it is an amalgam of pre- and post-Amarna styles. The hint of a paunch, with the belt dipping below it, and the thickness of the body as seen in profile are derived from statues like the standing figure of Tutankhamun [[59]], which in turn echoes Akhenaten's sagging belly [[53]]. But the boy king's thickish waist, fleshy rib cage, and undeveloped chest and shoulders are very different from Sety's elegant, manly form, with its taut, bifurcated midriff, high-set pectorals, and broad, rather muscular shoulders. One would have to go all the way back to the Middle Kingdom to find a figure so softly modeled and yet so virile [[see 22]]. It is entirely possible that Sety's master sculptor had been looking at just such a figure, somewhere in Karnak temple.

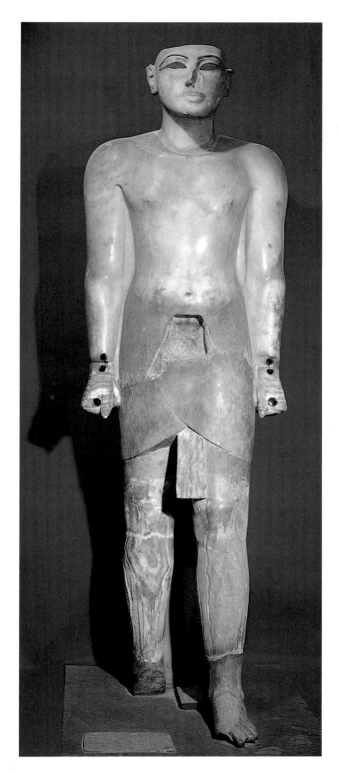

147

[[67]]

Composite statue of King Sety I
DYNASTY 19, CA. 1306–1290 B.C.
ALABASTER (CALCITE); HT. 238 CM

The face seems less sensitive, perhaps because it was designed around the colorful focus of inlaid eyes and brows, now lost. Like the torso, it is a hybrid, combining something of the shape of Tutankhamun's face, his earring holes, and his throat creases [[see 59]], with a short round jaw and full mouth, reminiscent of Amenhotep III [[see 46]]. What is left of the nose, however, seems to be the spring of an aquiline beak, a trademark of Sety in his relief representations and very likely, therefore, the most striking feature of the man's own face.

There is some doubt whether this statue was originally made for Sety. His name is on it, but the inscription is only lightly carved, as if it were an afterthought or the work of some lesser artisan usurping this magnificent work for Sety's benefit. The Ramesside rulers, especially Sety's son, Ramesses the Great, are notorious for their widespread usurpation of earlier royal monuments. In this case, however, there does not seem to be any erasure of a prior inscription. It is likely that Sety's men, if they did not actually begin the statue, put on the finishing touches, giving it an identity — and life — by adding his name. If so, this beautiful hybrid was most likely begun for Sety's father, Ramesses I, the founder of the Nineteenth Dynasty, for whom no statues are known. A military man like Horemheb, who chose him, Ramesses I was already advanced in years when he came to the throne, and the two short years of his reign cannot have been time enough to finish very much sculpture. Sety was a dutiful son, who built monuments to his father's memory. But, as king, he put his own name, without impropriety, on unfinished works continued during his reign.

Ramesses the Great
(CA. 1290–1224 B.C.)

The small, noble-looking head of a statue of Ramesses II [[68]] was probably carved early in his reign, for it has strong similarities to a bust of the king in Cairo and to a famous seated figure of him in Turin, both believed to be among his earliest representations. The unusual bi-colored granite has a patch of pink in the area of the forehead, so symmetrically placed that it might have been planned. Presumably, the spot would have been covered by a layer of paint when the statue was new. Whether the Egyptians would have considered this hidden mark to be an insignificant flaw or a meaningful symbol, such as a sign of the sun god Re, is something we simply don't know.

The stylistic heritage of Ramesses' idealized features is obvious when one compares them with a typical post-Amarna face, like that of the anonymous standard-bearer [[66]]. The shape of the eyes, especially the fleshy plasticity of the upper eyelids; the round, childlike planes of the face; the faintly pursed lips with their well-defined

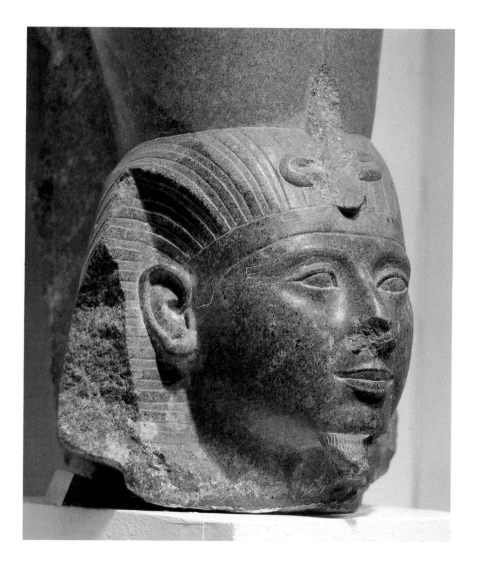

〚 68 〛
Head of King Ramesses II
DYNASTY 19, CA. 1290–1270 B.C.
GRAY GRANITE WITH A PATCH OF PINK; HT. 58 CM

curves and strongly marked corners — even the earring holes in the earlobes — there is not a great deal to differentiate any of these from the features of statues made during the reigns of Tutankhamun, Ay, and Horemheb.

Nonetheless, the head represents a new style, in both spirit and details. There is a new quality of reticence. The features are proportionately smaller and tighter, especially the mouth. The sweet dreaminess that makes post-Amarna sculpture so appealing is gone. Although its expression is rather withdrawn, this is the face of a ruler of men: reasonably accessible, benevolent but firm. Like his father, Sety I 〚67〛, Ramesses was shown here with an aquiline beak of a nose. This may have been a family trait, although for Ramesses it seems to be really noticeable only on images made early in his reign, perhaps by sculptors who were accustomed to carving the likeness of his father.

Ramesses II ruled for sixty-seven years. The memory of this extremely long and reasonably successful reign was a beacon to the weaker kings of the next century and a half. Bedeviled by dynastic quarrels and other political threats both at home and abroad, they tried to bolster

their own status by imitating him, usually by the pathetic expedients of adopting his name and copying his statues. To us, he is Ramesses the Great, partly for his reputation among the Egyptians, partly because his mark is still very evident in temples and statues of unequaled numbers and size. Privately, scholars sometimes call him Ramesses the Ubiquitous.

This nickname is not kindly meant, especially when it refers to his habit of usurping earlier royal monuments, a tradition that he carried to unprecedented extremes. Ramesses looms in the hugeness of so many of his monuments, especially the colossal statues that along with the pyramids form the basis of our image of ancient Egypt. Although he knew it only from the descriptions of travelers, the poet Shelley immortalized one of these shattered giants as the symbol of futile vainglory. Shelley's version of the inscription—"My name is Ozymandias, king of kings / Look on my works, ye Mighty, and despair!"— is freely borrowed from the first-century B.C. writer Diodorus, who seems to have taken it from an even earlier account by a Greek tourist, Hecataeus of Abdera. Ozymandias is Ramesses. The fallen Ozymandias, with its inscription loosely translatable as "King of Kings," still lies where once it was erected in the Ramesseum, the king's funerary temple not far from his tomb in the Valley of the Kings ⟦69⟧. When complete, this seated figure was about fifty-five feet high—several feet shorter than the seated statues of Ramesses on the façade of his temple at Abu Simbel.

Starting with the Great Pyramid and the Great Sphinx, the Egyptians invented gigantic architecture and art, as we still know it today. We often surpass them in the size of our structures, but modern sculptors rarely approach the scale of their largest statues. Very likely this is due in part to aesthetic problems that the Egyptians refused to acknowledge. They simply designed and executed all their human figures as if they were human in scale. This approach usually works brilliantly on little statues ⟦such as 22, 88⟧. On colossi, it is a mixed blessing. Seen from the air, the seated colossi of Abu Simbel have definite dramatic impact. But to the visitor approaching on foot, they reveal themselves as impressive but faintly ridiculous outcroppings of stupendous knees and monster feet. Staring up the nostrils of heads unflatteringly diminished by their distance, the viewer is in no position to perceive a coherent human image or even to appreciate that, as sculpture, the work is really quite respectable. Bigness is the message, and it obliterates everything else.

As if to demonstrate how fine the best of his colossal statues could be, the head of another of Ramesses'

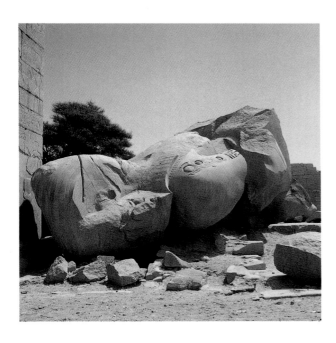

⟦ 69 ⟧

**Bust of King Ramesses II from a
seated colossus**
DYNASTY 19, CA. 1290–1224 B.C.
PINK GRANITE; ORIGINAL HT. OF STATUE CA. 18 M

giants at the Ramesseum has come to ground almost intact, except for the battering of its nose [[70]]. The survival of this considerable fragment, over eight feet in height, is the more remarkable in that no trace of its body has been found. However, thanks to Diodorus' ancient description of the temple, we know that the head belonged to a seated statue, which would have been at least eighteen feet tall. Traces of paint on the dark gray granite show some of the original color scheme. The *nemes* headcloth, as usual, was striped in blue and yellow, and the lips were bright red. There seems to be no sign of paint on the face itself. As on some other hard stone statues, the areas of bare skin may have been left unpainted. If so, the blackish color of the stone cannot, in this instance, be interpreted as indicating a black or very dark skin for Ramesses, for the battered body of a second seated colossus, the pair to this one, is reddish quartzite, and the "Ozymandias" figure was carved in pink granite [[69]]

Although the Ramesseum head may not look very much like the small head of Ramesses II [[68]], the two share a style. Their differences are probably due mostly to their chronological separation. The colossus has a breadth of face characteristic of most of Ramesses' later sculpture and especially noticeable on his oversized representations. Thus, it may in part be a small concession to the perspective distortions caused by great size (though his face is at least as broad on many life-sized statues). The eyes have certainly been designed to compensate for their height: they are large and the post-Amarna plasticity of the upper lids has been exaggerated. The eyeballs curve back sharply so that the gaze, from within deep pools of shadow, is not outward but down — toward the puny mortals standing below. The mouth is also large, the well-formed lips punctuated by deep shadows at the corners, which emphasize the almost prissy tightness of the faint smile. Handsome, pleasant, slightly more than human in its perfection, this head is one of the most successful Ramesside attempts to achieve their own form of idealism.

The charm and feminine grace of the post-Amarna Period [[see 63]] still echo in the plump, sweet features of the bust of a life-sized statue representing a wife or daughter (or both) of Ramesses the Great [[71]]. Petrie, who found it in a chapel near the Ramesseum, christened it the White Queen, a name that conveys very nicely the effectiveness with which the fine-textured and very white limestone of the unpainted face is set off by the faded but still colorful polychromy of her wig and ornaments.

The White Queen is an example of the humanistic idealism of Ramesside style at its best. There is a tremulous softness to the round face, with its full cheeks and

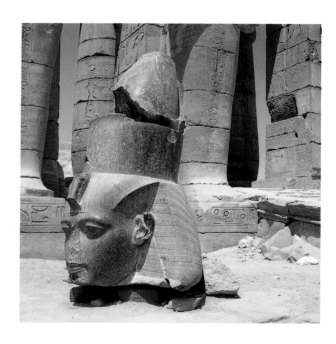

[[70]]
**Head of King Ramesses II from a
seated colossus**
DYNASTY 19, CA. 1290–1224 B.C.
DARK GRAY GRANITE; HT. 267 CM

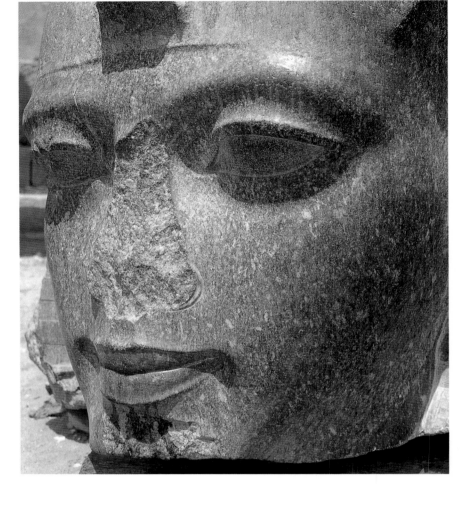

〚 70 〛
detail

knobbed little double chin. It corresponds better with the flesh lines on the throat than do the leaner faces of Amarna and post-Amarna statues, where this detail originated. As on the head of Ramesses II 〚68〛, the queen's eyes and mouth are rather small. The eyelids are almost flat, emphasized only by an incised cosmetic line drawn out to a long point. The rather full, slightly smiling mouth still shows its inheritance from the sculpture of Akhenaten or Amenhotep III, but the lips lack the generous curves that make them so distinctive.

The queen's face seems the more delicate for the massive weight of her headdress, a huge wig of little corkscrew curls — each one carefully drilled at the bottom — which supports the double uraeus typical of a New Kingdom queen and a circular structure ringed by more cobras. This platform, the same as that worn by Tuthmosis III's mother on her statue some two hundred years earlier 〚41〛, originally carried two tall plumes made of a lighter material, probably metal. The cumbersome artificiality of the whole superstructure is emphasized by the band painted across the woman's forehead. Its yellow color indicates that it was of gold: a frame or reinforcement for the wig itself, or the lower edge of some inner hair covering.

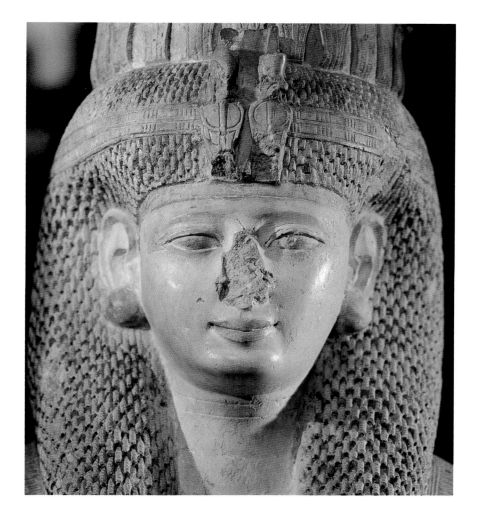

Also of gold was the queen's jewelry; painted yellow on the statue, it looks like a meticulous copy of the real thing. Earrings are not often represented on statues, but she wears big gold buttons. The beads of her collar necklace are mostly tall-stemmed ovals. These are hieroglyphic signs, used to write the word *nefer*, beautiful. Like Nakhtmin's wife ⟦63⟧, she holds a second necklace, a *menit* to rattle as a priestess, in honor of a goddess. The little beads are almost hidden by the heavy flat counterweight, designed to hold the necklace in place on those occasions when it was actually worn. It is appropriately decorated with the head of the goddess.

As so often happens when only the upper half of a statue survives, the owner's name, written on the lower part of the back pillar, has been lost. Some of her titles as priestess, however, remain. The same titles were inscribed on a colossal statue, found just a few years ago at Akhmim in Middle Egypt, which represents Merytamun, a daughter of Ramesses and — after the death of her mother, Nefertary — his Great Royal Wife. Very possibly, therefore, this bust also represents Merytamun, although other royal women, during the king's sixty-seven-year reign, probably held these titles as well.

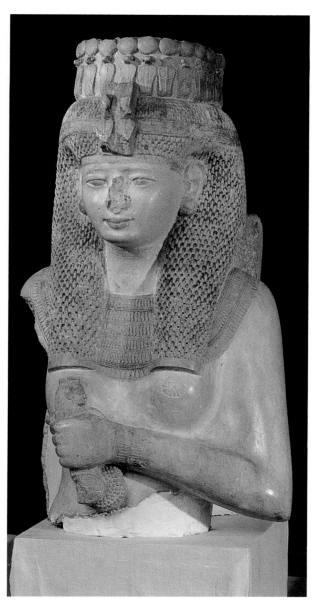

⟦ 71 ⟧

A queen of Ramesses II
DYNASTY 19, CA. 1290–1224 B.C.
LIMESTONE, PAINTED; HT. 75 CM

Of the three intermediate periods, only the Third produced a substantial body of fine and sometimes excellent art. Like the earlier intermediate periods, this was a time of weakness and breakdown of centralized political control. However, the Third Intermediate Period was spared the calamities of foreign domination, as occurred in the Second Intermediate Period, or widespread civil strife, as plagued the First. Upper and Lower Egypt more or less went their own ways. Most of the time, they still acknowledged one king; sometimes they had rival rulers. In Upper Egypt, Karnak temple had amassed such vast wealth and power that its High Priests were effectively rulers of the south — and some of them proceeded to claim the title of pharaoh. The true royal dynasties were based in the north, in Lower Egypt. Here the political situation was complicated by the rise of small principalities — many controlled by Libyan mercenary soldiers settled in the Delta by kings of the late New Kingdom — which varied widely in their degree of independence from the king. But the north, particularly the Delta, was finally coming into its own as the dominant part of Egypt, agriculturally much more productive than the narrow valley and better situated for international relations. Although the glory of Karnak was still untarnished, Thebes was already beginning to show a certain insularity and early signs of its eventual decline to a provincial backwater.

As so often in ancient Egypt, there seems to have been a direct correlation between the strength of the government and the vitality of the arts. For all its problems, the country at least maintained some sort of unity and, with it, stability and prosperity sufficient to support the production of buildings and statues. Nevertheless, the weakness and confusion of Third Intermediate Period politics seem to have infected the arts to some degree. Although well trained and capable of great finesse, artists failed to develop a strong or distinctive new style in stone sculpture. They contented themselves with repeating New Kingdom styles in the poses, faces, and costumes of their statues — to the extent that their work is now sometimes dismissed as dry and imitative. In fact, with a little practice, it is usually quite easy to distinguish a Third Intermediate Period statue from one made during the New Kingdom. Despite their fidelity to the older style, the later sculptors lived in a different world. Their altered sensibilities found expression in perceptible stylistic changes.

As is often the case with Egyptian archaism, however, we cannot tell whether these changes were inadvertent or deliberate "improvements" on the old models.

This description of Third Intermediate Period sculpture is based almost entirely on examples from Karnak. The Cachette yielded a great deal of sculpture from this period, giving us a fairly clear idea of developments in this great temple. It is a good example of how archaeology, and the accidents of preservation, inevitably shape our picture of ancient art.

Statues of Third Intermediate Period kings are rare. A limestone statuette of Osorkon II shows him presenting, or perhaps launching, a sacred bark [[72]]. In his role as chief worshipper of the gods, the Egyptian king was usually represented presenting offerings [[see 39]]. A few statues, however, represent more specific cult activities. Most of these date to the New Kingdom, and this statue, as we might expect, is a repetition of a New Kingdom pose. More than half of the ceremonial boat has been lost, but the ornate circle of its stern still rests against the king's chest. In front of this, the diagonal line of a long steering oar crosses the side of the vessel and the cabin, which is a shrine for the cult image. When complete, the boat's prow may have projected a little beyond the front of the base; but it is obviously a miniature, a model boat of a kind that stood in the sanctuaries of many temples. During religious festivals, when the gods appeared in ceremonial processions, they traveled by boat — or, rather, their statues traveled in the shrines of these elaborate model barks, borne on the shoulders of their priests. The king's image attests to his spiritual presence on such occasions.

Bent forward over his left knee and balanced by his outstretched right leg, Osorkon seems set to give the little boat a good push. Despite his stretched and rather precarious stance, the king's raised head and serene expression betray no sense of physical effort. Since the statue does not portray a specific event or a real action, naturalistic details of that sort would be inappropriate. With the Egyptian knack for this kind of imagery, the sculptor has frozen a momentary action into an eternal, magical statement.

On a more mundane level, a statue of this kind made a gracious and generous gift to the god, from the king himself or in his honor. This statuette would have been a sumptuous offering. The odd reddish color of the royal headdress and kilt may be the remains of an undercoating for gilding, which is now lost. Loss and damage, however, do not destroy the main evidence of the high quality of this little figure: the beauty of the king's body.

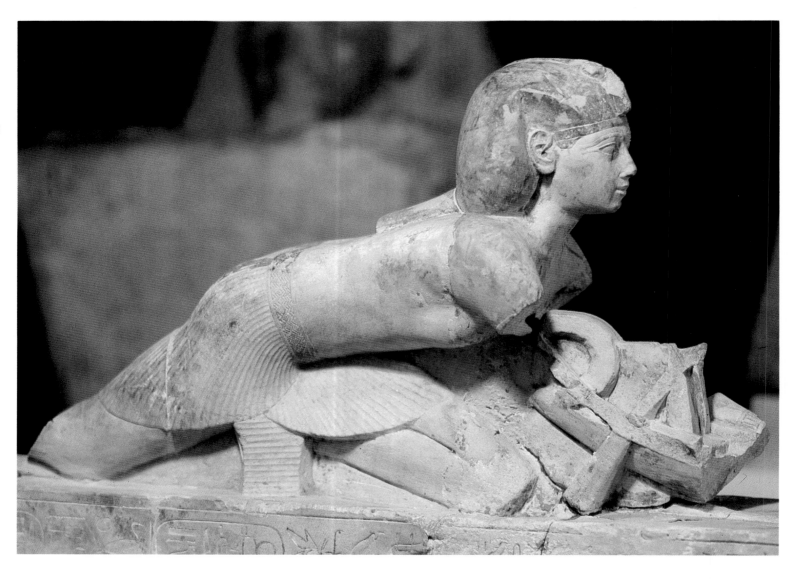

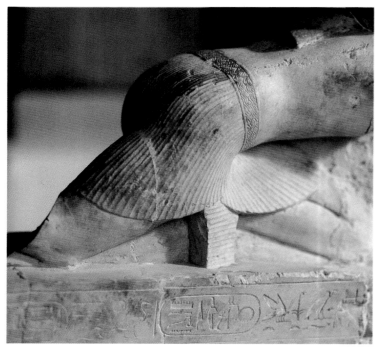

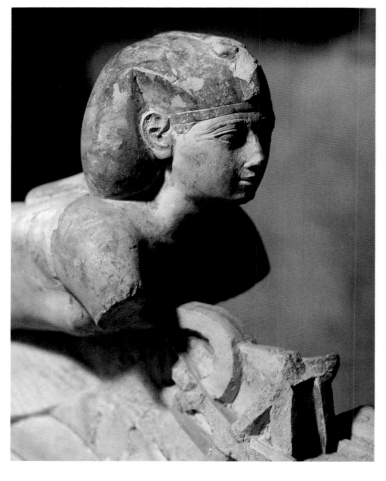

〚 72 〛

King Osorkon II presenting a sacred boat
DYNASTY 22, CA. 883–855 B.C.
PAINTED LIMESTONE; HT. 18 CM

His slender, rather delicate physique derives from the early New Kingdom, perhaps specifically from representations of the great Tuthmosis III [[see 39, 40]]. But the softness and lack of muscularity are offset by the slightly rangy effect of longer torso and limbs, which suggest a latent vigor. The face is also reminiscent of Tuthmosis III, with its small half smile and elegantly drawn almond eyes.

The statue of Shebensopdet [[73]] is a great rarity: the solo figure of a private woman, made for a temple. Why the Egyptians should have been so reticent about placing statues of women in temples — even the temples of goddesses — has not been explained. Possibly, the reason was religious, since women played only an auxiliary role in cult practices and temple ritual. Perhaps it was simply a matter of propriety — despite its sanctity, a temple may still have been too public a place for a respectable female to show herself or her statue, without attendants or protectors. Whatever the reasons, this restriction cannot have been a full taboo, since there were exceptions, like Shebensopdet. In her case, the favor may have had something to do with the fact that she was exceptionally well connected: her grandfather was King Osorkon II, and her father was High Priest at Karnak, where the statue was placed. Even so, as the inscription makes clear, she did not herself donate and dedicate the figure. It was her husband's gift.

Shebensopdet's figure is extremely formal. Whether or not it had anything to do with the unusual circumstance of her being represented in the temple, there is no mistaking the severe propriety of her ramrod posture on the low-backed chair, the careful placement of her hands on her lap, or the set, expressionless look of her face. Clearly, this is a woman who knows how to conduct herself in the very highest society, including that of her god. It is unlikely that the statue reproduces anything of Shebensopdet's actual features. Her flat, perfectly almond-shaped eyes, squarish jaw, and full but firmly held mouth derive from the faces of statues made during the later New Kingdom, some four centuries earlier [[see 70]]. Court ladies of that long-gone era had set the style of her wide-sleeved dress. Even the lotus she holds in her left hand — a symbol of resurrection but also a charming, ladylike accessory — is a New Kingdom touch.

Shebensopdet's almost prim reticence, however, gives her statue a character quite different from the decorative, often charming female figures of the New Kingdom [[for example, 63, 71]]. Her dress is far more severe. The pleats and ties beloved of the New Kingdom [[compare 63]] have been suppressed in order to provide a smooth surface for the divine figures incised on her sleeves and skirt.

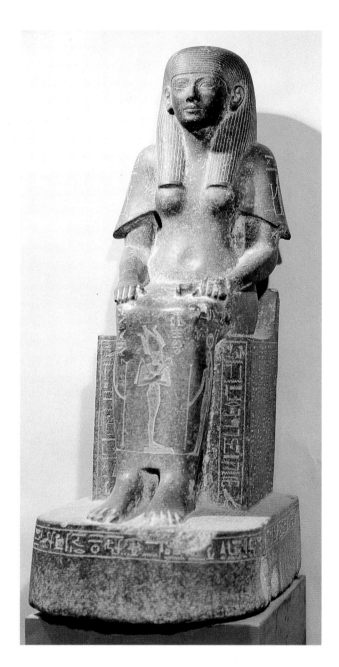

[[73]]
Lady Shebensopdet
DYNASTY 22, CA. 883–845 B.C.
GRANITE; HT. 83.5 CM

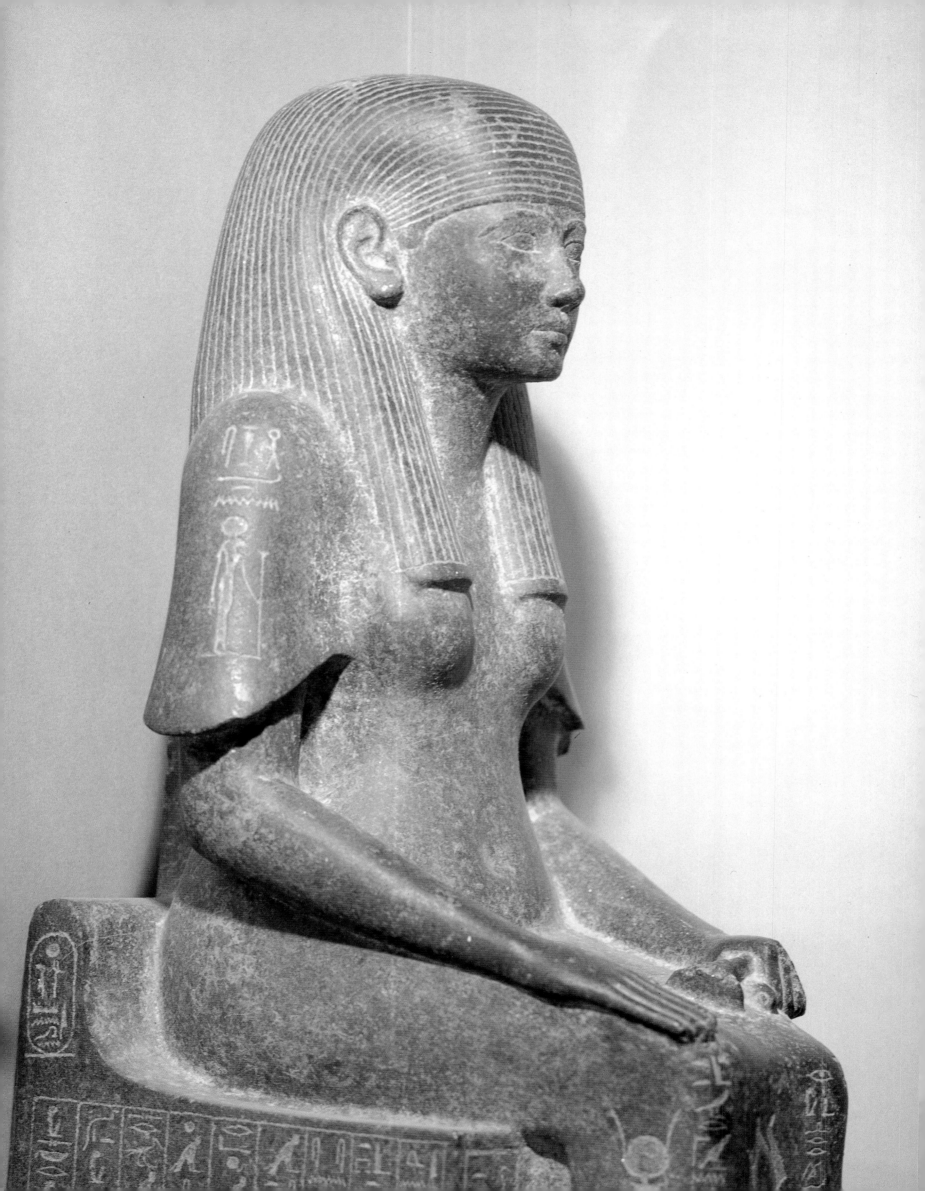

This decoration is evidence of a changed sensibility. In the past, Egyptians had restricted writing on the bodies of their statues to a minimum. Longer texts and pictures were confined to nonfigural areas, like back pillars or bases. Only in the Third Intermediate Period did they develop a habit of spreading them over the figure itself. This tendency could have been disastrous if statues had come to be regarded as mere blank pages to be covered with the all-important word. Fortunately, that seldom happened. Good taste prevailed — or the magic power believed to inhere in the image itself. The additional material was confined to the figure's clothing, where, like a sumptuous brocade, it provides enrichment but not distraction.

The block statue of a man named Nebnetjeru [[74]], with its handsome, idealized New Kingdom–style features and noncommittal expression, its contrast of simple, firm shapes and minimum personal content with the tapestry of decoration and inscription that covers all of his cloaked form, is very similar to the seated figure of Shebensopdet [[73]]. This is not surprising, for Nebnetjeru was Shebensopdet's father-in-law, and his son Hor commissioned both statues. They were probably made in the same sculpture workshop. Along with a block statue of Hor himself, they stood in Karnak temple until eventually they all ended up in the Cachette.

It is clear enough why we call this type of statue a block statue (the French call it *statue cube*). However, the form is less abstract than it may look at first. A block statue depicts a man — not a woman — hunkered down on the ground, with his legs drawn up against his body and his feet planted flat. This position would be difficult for many Western adults to achieve, and very few would be able to sustain it comfortably for any length of time. Even today, however, Egyptian farmers and villagers habitually adopt this pose while resting or waiting. They can hold it in apparent comfort for hours, their arms folded over their knees, just like their ancient forebears.

Block statues first appeared in the Middle Kingdom, when private persons were beginning to regularly place statues of themselves in temples, and may well have been created for this new purpose. The pose is passive and respectful, eminently suitable for a guest in a god's house. Sitting modestly on the ground, the subject awaits his share of the offerings and prayers. At the same time, the geometric shape is arresting and it focuses attention on two salient features: the head and the inscription.

Of all Egyptian sculptural forms, only the block statue can be called consciously abstract, in the sense that good sculptors always stressed the rectangular mass of the body and avoided distracting details. The face of a block

[[73]]
detail
also opposite page

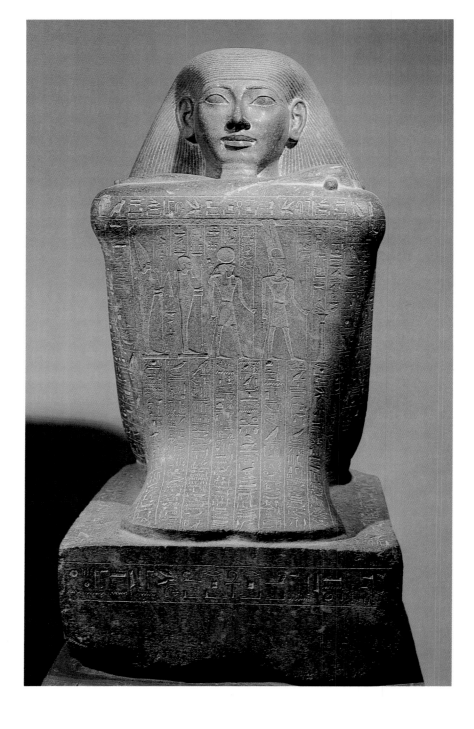

〚 74 〛
Block statue of Nebnetjeru
DYNASTY 22, CA. 883–845 B.C.
GRANITE; HT. 110 CM

statue tends to be broad and square. Eyes and mouth are usually simple and set in horizontal lines. The breadth and horizontality of the head are often emphasized by a flaring shoulder-length wig, which unites it firmly with the body. Often, as on Nebnetjeru's statue, a chin beard — looking rather like a little prop — makes another connection between head and body, further solidifying the composition.

The subject of a block statue may wear only a long kilt. More often, he is enveloped in a heavy cloak, which covers everything but his hands and head, concealing and flattening the contours of the body and providing ideal surfaces for lengthy inscriptions and sizable illustrations. The compact shape of a block statue makes it resistant to accidental damage. Thus, it had very practical advantages

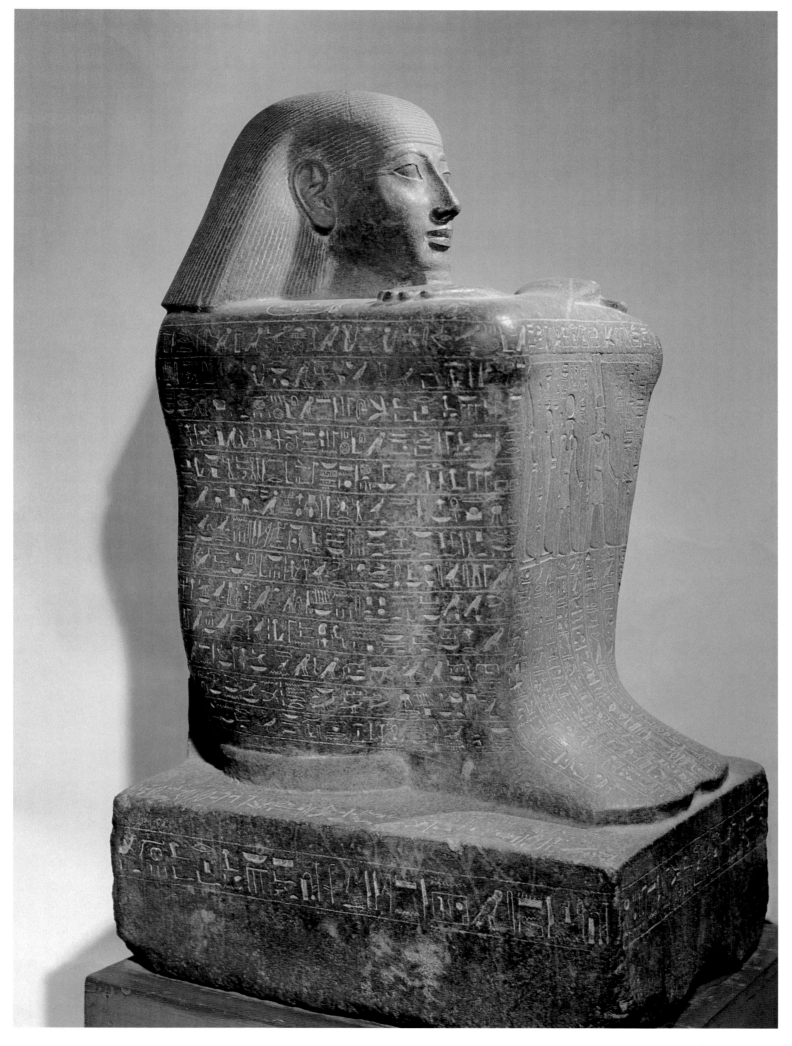

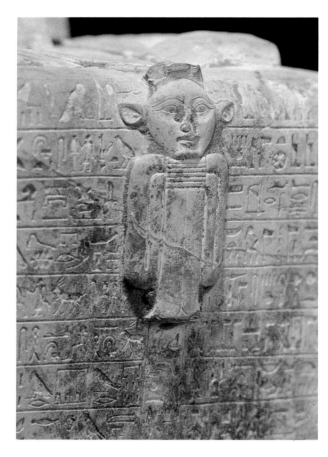

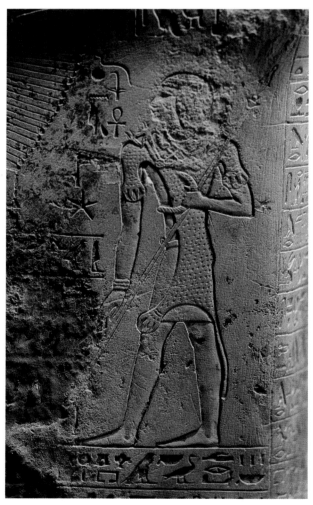

[[75]]

details

in a semipublic place like a temple, where it would be exposed to strangers hurrying back and forth, bumping into it now and then, and occasionally taking time to stop and read the owner's account of his virtues, perhaps even being persuaded to offer a prayer in his behalf.

Following the Middle Kingdom, block statues continued to be made throughout the New Kingdom, but they did not really suit the prevailing fondness for rounded forms, fleshy softness, and elaborate costume and accessories. In the Third Intermediate Period, however, the taste for a web of surface ornament over a simple, strong shape brought a new appreciation for this uniquely Egyptian statue type. Nebnetjeru's figure is a superb example. His noble face and compactly folded body convey an attractive sense of alert and confident expectation. But the statue is almost too simplified — or would be, if it were not for the flicker of little hieroglyphs all over the cloak and the panel of four gods displayed across the front.

Unvarying consistency in the style of any art, if it is sustained over too long a period, suggests a drying up of creative impulses. Something of the kind was happening in the great workshops around Karnak temple as the Third Intermediate Period progressed, to judge from such examples as the block statue of Djedkhonsuiufankh [[75]]. Like Nebnetjeru's block statue [[74]], it was pulled from the Cachette. Stylistically, the two are so similar that they might almost have come from the same studio. Djedkhonsuiufankh has the same vaguely New Kingdom features. His head is anchored to the body by the firm lines of a virtually identical headdress and beard. The cube of the body is again covered with delicately incised scenes and texts. But this statue was made around 750 B.C., about a century later than Nebnetjeru's.

Nebnetjeru sits on a round flat cushion. Djedkhonsuiufankh's base has been provided with a tiny step to serve the same function. This step and the thin back pillar give a squared-off look to the statue's profile. Djedkhonsuiufankh is a little squatter than Nebnetjeru, and his head seems to sit lower on his shoulders. The softness of the limestone and its matte surface may have encouraged this sculptor toward softer modeling of the face, especially in the round cheeks. He has also lavished considerable detail on the sunk relief scenes of the sides, which show Djedkhonsuiufankh in priestly regalia before the sacred boat of the god Sokar and (not illustrated) kneeling before the god Khonsu, after whom he was named. The main feature on the front is a large amulet of the goddess Hathor, worn, apparently, on a cord just long enough to let it dangle conspicuously over his knees. The emblem, which represents the head of the cow-eared goddess as the

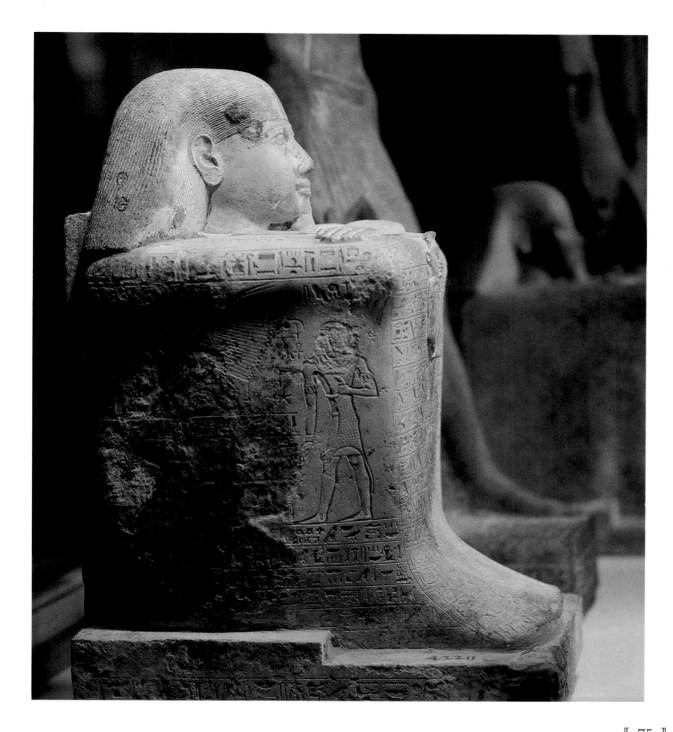

163

〚 75 〛
Block statue of Djedkhonsuiufankh
DYNASTY 23, CA. 828–712 B.C.
LIMESTONE; HT. 40 CM

top of a floppy, looped knot, is boldly prominent and at least as large as life.

Djedkhonsuiufankh was Second Priest of Amun at Karnak. The statue is probably posthumous. Like Nebnetjeru's, it was made for him by his son. These statues and Shebensopdet's 〚73〛 are expressions of the immense family pride of Karnak's priestly dynasties in this period, with their royal connections and autonomous powers. Djedkhonsuiufankh's inscriptions include a genealogy going back sixteen generations.

From this time until the end of the pharaonic period, block statues retained their popularity 〚see 89〛. Seldom, however, did they achieve the harmony of works like these, with their fine balance between dignified simplicity and decorative appeal.

Chapter 6 Egypt the Ancestor

The Late Period

Dynasties 25–30
and the Ptolemaic Period
(CA. 750–30 B.C.)

64

OF THE FOUR major divisions of ancient Egyptian history, the Late Period is the most loosely defined. In this book, it is understood to cover the time from the Kushite invasion to the end of the Ptolemaic Dynasty, from about 750 to 30 B.C. This makes it the longest of the historic periods. It is also by far the most complex, politically and culturally. During these centuries, the country suffered a number of invasions and rule by several foreign dynasties, some of them very long-lived. But Egypt lost more than independence and dominion. The world around it was growing up fast, and vigorous young cultures were spreading new ideas and new ways of looking at the world. For the first time, Egyptians' traditional assumptions about their unique status in the world and their superiority over all other civilizations were being seriously challenged.

For the most part, these changes were only indirectly reflected in sculpture and the other major arts of the Late Period. The last chapter of ancient Egyptian art is a worthy successor to what had gone before. In a curious way, it seems to sum up its past, almost like the last movement of a great symphonic work. Most of the earlier motifs — the majestic simplicity of the Old Kingdom, the brooding intensity of the Middle Kingdom, the delicacy and sophistication of the New Kingdom — were recapitulated, recombined, and embellished in a final series of variations. Portrait representations, present from the beginning (see Chapter 2) and recurring sporadically, became a major theme, with new and original variations. None of this was deliberately orchestrated, of course, or even consciously planned. But neither was it coincidental. The relationship of late Egyptian art with its own past is both imitative and creative. In part, it expresses the uncanny consistency of Egyptian culture over the thirty centuries of its development. To a large extent, however, its retrospection is quite deliberate. More than ever before, Egyptians of the Late Period looked back to the glories of the past ages and consciously tried to emulate and recreate them. In sculpture and other arts, archaism became so systematic and widespread that it can almost be called a movement.

In about 750 B.C., the Kushite ruler Piankhy (Piye) invaded from the south and conquered Egypt. His victories were consolidated by his brother, Shabako, who established the Twenty-fifth Dynasty, which reigned until 657 B.C. These kings were the first non-Egyptians to rule Egypt since King Ahmose expelled the Hyksos eight centuries before.

Although they were foreigners, Egypt was not exactly foreign to the Kushites. Since prehistoric times, the Nile valley had been in some ways a cultural as well as a geographical continuum. The peoples living south of the traditional boundary at Aswan had long been linked to Egypt by bonds of warfare, trade, and intermarriage [see 18]. Egypt, richer, stronger, and more unified, was constantly trying to control its sometimes unruly neighbors. It came closest to success during the New Kingdom, when military garrisons occupied a string of immense fortresses along the southern Nile and resident bureaucrats reported to a royal representative, the "King's Son of Kush." Egyptian temples were erected, and local princes were sent north to pharaoh's court as wards and hostages for their fathers' good behavior. In these almost colonial conditions, Kushites necessarily learned quite a lot about the occupying culture. The Egyptian religion, in particular, seems to have had a genuine appeal for them. To some degree, Kush was Egyptianized, and this influence persisted even after the withdrawal of Egypt at the end of the New Kingdom and the eventual rise of a strong native state.

Piankhy described his conquest of Egypt in some detail on a stela now in the Egyptian Museum. He repeatedly contrasts his religious purity with the impious practices of his defeated opponents. His claims are propagandistic, but they have a ring of sincerity. They may explain why the great religious center of Thebes, including the priests of Karnak, seems to have welcomed the foreigners as legitimate rulers. It certainly helped that the great god of the Kushites was their own Amun. Among the petty princes of the north, however, were many who resented the Kushites and continued to resist them whenever possible. But the reimposition of centralized rule was, as usual, beneficial for Egyptian culture and art, which were so strikingly revitalized that historians sometimes characterize this period as the Kushite renaissance.

The term renaissance is especially appropriate to the upsurge in archaizing evocations of the past. Unlike the sporadic, haphazard occurrences of earlier imitations [for example, 51], Kushite archaizing was systematic and quite

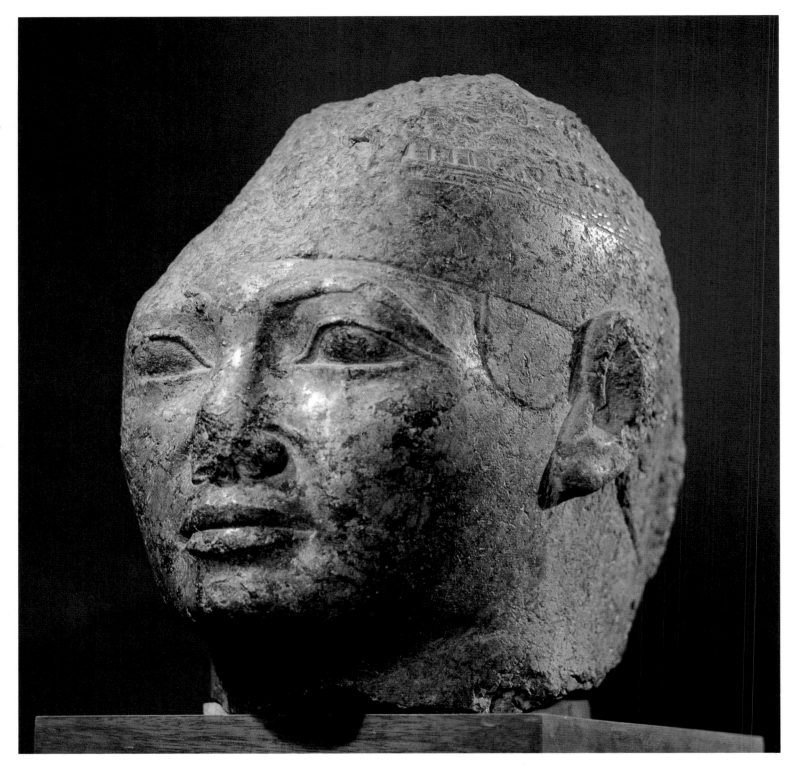

〚 76 〛

Head of a Kushite king
DYNASTY 25, CA. 698–690 B.C.
GRANITE; HT. 36 CM

sophisticated. Not limited to art, it influenced the language of official inscriptions and even caused high-ranking Egyptians to adopt long-obsolete and often meaningless titles, for the sake of their antiquity. In the arts, models were carefully chosen from every great period, with a fine appreciation of the spirit underlying each style.

The Kushites themselves may have been the moving spirits in this development. Besides stressing their religious orthodoxy, they deliberately associated themselves with Egypt's past in support of their claim to be the rightful heirs to the pharaohs of old. They caused ancient reli-

gious papyri to be reverently copied onto stone, and they restored and added to the great temples. These they then enriched with their own statues.

Kushite royal statues have splendid strong bodies, of Old Kingdom type. Their heads, however, are something quite different, because these foreigners were proud of their lineage and did not disguise it. For their sculptors, this created an unprecedented problem. They were required to represent a traditional Egyptian king and at the same time show that he was a Kushite. Naturally, they turned to the past for guidance, but that did not entirely resolve their dilemma. There was indeed a large stock of representations of Kushites, but, almost without exception, they were pictures of enemies, servile emissaries, and servants — usually unsympathetically rendered and often little more than caricatures. From these awkward precedents, the sculptors contrived a remarkably successful series of royal images, which are a tactful blend of idealism, strength, and originality.

The over-life-size red granite head of an anonymous Kushite king [[76]] gives some idea of their achievement. When complete, its body would have been a creditable version of a vigorous Old Kingdom figure type, probably a little longer in the torso and broader of shoulder, like that of Mentuemhat [[78]]. There would have been more jewelry than Egyptian kings usually wore, some of it distinctively Kushite. The close-fitting hairdo, often adopted by the Kushites in preference to the traditional Egyptian crowns, may well have been their native royal headdress, for it is unique to these kings. Although often described as a skullcap, it probably represents close-cropped hair, on which is worn a broad bandeau. Streamers hang down from the back, and along the top edge stands a row of very stylized cobras. Damage to this head has destroyed the uraeus at the forehead, but this king, being Kushite, would have worn a pair of them, another peculiarity in which they are unique among Egyptian kings.

The face is idealized but commanding. In a most interesting way, it is and is not Egyptian. The large almond eyes and the elegantly tapered, artificial-looking eyebrows have their prototypes in the New Kingdom [[see, for example, 58]]. But it would be hard to find earlier examples among Egyptian kings or notables of such a round head, of a face so broad at both cheekbones and jaw, such a square short chin or so massive a bull neck. An ancient Egyptian would have been more struck than we are by this combination of elegant features with a foreign-looking facial structure. He might have been startled by the strong folds that curve down from nose to mouth, giving the expression a hint of disdain. These are not the nasolabial

furrows of aging Egyptian faces [such as 56]. Arching over the nostrils into almost ornamental curves, they resemble the long arched folds conventionally used to denote foreign physiognomies since the Old Kingdom. The sculptor may have been borrowing discreetly from some earlier head of a Kushite warrior or prisoner. However, it might be a portrait feature. Only one Kushite king, Shebitku, is shown in relief with just such a curve from nostril to mouth. There are no definitely identified statue heads of Shebitku, but he may well be represented here.

Whether it was due to the general stimulus of a vigorous new dynasty or inspired by Kushite archaism, which encouraged sculptors to examine the achievements of the past, or whether it was a by-product, in some way, of the complex challenge of representing foreigners as true pharaohs — whatever the causes, portraiture was revitalized in private sculpture of the later Kushite Period. These Twenty-fifth Dynasty portrait statues are not very numerous, but they have great significance for Egyptian art. They represent a kind of breakthrough to a closely observed, unsparing realism, more expressive of personality and much more detailed in the depiction of skin, flesh, and underlying bone structure than anything the Egyptians had done in the past. They begin the long line of Late Period portrait representations, one of the major achievements of Egyptian art.

A small sandstone standing figure of Djedasetiufankh with an offering table is one of these portrait statues [77]. More precisely, it is a statue with a portrait head, which rests incongruously on a slender body so sketchily modeled as to seem almost childlike in its lack of definition. But the Egyptians had never minded combining individualized heads with highly idealized bodies [see 7]. The top and bottom of this statue were found in the Karnak Cachette; the section between hips and ankles is a modern restoration, which accurately reconstructs the flared front panel of Djedasetiufankh's pleated New Kingdom–style skirt and the pedestal of the offering table.

The man's shaven skull is naturalistically modeled, low and slightly ridged along the top, with a prominent bulge at the forehead. These gentle curves surmount a coarse-looking face, which seems almost deformed by pads of thick subcutaneous flesh that blanket the small features. However, there is nothing soft about this face. Shrewd eyes peer out from under the swollen lids. The ridges of the cheeks along the nose and the pouches below the corners of the mouth seem imprinted by a stern, inflexible will. The tiny upturn of the lips suggests intelligence, not humor. Despite his slight form and reverent stance, Djedasetiufankh looks like a tough customer.

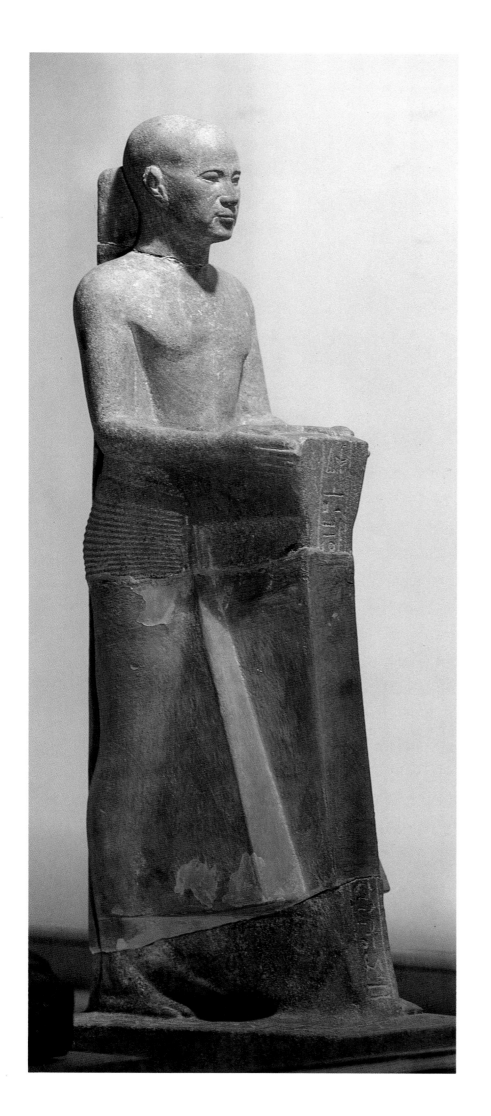

⟦ 77 ⟧
Djedasetiufankh with an offering table
DYNASTY 25/26, CA. 690–650 B.C.
RED SANDSTONE; HT. 47 CM

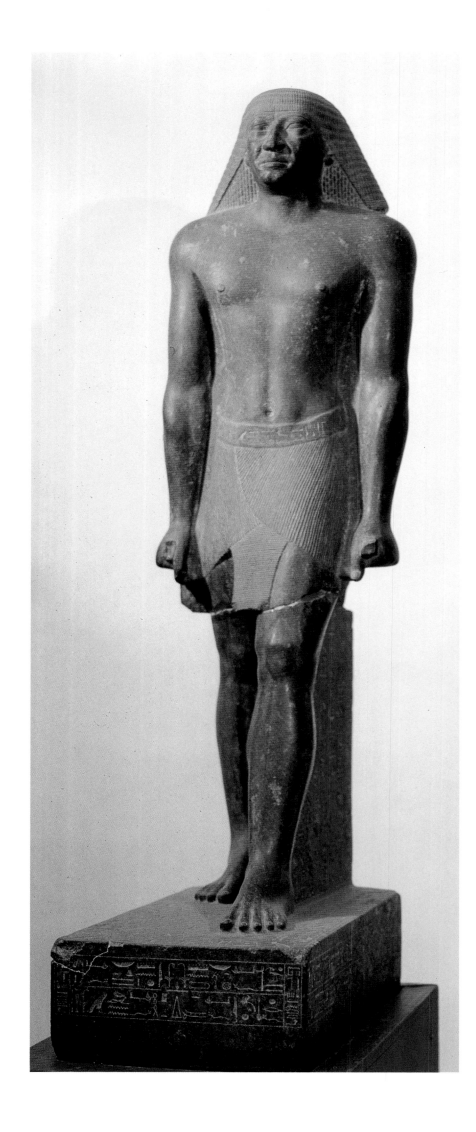

⟦ 78 ⟧
The Mayor of Thebes Mentuemhat
DYNASTY 25/26, CA. 690–650 B.C.
GRANITE; HT. 135 CM

Even more uncompromising — and probably the finest of all Kushite portraits — are the faces of two statues made for one man, Mentuemhat [[78, 79]]. This remarkable individual, a native Theban, held the relatively modest offices of mayor of Thebes and Fourth Priest of Amun. In fact, however, he seems to have been the boss of southern Egypt. Mentuemhat supported the Kushites, who presumably gave him a more or less free hand with local affairs. When Assyrian invaders sacked Thebes in 660 B.C., it was he — so his inscriptions tell us — who took charge of restoring the temples. When the Kushites withdrew from Egypt and Psamtik I, already ruling in the north, moved to extend the power of his Twenty-sixth Dynasty over all the land, it was Mentuemhat with whom he negotiated a peaceful takeover of the south, in 656 B.C. Mentuemhat built himself a monumental tomb in the most fashionable part of the Theban necropolis and scattered his statues liberally through the local temples. Over a dozen are still preserved, at least eight complete with heads. All of them are idealized representations except these two, unquestionably the finest.

The standing figure [[78]], almost life-size, is almost ostentatiously archaizing. When borrowing from the past, sculptors of the Kushite era normally limited themselves to a single style throughout a work, perhaps because their models were actual old statues. Here, however, Mentuemhat sports a double wig of New Kingdom vintage [[see 63]], over a strong, youthful body of classic Old Kingdom type. Statues like that of King Mycerinus [[7]], made almost two thousand years earlier, were the inspiration for these broad shoulders, the high-chested torso with its strong vertical dividing line, and the muscular arms and legs. But this is by no means a mechanical copy. Mentuemhat's torso is longer and a trifle softer in modeling. The breasts are set a little lower, and the belt curves down under an abdomen just slightly fleshier. It is an equally fine figure of a man, but the tautness of the early statues is gone. Mentuemhat lived in a very different age, and its spirit was inevitably reflected in his statue.

It was a spirit that could permit and perhaps even deliberately foster startling effects, like this juxtaposition of a handsome, youthful body with an aging, harshly individualistic face. The superb workmanship of Mentuemhat's statue may intensify for us the slight shock of incongruity, but we have already seen a similar disparity between the face and body of his contemporary, Djedasetiufankh [[77]].

Taken by itself, the face of Mentuemhat's standing statue is beautifully realized. Strong features, set in the stern lines of a domineering will, are beginning to blur as

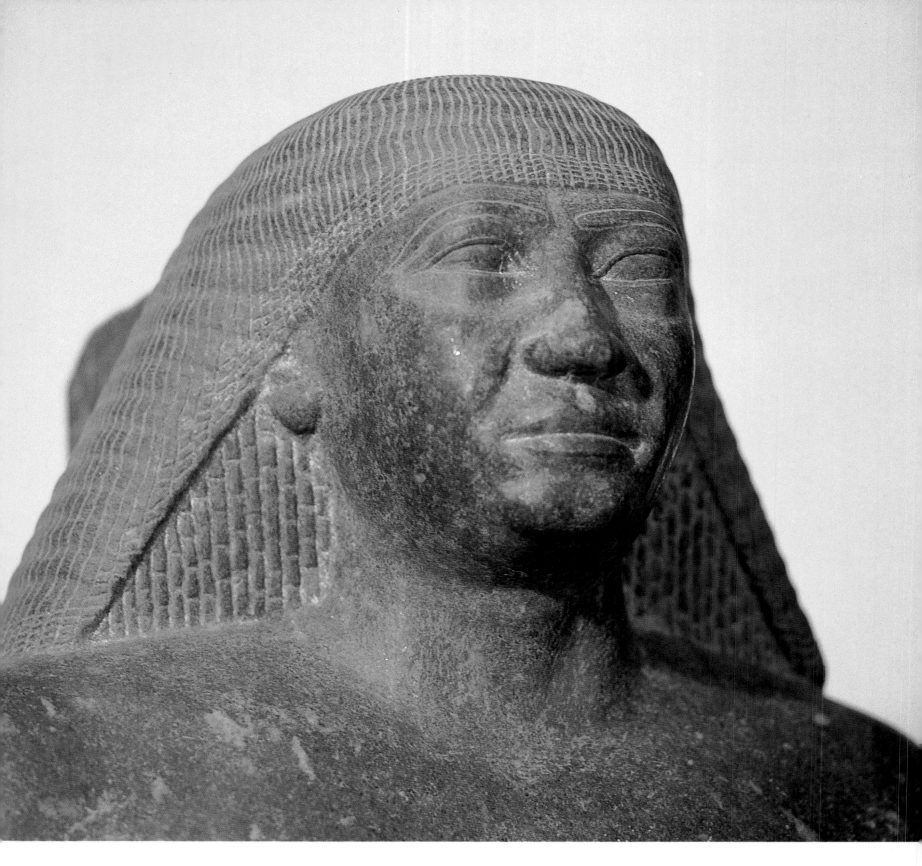

〚 78 〛
detail

the fleshy deposits of age collect below the chin, bulge along the lines from nose to mouth, and puff out the skin of the upper lids. The expression is imperious, grim, almost scowling. A similar harshness of visage characterizes most Kushite portraits. They look forbidding and even unpleasant — and thereby introduce another facet of personality into Egyptian portraiture. Many statues before this time had been less than flattering. More than one period had produced faces with somber and even rather brutal expressions 〚3, 29, 57〛. But the ferocious intensity of a

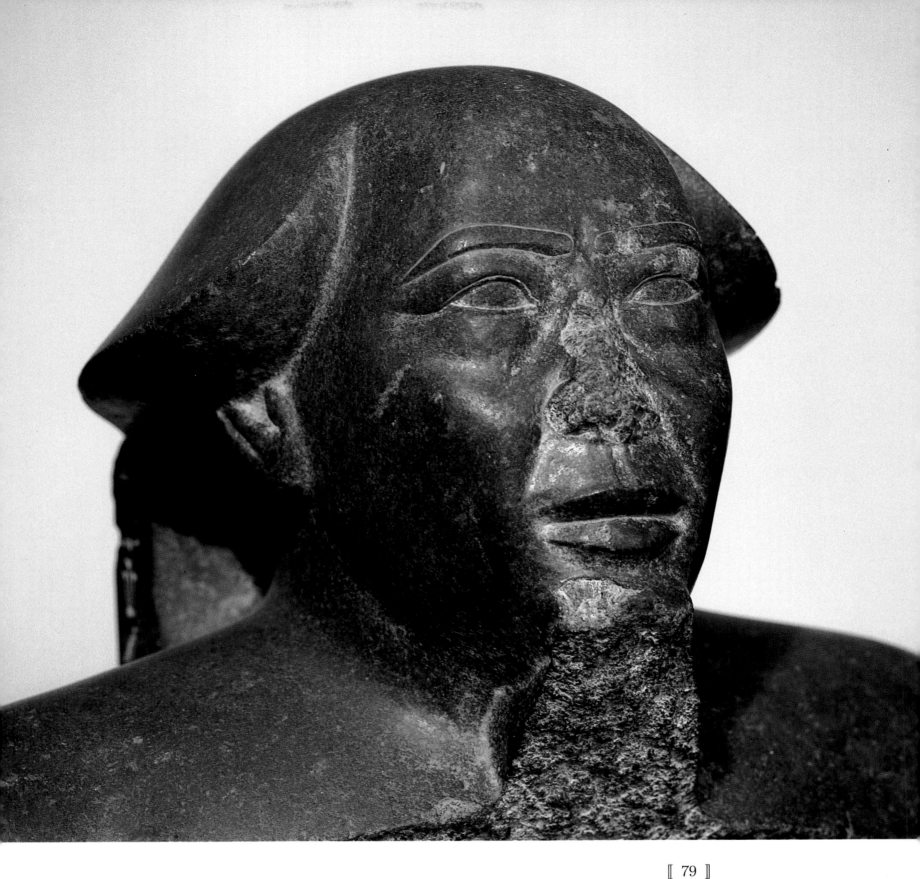

Bust of Mentuemhat
DYNASTY 25/26, CA. 690–650 B.C.
GRANITE; HT. 50 CM

face like this, whatever its significance, conveys a sense of personal force new to Egyptian sculpture.

The second portrait statue of Mentuemhat 〚79〛 is the life-sized bust from what was probably a kneeling figure. The nose has been broken off and also the area just below the chin, where apparently one of Mentuemhat's hands was cupped under his mouth in a begging gesture, intended to solicit offerings. Statues in this mendicant pose first appeared during the New Kingdom. They are quite rare. Several have the unusual and distinctive hair-

style worn here by Mentuemhat. The hair at the sides flares out over the tops of the ears, but the crown of the head and perhaps the back of the neck are shaved. Mentuemhat is not shown naturally balding, but with a kind of tonsure.

By comparison with his standing statue, the face of the bust looks almost placid. But there is nothing ingratiating about this stern visage, whose expression has sometimes been described as cynical. The man represented here is older and heavier than the standing figure. He has a distinct double chin. His cheeks are slabs, broken only by vertical creases on either side of the mouth. His eyes, embedded in swollen pockets of flesh, peer intently and suspiciously. This portrait, too, seems animated with the force of a personality.

Though it has his titles, the incomplete inscription on the back pillar of the bust does not include Mentuemhat's name. The statue was found at Karnak in the temple of Amun's consort Mut, where there is other evidence of Mentuemhat's restorations, presumably after the disastrous Assyrian invasion. The text on this statue seems to describe the same activities. We can be almost certain, therefore, that the bust represents Mentuemhat. Nonetheless, it would be helpful if someday the bottom of this statue should turn up with his name on it, because, when we compare this face with the portrait on the standing figure (which does bear Mentuemhat's name), it is difficult to feel sure that they represent the same man. Advancing age could explain the filling out of cheeks and chin and the progressive puffing and drooping of the skin around the little eyes. But could the round cheeks and knobby, cleft chin of the younger face really be seen, even a decade or two later and by another sculptor, as the long-jawed countenance of the bust, markedly tapered despite its layers of fat? Did one of these faces really capture Mentuemhat's likeness? Or did the truth lie somewhere between the two?

Such questions are worth considering for the very reason that they intrigue us, whereas they might not have meant much at all to the Egyptians. We are so interested in the individual, and so conditioned by the long tradition of Western portraiture and by photography, that we find it very difficult *not* to assume the existence of a real face in a unique set of features. For the Egyptians, even at this late date, the image had the autonomy of an agent. Its purpose was magical, its power derived from its inscriptions and from ritual. The faces of Mentuemhat's other, idealized statues look very little like either of these. It didn't matter. Such a variety may well have been considered desirable. As puzzling as we may find this attitude, it does not di-

minish the vividly lifelike qualities or the superb artistry of Egyptian portraits like Mentuemhat's.

In his priestly duties, Mentuemhat's superior was the High Priest of Amun, Horemakhet, who may well have kept an eye on the great Theban in other respects, too, for Horemakhet was a son of the Kushite king Shabako. He was one of the few Kushite nobles who, in the train of the conquerors, actually settled down to make his career in Egypt. Amun was the great adopted god of his own people, and Horemakhet's role at Karnak illustrates the apparent amity among Egyptian and Kushite devotees of this cult. There is no reason to doubt the sincerity of his religious vocation, but it was obviously much to the advantage of his royal relatives that Horemakhet controlled Karnak's immense economic resources and political prestige.

Horemakhet's small standing statue [[80]], from the Karnak Cachette, is in almost perfect condition. Made at almost the same time as Mentuemhat's standing figure [[78]], it is strikingly similar in pose, anatomy, and costume — another example of the Kushite version of the Old Kingdom ideal. Horemakhet's shaven head probably refers to the purification required of priests while on duty. He wears a standard beaded collar necklace, but over it is hung a string of beads, from which hangs the hieroglyph *ankh*, "life." This sign was a very popular amulet in Egypt, to judge from the many preserved examples, but it is seldom represented on statues. It was not an insignia of office, so we must assume it was a personal talisman, included by Horemakhet's own choice.

The statue's austere, expressionless face is less a portrait than an expression of the man's ethnic identity. Like his royal relatives, he seems to make a point of proclaiming his foreign origin. In his case, however, the point is not reinforced by exotic regalia [[compare 76]] but achieved solely by facial features rarely combined in representations of native Egyptians: a small skull with rather angular planes; long, narrow eyes; a mouth very wide for its short round chin; a forward thrust to the lower half of the face. Horemakhet's statue is convincing as a type, but there is little suggestion of individual personality. The statue of another Kushite working in Thebes, one Iriketakana [[81]], shows how tellingly an Egyptian sculptor could combine foreign features with the harsh, forceful expression of Kushite Period portraiture.

Horemakhet's nephew Tanwetamani, the last Kushite pharaoh, was driven from Egypt by the Assyrians. The princes of Lower Egypt had never reconciled themselves to Kushite rule. One of their number, Psamtik I,

The Saite Period, Dynasty 26
(664–525 BC.)

had already begun, with Assyrian encouragement at first, to extend his control over the north. In 656 B.C., he completed the reunification of Egypt by receiving the allegiance of Thebes and the south under a settlement worked out with Mentuemhat. The takeover was so diplomatic that even Kushite Horemakhet kept his job. Psamtik I's dynasty, the Twenty-sixth, is considered Egyptian, although the family was descended from Libyan immigrants long settled in the Delta. Since their home base was the Delta city of Sais, the dynasty and its period are often called Saite.

Psamtik I's chief official at Thebes was the Vizier of Upper Egypt, Nespakashuty. A younger contemporary of Horemakhet and Mentuemhat, he made his career in a period of transition. While it may be coincidental, it seems fitting that his two best statues show him once in a more-or-less Kushite style, once in Saite style. In the first, a limestone statuette, he sits on the ground with his bent right leg lying flat and his left knee up 〚82〛. This pose goes back to the Old Kingdom 〚see 12〛, but it was also popular in the early New Kingdom, when such a statue would have worn this kind of shoulder-length hairdo — probably a wig — with tresses running flat across the top of the head 〚see 38〛. The model for this statue, therefore, was probably New Kingdom. This influence may also account for the soft, delicate modeling of the torso, although the broad shoulders and long limbs fit the masculine ideal of Nespakashuty's own day. The softness and naturalism of the figure enhance its rather casual look — Nespakashuty seems to be settled comfortably against his back pillar. It is typical of this time that the sculptor should have omitted any sign of Nespakashuty's short kilt or his belt on the left side of the statue. Omissions of this kind occur so frequently on carefully made Late Period statues that it is hard to explain them as mere carelessness. Also unexplained, on this particular statue, is the fact that the right foot, lying on its side, is carved from a separate piece of stone. It is detachable.

The narrowed eyes of this statue and the heaviness of the lower profile, due to the close spacing of nose, lips, and chin, are typical for idealized faces on statues made at Thebes during the Kushite Period. Most such statues represent Egyptians. Nespakashuty himself was certainly of Egyptian descent. But comparing a face like this one with the features of the Kushite Horemakhet 〚80〛 raises a suspicion that the Kushite kings had inspired a taste among their Theban subjects for a slightly exotic cast of feature.

Nespakashuty's second statue, in fine greenish graywacke and nearly life-size, shows him seated on the ground with his legs crossed 〚83〛. This is the pose of the

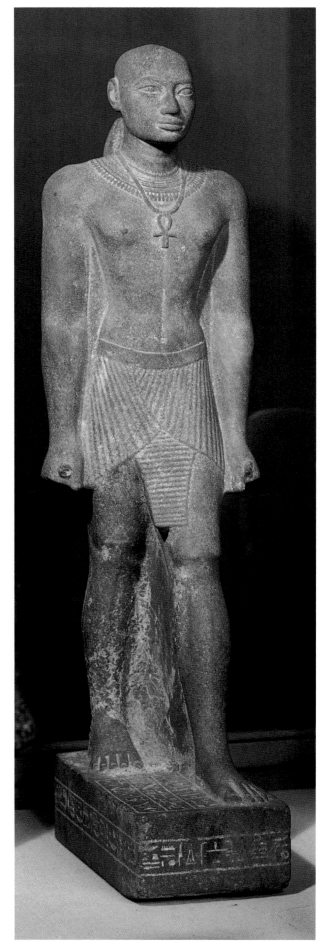

〚 80 〛

Standing High Priest of Amun Horemakhet
DYNASTY 25/26, CA. 690–650 B.C.
RED SANDSTONE; HT. 66 CM

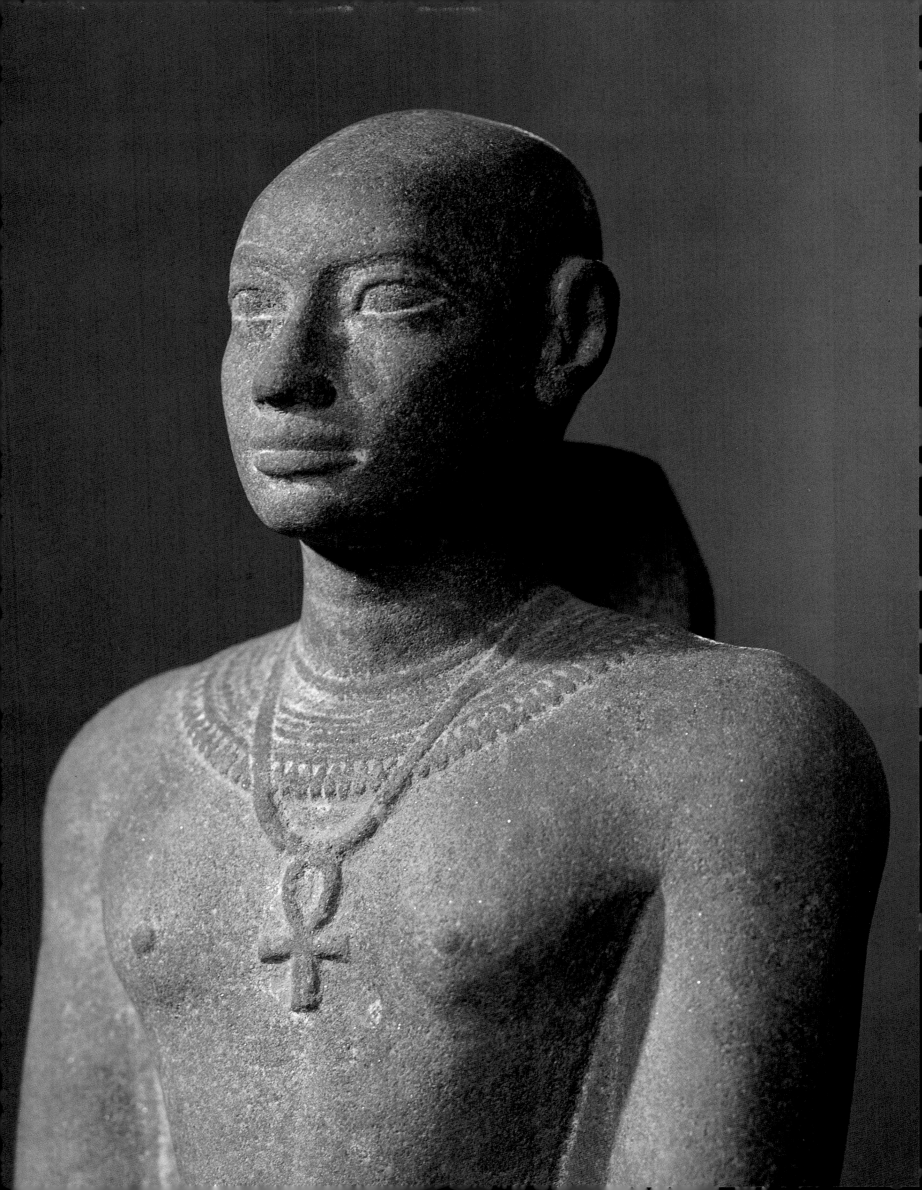

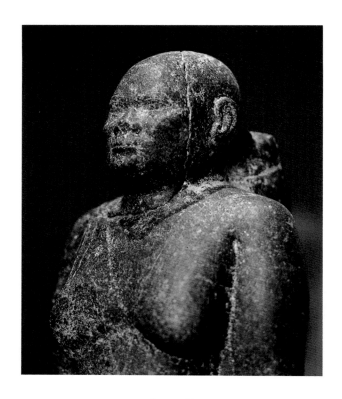

〚 81 〛

Iriketakana
DYNASTY 25, CA. 690–664 B.C.
GRANITE; HT. 44.2 CM

scribe, one of the most ancient of Egyptian statue types and one that never fell out of favor 〚see 14, 16, 50〛. The simplicity and apparent humility of the pose epitomize Egyptian reverence for the power of the written word. An example as elegantly formal as this one emphasizes the symbolic aspect of the scribe statue. Instinctively, we know that the man represented here was not one who actually sat bare chested on the ground, taking dictation. Master of the word, he was master of men as well.

The cool elegance of this statue, the restrained detail, and the almost sensuous pleasure in the lovely surfaces of the softly polished, fine-grained stone represent Saite style at its best. There is still archaizing reference to the past: Nespakashuty's confidently raised head and strong, vertically grooved torso are derived from Old Kingdom prototypes. Indeed, the sculptor may have been

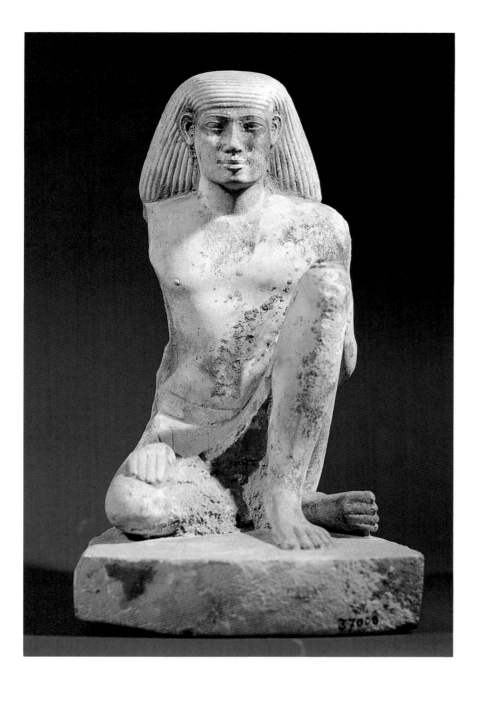

[[82]]
The Vizier Nespakashuty
DYNASTY 26, CA. 656–640 B.C.
LIMESTONE; HT. 27 CM

following two pages

[[83]]
Nespakashuty as a scribe
DYNASTY 26, CA. 656–640 B.C.
GRAYWACKE; HT. 80 CM

straining too hard for an old-fashioned effect when he carved the feet in so grotesquely impossible a position. The feet on Old Kingdom scribe statues tend to be awkwardly rendered [[see 14]] but seldom as clumsily as this.

On the whole, Saite sculptors were more selective than their predecessors of the Kushite Period, choosing among the simpler and more idealized earlier styles and adapting them more fully to their own taste. The result is suave and somewhat mannered — too refined, perhaps, to have instant appeal for modern tastes. Critics sometimes dismiss Saite style as dry and academic, but they make a mistake. The Egyptians knew better. For the next five hundred years, as long as they continued to make sculpture, their idealized statues imitated the Saite look.

The quiet pleasures of this style in its full development may be appreciated in the block statue of Pakhraf,

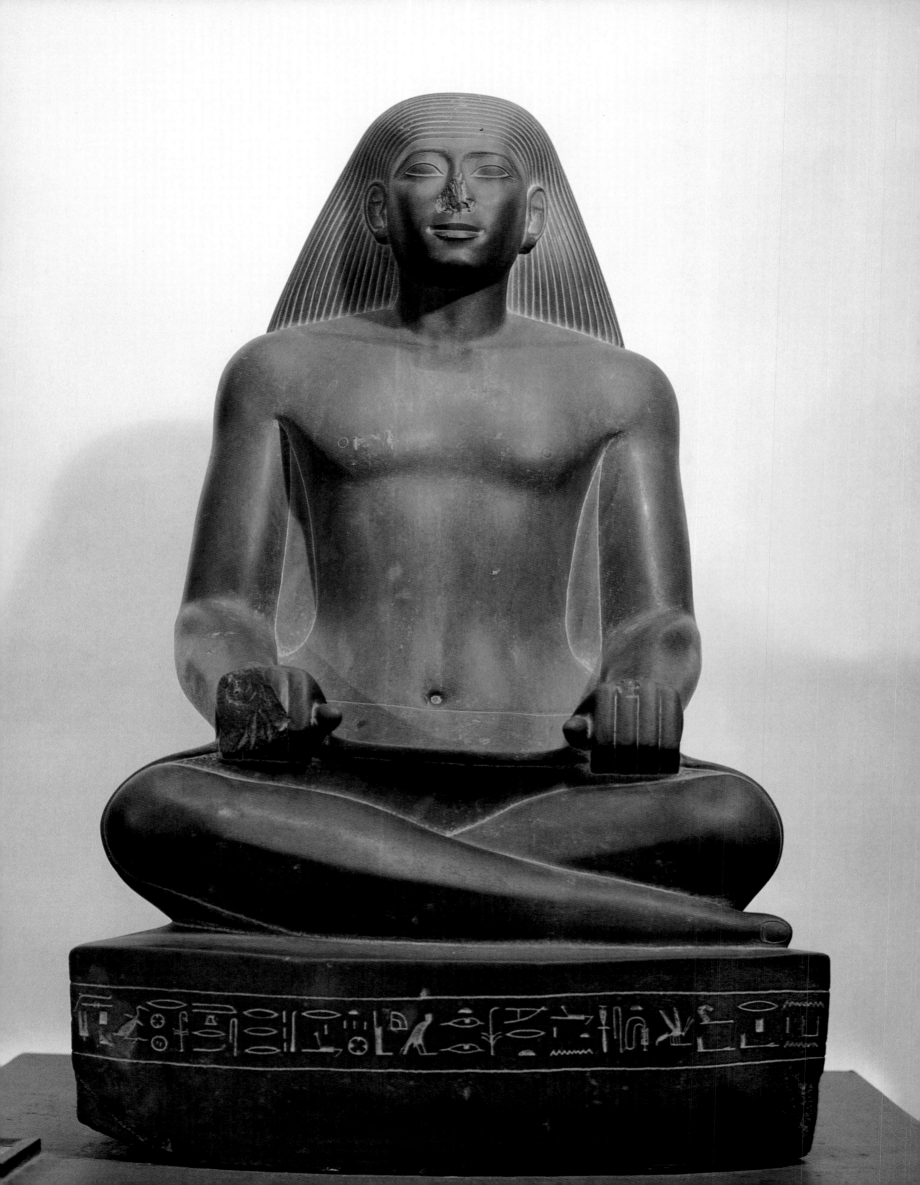

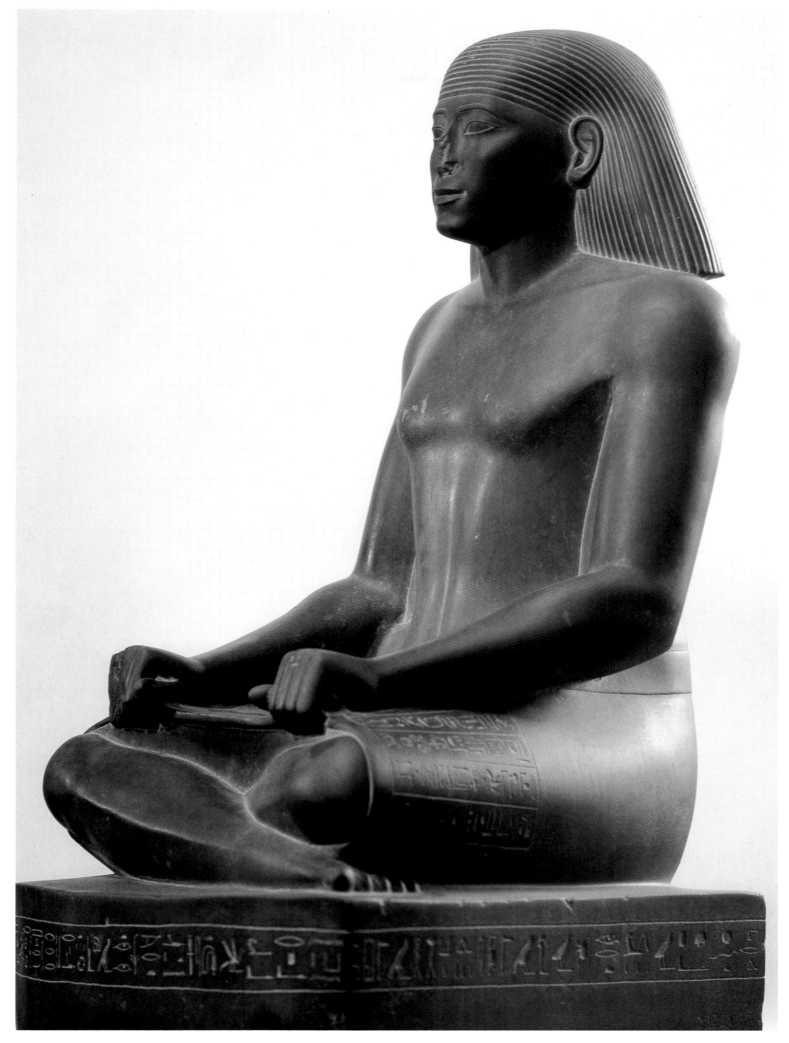

probably made later in the long reign of Psamtik I [[84]]. His pose is more immediately apparent to us than on the earlier block statues in this book [[74, 75]] because his limbs are softly outlined, as if the enveloping cloak were only a veil. Their rounded forms give an impression of an attractively long-limbed young man. The body is not a simple tapered block but a subtle composition of long curves, unbroken by any inscription or decoration, except for an emblem of Hathor, like a bold appliqué on the front of the legs. As often in Saite sculpture, the beauty of the stone is particularly appealing.

Pakhraf's face is long and unusually thin for a block statue, although it is well connected to the body by the typical wide wig and beard. His features are characteristically Saite: long almond eyes under straight brows, very long cheeks and nose, and the so-called Saite smile. This smile, benign but oddly enigmatic, is mainly produced by a deep sickle-shaped curve along the bottom of the lower lip. The single most noticeable feature of Saite style, it is often considered the inspiration for the similar "archaic smile" on early Greek sculpture, which at this time was beginning its brilliant development, certainly with some influence from Egyptian sculpture.

The only women regularly represented in statues of the Kushite and Saite Periods were the Divine Consorts of Amun, priestesses who played the role of the great god's wife on earth. Clearly, such a woman had to be of the highest birth, and, since the beginnings of this office in the New Kingdom, Divine Consorts had been royal princesses. The Kushites, alert for ways to encourage their Theban supporters and emphasize their common religious beliefs, while keeping control behind the scenes, quickly saw the political possibilities of the job. They arranged for a Kushite princess to be "adopted" by the reigning Divine Consort as her successor. The Saites also saw the advantages of this arrangement. The main public manifestation of Psamtik I's takeover of Thebes, as negotiated with Mentuemhat, was the dispatch to Thebes of his own daughter, Nitocris, to be adopted by the Kushite Divine Consort. She in turn eventually adopted her grandniece and successor, Ankhnesneferibre. It is Ankhnesneferibre who is represented in a small standing statue that combines Saite suavity with girlish charm [[85]].

Although her dress is indicated only by the hem at the ankles, Ankhnesneferibre is in full regalia, with the tall crown, consisting of sun disk, cow horns, and two plumes set on a platform of uraeus cobras, which had been worn by queens and goddesses alike since the New Kingdom [[a similar crown once topped the statue of Queen Isis, 41]]. The graceful object in her left hand is a fly whisk,

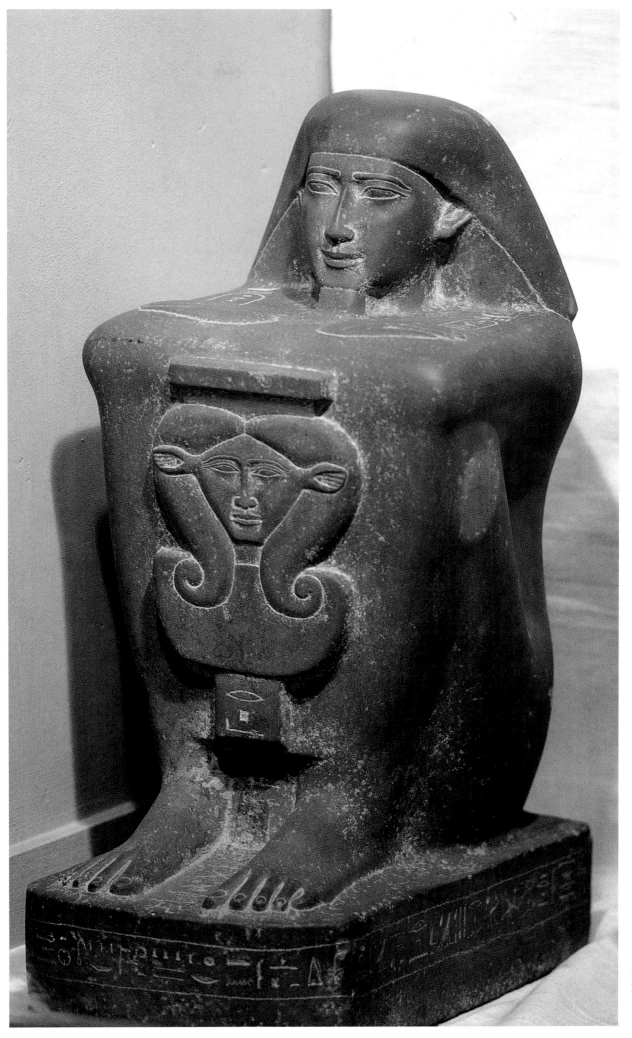

〖 84 〗
Block statue of Pakhraf
DYNASTY 26, CA. 640–610 B.C.
BASALT; HT. 48 CM

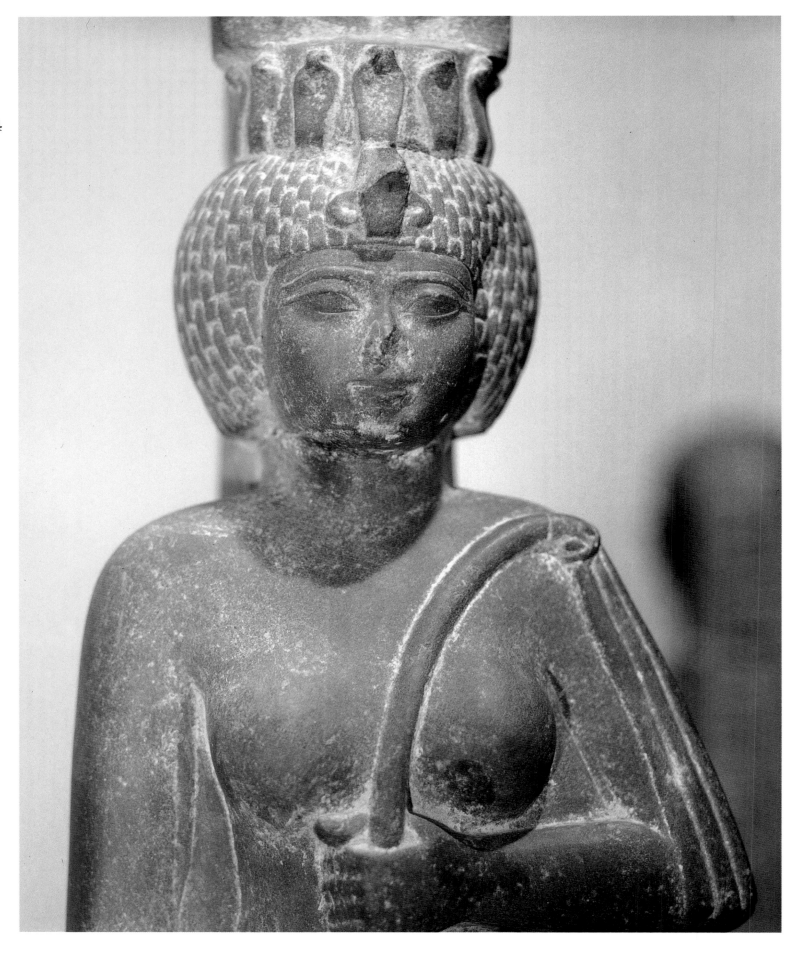

a feminine equivalent of a royal scepter. Only her hairstyle departs from traditional fashions. This round, curly bob became stylish for women in the Saite Period and retained its popularity for a very long time, well into the Ptolemaic Period.

Smooth surfaces, a studied simplicity, and the Saite smile mark Ankhnesneferibre's figure as characteristically Saite. Her round, chubby face is unusual, however, and so is the plumpness of her hips and thighs as seen in profile. Other statues of women made during this dynasty (mostly goddesses) show similar round, heavy breasts. However, though well padded around the hips, they are not as tubby as Ankhnesneferibre. As usual, when an idealized Egyptian statue shows unexpected traits, we can only wonder whether these features actually belonged to the person represented or were included for other reasons. In this case, the intention could simply have been to suggest delectable youthfulness in this wife of a god, regardless of her real age or appearance. The considerable charm of Ankhnesneferibre's statue lies mainly in its suggestion of a very young woman playing her exalted role to perfection — and really quite enjoying it.

Although almost all the statues chosen for this book are human figures, the Egyptians also created symbolic sculptural compositions, which included representations of their animal-headed gods [see 46]. Such creatures can look splendidly noble; but our response to their images tends to be inhibited by repugnance to their bizarre, unnatural forms and curiosity about how literally the Egyptians believed in them. It can require an effort of will to respond to the sculptural merits of such representations.

At first sight, a statue like [86] may seem almost ludicrous. Standing passive and acquiescent, the man appears to be doing duty as a chin rest for the oversized cow. But her queenly headdress and necklace show that the beast is a manifestation of the great goddess Hathor [shown as a woman on 7]. She is demonstrating, in a most direct way, her backing and protection of the statue's owner, an official named Psamtik. Statue groups composed of cow and protégé had first appeared in the New Kingdom, when they were reserved for kings. In commissioning this statue for his tomb, therefore, Psamtik had in mind a prestigious and efficacious image. It is unlikely that its humorous aspect ever occurred to him. We, however, may appreciate the qualities of the two figures better if we look at them separately.

Psamtik lived at the end of the Twenty-sixth Dynasty; his statue was carved in late Saite style. When we look back at earlier Saite statues [83, 84], we can see that some changes have taken place in the representation of

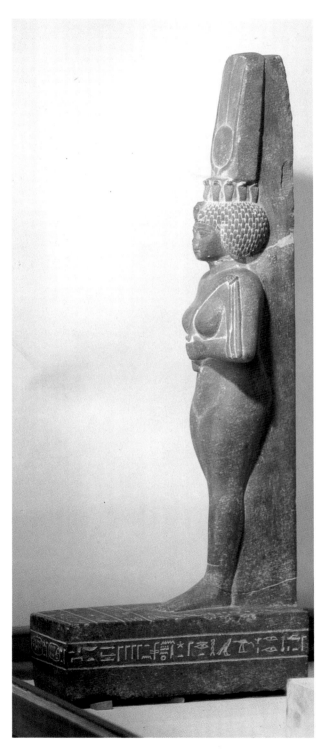

[85]

The Divine Consort Ankhnesneferibre
DYNASTY 26, CA. 589–526 B.C.
BASALT; HT. 71 CM

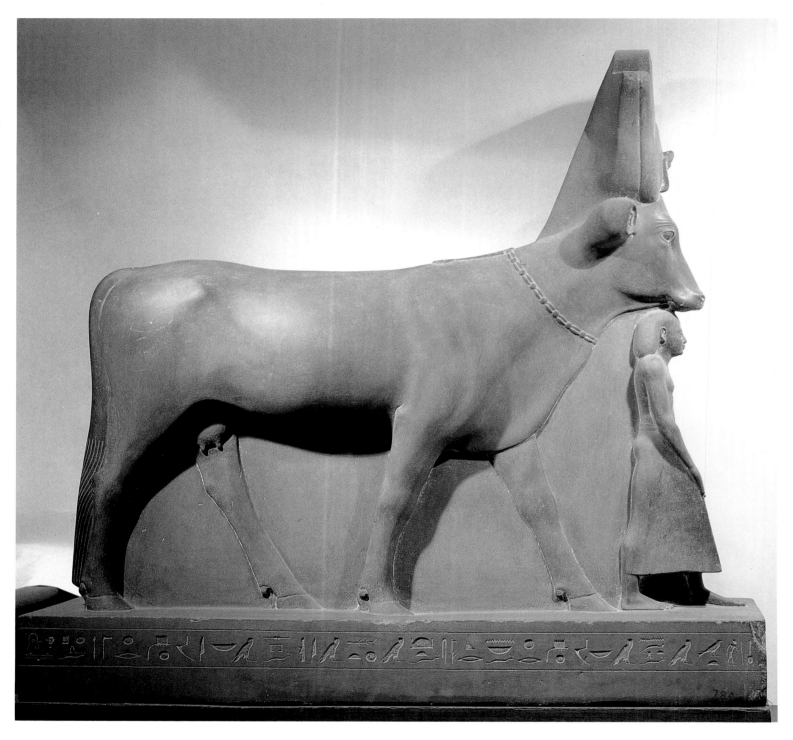

⟦ 86 ⟧

Psamtik protected by Hathor
DYNASTY 26, CA. 570–526 B.C.
GRAYWACKE; HT. 105 CM

the human figure. Psamtik still wears a Saite smile, and his body is still idealized and elegantly modeled. Although the front of his long kilt is covered with an inscription, there is an overall sense of smooth, subtly modeled surfaces. Both face and body, however, are softer and looser of flesh. The firm, rather schematic vertical line dividing the torso of the seated scribe Nespakashuty ⟦83⟧ has given way to a slightly more drooping breast, a rounded ribcage, and a teardrop-shaped bulge of abdomen around the navel. The handsome face has pouches under the eyes and the definite beginnings of a double chin.

The cow is lovely. We can see that, even though most of us are not equipped to fully appreciate Egyptian

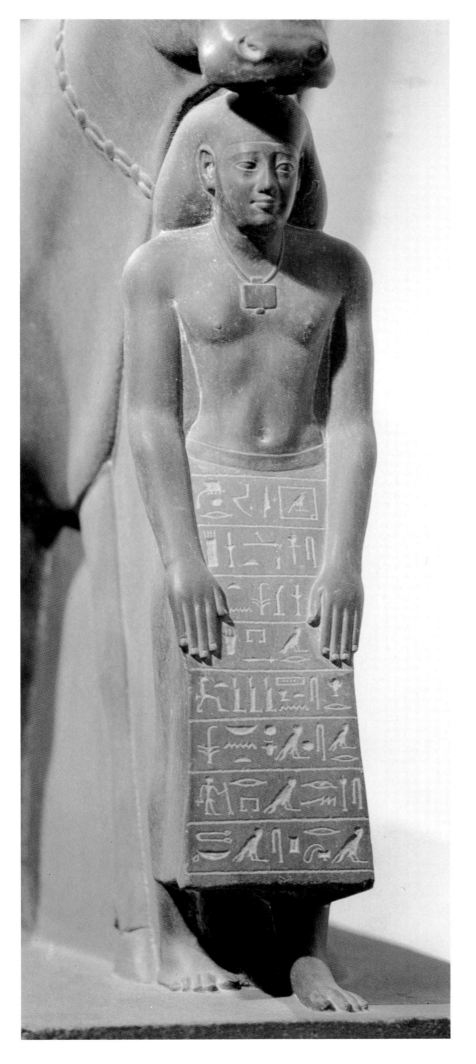

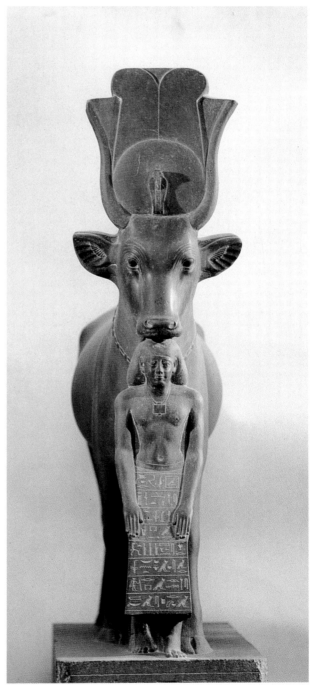

renderings of animals. This is partly because we are not accustomed to the divine in animal form, but even more due to the simple fact that very few of us are sufficiently familiar with such animals to recognize the accuracy of observation, which an Egyptian, in his rural society, displayed as a matter of course. This sculptor has simplified the modeling of the animal's body, using its large forms to express the beauty of the softly modulated, greenish gray stone. The cow's shoulder muscles have been reduced to mere decorative shadows, while her hipbones have been emphasized as pointed knobs, to pick up highlights that enliven the massive hindquarters. Since negative space has been left between her legs and behind Psamtik, much of the cow is actually in high or low relief; but the transitions have been so skillfully handled that we are hardly aware that she is not a fully freestanding figure. Her eyes and the wrinkles above them have been subtly humanized, and her ears, necessarily made thick in the heavy stone, are decoratively stylized. Even those who know or respect cows not at all may read in her face a wisdom and maternal steadfastness residing in, but far transcending, the animal form.

This statue is unusual among Late Period statues, in having been made for Psamtik's tomb at Saqqara, where it was found together with a pair of seated statues representing Osiris and Isis. By now, large stone statues for the tomb were well on their way to becoming obsolete. Comparing this set of statues with their early equivalents in Chapter 2, we sense a change in spirit. In the late group, the image of the deceased is overshadowed, in both size and number, by the figures of the gods. Their protective presence seems to have been Psamtik's main concern.

The fleshiness of Psamtik's face is modeled as a series of sagging pouches and downward lines that seem to contradict his little Saite smile, setting up an ambivalence in the expression of this idealized face, which may have been unintentional. A similar ambivalence, however, seems to prevail on many of the faces of portrait statues in the late Saite Period and the succeeding Persian Period — a kind of moodiness that is hard to define but gives many of them an almost intimate quality. The small kneeling statue of Psamtik-sa-Neith, for example, looks as if it is about to speak, so expressive is his distinctive face [[87]]. The thin-lipped, pursed little mouth is drawn up at the corners in almost a parody of the Saite smile. From certain angles Psamtik-sa-Neith really does seem to be smiling. But the weariness of the eyes, with their series of bags and pouches extending down over the cheekbones, the tautness of the fleshy ridges curving away from the nose, the stiffness of the elongated planes above and below the

opposite page

[[87]]

Psamtik-sa-Neith with a shrine
DYNASTY 26/27, CA. 550–500 B.C.
GRAYWACKE; HT. 44.5 CM

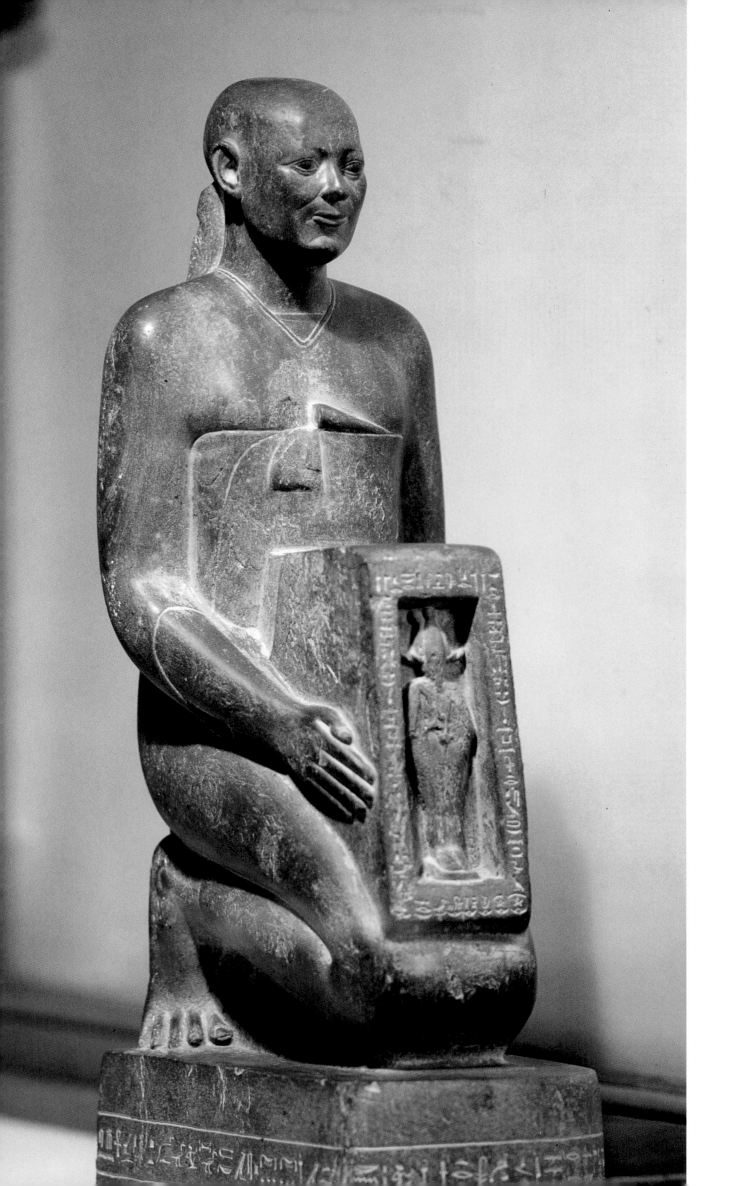

mouth, and the sudden jut of the chin all suggest a negative mood and considerable tension. From some angles, Psamtik-sa-Neith looks almost on the brink of tears.

The tension of the face is echoed in the ramrod uprightness of the body, pressed against the thin back pillar almost as if it were a posture device. Psamtik-sa-Neith holds a little rectangular shrine containing a figure of Osiris. From the front, it appears to rest on his thighs. In profile, it seems to sit between them. The sculptor is teasing our eyes: he has cut away the bottom of the box along the curves of the legs, so that its form and placement are even less naturalistic than the flat, schematic hands pressed against its sides.

Psamtik-sa-Neith's clothes are something new in Egyptian representations. He wears two shirts, an undergarment of which only the T-shirt-like neckline can be seen and a V-necked pullover with slant-edged sleeves below the elbow. Over these, a long skirt is wrapped just below the breast. Its two upper corners, shown as a rolled edge and a flap, suggest that it was held in place by rolling the top, much as one secures a bath towel. The fabric seems at least as thick as a bath towel, to judge from the way it encases the torso, like a tube. This costume is often assumed to be foreign in origin, or at least in influence, since it first appeared on statues at almost exactly the time Egypt was taken over by the Achaemenid Persian Empire. Persian reliefs do show shirts like this one, with slanted sleeves, but no real match has been found for the Egyptian "Persian wrap" skirt. It continued to be shown on Egyptian statues long after the Persians had left Egypt, through the Fourth Century B.C., and on into the long rule of the Greek Ptolemies. Whatever its origin, the "Persian wrap" seems to have been considered native costume by its Egyptian wearers.

The Persian Period and the Last Native Dynasties, Dynasties 27–30
(525–343 B.C.)

The King of Kings Cambyses defeated the last Saite ruler and took Egypt in 525 B.C. The Persian occupation, which lasted until 404 B.C., is known as the Twenty-seventh Dynasty. Cambyses and his successors gave themselves the titles of pharaoh, but they incorporated their new conquest into the expanding Achaemenid Empire as a satrapy (province). For the first time in its recorded history, Egypt had lost even nominal independence. Revolts became increasingly frequent and bitter, but the Egyptians did not succeed in expelling the Persians; their eventual withdrawal was mainly due to trouble elsewhere in the empire and family feuds back home. The very ephemeral Twenty-eighth Dynasty, the short-lived Twenty-ninth, and the Thirtieth all arose in the Delta, now firmly established as the seat of action and interaction with the East

and the Mediterranean world. The Thirtieth Dynasty (380–343 B.C.), consisting mainly of two kings, Nectanebo I and II, provided a stable government for nearly forty years, long enough to launch ambitious programs of temple building and to establish a sculptural style. This was closely modeled on Saite style and, for the most part, highly idealized; but the portrait tradition was also carried on.

A little wooden figure of an old man in a cloak, hardly over a foot tall, is really just the ghost of a statue ⟦88⟧. The feet are gone, along with the base, which may once have held his name. The paint intended to imitate life has disappeared, leaving only traces of white on the cloak and dark red on the neck. The elderly face, with its imperious expression, has been worn down almost to the semblance of a skull, with gaping sockets that once held inlaid eyes. The wood is cracked and roughened, yet the proud, erect form is eloquent of a dignity and authority that defy time and change. He might be a Roman senator, or a medieval abbot, or another Gandhi. Instead, he is an Egyptian of the fourth century B.C. The cloak, which falls about him in such monumental folds, is a native garment. His head is shaven, in the manner of an Egyptian priest. His face, the product of another stage in the long history of Egyptian portraiture, seems to carry reminiscences of both the grim ferocity of the Kushite Period ⟦see 78, 79⟧ and the mournful ambivalence of the late Saite and Persian Periods ⟦see 87⟧.

The feature that most enhances the timeless quality of this figure, its great heavy mantle, is almost unique in Egyptian statuary. It provides our best clue to just when the statue was made. Egyptians must always have worn substantial cloaks to ward off the desert cold of the nights, but they were reluctant to let them obscure the forms of the body, except for the special case of the block statue ⟦see 74, 75, 84⟧. Seated or standing cloaked figures of Middle Kingdom type seem skimpily wrapped ⟦see 31⟧, as do the kings in their short robes ⟦see 3, 18⟧. Large cloaks are occasionally depicted in reliefs and paintings, but as late as the Saite Period, on a relief showing a man with his mantle wrapped over one shoulder very much like this, the fabric hugs his body as if it were gauze. Heavy, warm-looking garments were first regularly shown at the end of the Saite Period, in the form of the "Persian wrap" skirt, often worn over a substantial shirt or two ⟦see 87⟧. A fourth-century date for this statue, during the Thirtieth Dynasty, is made probable by a relief of this period showing a man who wears the same mantle: long and covering one shoulder, so heavy it forms a peak as it bends over the shoulder and flares stiffly away from the body.

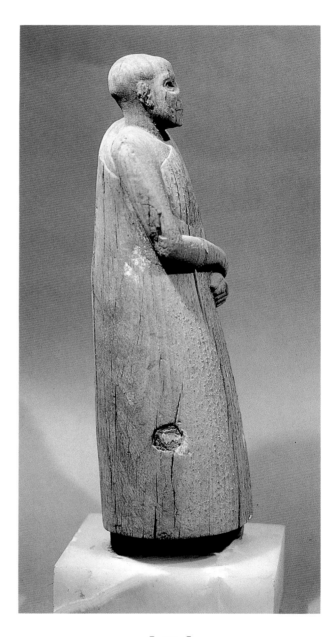

⟦ 88 ⟧

Old man in a cloak
DYNASTY 30, CA. 380–343 B.C.
WOOD; HT. 35 CM

Wooden sculpture of the Late Period has not survived well. Examples are few, and most are in very bad shape. Perhaps fewer were made as tomb sculpture became rarer, since the relative fragility and small size of wooden figures were less well suited to conditions in the temples. The statuette of an old man shows that the tradition of splendid wooden statues had not died; wood carvers were still responding creatively and inventively to this medium, so much less intractable than stone.

Alexander the Great and the Ptolemies (332–30 B.C.)

A second Persian invasion in 342 B.C. ended the Thirtieth Dynasty—the last line of native Egyptian pharaohs—and brought Egypt again into the Achaemenid Empire. But the Macedonian Alexander the Great had launched his amazing campaign of world conquest. He inflicted a major defeat on the Persian king in 333 B.C. and a year later reached Egypt, which the Persian governor handed over to him without a fight. It is likely that many Egyptians regarded Alexander as a deliverer. He, in turn, was punctilious in observing certain Egyptian customs, traveling to Memphis for a traditional coronation. But he also founded the city of Alexandria on the Mediterranean coast, an event that both symbolized and made possible Egypt's growing involvement in international affairs.

Alexander's early death in 323 B.C. left his general, Ptolemy, as effective ruler of Egypt. Ptolemy carried on faithfully for Alexander's heirs, first his brother, Philip Arrhidaeus, and then his short-lived posthumous son, Alexander. In 305 B.C., with no one left to contest his claim, Ptolemy I took the royal titles for himself, founding the dynasty that was to reign for three centuries. Though they spoke Greek, affected Greek culture, and governed through a vast bureaucracy of largely Greek descent, the Ptolemies followed Alexander's lead in presenting themselves to their subjects as true pharaohs. Alexandria and a few other cities were Greek enclaves in a land that was encouraged to cling to its traditional beliefs and customs, for the sake of maintaining peace and maximum economic output. Great temples continued to be built, following the style of the Thirtieth Dynasty. The innumerable statues dedicated in them were carved in the old manner, both portraits and idealized images. Some Greek influence appeared almost at once, but throughout the long centuries of Hellenistic rule it remained largely superficial, limited almost entirely to hairstyles and beards in the Greek fashion and to Ptolemaic insignias of office.

During the absentee reign of Alexander's brother, a block statue was carved for a temple official named Djedhor and set up somewhere in his town of Athribis, in the Delta [[89]]. The tall, rather narrow shape of the squat-

opposite page

[[88]]

detail

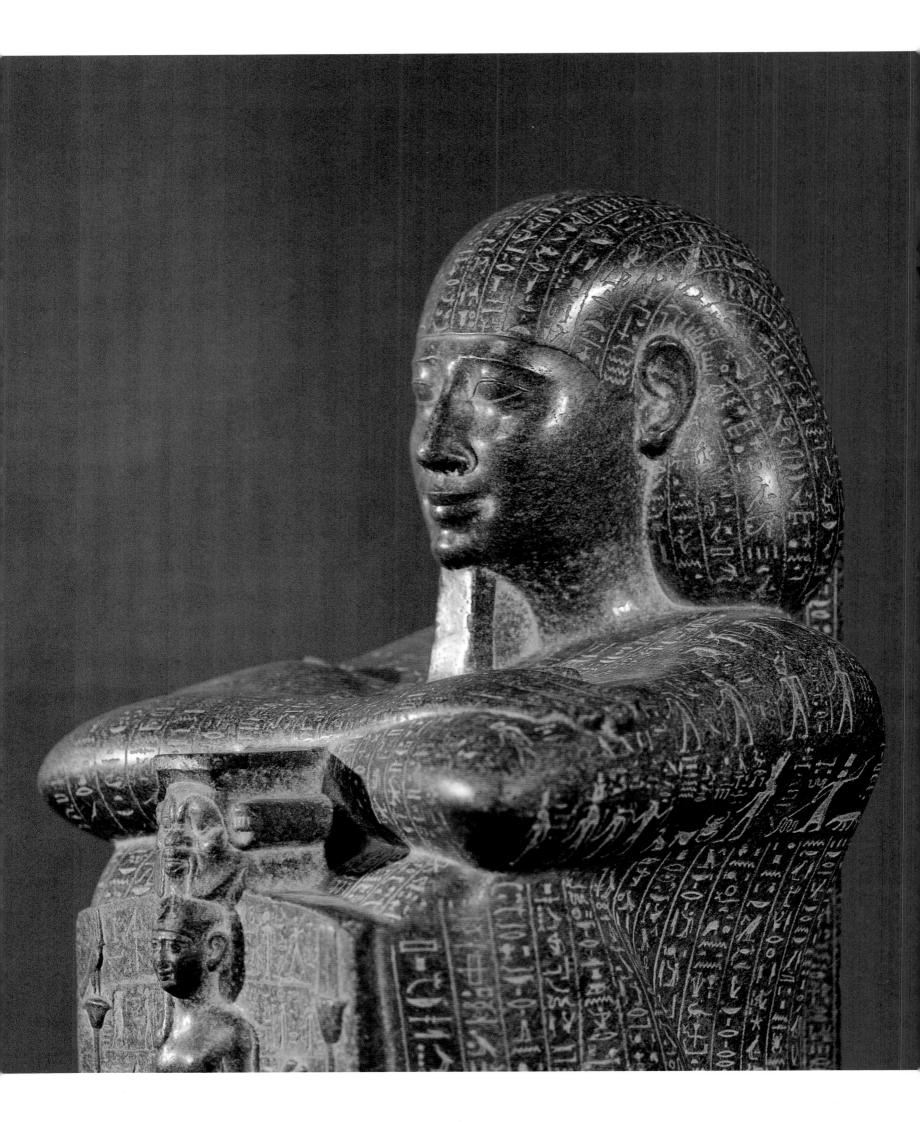

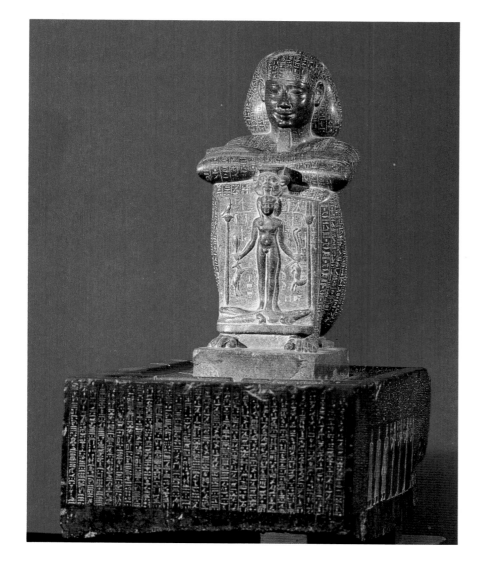

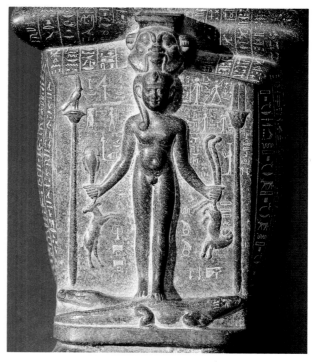

〚 89 〛
Healing statue of Djedhor
MACEDONIAN PERIOD, 323–317 B.C.
BASALT; HT. 96 CM

ting figure resembles that of the Saite block statue of Pakhraf 〚84〛, although the outlines of the cloaked limbs are even more apparent. Djedhor's benign mask of a face is strongly reminiscent of Saite style. His straight brows, almond eyes, long nose, and sickle curve of a smile imitate the features of statues like 〚84〛 and 〚86〛. This revival of a style that had itself borrowed heavily from earlier styles was a final twist in the long and complex story of Egyptian sculpture's response to its past. It was the last of the idealizing figure styles, and it endured for over four centuries, from the Thirtieth Dynasty all through the Ptolemaic Period.

In front of Djedhor's legs, resting on his feet, is a stela with an image of the child god Horus triumphant over crocodiles, serpents, and other wild beasts. This iconic being is surrounded by protective images and inscriptions, which overflow onto the rest of the statue, covering all of Djedhor's body except his bare feet, hands, and face. Here, certainly, is an Egyptian statue overcome by the written word. Even so, the scribe has refrained from writing on the figure's naked skin.

⟦ 89 ⟧
detail

Like the inscriptions on many temple statues, Djedhor's texts address the reader, soliciting prayers in return for magical benefits. Here, however, the benefits are stressed, and they are quite specific. The images and spells are mainly designed to protect against snake and scorpion bites and the threat of crocodiles and other dangerous animals. This protection was to be obtained by pouring water over the statue. Gathering magic as it ran down the potent surfaces, the energized water collected in two basins on the base, where it could conveniently be bottled and taken home for use as a potion. This kind of "healing statue" seems to have been popular during the fourth century B.C. It is easy to understand the appeal, for a donor, of a memorial that was so ostentatiously philanthropic. The worn surfaces in the basins of this statue suggest that it was appreciated and much used.

On the sides of the statue base, Djedhor's career is described in adulatory detail. So great were his benefactions that he named himself "The Savior" (or The Invoker), implying a semidivine status, which would have been an added attraction for potential users of his statue. Among his blessings on earth were his family, who are not only named but also represented on the long sides of the base in carefully carved sunk relief. Sons, daughters, and wife follow the figure of Djedhor, the women making religious music by shaking two kinds of sistra.

It would be easy enough to dismiss Djedhor's statue as a mere artifact, a late vagary in a great tradition. But those who have followed the long course of Egyptian sculpture may be able to see it sufficiently through Egyptian eyes to appreciate it as a work of art in its own right, appealing though odd. We have already noted the intrinsic realism in the pose of the block statue, together with the Egyptians' response to its abstract qualities and the convenience of its broad cloaked surfaces as a vehicle for inscriptions and figures ⟦74, 75⟧. We have seen the develop-

ment of the smiling Saite face, which is revived here. And we know that all Egyptian statues were basically magic substitutes for the person represented, their potency guaranteed by the magic power of the words written on them. To all these qualities, this statue adds a new aesthetic sense, which was to grow in Ptolemaic times and is most evident on the walls of Ptolemaic temples: a love for small-scale patterns of figures or texts, drawn like a net over all empty surfaces. This taste has sometimes been dismissed as mere horror vacuii, but, in fact, the total effect is usually attractive.

The interaction of all these factors, in the hands of an artist whose subtlety equaled his skill, could still produce a work of art — esoteric and even bizarre to the outsider but lovely in its proportions, its balance of weight and delicacy, its lacework of pattern dancing over the stiff, closed shapes and the benign, confident glow of its handsome face. For the purposes of a benefactor who proffers help in return for recognition and veneration, the statue is very nearly perfect.

At some time in the second half of the Ptolemaic Dynasty, the standing figure of a young girl was carved. Only the bust is now preserved [[90]]. Her features show the elegant, somewhat narrowed almond eyes and the enigmatic smile inherited from the Saite past. Ptolemaic tastes, however, ran to fleshiness in the female face and body. This girl's round, broad face and full cheeks are therefore typically Ptolemaic in style. Here, they also serve to convey an impression of youth.

The sculptor's intention is even clearer in his treatment of her bosom. The breasts are large and round in the Ptolemaic fashion but set very high. The garments covering them are hard to decipher. There seems to be a round-necked shirt, the sleeve of which may be visible just above her elbow. Over this is something with a V-neckline or perhaps the shoulder straps of a traditional Egyptian dress. It is obscured under some kind of shawl or capelet that hangs over the left upper arm and seems to have passed under the right arm.

The girl clasps a lotus in the manner of Egyptian women [[see 73]], and she wears what passes for a traditional feminine wig. But the Ptolemaic love of pattern has taken over: the long curls are stylized into a pleasing but utterly artificial design, most attractive in the back view. Her own hair shows below the wig on her forehead, just as in the Old Kingdom [[see 4]]. This is probably a reinvention, rather than an archaizing imitation — in fact, the bangs are naturalistically rendered, in the Greek manner.

As in all of the Late Period, Ptolemaic sculpture representing a private woman is most unusual. It would

〚 90 〛
Bust of a girl
PTOLEMAIC PERIOD, CA. 120–70 B.C.
GRANITE; HT. 31 CM

be interesting to know who this girl was and how she came to have this statue. The inscription on the back pillar invokes the god Amun and starts to name her parents. The rest is lost, leaving us just the image of a buxom child, an endearingly adolescent blend of sturdiness and sweet artifice.

Toward the end of the Ptolemaic Period, Egyptian sculpture showed signs of moving in a new direction. Having explored the nuances of portraiture and every elegant subtlety of idealism in the human face, some sculptors began to make statues in which the natural features of an individual were unrealistically enlarged, or cast into exaggerated patterns, with striking results: schematic yet very expressive. There are only a few of these late Ptolemaic heads, not enough to indicate whether they represent the beginnings of a movement or simply the experiments of individual sculptors. But examples like the little head of a wrinkled old man 〚91〛 offer a tantalizing glimpse of the vitality and continued creativeness of Egyptian sculpture, as its three thousand years and more neared an end.

Like many officials under the Ptolemies, this man is shown wearing his hair short and full in the Greek manner, even crowned with a laurel wreath. Very likely he was of Greek descent, for the head was found in the ruins of one of the great Greek cities that arose and flourished in Ptolemaic Egypt. The sculpture, however, is Egyptian. Not only is it carved in Egyptian limestone, with a back pillar in the age-old Egyptian manner, but also the short locks of hair are rendered in a most un-Hellenistic way as clumps of parallel lines. This schematic patterning sets the key for the modeling of much of the face.

The lower part of the face is relatively naturalistic and highly idiosyncratic — the arched nostrils of the thin nose lead into long flaps, which angle down past the mouth to the square jaw; skin sags over the cheeks in vertical folds; the mouth is an overblown cupid's bow above a broad, knobby chin. These features are boldly rendered and the carving looks rather rough, but the sculptor has included quite a bit of modeled detail in the double pouches that mark each cheekbone and the bunched flesh at the corners of the lips. But all of this seems mainly a foundation for the extraordinary treatment of the upper face.

Above the strong bony arches of the brows rise five curving rows of creases. They are so symmetrical, so parallel, and so deep that the exaggeration is a little shocking. Bounded by the neat, stylized ridges of hair and the casually naturalistic plasticity of the cheeks and chin, they dominate the face with the artificial intensity of a mask. They compel our attention, and they force our eyes down to the base of the pattern: the large, bulging, staring eyes. And that is where we are intended to look. All the late Ptolemaic heads of this type, though differing in almost every other detail, concentrate their life and their expression in a fixed, intense gaze. In all of Egyptian sculpture, this is the closest approach to an overt expressionism, and there is no denying its power.

When Cleopatra, the last of the Ptolemies, was defeated by Augustus Caesar in 30 B.C., Egypt came under Roman rule. The Romans did not deliberately set out to change Egypt — temples were still built for the Egyptian gods, and on their walls the emperors were represented as pharaohs — but they destroyed Egypt's last vestiges of independence, and they systematically drained its wealth. Now the ancient civilization began its long decline; one of the first things to die was sculpture. Competent sculptors still found work, turning out imperial portraits in Roman style. But native Egyptians could no longer afford — or were no longer permitted — to place statues in their temples. The few crude exceptions are just pathetic reminders of what had been lost.

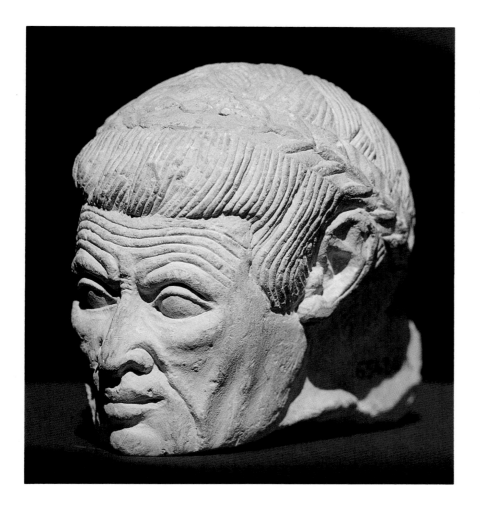

⟦ 91 ⟧

Head with a laurel wreath
PTOLEMAIC PERIOD, CA. 80–50 B.C.
LIMESTONE; HT. 8.5 CM

One of the last ancient Egyptian statues, made a decade or so before Cleopatra's downfall, was a standing figure slightly under life-size, representing one Horsihor, a priest of Thoth ⟦92⟧. As on the head with a laurel wreath ⟦91⟧, Horsihor's short, flocky hair is indicated by a stylized pattern derived from Greek sculpture. But his receding hairline goes back to the Old Kingdom ⟦see 9⟧. There is a distinctive quality to his long bony face, especially in the thin lips and the large knob of a chin, with a dimple in the middle of it and a deep indentation above. But the details of fleshy modeling are simplified — one might almost say suppressed — so that again one's attention is directed to the eyes. They are not large, but their almost unnatural roundness and the deep shadow cast by the overhanging brows give them a hypnotic intensity.

Horsihor's long narrow body is wrapped in a cloak, which went round the hips and over the left shoulder and apparently had to be held in place with the left hand. It must have been made of fairly lightweight cloth, since the straight edges crush easily into long creases and the strands of the fringed edge below clump together, forming a toothlike design. The cloak resembles a toga. It was purely Egyptian, however, and had been worn since at least the beginning of the Ptolemaic Period. The T-shirtlike garment underneath goes back even further ⟦see 87⟧.

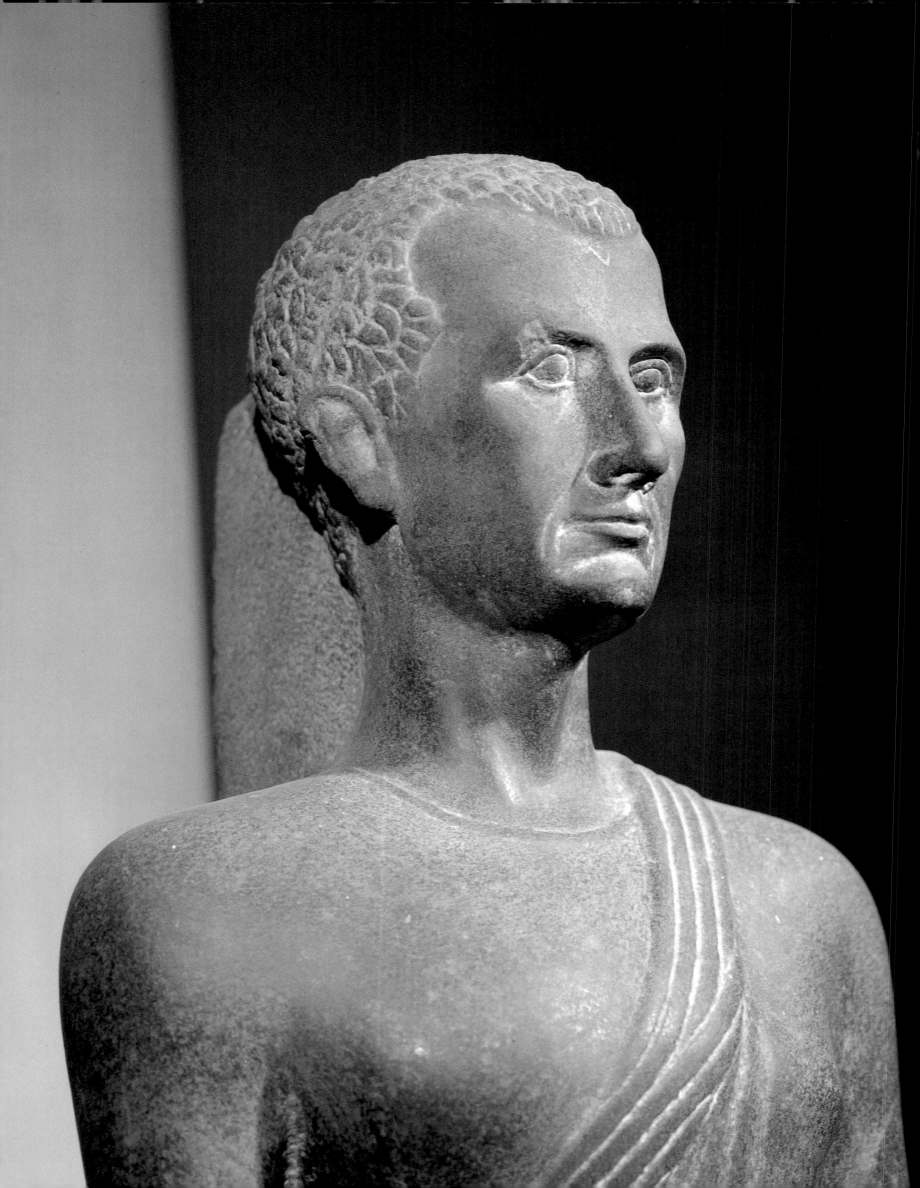

With the costume of its day, the Greek-inspired texture of its hair, and its mesmeric gaze, Horsihor's figure is entirely a product of its time. Yet, being Egyptian, its time encompassed all that had gone before. So much in this statue: the frontally oriented standing pose and the closed fist of the hanging arm, the back pillar, the high seriousness expressed in the face — even such details as the diagonal ridge indicating the arm muscle just below the elbow — represents the living heritage, continually renewed and handed on, over thousands of years.

"Egyptian sculpture is all alike." In the pages of this book we have seen how misleading is this old cliché. Change is part of the human condition. It may creep up on us by slow degrees. It may be the deliberate result of experimentation, new technology, or the urge to do things better. Sometimes it comes as a revolution, in the name of new ideas. To all these forms of change the ancient Egyptians, mortal like us, were as subject as we. Unlike us, they resisted — but they could not freeze time. Indeed, at least once, in the Amarna Period, they experienced a cultural revolution as swift and radical as any that we have seen.

Nonetheless, like all the great old clichés, this one contains an important truth. By resisting change, by denying it, by trying even to reverse it in their attempts to revive the past through imitating it, the Egyptians did manage to conserve a great deal throughout the long ages of their history. This stubborn conservatism was intensified in their sculpture, which, whether it was made for a tomb or a temple, was intended to endure eternity unchanged.

That eternal purpose, arising from religious and magical beliefs largely alien to our understanding, was the strongest single determinant of the nature of Egyptian sculpture. The specifications of eternity underlie much of what seems to us enigmatic or foreign in this art — the repetitive frontal poses, the ubiquitous inscriptions, the back pillars and negative space, the far-seeing gaze of almost expressionless, idealized faces. Ironically, the quest for the eternal is also the prime ingredient of universal humanity, which we can share in the best of Egyptian sculpture. The deliberate simplicity of Old Kingdom statues; the rejection of flattery in representations of aging men; the elegant aloofness of Queen Hatshepsut's sphinx; the memorable features of faces as different as Djoser, Nefertiti, and Mentuemhat — all reflect a will to eliminate whatever is ephemeral and trivial, so that what remains will be true for all human time. And — for us as for them — it is.

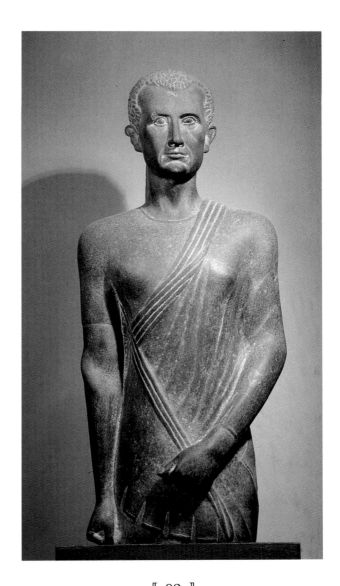

〚 92 〛
Horsihor
PTOLEMAIC PERIOD, CA. 50–30 B.C.
BASALT; HT. 83 CM

Maps

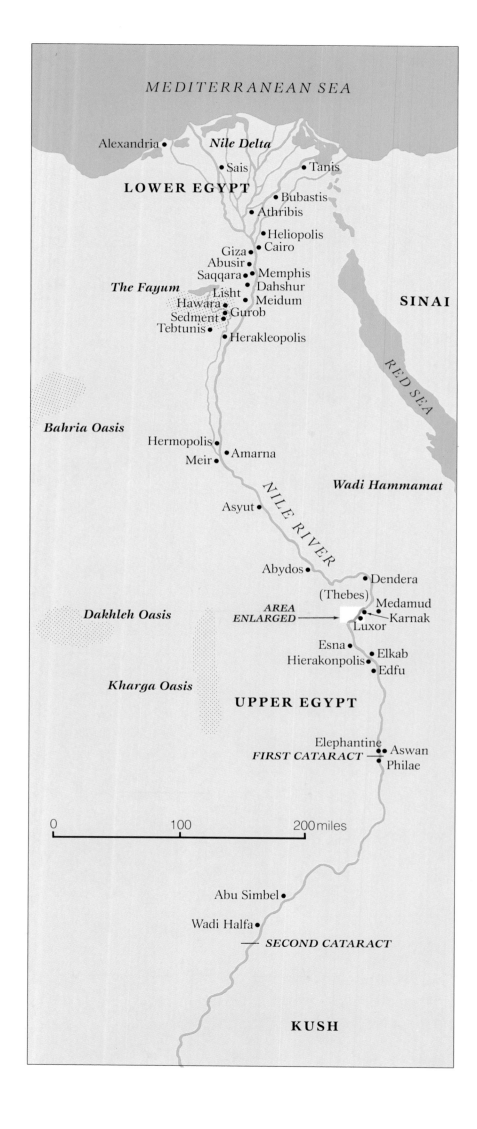

Ancient and modern Egyptian sites

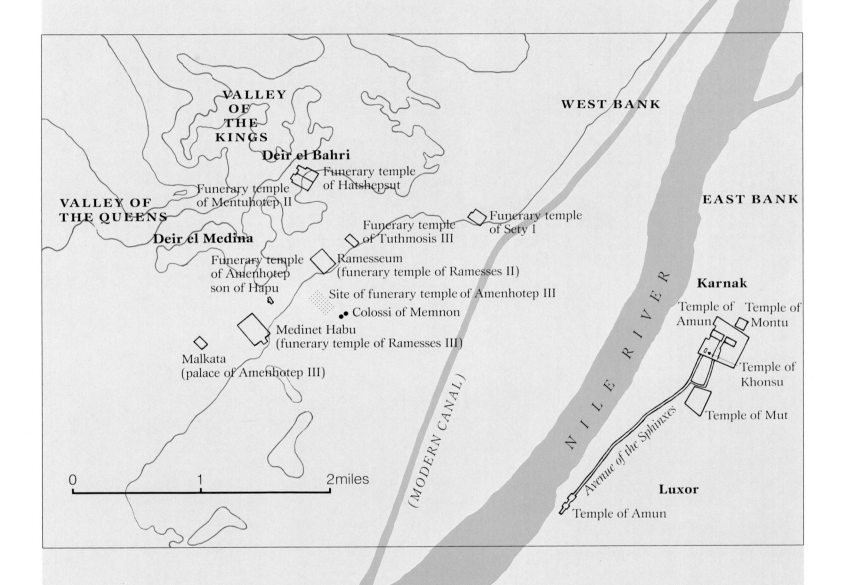

VALLEY
OF
THE
KINGS

WEST BANK

Deir el Bahri

Funerary temple
of Hatshepsut

Funerary temple
of Mentuhotep II

VALLEY OF
THE QUEENS

EAST BANK

Funerary temple
of Sety I

Deir el Medina

Funerary temple
of Tuthmosis III

Funerary temple
of Amenhotep
son of Hapu

Ramesseum
(funerary temple of Ramesses II)

Site of funerary temple of Amenhotep III

Colossi of Memnon

Karnak

Temple of
Amun

Temple of
Montu

Medinet Habu
(funerary temple of Ramesses III)

Temple of
Khonsu

Malkata
(palace of Amenhotep III)

Temple of Mut

N I L E R I V E R

0 1 2 miles

(MODERN CANAL)

Avenue of the Sphinxes

Luxor

Temple of Amun

Detail of the Theban area showing monuments
mentioned in this book

Chronology of Pharaonic Egypt

The chronology used in this book is based primarily on J. Baines and J. Málek, *Atlas of Ancient Egypt*. Until about 664 B.C., Egyptian dates are approximate or conjectural. As a result, there are a number of different chronologies of ancient Egypt; however, most do not disagree by more than a few years. The "relative chronology" — the relations of periods, dynasties, and kings to each other — is (except for obscure and disorganized periods) quite certain. Individual regnal dates are given here for only the most important kings and those mentioned in the text. Slight overlaps are due to divided rule, usually by competing dynasties, or to the practice of some Middle Kingdom and New Kingdom kings, who, late in their reigns, brought their sons to the throne as co-regents. For a few reigns, the dates are too uncertain for conjecture.

Royal names often have variant versions, usually the result of discrepancies between Egyptian and ancient Greek traditions. The most common of these are given below in parentheses, following the form used in this book.

Early Dynastic Period	Dynasty 1	CA. 2920–2770 B.C.
	Dynasty 2	CA. 2770–2649 B.C.
	Khasekhem	
Old Kingdom	Dynasty 3	CA. 2649–2575 B.C.
	Djoser	CA. 2630–2611 B.C.
	Dynasty 4	CA. 2575–2465 B.C.
	Snefru	CA. 2575–2551 B.C.
	Cheops (Khufu)	CA. 2551–2528 B.C.
	Chephren (Khafre)	CA. 2520–2494 B.C.
	Mycerinus (Menkaure)	CA. 2490–2472 B.C.
	Dynasty 5	CA. 2465–2323 B.C.
	Userkaf	CA. 2465–2458 B.C.
	Menkauhor	CA. 2396–2388 B.C.
	Dynasty 6	CA. 2323–2150 B.C.
	Tety	CA. 2323–2291 B.C.
	Pepy II	CA. 2246–2152 B.C.
	Dynasties 7–8	CA. 2150–2134 B.C.
First Intermediate Period	Dynasties 9–10	CA. 2134–2040 B.C.
Middle Kingdom	Dynasty 11	CA. 2134–1991 B.C.
	Mentuhotep II	CA. 2061–2010 B.C.
	Dynasty 12	CA. 1991–1783 B.C.
	Amenemhat I (Ammenemes I)	CA. 1991–1962 B.C.
	Sesostris I (Senwosret I)	CA. 1971–1926 B.C.
	Sesostris III (Senwosret III)	CA. 1878–1841 B.C.
	Amenemhat III	
	(Ammenemes III)	CA. 1844–1797 B.C.
	Dynasty 13	CA. 1783–1633 B.C.
	Hor	
Second Intermediate Period	Dynasties 14–17	CA. 1786–1550 B.C.

Dynasty 18	CA. 1550–1307 B.C.	*New Kingdom*
Ahmose (Amasis I)	CA. 1550–1525 B.C.	
Amenhotep I (Amenophis I)	CA. 1525–1504 B.C.	
Tuthmosis I	CA. 1504–1492 B.C.	
Tuthmosis II	CA. 1492–1479 B.C.	
Hatshepsut	CA. 1473–1458 B.C.	
Tuthmosis III	CA. 1479–1425 B.C.	
Amenhotep II (Amenophis II)	CA. 1427–1401 B.C.	
Tuthmosis IV	CA. 1401–1391 B.C.	
Amenhotep III (Amenophis III)	CA. 1391–1353 B.C.	
Amenhotep IV	CA. 1353–1335 B.C.	
(Amenophis IV)/Akhenaten	(Amarna Period)	
Tutankhamun	CA. 1333–1323 B.C.	
Ay	CA. 1323–1319 B.C.	
Horemheb	CA. 1319–1307 B.C.	
Dynasty 19	CA. 1307–1196 B.C. (Ramesside)	
Ramesses I	CA. 1307–1306 B.C.	
Sety I (Sethos I)	CA. 1306–1290 B.C.	
Ramesses II	CA. 1290–1224 B.C.	
Dynasty 20	CA. 1196–1070 B.C. (Ramesside)	
Ramesses III	CA. 1194–1163 B.C.	

Dynasty 21	CA. 1070–945 B.C.	*Third Intermediate Period*
Dynasty 22	CA. 945–712 B.C.	
Osorkon II	CA. 883–855 B.C.	
Dynasty 23	CA. 828–712 B.C.	
Dynasty 24	CA. 724–712 B.C.	

Dynasty 25	CA. 750–657 B.C. (Kushite)	*Late Period*
Shabako	CA. 712–698 B.C.	
Shebitku (Shabataka)	CA. 698–690 B.C.	
Taharqa	CA. 690–664 B.C.	
Dynasty 26	664–525 B.C. (Saite)	
Psamtik I (Psammetichus I)	664–610 B.C.	
Apries	589–568 B.C.	
Amasis (Amasis II)	570–526 B.C.	
Dynasty 27	525–404 B.C. (Persian rule)	
Dynasty 28	404(?)–399 B.C.	
Dynasty 29	399–380 B.C.	
Dynasty 30	380–343 B.C.	
Nectanebo I (Nekhtnebef)	380–362 B.C.	
Nectanebo II (Nekhthorheb)	360–343 B.C.	
Second Persian conquest (sometimes called Dynasty 31)	342–332 B.C.	
Macedonian conquest	332–305 B.C.	
Alexander the Great	332–323 B.C.	
Ptolemaic Period (sometimes called Dynasty 31)	305–30 B.C.	
Ptolemy I Soter	305–284 B.C.	
Ptolemy II Philadelphus	285–246 B.C.	
Cleopatra VII	51–30 B.C.	
Roman conquest	30 B.C.	

Glossary

Akhenaten Tenth king of the Eighteenth Dynasty (CA. 1353–1335 B.C.) Son of Amenhotep III and Tiye; father of six daughters by his principal wife, Nefertiti; probably also the father of Tutankhamun by a minor wife. Ascending the throne as Amenhotep IV, he changed his name to honor his god, the Aten, whose cult he tried to establish over all other Egyptian gods. Founded the city of Akhetaten.

Akhetaten The residence city founded by Akhenaten at a site in Middle Egypt, now known as Amarna (see Map 1).

Amarna Modern name for the site where Akhenaten founded his residence city of Akhetaten.

Amarna Period Named for the site Amarna; used to designate the part of Akhenaten's reign spent here or, less accurately, the entire length of his rule.

Amenophis Greek version of an Egyptian name, often used in modern times for "Amenhotep," especially for Amenhotep III.

Amun The main god of Thebes, represented as a man with a crown bearing two tall plumes; also associated with a ram. His major temples were at Karnak and Luxor. During the New Kingdom and later, a major national god, often called Amun-Re.

Amunet A consort of Amun. Her name is a feminine version of his.

ankh The Egyptian word for "life," written with a loop-topped hieroglyphic sign, possibly derived from the shape of a sandal strap; from its written signification, this sign became the symbol of life, one of the most powerful and long-lived of all Egyptian symbols.

archaism The deliberate copying or evocation of works of earlier times; apparent in Egyptian art as early as the Old Kingdom and frequently thereafter. In the art of the Late Period, archaizing tendencies were pervasive.

atef An elaborate crown worn by the king and by certain gods.

back pillar The rectangular pillar carved at the back of many Egyptian stone statues.

beard Natural beards are rarely shown on sculpture (see nos. 25, 29). In the New Kingdom, especially, private individuals occasionally have a short chin beard, which is presumably real (no. 42). From the Old Kingdom on, the king often wears a long, square-ended artificial beard, fastened by a strap along the jawbone (no. 6). The divine beard, attached in the same way, was narrower and braided or bound in a plaited pattern with a rounded curl at the end (see no. 43). The divine beard could be worn by a king (see no. 18), or even a private person, in invocation of Osiris, with whom the dead were in some sense identified.

block statue A type of Egyptian statue, representing a man squatting on the ground, with his arms folded on his knees; the figure is often enveloped in a cloak (see nos. 74, 75, 84).

Blue Crown Egyptian *khepresh:* a helmet-shaped crown, colored blue and often covered with little disks or circles; first appears in the Eighteenth Dynasty (see no. 54).

Cachette *See* Karnak Cachette.

cartouche a hieroglyphic sign in the form of an oval doubled loop of rope with the ends bound together; encloses royal names and, in the Amarna Period, the names of the Aten.

Colossi of Memnon Two colossal seated statues of Amenhotep III, still in place at the entrance to the site of his funerary temple on the west bank of Thebes (see Map 2); only the northern statue was called Memnon by the Greeks and Romans, after the Greek mythological hero whose name sounded rather like their pronunciation of Amenhotep. This statue was famous for making a sound at dawn (probably due to expansion of the stone); this phenomenon was probably caused by an earthquake shortly after the Romans conquered Egypt and was inadvertently brought to an end when both statues were restored under Septimius Severus.

cosmetic line A line in relief or paint extending from the outer corner of the eye toward the temple, often as an extension of a rim along the upper eyelid and usually paralleled by an extension of the eyebrow above it; these lines have the look of applied cosmetics.

djed A pillar-shaped symbol, possibly to be identified as part of a spinal column, associated with Osiris; used for writing the word *djed,* "stability."

Double Crown A combination of the Red and White Crowns of Lower and Upper Egypt, symbolizing their union in one king; primarily a royal crown but also worn by a few deities, such as the goddess Mut.

double wig An elaborate wig represented on statues of men of the New Kingdom and later (see nos. 47, 63, 66, 78); its modern name derives from the contrasting textures of the strands of the upper part and the echeloned curls of the under sections beside the face, which, especially in the later New Kingdom, extend down as lappets onto the chest.

dynasty A ruling family; the dynasties of Egypt are arranged according to ancient Egyptian chronological records.

Fayum An oasislike region southeast of the Nile Delta (see Map 1).

Hathor One of the most important Egyptian goddesses; her main temple was at Dendera (see nos. 7, 75, 86).

Horus A god, the son of Osiris and Isis, associated with the living king and represented as a falcon (see no. 6) or a falcon-headed man. In the Late Period, he is often shown as a naked child (see no. 89), emphasizing his role as the son of Isis.

Hyksos Foreign rulers of Egypt during the Second Intermediate Period; designated as Dynasties 15 and 16 (CA. 1684–1550 B.C.).

Isis One of the great Egyptian goddesses, the wife of Osiris and the mother of Horus. In the former capacity, she acted as mourner for all the deceased. In the Late Period, she became increasingly popular as a maternal deity.

Itjet-tawy Residence city of kings of the Twelfth Dynasty, near the site of modern day Lisht (see Map 1).

ka A component of the spirit, sometimes described as the vital force (see no. 34).

Karnak Modern (Arabic) name for the area on the east bank of ancient Thebes that included the precinct of the great temple of Amun and other temples nearby, including the satellite precinct of the goddess Mut to the south (see Map 2).

Karnak Cachette A large deposit of statues and other temple objects, buried in antiquity in a courtyard of Karnak temple.

khepresh *See* Blue Crown.

Khonsu A lunar god, the son of Amun and Mut; he had a temple within the precinct of the Amun temple at Karnak (see no. 60).

Kush The ancient Egyptian name for much of the Nile Valley south of the ancient boundary at Aswan (see Map 1). *Also see* Nubia.

Kushite A person from Kush; often used to describe the Twenty-fifth Dynasty of rulers from Kush.

Lower Egypt The lower Nile valley in Egypt; northern Egypt (see Map 1).

Memnon *See* Colossi of Memnon.

Memphis Egypt's first and most important capital, traditionally founded by Menes, the first king of the First Dynasty; modern-day Mitrahineh, near Cairo (see Map 1).

menit A necklace made of many strands of little beads, with a round-ended counterweight; it was shaken like a rattle in temple ceremonies, particularly in honor of goddesses, and had strong religious symbolism (a hand-held *menit* is clearly visible in nos. 47, 63, and 71; one is worn by the god Khonsu on no. 60 and by a king on no. 29).

mummiform Wrapped like a mummy, so that arms and legs are bound and hidden; Osiris is usually shown mummiform, as in his representation on the skirts of nos. 66, 73.

Mut The reigning goddess at Thebes; her temple at Karnak lay just south of the temple of Amun, her consort. Her headdress is a Double Crown.

Nebmaatre The prenomen of Amenhotep III, one of his five names.

negative space Fill left to block the interstices of most Egyptian stone statues.

Nekhbet A goddess, usually shown as a vulture, who protected Upper Egypt; the counterpart of Wadjet.

nemes A king's headdress consisting of a cloth, often pleated, that entirely covered the head, with two lappets falling in front over the breast and the back bound into a clubbed queue; colored examples show alternating blue and yellow stripes. There are archaic forms at the beginning of the Old Kingdom (see no. 3), but the canonical shape was established by the Fourth Dynasty (see no. 6); from then until the end of the Ptolemaic Period, it was the royal headdress most frequently represented in sculpture.

nome Major administrative division or province of Egypt (the word is not Egyptian, but borrowed in modern times from Greek).

Nubia Modern name for the region south of the First Nile Cataract at Aswan, down to about the Fourth Cataract, a territory now divided between Egypt and the Sudan. Used with reference to ancient Egypt, it is a general designation of foreign lands to the immediate south.

nu-jar Small globular bowl with rimmed opening, used for offering milk and other liquids; held by Tuthmosis III in no. 39.

Nymaatre The prenomen of Amenemhat III.

Osiride In the form of the royal god of the dead, Osiris: with arms crossed over chest; sometimes, but not necessarily, mummiform (see. no. 18).

pharaoh An Egyptian word for king, beginning in the New Kingdom but in common use only from late in the Ptolemaic Period; derived from Per-aa, "Great House" or Palace, much as the president of the United States can be referred to as "the White House."

philtrum The vertical indentation between the nose and the upper lip.

provenance Where an ancient object comes from; usually where it was found.

Re The main solar deity and thus, in some respects, the premier god of Egypt. Other gods were sometimes exalted by being identified with him, especially Amun-Re.

Red Crown The Crown of Lower Egypt: a cylinder that flares somewhat to its top, which supports at the back a tall, narrow, slightly backward-slanting element; from the base of this emerges a very thin line like a wire, which curves forward and up and ends in a spiral; probably because of the obvious practical problems, this wirelike part is not represented on stone statues (see no. 18).

relief, raised and sunk Two-dimensional art created by carving the representations so that they have some degree of plasticity. Egyptian relief was ordinarily painted and may, indeed, be considered as primarily a kind of reinforced painting, made more permanent by being carved as well. In raised relief, the background is cut back so that the figures are raised. In sunk relief, a peculiarly Egyptian technique, the background is not cut down, but the figure is outlined by a sort of trench, within which it is modeled; the figures carved on nos. 27, 66, 73, and 89 are all in sunk relief.

Renenutet A maternal and harvest goddess, shown in the form of a cobra or a cobra-headed woman.

Saite Native to the city of Sais in the eastern Nile Delta (see Map 1); often applied to the Twenty-sixth Dynasty, a line of Saite princes.

seated scribe statue A type of statue that represents the subject seated crosslegged on the ground, usually with a papyrus scroll on his lap; not one of the most common statue types but among the longest lived. Beginning in the Fourth Dynasty, it continued to be made until after the fourth century B.C. (see nos. 16, 50, 83).

serdab Enclosed statue chamber in a tomb.

shawabti Statuette placed in the tomb (often in large numbers) to take the place of the deceased in performing certain manual tasks in the afterlife. Also written as *shabti, ushebti.*

sistrum A glorified rattle, often in the shape of a shrine, which, when shaken, produced a tinkling sound from metal disks strung on wires. Like the *menit,* it was a sacred instrument, most often played by women in religious ceremonies. It was very closely associated with the goddess Hathor.

Sobek A crocodile god, whose main temple was in the Fayum (see no. 46).

sphinx A lion with human head (and sometimes human arms: see nos. 36, 64); originated in the Fourth Dynasty as an emblem of royal might (see nos. 28, 37).

standard A religious emblem consisting of a tall slender pole topped with the head or figure of a god; standard-bearer statues support one or two of them (see nos. 29, 66).

stela A slab of stone or wood, with carved or painted figures and/or inscriptions; placed in tombs or temples, occasionally held by statues.

sunk relief *See* relief.

Thoth A major god, in the form of an ibis or an ibis-headed man. The baboon was also sacred to him. He was a lunar deity and the god of writing.

Upper Egypt The upper Nile valley in Egypt: southern Egypt.

uraeus The cobra at the forehead of kings, queens, and some deities.

Vizier The highest official of royal administration; in most periods there were two, one for Upper Egypt and one for Lower Egypt (see nos. 82, 83).

Wadjet A goddess, usually represented as a cobra, who protected Lower Egypt. *Also see* Nekhbet.

was A divine scepter with the head of an animal and a forked bottom; held, along with an *ankh* and a *djed,* in no. 60.

White Crown The crown of Upper Egypt: a tall white cylinder, which tapered gradually to the top and then widened to a small bulbous finial (see no. 22).

Documentation

The interested reader will find books of general interest listed here and at the start of every chapter heading below. English-language publications have been cited whenever possible. Those who want to read more will find that almost every book listed contains a bibliography or reading list. Full bibliographical data are given in the combined listing after this section.

For the individual statues, the aim has been to provide in each case one or two recent, reasonably accessible references in English, in which the reader can find further information and a complete bibliography. Unfortunately, this has not always been possible. A limited number of additional references note divergent opinions, new studies, and, occasionally, related material mentioned in the text.

History

No really good history of ancient Egypt exists in English. The reader should be cautious about depending on the numerous reprints of histories written fifty or even more years ago. A few of them may be classics, but all have been seriously outdated by subsequent excavations and research.

W. W. Hallo and W. K. Simpson, *The Ancient Near East: A History:* the most up to date; very concise (ends with the conquest of Alexander the Great).

The Cambridge Ancient History, 3d ed., vol. I, part 2: *Early History of the Middle East,* ed. I. E. S. Edwards, C. J. Gadd, and N. G. L. Hammond; vol. II, part 1: *History of the Middle East and the Aegean Region,* ed. Edwards, Gadd, Hammond, and E. Sollberger: thorough, but some chapters, which were written as early as the 1950s, are already slightly out of date.

General Reference and Cultural History

W. Y. Adams, *Nubia: Corridor to Africa.*

J. Baines and J. Málek, *Atlas of Ancient Egypt.*

W. C. Hayes, *The Scepter of Egypt:* through the New Kingdom only; heavy emphasis on cultural history, as illustrated in the Metropolitan Museum of Art, New York; somewhat out of date.

W. Helck, E. Otto, and W. Westendorf, eds., *Lexikon der Ägyptologie:* an encyclopedia of Egyptology, with entries in German, English, and French.

T. G. H. James, *Ancient Egypt: The Land and Its Legacy.*

B. G. Trigger, B. J. Kemp, D. O'Connor, and A. B. Lloyd, *Ancient Egypt: A Social History.*

Art History

W. S. Smith, *The Art and Architecture of Ancient Egypt:* this is the standard work covering all the arts of Egypt.

C. Aldred, *Egyptian Art:* more concise than Smith; omits the Ptolemaic and Roman periods.

H. Schäfer, *Principles of Egyptian Art:* deals primarily with two-dimensional representations but represents a unique attempt to analyze Egyptian art.

J. Vandier, *Manuel d'Archéologie Égyptienne,* vol. III: *Les Grandes Époques: La Statuaire:* a major research source for the Old through New Kingdoms.

Museum Catalogues

The museums in both Cairo and Luxor have excellent recent catalogues, which are highly recommended to anyone who is interested in any aspect of ancient Egypt or who plans to visit Egypt.

For Cairo: M. Saleh and H. Sourouzian, *The Egyptian Museum Cairo: Official Catalogue* (it is very frequently referred to below, cited as *Cairo*).

J.-P. Corteggiani, *The Egypt of the Pharaohs:* an unofficial catalogue, especially good for historical and archaeological details (cited below as *Corteggiani*).

For Luxor: Luxor Museum of Ancient Egyptian Art, *Catalogue* (cited below as *Luxor*).

<div style="text-align:center">

Chapter 1
The Art of Egyptian Sculpture

</div>

History

W. B. Emery, *Archaic Egypt:* the first dynasties.

M. A. Hoffman, *Egypt before the Pharaohs:* the predynastic period.

Sculpture Conventions

An elaborate, thin-walled stone vessel from the beginning of the Dynastic Period: Hayes, *Scepter of Egypt* I, fig. 31, p. 43; see also *Cairo,* no. 13. The Narmer palette, very frequently illustrated, may be found in *Cairo,* no. 8.

For archaic standing statues with negative space but without back pillar, the staff and baton held clumsily against the body, see the two statues of Sepa in the Louvre: Smith, *Art and Architecture of Ancient Egypt,* p. 68, fig. 57.

Examples of Egyptian statues in Hellenistic style but with back pillars include Ptolemaic royal portraits, such as two in Copenhagen, Ny Carlsberg Glyptothek AEIN 933 and AEIN 294: O. Koefoed-Petersen, *Catalogue des Statues et Statuettes Égyptiennes,* nos. 132, 134, pls. 138–139, 141; and Alexandria Museum 21992 (a queen as Isis, with uraeus and traditional crown): D. Wildung and G. Grimm, *Götter Pharaonen,* no. 117.

J. H. Breasted, Jr., *Egyptian Servant Statues:* illustrates many of the small subsidiary figures placed in tombs as servants; in contrast with the formal statues pictured and discussed in this book, they are shown in workaday poses, which are often asymmetrical and occasionally rather lively. Both stone and wood examples usually lack a back pillar or negative space.

H. G. Fischer, in *L'Écriture et l'Art de l'Égypte Ancienne,* discusses the relationship between art and hieroglyphic writing and, on pp. 55–58, how it influenced the advanced left leg on standing statues; on this subject, see also his *The Orientation of Hieroglyphs,* pp. 7–8.

The cloth that replaces the wand and staff on stone statues is discussed by H. G. Fischer, "An Elusive Shape within the Fisted Hands of Egyptian Statues," in *Ancient Egypt in the Metropolitan Museum Journal, Volumes 1–11 (1968–1976),* pp. 143–155.

A wealth of information about the meaning and manufacture of statues can be found in M. Eaton-Krauss, *The Representations of Statuary in Private Tombs of the Old Kingdom.*

<div style="text-align:center">

Chapter 2
The First Great Period

</div>

History

J. Malek, *In the Shadow of the Pyramids: Egypt during the Old Kingdom.*

Art History

C. Aldred, *Old Kingdom Art in Ancient Egypt.*

W. S. Smith, *A History of Egyptian Sculpture and Painting in the Old Kingdom.*

〚1〛 King Khasekhem: Cairo, JE 32161; from Hierakonpolis; *Cairo,* no. 14; *Corteggiani,* no. 8. The limestone statue of this king, also found at Hierakonpolis, is in Oxford, Ashmolean Museum 1896–1908 E.517: P. R. S. Moorey, *Ancient Egypt,* p. 25, fig. 9.

⟦2⟧ The funerary priest Hetepdief: Cairo, CG 1; from Memphis; *Cairo,* no. 22; *Corteggiani,* no. 9; E. L. B. Terrace and H. G. Fischer, *Treasures of the Cairo Museum,* no. 2, pp. 25–28.

⟦3⟧ King Djoser: Cairo, JE 49158; from Saqqara; *Cairo,* no. 16; *Corteggiani,* no. 10; C. M. Firth and J. E. Quibell, *The Step Pyramid,* I, pp. 9, 51; II, pls. 29, 30. The excavators of this statue, as well as Smith, *History of Egyptian Sculpture and Painting in the Old Kingdom,* p. 14, refer to the skin as yellow, but where best preserved the color appears as a rich red-brown.

⟦4⟧ Rahotep and his wife Nofret: Cairo, CG 3, 4; from Meidum; *Cairo,* no. 27; *Corteggiani,* no. 13. For a diadem very like Nofret's (although it was made centuries later for a princess and incorporates royal insignia), see *Cairo,* no. 112.

⟦5⟧ Reserve head: Cairo, JE 46216; from Giza; *Cairo,* no. 32. Reserve heads are discussed by Smith, *History of Egyptian Sculpture and Painting in the Old Kingdom,* pp. 23–30; for a recent assertion of the theory that they were sculptors' models, see N. B. Millet, "The Reserve Heads of the Old Kingdom," in *Studies in Ancient Egypt, the Aegean, and the Sudan: Essays in Honor of Dows Dunham,* ed. W. K. Simpson, pp. 129–131. Newly discovered traces suggest that at least one reserve head may originally have been painted: J. Knudsen, "A Question of Paint: An Investigation into Traces of Paint on the Reserve Head from the Tomb of Ka-nofer" and "Further Investigations into the Paint on the Reserve Head from the tomb of Ka-nofer."

⟦6⟧ King Chephren: Cairo, CG 14; from Giza, Chephren Valley Temple; *Cairo,* no. 31; *Corteggiani,* no. 16; Terrace and Fischer, *Treasures of the Cairo Museum,* no. 6, pp. 41–44. For Tutankhamun's lion throne, see *Cairo,* no. 179.

⟦7⟧ King Mycerinus with the goddess Hathor and the personification of Thebes: Cairo, JE 40678; from Giza, Mycerinus Valley Temple; G. A. Reisner, *Mycerinus,* pp. 41–42, pl. 38b. Compare *Cairo,* no. 33, another of the triads in this series; also Boston MFA 09.200: W. S. Smith, *Ancient Egypt as Represented in the Museum of Fine Arts, Boston,* fig. 23, p. 48.

⟦8⟧ Head of King Userkaf: Cairo, JE 90220; from Abusir; *Cairo,* no. 35; Terrace and Fischer, *Treasures of the Cairo Museum,* no. 9, pp. 53–56. Few would now accept the initial identification of this head as a representation of the goddess Neith: H. Ricke, "Der Kopf der Göttin Neith und der Untere Tempel," in *Das Sonnenheiligtum des Königs Userkaf,* vol. 2, *Die Funde,* ed. E. Edel et al., pp. 139–148.

⟦9⟧ The "Sheikh el Beled": Cairo, CG 34; from Saqqara, tomb of Ka-aper; *Cairo,* no. 40; *Corteggiani,* no. 48. For a recent attempt to date this statue to the Fourth Dynasty, see C. Vandersleyen, "La date du Cheikh el-Beled," *Journal of Egyptian Archaeology* 69 (London, 1983): 61–65. A statue that may represent the same individual as a young man: *Cairo,* no. 42.

⟦10⟧ Khnumhotep, a dwarf: Cairo, CG 144; from Saqqara; C. Vandersleyen, ed., *Das alte Ägypten,* no. 142b; Aldred, *Old Kingdom Art in Ancient Egypt,* no. 52; R. Engelbach, "Some Remarks on the *Ka*-statues of Abnormal Men in the Old Kingdom," *Annales du Service des Antiquités de l'Égypte* 38 (Cairo, 1938): pl. 36.

⟦11⟧ The funerary priest Kaemqed: Cairo, CG 119; from Saqqara; *Cairo,* no. 47.

⟦12⟧ The physician Nyankhre: Cairo, JE 53150; from Giza; J. Leclant, ed., *Le Temps des Pyramides,* fig. 196; Aldred, *Old Kingdom Art in Ancient Egypt,* no. 49; H. Junker, *Gîza XI,* pp. 87–91, pls. 9b, 10a–b; Engelbach, "Some Remarks on the *Ka*-statues of Abnormal Men in the Old Kingdom," pl. 37, 1.

⟦13⟧ Bust of a man: Cairo, JE 72221; from Giza; S. Hassan, *Excavations at Giza* V, p. 254, pl. 31; S. Donadoni, *Egyptian Museum Cairo,* p. 52. A scribe's statue of about the same date, with a similarly fleshy body and an individual, even bonier countenance is the famous "Scribe Rouge" in the Louvre: Aldred, *Old Kingdom Art in Ancient Egypt,* no. 40.

⟦14⟧ Seneb and his family: Cairo, JE 51281; from Giza; *Cairo,* no. 39; Terrace and Fischer, *Treasures of the Cairo Museum,* no. 12, pp. 65–68. For a

recent argument that Seneb's tomb and his statue were made during the Fourth Dynasty, see N. Cherpion, "De quand date la tombe du nain Seneb?" *Bulletin de l'Institut Français d'Archéologie Orientale du Caire* 84 (Cairo, 1984): 35–54. However, this has been decisively refuted by S. Falke, in an unpublished dissertation written for the Freie Universität, West Berlin.

⟦15⟧ Standing king: Cairo, JE 39103; from north Saqqara; J. E. Quibell, *Excavations at Saqqara (1906–7),* pp. 19–20, pls. 30(3), 31(2), 32(3). The suggestion that the statue may represent Menkauhor was made by J. Berlandini, "La pyramide 'ruinée' de Sakkara-Nord et le roi Ikaouhor-Menkaouhor," *Révue d'Égyptologie* 31 (Paris, 1979): 27.

⟦16⟧ Bust of Mitry as a scribe: Cairo, JE 93166; from Saqqara; Abd El Hamid Zayed, "Deux statues de scribe accroupi en bois (Mitri)," in *Trois Études d'Égyptologie,* pp. 17–18, figs. 12, 14, 15. Among the sizable wooden statues preserved in this tomb are the figure of a hunchback, Cairo, JE 52081: Engelbach, "Some Remarks on the *Ka*-statues of Abnormal Men in the Old Kingdom," pl. 37, 2; and standing figures of Mitry and his wife, several of which are in the Metropolitan Museum of Art, MMA 26.2.2-.4: Hayes, *Scepter of Egypt* I, 111–112, figs. 64, 65. Another statue of Mitry's wife: *Cairo,* no. 55.

⟦17⟧ Meryre-haishetef in the nude: Cairo, JE 46992; from Sedment; *Cairo,* no. 64. The two other nude wooden statues of Meryre-haishetef that were found with this one are British Museum 55722: T. G. H. James and W. V. Davies, *Egyptian Sculpture,* p. 24, fig. 22; and Copenhagen Ny Carlsberg Glyptothek AEIN 1560: Koefoed-Petersen, *Catalogue des Statues et Statuettes Égyptiennes,* no. 11, p. 12, pl. 13. Some examples of statues in late Old Kingdom style: Smith, *History of Egyptian Sculpture and Painting in the Old Kingdom,* pl. 26.

History

Dietrich Wildung, *Sesostris und Amenemhet.*

Art History

C. Aldred, *Middle Kingdom Art in Ancient Egypt.*

C. Aldred, "Some Royal Portraits of the Middle Kingdom in Ancient Egypt," in *Ancient Egypt in the Metropolitan Museum Journal, Volumes 1–11 (1968–1976),* pp. 1–24.

B. V. Bothmer, "Block Statues of the Egyptian Middle Kingdom," I, *Brooklyn Museum Bulletin* 20 (1959): 11–26; II, *Brooklyn Museum Annual* 2–3 (1960–1962): 19–35.

H. G. Evers, *Staat aus dem Stein: Denkmäler, Geschichte und Bedeutung der ägyptischen Plastik während des Mittleren Reichs:* one of the most important of Egyptian art historical studies; vol. 1 has a large collection of splendid plates, mostly of Middle Kingdom sculpture.

L. Habachi, *The Sanctuary of Heqaib:* an extraordinary group of excavated Middle Kingdom statues and reliefs.

⟦18⟧ King Mentuhotep II: Cairo, JE 36195; from Thebes, Deir el Bahri; *Cairo,* no. 67; Aldred, *Egyptian Art,* fig. 68, p. 109.

⟦19⟧ Hetep in sedan chair: Cairo, JE 48858; from Saqqara; Aldred, *Middle Kingdom Art in Ancient Egypt,* no. 36; Wildung, *Sesostris und Amenemhet,* p. 96, fig. 86. For the sedan chair of Cheops' mother, see *Cairo,* no. 29 (no. 62 shows one in use, but it is a full-sized chair, with a footrest). Hetep's statue has been called a precursor of the block statue, but the earliest known true block statue was made for an individual who was at least a contemporary of Hetep and perhaps somewhat older: Wildung, *Sesostris und Amenemhet,* pp. 98, 99, figs. 88, 89.

⟦20⟧ Osiride statue of King Sesostris I: Luxor Museum J. 174; from Thebes, Karnak; *Luxor,* no. 25, pp. 23–24.

Chapter 3
The Classic Period

⟦21⟧ Colossal statue of King Sesostris I: Cairo, JE 38287; from Thebes, Karnak; Leclant, ed., *Le Temps des Pyramides,* fig. 209, p. 211 (detail of head); Evers, *Staat aus dem Stein* I, pl. 34 (right).

⟦22⟧ King Sesostris I: Cairo, JE 44951; from Lisht; *Cairo,* no. 88. The Metropolitan Museum of Art pair to this, almost exactly like it except for a Red Crown, is MMA 14.3.17: Hayes, *Scepter of Egypt* I, fig. 117, p. 192. For a recent suggestion that the statues were made, not in the Twelfth, but in the Thirteenth Dynasty, see S. B. Johnson, "Two Wooden Statues from Lisht: Do They Represent Sesostris I?" *Journal of the American Research Center in Egypt* 17 (Locust Valley, N.Y., 1980): 11–20. The article is a useful reminder that archaeological evidence can be extremely ambiguous and must be evaluated with great care. But the style of these statues agrees much better with other statues of Sesostris I (for example, the torso of the seated statue MMA 25.6: Hayes, *Scepter of Egypt* I, fig. 110, p. 180) than with the more standardized figures of the following dynasty (such as no. 34 below). The faces of Sesostris I that most closely resemble this statue are to be found in relief: see Aldred, *Middle Kingdom Art in Ancient Egypt,* figs. 21 and, especially, 22.

⟦23⟧ Head of a woman: Cairo, JE 39390; from Lisht; *Cairo,* no. 89; Wildung, *Sesostris und Amenemhet,* fig. 74, p. 84. For the real gold hair rings of a princess who lived a little later in this dynasty, see C. Aldred, *Jewels of the Pharaohs,* p. 39.

⟦24⟧ Standing woman: Cairo, JE 34297; from Bersheh; unpublished. For a discussion of foreign-looking motifs in the Middle Kingdom, see Smith, *Art and Architecture of Ancient Egypt,* pp. 203–215, especially fig. 205A and B on p. 205, which reproduces patterns from the tomb of Hepdjefa at Asyut, very similar to those on this dress; also see M. C. Shaw, "Ceiling Patterns from the Tomb of Hepzefa," *American Journal of Archaeology* 74 (1970): 25–30. These patterns are not related to the designs, apparently based on beaded networks, on the dresses of some Middle Kingdom servant figures: Breasted, *Egyptian Servant Statues,* pls. 58–60. The most complete discussion of patterned fabrics is still E. Riefstahl, *Patterned Textiles in Pharaonic Egypt.*

⟦25⟧ Standing Hepkem: Cairo, CG 440; from Meir; L. Borchardt, *Statuen und Statuetten von Königen und Privatleuten,* II, pp. 42–43, pl. 73.

⟦26⟧ Head of King Sesostris III: Luxor Museum J. 34; from Thebes, Karnak; *Luxor,* no. 40, pp. 32–35.

⟦27⟧ Seated King Amenemhat III: Cairo, CG 385; from Hawara; Wildung, *Sesostris und Amenemhet,* fig. 181, p. 207; Aldred, *Middle Kingdom Art in Ancient Egypt,* figs. 61, 62, 64.

⟦28⟧ King Amenemhat III as a sphinx: Cairo, CG 394; from Tanis; *Cairo,* no. 102. On its possible propagandistic aspects, see D. Wildung, *Egyptian Saints: Deification in Pharaonic Egypt,* pp. 199–200.

⟦29⟧ King Amenemhat III as a priest: Cairo, CG 395; from the Fayum; *Cairo,* no. 103; *Corteggiani,* no. 42; Terrace and Fischer, *Treasures of the Cairo Museum,* no. 17, pp. 85–88.

⟦30⟧ Head of the god Amun: Cairo, TR 13/4/22/9; provenance not known; Wildung, *Sesostris und Amenemhet,* fig. 61, p. 68; E. Drioton, *Le Musée du Caire,* no. 50.

⟦31⟧ Seated cloaked man: Cairo, CG 42041; from Thebes, Karnak; G. Legrain, *Statues et Statuettes des Rois et des Particuliers* I, pp. 24–25, pl. 25.

⟦32⟧ Khentykhetyemsaef-seneb: Cairo, CG 408; from Abusir or north Saqqara; Wildung, *Sesostris und Amenemhet,* fig. 9, p. 18; Borchardt, *Statuen und Statuetten von Königen und Privatleuten,* II, p. 20, pl. 67.

⟦33⟧ Sikaherka: Cairo, JE 43928; from Thebes, Karnak; *Corteggiani,* no. 38; Terrace and Fischer, *Treasures of the Cairo Museum,* no. 18, pp. 89–92.

⟦34⟧ *Ka*-statue of King Hor: Cairo, CG 259; from Dahshur; *Cairo,* no. 117; *Corteggiani,* no. 44.

⟦35⟧ Head of a king: Cairo, JE 54857; from Medamud; Service des Antiquités de l'Égypte, *Centenaire de l'Institut Français d'Archéologie Orientale,* no. 58, pp. 92–93.

History

T. G. H. James, *Pharaoh's People: Scenes from Life in Imperial Egypt.*

D. B. Redford, *History and Chronology of the Eighteenth Dynasty of Egypt.*

The excavation of the Karnak Cachette is described by C. Traunecker and J.-C. Golvin, *Karnak: Résurrection d'un Site,* pp. 169–174.

Art History

C. Aldred, *New Kingdom Art in Ancient Egypt during the Eighteenth Dynasty.*

J. Malek, "The Saqqara Statue of Ptahmose, Mayor of the Memphite Suburbs," *Révue d'Égyptologie* 38 (Paris, 1987): 117–137: very interesting findings on the important and complicated relationship between statue types and their locations, a subject that has been very little studied.

M. Müller, *Die Kunst Amenophis' III. und Echnatons.*

⟦36⟧ Amenhotep I as a sphinx: Cairo, CG 42033; from Thebes, Karnak Cachette; I. Lindblad, *Royal Sculpture of the Early Eighteenth Dynasty in Egypt,* p. 37–38, pl. 20.

⟦37⟧ Queen Hatshepsut as a sphinx: Cairo, JE 53113; from Thebes, Deir el Bahri; *Corteggiani,* no. 48; R. Tefnin, *La Statuaire d'Hatshepsout,* pp. 129–133, pls. 31b–32. The pair to this sphinx (more heavily restored) is Metropolitan Museum of Art 31.3.94: Aldred, *Egyptian Art,* fig. 115, p. 154, and *New Kingdom Art in Ancient Egypt,* fig. 24.

⟦38⟧ Senenmut with the Princess Neferure: Cairo, CG 42116; from Thebes, Karnak Cachette; Terrace and Fischer, *Treasures of the Cairo Museum,* no. 20, pp. 97–100. A limestone statuette of a nursing woman in this pose is Brooklyn Museum 51.224: J. Cooney, *Five Years of Collecting Egyptian Art,* no. 4, pp. 4–5, pl. 13. A number of Senenmut's numerous statues are illustrated in B. V. Bothmer, "More Statues of Senenmut," *Brooklyn Museum Annual* 11 (1969–1970): 124–143. For his career and monuments, see P. Dorman, *The Monuments of Senenmut.*

⟦39⟧ King Tuthmosis III kneeling: Cairo, JE 43507A; from Deir el Medina; *Cairo,* no. 135; *Corteggiani,* no. 49.

⟦40⟧ King Tuthmosis III standing: Cairo, CG 42053; from Thebes, Karnak Cachette; *Cairo,* no. 133 (number wrongly given as CG 42035); Smith, *Art and Architecture of Ancient Egypt,* fig. 231, p. 237.

⟦41⟧ Queen Isis, mother of King Tuthmosis III: Cairo, CG 42072; from Thebes, Karnak Cachette; *Cairo,* no. 137.

⟦42⟧ Djehuty kneeling with altar: Cairo, CG 42123; from Thebes, Karnak; Aldred, *New Kingdom Art in Ancient Egypt,* no. 41.

⟦43⟧ Standing god: Cairo, CG 38068; from Thebes, Karnak, 1860; Vandersleyen, *Das alte Ägypten,* no. 182; G. Daressy, *Statues de Divinités,* pl. 6. The god has usually been identified as Tatenen or Ptah-Tatenen, but H. A. Schlögl, *Der Gott Tatenen nach Texten und Bildern des Neuen Reiches,* pp. 103–104, argues that he cannot be. For a recent discussion of the penis sheath, see J. Baines, "Ankh-sign, Belt, and Penis Sheath," *Studien zur Altägyptischen Kultur* 3 (Hamburg, 1975): 1–24.

⟦44⟧ King Tuthmosis IV with a standard: Cairo, JE 43611; from Thebes, Karnak; B. M. Bryan, "Portrait Sculpture of Thutmose IV," *Journal of the American Research Center in Egypt* 24 (1987): 12–20, figs. 20–24, 26. Later kings were sometimes represented worshiping their own statues; for an example (Ramesses II), see Wildung, *Egyptian Saints,* fig. 23, p. 26.

⟦45⟧ King Amenhotep III and Queen Tiye: Cairo, JE 33906; from Thebes, funerary temple of Amenhotep III; M. Müller, *Die Kunst Amenophis' III. und Echnatons,* IV-21–IV-22; because of the difficulties of photographing it, this statue has seldom been published. A good picture of it in its museum setting is given in the frontispiece of Donadoni, *Egyptian Museum Cairo.*

⟦46⟧ King Amenhotep III with the god Sobek: Luxor Museum J. 155; from Dahamsha, the ancient Sumenu; *Luxor*, no. 107, pp. 82–84; M. Müller, *Die Kunst Amenophis' III. und Echnatons,* IV-35.

⟦47⟧ Khaemwaset and Menena: Cairo, JE 87911; from Bubastis; *Cairo,* no. 152; L. Habachi, *Tell Basta,* pls. 39, 40, 41A, pp. 104–106.

⟦48⟧ Tjay: Cairo, JE 33255; from Saqqara; *Cairo,* no. 153; *Corteggiani,* no. 61. For a real gold necklace of the same type (but a more sumptuous, royal version), see *Cairo,* no. 240. The corpulent (headless) statue of Amenhotep III, Metropolitan Museum of Art 30.8.74: Aldred, *New Kingdom Art in Ancient Egypt,* fig. 80; Hayes, *Scepter of Egypt* II, fig. 142, p. 237.

⟦49⟧ Face of a man: Cairo, JE 34536; purchased at Thebes; unpublished.

⟦50⟧ Amenhotep son of Hapu as a scribe: Cairo, JE 44861; from Thebes, Karnak; *Cairo,* no. 148; Terrace and Fischer, *Treasures of the Cairo Museum,* no. 25, pp. 117–120. The pair to this statue, formerly Cairo, JE 44862, is now Luxor Museum J. 4: *Luxor* no. 117, pp. 90–91, pl. 8. For a picture of the two statues as they were found, see Traunecker and Golvin, *Karnak,* p. 182, fig. 168.

⟦51⟧ Amenhotep son of Hapu as an old man: Cairo, CG 42127; from Thebes, Karnak; *Cairo,* no. 149; Wildung, *Sesostris und Amenemhet,* fig. 203, p. 234 (calling it a usurped Middle Kingdom statue, an opinion rejected here). The standing statue of Amenhotep son of Hapu with Middle Kingdom wig and pose is well illustrated in Drioton, *Le Musée du Caire,* fig. 87. For a summary of the man's career and an account of his deification, see Wildung, *Egyptian Saints,* pp. 83–109.

⟦52⟧ Tama: Cairo, JE 35057; from Hawaret el Gurob, Fayum; *Cairo,* no. 154.

**Chapter 5
Revolution and Aftermath**

History

C. Aldred, *Akhenaten: King of Egypt.*

T. G. H. James, *Pharaoh's People.*

K. A. Kitchen, *Pharaoh Triumphant: The Life and Times of Ramesses II, King of Egypt.*

K. A. Kitchen, *The Third Intermediate Period in Egypt.*

D. B. Redford, *Akhenaten, the Heretic King.*

Art History

C. Aldred, *Akhenaten and Nefertiti.*

C. Aldred, *New Kingdom Art in Ancient Egypt.*

M. Müller, *Die Kunst Amenophis' III. und Echnatons.*

⟦53⟧ Colossal statue of King Akhenaten: Cairo, JE 49529; from Thebes, Karnak; M. Müller, *Die Kunst Amenophis' III. und Echnatons,* IV-114; Smith, *Art and Architecture of Ancient Egypt,* fig. 293, p. 300. For views of all three of the best preserved of these colossi and a few of the elaborate suggestions that attempt to explain some of their oddities, see Aldred, *Akhenaten,* pls. 33–35.

⟦54⟧ Head of King Akhenaten: Cairo, JE 67921A; from Amarna or its vicinity; *Corteggiani,* no. 62; M. Müller, *Die Kunst Amenophis' III. und Echnatons,* IV-120; R. Engelbach, "A Limestone Head of King Akhenaten in the Cairo Museum," *Annales du Service des Antiquités de l'Égypte* 38 (Cairo, 1938): 95–107.

⟦55⟧ Unfinished head of Queen Nefertiti: Cairo, JE 59286; from Amarna, sculptor's workshop; *Cairo,* no. 161; *Corteggiani,* no. 63; M. Müller, *Die Kunst Amenophis' III. und Echnatons,* IV-116; Aldred, *Akhenaten and Nefertiti,* fig. 36, p. 59.

⟦56⟧ Elderly man of Amarna: Cairo, JE 53249; from Amarna; Aldred, *New Kingdom Art in Ancient Egypt,* no. 142; H. Frankfort, "Preliminary Report on the Excavations at El-ʿAmarnah, 1928–9," *Journal of Egyptian Archaeology* 15 (London, 1929): 149, pls. 20, 21.

〚57〛 Head of an aged royal person: Cairo, JE 37930; provenance not known; M. Müller, *Die Kunst Amenophis' III. und Echnatons,* IV-102–IV-104. The author reviews earlier theories about alterations to the head and its identification as Ay. Although in general agreeing with them, she refuses to connect the forehead boss with a uraeus. For the famous wooden head of the aged Queen Tiye (West Berlin 21834), see Müller and Settgast, *Nofretete Echnaton,* no. 74; Aldred, *Akhenaten and Nefertiti,* cat. no. 19 and color pl. opposite p. 80.

〚58〛 Half-length figure of King Tutankhamun: Cairo, T. 16; from Thebes, Valley of the Kings, tomb of Tutankhamun; Donadoni, *Egyptian Museum Cairo,* p. 118; H. Carter and A. Mace, *The Tomb of Tut-ankh-Amen,* I, pl. 25. The famous gold mummy mask: *Cairo,* no. 174; also pl. 12, no. 25, in the catalogue of the Tutankhamun exhibition sent to the United States in the 1970s: *Treasures of Tutankhamun;* earrings designed for large earlobe perforations are also shown here, on pl. 17 (cat. no. 29), and in Aldred, *Jewels of the Pharaohs,* pls. 121, 122.

〚59〛 Colossal statue of King Tutankhamun: Cairo, JE 59869; from Thebes, vicinity of Medinet Habu; *Cairo,* no. 173.

〚60〛 The god Khonsu with the face of Tutankhamun: Cairo, CG 38488; from Thebes, Karnak temple of Khonsu; Donadoni, *Egyptian Museum Cairo,* p. 131; Daressy, *Statues de Divinités,* p. 131, pl. 28. G. Maspero, "La statue de Khonsu," *Annales du Service des Antiquités de l'Égypte* 3 (Cairo, 1902): 181, saw the features as those of a consumptive.

〚61〛 The god Amun with the features of Tutankhamun: Thebes, in Karnak temple; M. Eaton-Krauss, "Tutankhamun at Karnak," *Karnak* 9 (forthcoming): nn. 5, 17; P. Barguet, *Le Temple d'Amon-Rê à Karnak,* p. 133, frontispiece, and pl. 22, 1.

〚62〛 Amunet, the consort of Amun: Thebes, in Karnak temple; Eaton-Krauss, "Tutankhamun at Karnak," nn. 5, 17; Barguet, *Le Temple d'Amon-Rê à Karnak,* p. 133, pl. 22, 2; G. Legrain, "Rapport sur les travaux exécutés à Karnak," *Annales du Service des Antiquités de l'Égypte* 5 (Cairo, 1904): 30, pl. 4, 2, records the finding of the statue's head.

〚63〛 Nakhtmin and his wife: Cairo, CG 779A-B; provenance not known; *Cairo,* nos. 195, 196; *Corteggiani,* no. 78; Terrace and Fischer, *Treasures of the Cairo Museum,* no. 31, pp. 137–140. For an actual example of a *menit* necklace (Metropolitan Museum of Art 11.215.453), see Aldred, *Jewels of the Pharaohs,* pl. 114; Hayes, *Scepter of Egypt* II, fig. 153, p. 253.

〚64〛 Sphinx, probably King Horemheb: Thebes, in Karnak temple; G. Legrain, *Les Temples de Karnak,* pp. 65–66, fig. 49; on later use of the sphinx, see J. Lauffray, "La colonnade-propylée occidentale de Karnak dite 'kiosque de Taharqa' et ses abords," *Kêmi* 20 (Paris, 1970): 140–141, fig. 31.

〚65〛 Head of the goddess Mut: Cairo, CG 602; from Thebes, Karnak; J. Leclant, ed., *L'Empire des Conquérants,* fig. 169; R. Hari, *Horemheb et la Reine Moutnedjmet, ou la fin d'une Dynastie,* pp. 203–206, figs. 46–48.

〚66〛 Man bearing a standard: Cairo, CG 42194; from Thebes, Karnak Cachette; *Corteggiani,* no. 96; M. S[eidel] in Müller and Settgast, *Nofretete Echnaton,* no. 69.

〚67〛 Composite statue of King Sety I: Cairo, CG 42139; from Thebes, Karnak Cachette; *Cairo,* no., 201; *Corteggiani,* no. 81.

〚68〛 Head of King Ramesses II: Cairo, CG 824; provenance not known; Borchardt, *Statuen und Statuetten von Königen und Privatleuten,* III, pp. 113–114, pl. 152.

〚69〛 Bust of King Ramesses II from a seated colossus: Thebes, at the Ramesseum; C. Leblanc, "Diodore, le tombeau d'Osymandyas et la statuaire du Ramesseum," *Mélanges Gamal Eddin Mokhtar* 2 (Cairo, 1985): 69–82, pl. 1; Smith, *Art and Architecture of Ancient Egypt,* fig. 354, p. 361. The statues on the façade of Abu Simbel are very frequently illustrated; for example, Smith, *Art and Architecture of Ancient Egypt,* fig. 352, p. 359; Aldred, *Egyptian Art,* fig. 155, p. 190.

〚70〛 Head of King Ramesses II from a seated colossus: Thebes, at the Ramesseum; Leblanc, "Diodore, le tombeau d'Osymandyas et la statuaire du Ramesseum," pp. 69–82, pl. 6.

⟦71⟧ A queen of Ramesses II: Cairo, CG 600; from Thebes, the vicinity of the Ramesseum; *Cairo,* no. 208: calls her Merytamun, following C. Desroches-Noblecourt in the exhibition catalogue *The Great Pharaoh Ramses II and His Time,* no. 28. The identification is based on comparison with titles on a colossal statue of Merytamun, recently found at Akhmim; for this, see K. P. Kuhlmann, *Materialien zur Archäologie und Geschichte des Raumes von Achmim,* pp. 16–17; in n. 63, he compares the two inscriptions and sensibly concludes that, while they may designate the same woman, they are not conclusive proof of identity. For the *menit* necklace, see the comments to no. 63 above.

⟦72⟧ King Osorkon II presenting a sacred boat: Cairo, CG 42197; from Thebes, Karnak Cachette; *Corteggiani,* no. 97. For a figure of Ramesses II in a similar pose, see *The Great Pharaoh Ramses II and His Time,* no. 64.

⟦73⟧ Lady Shebensopdet: Cairo, CG 42228; from Thebes, Karnak Cachette; *Corteggiani,* no. 98; R. El Sayed, "Un noble dame de la XXIIème dynastie," *Annales du Service des Antiquités de l'Égypte* 65 (Cairo, 1983): 111–125.

⟦74⟧ Block statue of Nebnetjeru: Cairo, CG 42225; from Thebes, Karnak Cachette; H. Kees, "Zu dem Lebensregeln des Amonspriesters Nebneteru (Kairo Cat. 42225)," *Zeitschrift für Ägyptische Sprache und Altertumskunde* 88 (Berlin, 1963): 24–26; Legrain, *Statues et Statuettes des Rois et des Particuliers* III, pp. 58–62, pl. 32.

⟦75⟧ Block statue of Djedkhonsuiufankh: Cairo, CG 42211; from Thebes, Karnak Cachette; Legrain, *Statues et Statuettes des Rois et des Particuliers* III, pp. 28–32, pl. 20.

**Chapter 6
Egypt the Ancestor**

History

A. K. Bowman, *Egypt after the Pharaohs, 332 B.C.–A.D. 642.*

S. Hochfield and E. Riesfstahl, eds., *Africa in Antiquity: The Arts of Ancient Nubia and the Sudan,* vol. I, *The Essays.*

N. Lewis, *Life in Egypt under Roman Rule.*

Art History

B. V. Bothmer, et al., comp. *Egyptian Sculpture of the Late Period, 700 B.C. to A.D. 100:* a pioneering study and still the standard work on Late Period art.

G. Grimm, *Kunst der Ptolemäer- und Römerzeit im Ägyptischen Museum Kairo.*

S. Wenig, *Africa in Antiquity: The Arts of Ancient Nubia and the Sudan,* vol. II, *The Catalogue.*

⟦76⟧ Head of a Kushite king: Cairo, CG 1291; provenance not known; Wenig, *Africa in Antiquity,* II, p. 51, fig. 25; Wildung and Grimm, *Götter Pharaonen,* no. 67; E. R. Russmann, *The Representation of the King in the XXVth Dynasty,* no. 29, p. 53, fig. 7.

⟦77⟧ Djedasetiufankh with an offering table: Cairo, 4/6/24/7 = JE 38043; from Thebes, Karnak Cachette; Vandersleyen, *Das alte Ägypten,* fig. 215. Statues holding an offering table are discussed by J. Dittmar, "Ein Bruchstück einer opfernden Figur in der Tübinger Sammlung," *Göttinger Miszellen* 41 (Göttingen, 1980): 21–32; she lists this figure as her no. 20.

⟦78⟧ The Mayor of Thebes Mentuemhat: Cairo, CG 42236; from Thebes, Karnak Cachette; *Cairo,* no. 246. For Mentuemhat's career and monuments, see J. Leclant, *Montouemhat: Quatrième Prophète d'Amon, Prince de Ville;* for another representation of him, see the comments to no. 80 below.

⟦79⟧ Bust of Mentuemhat: Cairo, CG 647; from Thebes, Karnak temple of Mut; *Corteggiani,* no. 101; Terrace and Fischer, *Treasures of the Cairo Museum,* no. 37, pp. 161–164.

⟦80⟧ Standing High Priest of Amun Horemakhet: Cairo, CG 42204; from Thebes, Karnak Cachette; J. Leclant, ed., *L'Égypte du Crépuscule,* fig. 122;

Terrace and Fischer, *Treasures of the Cairo Museum,* no. 36, pp. 157–160. Horemakhet is represented on a papyrus in the Brooklyn Museum (no. 47.218.3), taking part in a procession at Karnak, which occurred on 4 October 651 B.C. He is third in precedence after Mentuemhat and his son and is shown with a brown skin, darker than their reddish color: Smith, *Art and Architecture of Ancient Egypt,* fig. 386, p. 393.

〚81〛 Iriketakana; Cairo, JE 38018; from Thebes, Karnak Cachette; Aldred, *Egyptian Art,* fig. 183, p. 220; Wenig, *Africa in Antiquity,* II, p. 172, no. 83.

〚82〛 The Vizier Nespakashuty: Cairo, JE 37000; from Thebes, Karnak Cachette; unpublished.

〚83〛 Nespakashuty as a scribe: Cairo, JE 36662; from Thebes, Karnak Cachette; Aldred, *Egyptian Art,* fig. 190, p. 229; Wildung and Grimm, *Götter Pharaonen,* no. 70 (the illustration has an interesting error: a designer, blocking out the background to "silhouette" the statue, has carefully removed the negative space between arms and torso).

〚84〛 Block statue of Pakhraf: Cairo, JE 37171; from Thebes, Karnak Cachette; E. Pernigotti, "Una statua di Pakhraf," *Rivista degli Studi Orientali* 44 (Rome, 1969): 259–271.

〚85〛 The Divine Consort Ankhnesneferibre: Cairo, CG 42205; from Thebes, Karnak Cachette; Vandersleyen, *Das alte Ägypten,* fig. 221; Drioton, *Le Musée du Caire,* fig. 172.

〚86〛 Psamtik protected by Hathor: Cairo, CG 784; from Saqqara; *Cairo,* no. 251; Aldred, *Egyptian Art,* fig. 192, p. 231; Terrace and Fischer, *Treasures of the Cairo Museum,* no. 38, pp. 165–168. The seated figures of Isis and Osiris found with this statue: *Cairo,* nos. 250, 252. For a New Kingdom statue of Tuthmosis III in front of the Hathor cow, see *Cairo,* no. 138.

〚87〛 Psamtik-sa-Neith with a shrine: Cairo, CG 726; from Memphis; Terrace and Fischer, *Treasures of the Cairo Museum,* no. 39, pp. 169–172; Bothmer, *Egyptian Sculpture of the Late Period,* no. 65, pp. 78–79, pls. 61–62.

〚88〛 Old man in a cloak; Cairo, CG 140; from Abusir; Borchardt, *Statuen und Statuetten von Königen und Privatleuten,* I, pp. 103–104, pl. 31 (misdated as Old Kingdom). The costume is discussed by R. S. Bianchi, "The Striding Draped Male Figure of Ptolemaic Egypt," in *Das ptolemäische Ägypten,* ed. H. Maehler and V. M. Strocka, pp. 95–102, with reference to this statue on p. 100. For the Saite version of the cloak, see Smith, *Art and Architecture of Ancient Egypt,* fig. 393, p. 399.

〚89〛 Healing statue of Djedhor: Cairo, JE 46341; from Tell Atrib; *Corteggiani,* no. 113; E. Jelinkova-Reymond, *Les Inscriptions de la Statue Guerisseuse de Djed-Her-le-Sauveur.* For the inscriptions on this statue, and those on a fragment from another statue of the same man, see E. J. Sherman, "Djedhor the Saviour, Statue Base OI 10589," *Journal of Egyptian Archaeology* 67 (London, 1981): 82–102.

〚90〛 Bust of a girl: Cairo, 5/3/25/7; provenance not known; Leclant, *L'Égypte du Crépuscule,* fig. 148; Bothmer, *Egyptian Sculpture of the Late Period,* no. 122, pp. 157–158, pls. 122–123.

〚91〛 Head with a laurel wreath: Cairo, JE 65424A; from the Fayum, Tell Umm el-Breigat (ancient Tebtunis); Terrace and Fischer, *Treasures of the Cairo Museum,* no. 42, pp. 181–184.

〚92〛 Horsihor: Cairo, CG 697; from Alexandria; Leclant, *L'Égypte du Crépuscule,* fig. 146; Grimm, *Kunst der Ptolemäer- und Römerzeit im Ägyptischen Museum Kairo,* no. 16; Terrace and Fischer, *Treasures of the Cairo Museum,* no. 41, pp. 177–180.

Bibliography

Adams, W. Y. *Nubia: Corridor to Africa.* London: Allen Lane, 1977.

Aldred, C. *Akhenaten: King of Egypt.* London, 1988.

———. *Akhenaten and Nefertiti.* New York: Viking Press, 1973.

———. *Egyptian Art.* London: Thames & Hudson, 1980.

———. *Jewels of the Pharaohs: Egyptian Jewellery of the Dynastic Period.* London: Thames & Hudson, 1971.

———. *Middle Kingdom Art in Ancient Egypt.* London: Academy Editions, 1956.

———. *New Kingdom Art in Ancient Egypt during the Eighteenth Dynasty.* London: Academy Editions, 1961.

———. *Old Kingdom Art in Ancient Egypt.* London: Academy Editions, 1949.

———. "Some Royal Portraits of the Middle Kingdom in Ancient Egypt." In *Ancient Egypt in the Metropolitan Museum Journal, Volumes 1–11 (1968–1976).* New York: Metropolitan Museum of Art, 1977. Reprinted from *Metropolitan Museum Journal* 3 (1970): 27–50.

Baines, J. "Ankh-sign, Belt, and Penis Sheath." *Studien zur Altägyptischen Kultur* 3 (Hamburg: Helmut Buske Verlag, 1975): 1–24.

Baines, J., and J. Málek. *Atlas of Ancient Egypt.* New York: Facts on File, 1980.

Barguet, P. *Le Temple d'Amon-Rê à Karnak.* Recherches d'Archéologie, de Philologie et d'Histoire, 21. Cairo: Institut Français d'Archéologie Orientale, 1962.

Berlandini, J. "La pyramide 'ruinée' de Sakkara-Nord et le roi Ikaouhor-Menkaouhor." *Révue d'Égyptologie* 31 (Paris: Éditions Klincksieck, 1979): 3–28.

Bianchi, R. S. "The Striding Draped Male Figure of Ptolemaic Egypt." In *Das ptolemäische Ägypten,* ed. H. Maehler and V. M. Strocka. Mainz: Verlag Philipp von Zabern, 1978.

Borchardt, L. *Statuen und Statuetten von Königen und Privatleuten.* Catalogue Général des Antiquités Égyptiennes du Musée du Caire. 5 parts. Berlin: Reichsdrucherer, 1911–1936.

Bothmer, B. V. "Block Statues of the Egyptian Middle Kingdom." I, *Brooklyn Museum Bulletin* 20 (1959): 11–26; II, *Brooklyn Museum Annual* 2–3 (1960–1962): 19–35.

———. "More Statues of Senenmut." *Brooklyn Museum Annual* 11 (1969–1970): 124–143.

Bothmer, B. V., et al., comps. *Egyptian Sculpture of the Late Period, 700 B.C. to A.D. 100.* Brooklyn: Brooklyn Museum, 1960. Reprint New York: Arno Press, 1969.

Bowman, A. K. *Egypt after the Pharaohs, 332 B.C.–A.D. 642.* Berkeley: University of California Press, 1986.

Breasted, J. H., Jr. *Egyptian Servant Statues.* New York: Pantheon, 1948.

Bryan, B. M. "Portrait Sculpture of Thutmose IV." *Journal of the American Research Center in Egypt* 24 (1987): 3–29.

The Cambridge Ancient History. 3d ed. Vol. I, part 2: *Early History of the Middle East,* ed. I. E. S. Edwards, C. J. Gadd, and N. G. L. Hammond. Cambridge: Cambridge University Press, 1971. Vol. II, part 1: *History of the Middle East and the Aegean Region,* ed. Edwards, Gadd, Hammond, and E. Sollberger. Cambridge: Cambridge University Press, 1973.

Carter, H., and A. Mace. *The Tomb of Tut-ankh-Amen.* London: Cassell and Co., 1923.

Cherpion, N. "De quand date la tombe du nain Seneb?" *Bulletin de l'Institut Français d'Archéologie Orientale du Caire* 84 (Cairo, 1984): 35–54.

Cooney, J. *Five Years of Collecting Egyptian Art.* Brooklyn: Brooklyn Museum, 1956.

Corteggiani, J.-P. *The Egypt of the Pharaohs at the Cairo Museum.* London: Scala Books, 1987.

Daressy, G. *Statues de Divinités.* Catalogue Général des Antiquités Égyptiennes du Musée du Caire. Cairo: Institut Français d'Archéologie Orientale, 1906.

Dittmar, J. "Ein Bruchstück einer opfernden Figur in der Tübinger Samm-
 lung." *Göttinger Miszellen* 41 (Göttingen: Ägyptologisch Seminar
 der Universität Göttingen, 1980): 21–32.

Donadoni, S. *Egyptian Museum Cairo.* New York: Newsweek, 1972.

Dorman, P. *The Monuments of Senenmut: Problems in Historical Methodology.*
 London and New York: Kegan Paul International, 1988.

Drioton, E. *Le Musée du Caire. Encyclopédie Photographique de l'Art.* Paris:
 Éditions "Tel," 1949.

Eaton-Krauss, M. *The Representations of Statuary in Private Tombs of the Old
 Kingdom.* Ägyptologische Abhandlungen 39. Wiesbaden: Verlag
 Otto Harrassowitz, 1984.

———. "Tutankhamun at Karnak." *Karnak* 9 (forthcoming).

El Sayed, R. "Un noble dame de la XXIIème dynastie." *Annales du Service
 des Antiquités de l'Égypte* 65 (Cairo, 1983): 111–125.

Emery, W. B. *Archaic Egypt.* Gloucester, Mass.: Peter Smith Publisher, 1963.

Engelbach, R. "A Limestone Head of King Akhenaten in the Cairo Mu-
 seum." *Annales du Service des Antiquités de l'Égypte* 38 (Cairo, 1938):
 95–107.

———. "Some Remarks on the *Ka*-statues of Abnormal Men in the Old
 Kingdom." *Annales du Service des Antiquités de l'Égypte* 38 (Cairo,
 1938): pl. 36.

Evers, H. G. *Staat aus dem Stein: Denkmäler, Geschichte und Bedeutung der
 ägyptischen Plastik während des Mittleren Reichs.* 2 vols. Munich:
 Verlag F. Bruckmann A-G, 1929.

Firth, C. M., and J. E. Quibell. *The Step Pyramid.* 2 vols. Cairo: Service des
 Antiquités de l'Égypte, 1935.

Fischer, H. G. *L'Écriture et l'Art de l'Égypte Ancienne.* Paris: Presses
 Universitaires de France, 1986.

———. "An Elusive Shape within the Fisted Hands of Egyptian Statues."
 In *Ancient Egypt in the Metropolitan Museum Journal, Volumes 1–11
 (1968–1976).* New York, 1977. Reprinted from *Metropolitan Mu-
 seum Journal* 10 (1975): 9–21.

———. *The Orientation of Hieroglyphs.* Egyptian Studies II. New York:
 Metropolitan Museum of Art, 1977.

Frankfort, H. "Preliminary Report on the Excavations at El-ʿAmarnah,
 1928–9." *Journal of Egyptian Archaeology* 15 (London, 1929):
 143–149.

*The Great Pharaoh Ramses II and His Time: An Exhibition of Antiquities from
 the Egyptian Museum, Cairo.* Montreal: Ville de Montreal, 1985.

Grimm, G. *Kunst der Ptolemäer- und Römerzeit im Ägyptischen Museum
 Kairo.* Mainz: Verlag Phillipp von Zabern, 1975.

Habachi, L. *The Sanctuary of Heqaib.* 2 vols. Elephantine IV, Archäologische
 Veröffentlichungen 33. Mainz: Verlag Phillipp von Zabern, 1985.

———. *Tell Basta.* Suppléments aux Annales du Service des Antiquités de
 l'Égypte. Cairo: Imprimerie de l'Institut Français d'Archéologie
 Orientale (sous sequestré), 1957.

Hallo, W. W., and W. K. Simpson, *The Ancient Near East: A History.* New
 York: Harcourt Brace Jovanovich, 1971.

Hari, R. *Horemheb et la Reine Moutnedjmet, ou la fin d'une Dynastie.* Geneva,
 1964.

Hassan, S. *Excavations at Giza V.* Cairo: Egyptian University, 1944.

Hayes, W. C. *The Scepter of Egypt: A Background for the Study of Egyptian
 Antiquities in the Metropolitan Museum of Art.* 2 vols. New York:
 Metropolitan Museum of Art, 1953, 1959.

Helck, W., E. Otto, and W. Westendorf, eds. *Lexikon der Ägyptologie.* 6 vols.
 Wiesbaden: Verlag Otto Harrassowitz, 1972–1986.

Hochfield, S., and E. Riesfstahl, eds. *Africa in Antiquity: The Arts of Ancient
 Nubia and the Sudan.* 1, *The Essays;* 2, *The Catalogue.* Brooklyn:
 Brooklyn Museum, 1978.

Hoffman, M. A. *Egypt before the Pharaohs.* New York: Knopf, 1979.

James, T. G. H. *Ancient Egypt: The Land and Its Legacy.* Austin: University of Texas Press, 1988.

———. *Pharaoh's People: Scenes from Life in Imperial Egypt.* Chicago: University of Chicago Press, 1984.

James, T. G. H., and W. V. Davies. *Egyptian Sculpture.* London: British Museum Publications, 1983.

Jelinkova-Reymond, E. *Les Inscriptions de la Statue Guerisseuse de Djed-Her-le-Sauveur.* Bibliothèque d'Étude, 23. Cairo: Institut Français d'Archéologie Orientale, 1956.

Johnson, S. B. "Two Wooden Statues from Lisht: Do They Represent Sesostris I?" *Journal of the American Research Center in Egypt* 17 (Locust Valley, N.Y.): 11–20.

Junker, H. *Gîza XI.* Vienna: Österreichische Akademie der Wissenschaften, 1953.

Kees, H. "Zu dem Lebensregeln des Amonspriesters Nebneteru (Kairo Cat. 42225)." *Zeitschrift für Ägyptische Sprache und Altertumskunde* 88 (Berlin, 1963): 24–26.

Kitchen, K. A. *Pharaoh Triumphant: The Life and Times of Ramesses II, King of Egypt.* Warminster: Aris & Phillips, 1982.

———. *The Third Intermediate Period in Egypt.* Warminster: Aris & Phillips, 1973.

Knudsen, J. "A Question of Paint: An Investigation into Traces of Paint on the Reserve Head from the Tomb of Ka-nofer" and "Further Investigations into the Paint on the Reserve Head from the Tomb of Ka-nofer." Papers presented at annual meetings of the American Research Center in Egypt, 24 April 1987 and 1 May 1988.

Koefoed-Petersen, O. *Catalogue des Statues et Statuettes Égyptiennes.* Ny Carlsberg Glyptothek Publications, no. 3. Copenhagen, 1950.

Kuhlmann, K. P. *Materialien zur Archäologie und Geschichte des Raumes von Achmim.* Mainz: Verlag Phillipp von Zabern, 1983.

Lauffray, J. "La colonnade-propylée occidentale de Karnak dite 'kiosque de Taharqa' et ses abords." *Kêmi* 20 (Paris, 1970).

Leblanc, C. "Diodore, le tombeau d'Osymandyas et la statuaire du Ramesseum." *Mélanges Gamal Eddin Mokhtar* 2 (Cairo, 1985): 69–82.

Leclant, J., ed. *L'Égypte du Crépuscule.* L'Univers des Formes: Le Monde Égyptien: Les Pharaons, vol. 3. Paris: Gallimard, 1980.

———, ed. *L'Empire des Conquérants.* L'Univers des Formes: Le Monde Égyptien: Les Pharaons, vol. 2. Paris: Gallimard, 1979.

———. *Montouemhat: Quatrième Prophéte d'Amon, Prince de Ville.* Bibliothèque d'Étude, 35. Cairo: Institut Français d'Archéologie Orientale, 1961.

———, ed. *Le Temps des Pyramides.* L'Univers des Formes: Le Monde Égyptien: Les Pharaons, vol. 1. Paris: Gallimard, 1978.

Legrain, G. "Rapport sur les travaux exécutés à Karnak du 31 Octobre 1902 au 15 Mai 1903." *Annales du Service des Antiquités de l'Égypte* 5 (Cairo, 1904): 1–43.

———. *Statues et Statuettes des Rois et des Particuliers.* Catalogue Général des Antiquités Égyptiennes du Musée du Caire. 3 vols. and index. Cairo: Imprimerie de l'Institut Français d'Archéologie Orientale, 1906–1925.

———. *Les Temples de Karnak.* Brussels: Fondation Égyptologique Reine Élisabeth, 1929.

Lewis, N. *Life in Egypt under Roman Rule.* Oxford: Clarendon Press, 1983.

Lindblad, I. *Royal Sculpture of the Early Eighteenth Dynasty in Egypt.* Memoir 5. Stockholm: Medelshavsmuseet, 1984.

Luxor Museum of Ancient Egyptian Art. *Catalogue.* Cairo: American Research Center in Egypt, 1979.

Malek, J. *In the Shadow of the Pyramids: Egypt during the Old Kingdom.* Norman: University of Oklahoma Press, 1986.

———. "The Saqqara Statue of Ptahmose, Mayor of the Memphite Suburbs." *Révue d'Égyptologie* 38 (Paris, 1987): 117–137.

Maspero, G. "La statue de Khonsu." *Annales du Service des Antiquités de l'Égypte* 3 (Cairo, 1902): 181.

Millet, N. B. "The Reserve Heads of the Old Kingdom." In *Studies in Ancient Egypt, the Aegean, and the Sudan: Essays in Honor of Dows Dunham,* ed. W. K. Simpson. Boston: Museum of Fine Arts, 1981.

Moorey, P. R. S. *Ancient Egypt.* Rev. ed. Oxford: Ashmolean Museum, 1983.

Müller, H. W., and J. Settgast, eds. *Nofretete Echnaton.* Berlin: Ägyptisches Museum der Staatliche Museen Preussischer Kulturbesitz, 1976.

Müller, M. *Die Kunst Amenophis' III. und Echnatons.* Basel: Verlag für Ägyptologie, 1988.

Pernigotti, E. "Una statua di Pakhraf." *Rivista degli Studi Orientali* 44 (Rome, 1969): 259–271.

Quibell, J. E. *Excavations at Saqqara (1906–7).* Cairo: Imprimerie de l'Institut Français d'Archéologie Orientale, 1908.

Redford, D. B. *Akhenaten: The Heretic King.* Princeton: Princeton University Press, 1984.

———. *History and Chronology of the Eighteenth Dynasty of Egypt: Seven Studies.* Toronto: University of Toronto Press, 1967.

Reisner, G. A. *Mycerinus, the Temples of the Third Pyramid at Giza.* Cambridge, Mass.: Harvard University Press, 1931.

Ricke, H. "Der Kopf der Göttin Neith und der Untere Tempel." In *Das Sonnenheiligtum des Königs Userkaf.* Vol. 2, *Die Funde,* ed. E. Edel et al. Wiesbaden, 1969.

Riefstahl, E. *Patterned Textiles in Pharaonic Egypt.* Brooklyn: Brooklyn Museum, 1941.

Romano, J. "Observations on Early Eighteenth Dynasty Royal Sculpture." *Journal of the American Research Center in Egypt* 13 (1976): 97–111.

Russmann, E. R. *The Representation of the King in the XXVth Dynasty.* Monographies Reine Élisabeth 3. Brussels-Brooklyn: Fondation Égyptologique Reine Élisabeth and the Brooklyn Museum, 1974.

Saleh, M., and H. Sourouzian. *The Egyptian Museum Cairo: Official Catalogue.* Munich and Mainz: Prestel-Verlag and Verlag Phillipp von Zabern, 1987.

Schäfer, H. *Principles of Egyptian Art.* Trans. and ed. J. Baines. Oxford: Oxford University Press, 1974.

Schlögl, H. A. *Der Gott Tatenen nach Texten und Bildern des Neuen Reiches.* Orbis Biblicus et Orientales 29. Freiburg Schweiz-Göttingen: Universitätsverlag-Vandenhoeck und Ruprecht, 1980.

Service des Antiquités de l'Égypte. *Centenaire de l'Institut Français d'Archéologie Orientale.* Cairo: Institut Français d'Archéologie Orientale, 1981.

Shaw, M. C. "Ceiling Patterns from the Tomb of Hepzefa." *American Journal of Archaeology* 74 (1970): 25–30.

Sherman, E. J. "Djedhor the Saviour, Statue Base OI 10589." *Journal of Egyptian Archaeology* 67 (London, 1981): 82–102.

Smith, W. S. *Ancient Egypt as Represented in the Museum of Fine Arts, Boston.* Boston: Museum of Fine Arts, 1960.

———. *The Art and Architecture of Ancient Egypt.* Baltimore, 1958. 2d ed. rev. W. K. Simpson. New York: Penguin, 1981.

———. *A History of Egyptian Sculpture and Painting in the Old Kingdom.* London: Oxford University Press/Museum of Fine Arts, Boston, 1946.

Tefnin, R. *La Statuaire d'Hatshepsout.* Monumenta Aegyptiaca 4. Brussels: Fondation Égyptologique Reine Élisabeth, 1979.

Terrace, E. L. B., and H. G. Fischer. *Treasures of the Cairo Museum.* London: Thames & Hudson, 1970.

Traunecker, C., and J.-C. Golvin. *Karnak: Résurrection d'un Site.* Fribourg (Suisse): Office du Livre, 1984.

Treasures of Tutankhamun. New York: Ballantine Books, 1976.

Trigger, B. G., B. J. Kemp, D. O'Connor, A. B. Lloyd. *Ancient Egypt: A Social History.* Cambridge: Cambridge University Press, 1983.

Vandersleyen, C., ed. *Das alte Ägypten*. Propyläen Kunstgeschichte 15. Berlin: Propyläen Verlag, 1975.

———. "La date du Cheikh el-Beled." *Journal of Egyptian Archaeology* 69 (London, 1983): 61–65.

Vandier, J. *Manuel d'Archéologie Égyptienne*. Vol. III: *Les Grandes Époques: La Statuaire*. 2 vols. Paris: Éditions A et J Picard, 1958.

Vercoutter, J., et al. *The Image of the Black in Western Art*. I, *From the Pharaohs to the Fall of the Roman Empire*. New York: William Morrow and Co., 1976.

Wenig, S. *Africa in Antiquity: The Arts of Ancient Nubia and the Sudan*. II, *The Catalogue*. Brooklyn: Brooklyn Museum, 1978.

Wildung, D. *Egyptian Saints: Deification in Pharaonic Egypt*. New York: New York University Press, 1977.

———. *Sesostris und Amenemhet: Ägypten im Mittleren Reich*. Munich: Hirmer Verlag, 1984.

Wildung, D., and G. Grimm. *Götter Pharaonen*. Mainz: Verlag Phillipp von Zabern, 1978.

Zayed, Abd El Hamid. "Deux statues de scribe accroupi en bois (Mitri)." In *Trois Études d'Égyptologie*. N.p., 1956.